MW00845826

DIMENSIONISM

DIMENSIONISM

Modern Art in the Age of Einstein

edited by Vanja V. Malloy

Mead Art Museum
Amherst College
Amherst, Massachusetts

The MIT Press
Cambridge, Massachusetts
London, England

Published in conjunction with the exhibition *Dimensionism: Modern Art in the Age of Einstein*

University of California, Berkeley Art Museum and Pacific Film Archive, November 7, 2018–March 3, 2019

Mead Art Museum at Amherst College, March 28, 2019–June 2, 2019

This book was made possible with support from the Henry Luce Foundation and the Terra Foundation for American Art.

This book was set in Neue Haas Grotesk by the MIT Press. Printed and bound in the United States of America.

Library of Congress Cataloging-in-Publication Data
Names: Malloy, Vanja. | Container of (expression): Tamkó Sirató, Károly, 1905-1980. Manifeste dimensioniste. English. | Mead Art Museum (Amherst College), organizer, host institution.
Title: Dimensionism : modern art in the age of Einstein / Vanja Malloy.
Description: Cambridge, MA : The MIT Press, 2018. | Includes bibliographical references and index.
Identifiers: LCCN 2017058653 | ISBN 9780262038478 (hardcover : alk. paper)
Subjects: LCSH: Art and science--Exhibitions. | Tamkó Sirató, Károly, 1905-1980. Manifeste dimensioniste--Exhibitions. | Art, Modern--20th century--Themes, motives--Exhibitions.
Classification: LCC N72.S3 D56 2018 | DDC 701/.05--dc23 LC record available at https://lccn.loc.gov/2017058653

facing page: Joan Miró, *Composition*, 1937. Oil on composition board. 47¾ × 35¾ inches (121.3 × 90.8 cm). University of California, Berkeley Art Museum and Pacific Film Archive; Gift of Julian J. and Joachim Jean Aberbach.

10 9 8 7 6 5 4 3 2 1

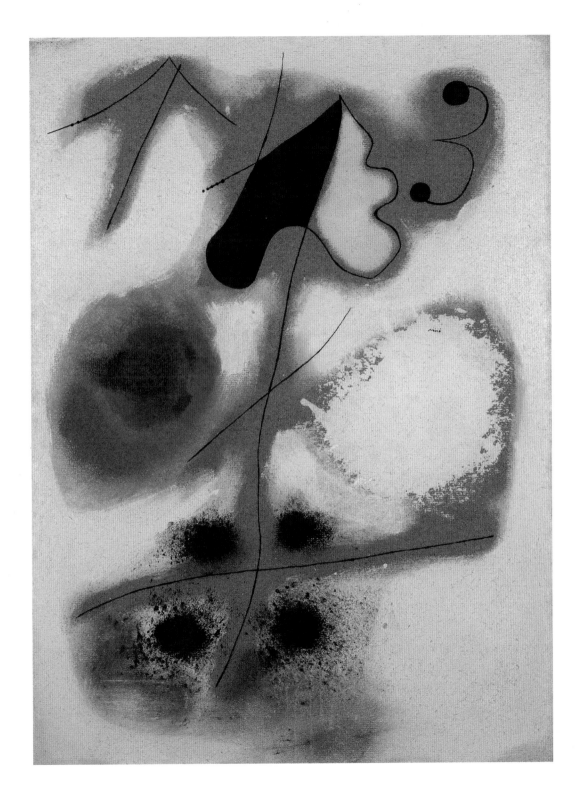

CONTENTS

DIRECTOR'S FOREWORD

The early twentieth century was a revolutionary moment in modern art and science. In the arts, the avant-garde challenged received knowledge and invented visual forms across media. Their explorations into speed, play, abstraction, and the unconscious represented a new age of modernity. Concurrently in the sciences, collective and imaginative research yielded paradigmatic breakthroughs in the fields of microbiology, physics, and astronomy. These discoveries had extraordinary implications: that time is not absolute; cosmic space is non-Euclidean; and the microcosmic and macrocosmic realms are vastly more complex and dynamic than previously imagined. Through advancements in telescopic and microscopic lenses, the unseen became seen, creating a new genre of scientific photography, new evidence for scientific inquiry, and fantastical images for the popular press. Vanja V. Malloy, curator of American art at the Mead Art Museum, has organized an extraordinary catalog and exhibition, *Dimensionism: Modern Art in the Age of Einstein*, that offers a rare and compelling account of the complex exchange between scientific thought and artistic practice at this vital moment in the history of modern art.

Dimensionism: Modern Art in the Age of Einstein takes its title in part from the little-known but influential Dimensionist Manifesto. Written in 1936 in Paris under the leadership of the Hungarian poet Charles Sirató, the Manifesto declared that artists

should respond to the scientific revolutions going on around them. During a time when the media was introducing the wider public to Albert Einstein's theory of relativity and early conceptions of our dynamic and expanding universe, the Manifesto argued that art, too, must expand itself. Two-dimensional painters sought to add a third dimension, and three-dimensional sculptors sought to add time as the fourth dimension, the better to explore Einstein's relativity, in which space and time are no longer separate categories. "All the old borders and barriers of the arts suddenly disappear," wrote the author of the Manifesto, because "this new ideology has elicited a veritable earthquake, a landslide, in the old artistic system."

An impressive array of artists lent their names to the Manifesto, including Hans Arp, Alexander Calder, Robert Delaunay, Sonia Delaunay, César Domela, Marcel Duchamp, Wassily Kandinsky, László Moholy-Nagy, Francis Picabia, and Sophie Taeuber-Arp. As this exhibition and publication reveal, however, the spirit of Dimensionism inspired artists beyond the Manifesto's initial endorsers, and reflected the drive of modern artists, in the words of the Manifesto, to be "pioneers of creative art," and to shun "older forms and exhausted essences as prey for less demanding artists!" It highlighted the ways in which science produced a unifying thread that joined together a diverse group of artists in search of a new vision for human existence and expression—one that obliterated old conceptions and parameters.

I would like to congratulate Dr. Malloy, who researched the Dimensionist Manifesto while writing her dissertation, "Rethinking Alexander Calder: Astronomy, Relativity, and Psychology," at the Courtauld Institute of Art. She also led an immense effort to translate the "History of the Dimensionist Manifesto," which Sirató wrote in 1966. The document appears here in English for the first time. Dr. Malloy, a scholar of science as well as art, brings to this exhibition and catalog an in-depth understanding of the profound ways in which science has transformed our ways of thinking and creating. The Mead Art Museum is proud to present this exhibition and catalog, which offers a remarkable window into a historical moment of encounter among artists and their self-conscious responses—through their artworks—to rapidly changing conceptions of the material world and of humans' agency within it.

This publication is the result of Dr. Malloy's vision, with additional scholarly essays by Oliver A. I. Botar, Linda Dalrymple Henderson, and Gavin Parkinson, all preeminent scholars of the intersections of modern art and science. I would like to thank Roger Conover at the MIT Press for his early enthusiasm and unwavering support of the project. And special thanks to Lawrence Rinder, director of the Berkeley Art Museum and Pacific Film Archive, for partnering as a touring venue. We are delighted that the exhibition can serve Amherst College students as an educational resource and a model of the interconnectedness of art and science, while also reaching a wider audience through its presentation at each of these venerable institutions.

We offer sincere gratitude to all our lenders as well as to our generous donors, who helped us realize this important exhibition and catalog. We are enormously grateful to the Terra Foundation for American Art for providing significant funding to support

the research, development, and implementation of this project and to the Henry Luce Foundation's American Art Program for its significant support of the exhibition. Vital funding for education programs was also provided by the Mead Art Museum's advisory board, with special thanks to board chair Charles "Sandy" Wilkes, the Wise Fund for Fine Arts, the Friends of the Mead Fund, the Hall and Kate Peterson Fund, and the Andrew W. Mellon Foundation, which supports the ongoing engagement of the museum with students and faculty at Amherst College. Publication support was provided by Younghee Kim-Wait. For ongoing support for an ambitious vision of a twenty-first century Mead Art Museum dedicated to innovative liberal arts education for a new generation of students, thank you to Carolyn "Biddy" Martin, president of Amherst College; and Catherine Epstein, dean of the faculty and Winkley Professor of History. We also thank our many colleagues at lending institutions and galleries who were critical to the success of this project.

David E. Little, Ph.D.
Director and Chief Curator
Mead Art Museum

ACKNOWLEDGMENTS

My interest in Dimensionism developed in 2010, when I first came across the mention of the 1936 Dimensionist Manifesto in Linda Dalrymple Henderson's seminal book *The Fourth Dimension and Non-Euclidean Geometry in Modern Art*. Coming from an academic background that blended science and art history, I was intrigued by this modern manifesto and its call for art to respond to the new science of its time. At first I could not find much literature on Charles Sirató, the Hungarian poet who wrote the Manifesto. However, as luck would have it, that same year the Artpool Art Research Center in Budapest, Hungary, and Magyar Műhely Kiadó copublished *The History of the Dimensionist Manifesto: Album I of Dimensionism (Non-Euclidean Arts)—The Systematisation of Avant-Garde Arts*, which included Sirató's unpublished manuscript "History of the Dimensionist Manifesto." This wonderful resource presented the text of the Manifesto, along with a history of its development as written by Sirató in 1966. It even reconstructed a number of the illustrations Sirató hoped would accompany his text. I was confronted, however, with the unfortunate reality that this exciting material was published in the author's native tongue, Hungarian, a language that I cannot read! Thankfully, Júlia Klaniczay, the director of Artpool Art Research Center, was very generous in helping me with my research and bridging the language divide whenever possible. It

was also through her that I learned of Oliver Botar's impressive work on Sirató and the Manifesto. His scholarship on this subject showed me the importance of this material in understanding the interdisciplinary exchange of ideas between science and the arts that took place in the early twentieth century. All of these influences inspired me to organize the exhibition, *Dimensionism: Modern Art in the Age of Einstein*, and this accompanying catalog, with the goal of introducing Dimensionism to a wider audience.

I am immensely grateful to David E. Little, the director and chief curator of the Mead Art Museum, who was a steadfast advocate for the exhibition from the outset and wholeheartedly encouraged me to pursue this project. I am also honored by the support that I received from Linda Henderson, Oliver Botar, and Gavin Parkinson, and thank them for the original and thought-provoking essays they contributed to this catalog. Not only are they preeminent scholars on this subject, but also I am personally indebted to them for their friendship and generosity in discussing this material with me over the past several years.

I am thankful to Krisztina Sarkady-Hart, who translated the text of the "History of the Dimensionist Manifesto," and to Oliver Botar, who translated the Dimensionist Manifesto. Júlia Klaniczay of Artpool Art Research Center was exceptionally helpful throughout this process, assisting us with the numerous questions we ran into in the process and sharing original research material. We all believe that the "History of the Dimensionist Manifesto" translation will be of tremendous interest to art historians and other scholars and we are proud to publish this document in English for the first time. I am deeply grateful to Roger Conover, executive editor of the MIT Press, for publishing this book and for his enthusiasm and unwavering support for this project, to Victoria Hindley, the associate acquisitions editor, and to the wonderful editorial, design, and production team at the press, especially Matthew Abbate. I also want to thank Matthew Christensen for preparing the index for this book. I am especially indebted to Ella Kusnetz, who copyedited the catalog manuscript.

One of the main goals of this exhibition is to introduce this subject to a wide audience. I am delighted that the show will travel to the University of California's Berkeley Art Museum and Pacific Film Archive and am grateful to Lawrence "Larry" Rinder and his colleagues for bringing this exhibition to their institution. I am thankful for the generous grant this exhibition received from the Henry Luce Foundation and would like to extend a special thanks to its president, Michael Gilligan, and to Teresa A. Carbone, program director for American art. I am also honored by the funding this exhibition received from the Terra Foundation for American Art, and would like to thank Elizabeth Glassman, the president and chief executive officer, and Carrie Haslett, program director for exhibition and academic grants. I am appreciative as well for the continued support provided by the Mead Art Museum's advisory board, the Weiss Fund for Fine Arts, the Friends of the Mead Fund, and the Andrew W. Mellon Foundation.

This exhibition required a large number of loans, and would not have been possible without the generosity of numerous individuals and institutions that lent to the exhibition. Special thanks are due to the following individuals, and to their colleagues:

Andria Derstine and Andrea Gyorody, Allen Memorial Art Museum, Oberlin; Christopher Bedford, The Baltimore Museum of Art, Baltimore; Anne Collins Goodyear, Frank H. Goodyear, and Joachim Homan, Bowdoin College Museum of Art, Brunswick, Maine; Susan Fisher, Sharon Matt Atkins, and Anne Pasternak, Brooklyn Museum, New York; Alexander S. C. Rower, Lily Lyons, Melissa Claus, and Alexis Marotta, Calder Foundation, New York; William M. Griswold, The Cleveland Museum of Art, Cleveland; Margaret C. Conrads and Mindy Besaw, Crystal Bridges Museum of American Art, Bentonville, Arkansas; Claire Whitner, Bo Mompho, and Lisa Fischman, Davis Museum, Wellesley College, Wellesley, Massachusetts; James Mundy and Mary-Kay Lombino, Frances Lehman Loeb Art Center, Vassar College, Poughkeepsie, New York; Francis Naumann and Dana Martin, Francis M. Naumann Fine Art, New York; Bruce Barnes, George Eastman Museum, Rochester, New York; Tom Gitterman and John Cowey, Gitterman Gallery, New York; Melissa Chiu and Sarah Stauderman, Hirshhorn Museum and Sculpture Garden, Smithsonian Institution, Washington, D.C.; Timothy Potts, The J. Paul Getty Museum, Los Angeles, California; Ilene Susan Fort, Stephanie Barron, and Michael Govan, Los Angeles County Museum of Art, Los Angeles; Michael Rosenfeld and Halley K. Harrisburg, Michael Rosenfeld Gallery, New York; Tricia Y. Paik, Mount Holyoke College Art Museum, South Hadley, Massachusetts; Harry Cooper and Sarah Cash, National Gallery of Art, Washington, D.C.; Dakin Hart, The Isamu Noguchi Foundation and Garden Museum, New York; Anna Marley and Brooke Davis Anderson, Pennsylvania Academy of the Fine Arts, Philadelphia; Jessica Nicoll and Aprile Gallant, Smith College Art Museum, Northampton, Massachusetts; Karen Lemmey and Stephanie Stebich, Smithsonian American Art Museum, Washington, D.C.; Richard Armstrong and Valerie Hillings, Solomon R. Guggenheim Museum, New York; Stephen Reily, Speed Art Museum, Louisville, Kentucky; Robert G. Trujillo, Glynn Edwards, and Malgorzata Schaefer, Stanford University Libraries, Stanford, California; Thomas Loughman, Erin Monroe, Marci King, Wadsworth Atheneum Museum of Art, Hartford, Connecticut; Siri Engberg, Walker Art Center, Minneapolis; Rowland Weinstein and Kendy Genovese, Weinstein Gallery, San Francisco; Adam D. Weinberg and Scott Rothkopf, Whitney Museum of American Art, New York; Kevin Murphy, Williams College Museum of Art, Williamstown, Massachusetts; Jock Reynolds, Pamela Franks, Laurence Kanter, and Mark Mitchell, Yale University Art Gallery, New Haven, Connecticut; Donna Gustafson and Thomas Sokolowski, Zimmerli Art Museum, Rutgers University, New Brunswick, New Jersey.

Other individuals provided assistance with loans or offered valued professional advice. I am pleased to thank: Elizabeth Athens, Center for Advanced Study in the Visual Arts, National Gallery of Art, Washington, D.C.; Sarah Montross, DeCordova Sculpture Park and Museum, Lincoln, Massachusetts; Alice Levi Duncan, Gerald Peters Gallery, New York; Thayer Tolles and Randall Griffey, The Metropolitan Museum of Art, New York; Bradley M. Bailey, The Museum of Fine Arts, Houston; Kathleen A. Foster, Philadelphia Museum of Art; Erica Hirshler, Museum of Fine Arts Boston; Scott Niichel, Sotheby's, New York.

ACKNOWLEDGMENTS

At the Mead Art Museum, planning and implementation of this exhibition were carried out by the museum's talented and dedicated staff: Danielle Amodeo, marketing and programming coordinator; Eric Dalton, museum writer and editor; Jocelyn Edens, assistant museum educator; Cecilia "Keffie" Feldman, acting curator of education; Stephen Fisher, collections manager; Tim Gilfillan, preparator; Eileen Smith, financial and administrative assistant; and Mila Waldman, study room manager and European print specialist. I also want to thank Julia Cardenas of the Amherst College class of 2020, who assisted me in many aspects of this exhibition and publication.

I am most appreciative of colleagues at Amherst College, especially Mary Strunk, assistant director of the grants office, who was invaluable in helping us secure funds for this exhibition; Lisa Stoffer, director of the grants office; the faculty from the department of art and history of art; Justin Smith, general counsel; Rachel Rogol, assistant director of marketing; Sara Smith, subject librarian at Frost Library; and Mark Eddington, director of Amherst College Press.

Finally, I am eternally grateful to my family, especially my husband, Patrick, and our children, Gwenyth and Oliver, for their support through every step of this project.

Vanja V. Malloy, Ph.D.
Curator of American Art
Mead Art Museum

INTRODUCTION

Vanja V. Malloy

Imagine a place in which time is not constant, cosmic space is warped (or non-Euclidean), and it's infinitely expanding. A place in which we have photographic evidence that our galaxy is surrounded by countless others, and that stars – thought to be static for millennia – are actually whizzing around at extraordinary speeds and undergoing complex life cycles. At the microbial level, every square inch of surface is squirming with movement, as photographs and film footage document layers of new realities that we cannot see with our eyes, ranging from amoebas undergoing cell division to geometric atomic structures. The speed of light is now known to be a universal constant, and its precise calculation has allowed scientists to decipher some of the fundamental laws of the universe. But our study of the quantum level suggests that not everything can always be known, as science shows that chance and uncertainty play a defining role in this realm. These new realities are not the fictional backdrop to an immersive science fiction novel; they are the realities of our universe as we learned them in the early twentieth century. These advances reflect an enormous uprooting of long-accepted "truths" and gesture to the limitations of our senses to accurately represent the physical realities that surround us.

Dimensionism: Modern Art in the Age of Einstein sets out to situate modern art in this complex historical context, examining how a diverse group of artists working in

the early twentieth century engaged with science and the philosophy of science through their art. The exhibition and catalog call attention to the 1936 Dimensionist Manifesto (see figures 1.2, 1.3; English translation on pages 170–179) written in Paris by the Hungarian poet Charles Sirató and endorsed by an international body of artists including Hans Arp, Alexander Calder, Marcel Duchamp, Robert Delaunay, Sonia Delaunay, Wassily Kandinsky, László Moholy-Nagy, Francis Picabia, and Sophie Taeuber-Arp, among others.[1] The twentieth century was an age defined by Albert Einstein, who became a fixture in popular culture, along with his 1905 special theory of relativity and 1915 general theory of relativity. Through its embrace of Einstein and his fourth dimension of space-time, the Dimensionist Manifesto undoubtedly reflects the popularization of relativity.[2] Yet the discoveries of the early twentieth century extended far beyond this one scientist's advances in theoretical physics – as remarkable as they were – and spanned many other fields, including mathematics, astronomy, biology, quantum mechanics, and engineering. And while the Manifesto can be understood as a product of the Einstein era, it was also constructed deliberately to embrace artistic interest in a range of sciences that asserted the presence of an invisible metareality just beyond the realm of human perception. "All the old limits and boundaries of the arts disappear," wrote the Manifesto's author, because "this new ideology has elicited a veritable earthquake and subsequent landslide in the conventional artistic system." Just as critically, while the Manifesto's collection of signatures represents an impressive grouping of some of today's best known modern artists, the movement of Dimensionism was intended to expand far beyond these initial endorsers, reflecting the drive of many modern artists throughout Europe and America to discover a new vision for human existence and expression in an era that redefined fundamental realities such as time and space.

This Manifesto and the interdisciplinary exchange it documents are often omitted in the predominant narrative of modern art. C. P. Snow famously observed in his 1959 lecture "The Two Cultures" that the professionalization of the sciences in the 1800s facilitated the common misperception that art and science belong to two irreconcilable strata of thought.[3] Snow's viewpoint can in part explain the gulf that seems to separate modern art from the science of its time. Thankfully, however, much new scholarship has challenged that assumed schism by seeking to recoup the interconnections and exchanges between these two areas of interest. In particular, the writings of the art historians Linda Dalrymple Henderson and Gavin Parkinson have documented the substantial impact of scientific thought on the artists of the early twentieth century.[4] Parkinson's 2008 book *Surrealism, Art and Modern Science: Relativity, Quantum Mechanics, Epistemology* shows how the Surrealists came to know the theory of relativity and quantum mechanics and how they responded to these new areas of physics through their artwork. Henderson's 1983 book *The Fourth Dimension and Non-Euclidean Geometry in Modern Art*, reissued in a revised edition by the MIT Press in 2013, examines how artists of the early twentieth century engaged with spatial conceptions of the fourth dimension, such as the hyperspace philosophy of J. M. Hinton and P. D. Ouspensky, as well as the new perception of reality fostered by the

developments of X-rays, ether, and radioactivity.[5] I first learned about the Dimensionist Manifesto from Henderson's book, and it was her introductory discussion of this document that inspired my curiosity about its content, its creator, and its importance in returning science and the philosophy of science to our understanding of modern art.[6]

Part of what makes the Dimensionist Manifesto so remarkable is that it bridges the artistic mediums of poetry, painting, and sculpture, by placing the new scientific thought as a central factor in the conceptual development of an artist's work. The opening text of the Manifesto outlines this mission:

> Dimensionism is a general movement of the arts. Its unconscious origins reaching back to Cubism and Futurism, it has been continuously elaborated and developed since then by all the peoples of Western civilization.
>
> Today the essence and theory of this great movement bursts with absolute self-evidence.
>
> Equally at the origin of Dimensionism are the European spirit's new conceptions of space-time (promulgated most particularly by Einstein's theories) and the recent technical givens of our age.
>
> The absolute need to evolve, an irreducible instinct, has sent the avant-garde on their way toward the unknown, leaving dead forms and exhausted essences as prey for less demanding artists.
>
> We must accept – contrary to the classical conception – that Space and Time are no longer separate categories, but rather that they are related dimensions in the sense of the non-Euclidean conception, and thus all the old limits and boundaries of the arts disappear.
>
> This new ideology has elicited a veritable earthquake and subsequent landslide in the conventional artistic system. We designate the totality of relevant artistic phenomena by the term "DIMENSIONISM."[7]

Responding to the new science, Dimensionist art seeks to provide symbolic representations of the new conceptions of physical reality, in part by breaking free from its given format and expanding itself into the next dimension – with poetry "leaving the line" to encompass the pictorial plane (figures A.1–8), two-dimensional painting adding a third dimension of depth by which the painting enters into space (figure 0.1), and sculpture incorporating movement to occupy the fourth dimension of space-time (figure 0.2). While the original 1936 Manifesto explains this law formulaically as "N + 1," the later 1969 version articulates the idea in more detail:

> The formula "N + 1" expresses the Dimensionist development of the arts. … We [i.e., the signers of the Manifesto] generalized its application in order that we might attribute – in the most natural way possible – the seemingly chaotic, unsystematic, and inexplicable artistic phenomena of our age to *one single common law*. Animated by a new feeling for the world, the arts – in collective fermentation …

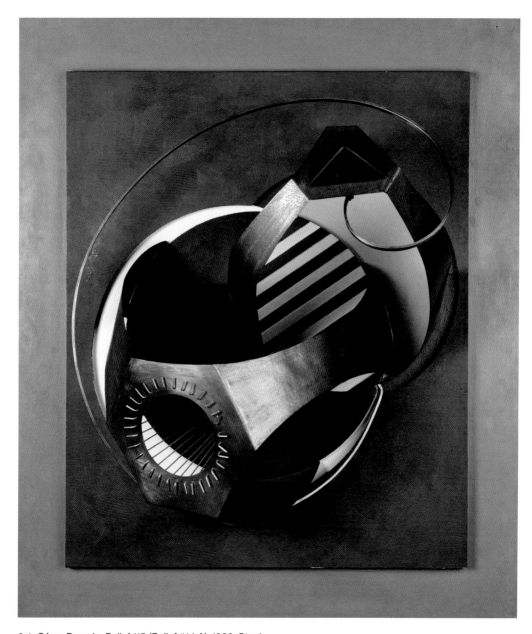

0.1 César Domela, *Relief 115 (Relief #14 A)*, 1938. Steel and red copper. 41.1 × 35 × 14 inches (104.5 × 89 × 36 cm). Musée National d'Art Moderne, Centre Georges Pompidou, Paris, France (AM2000-DEP3).

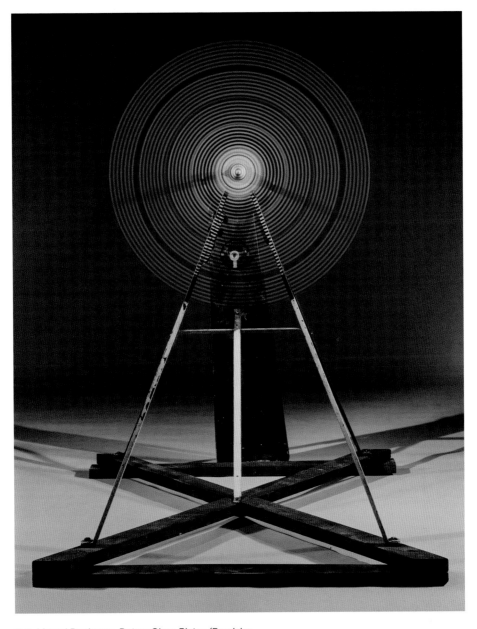

0.2 Marcel Duchamp, *Rotary Glass Plates (Precision Optics)*, 1920. Painted glass, iron, electric motor, and mixed media. 65¼ × 62 × 38 inches (165.7 × 157.5 × 96.5 cm). Yale University Art Gallery, New Haven; Gift of Collection Société Anonyme (1941.446a-c).

– have been set into motion, and each has absorbed a new dimension, each has found a new form of expression inherent in the new dimension (N + 1), opening the way to the weighty spiritual/intellectual consequence of this fundamental change.[8]

In its outlined goals for each artistic medium the Manifesto breaks down barriers between artistic categories, and it takes an equally interdisciplinary approach to the sciences, citing inspiring advances in fields as disparate as physics, biology, mathematics, and engineering. But while retaining a broad focus on all of the arts and sciences, the document draws most explicitly on the "modern spirit's completely new conception of space and time" in its discussion of sculpture.[9]

Sculpture [has stepped] out of closed, immobile forms (i.e., out of forms conceived of in Euclidean space), in order … [to] appropriate for artistic expression [Hermann] Minkowski's four-dimensional space. It has been, above all, "solid sculpture" that has opened itself up, first to inner space, and then to movement; this is the sequence of developments: Perforated sculpture; *sculpture-ouverte*, Mobile sculpture; Kinetic sculpture.[10]

In order to unify the multiple frames of reference introduced by Einstein's special theory of relativity in 1905, Hermann Minkowski, in 1908, had formulated the fourth dimension as time in the space-time continuum.[11] "Space and time are no longer separate categories," the Manifesto states in its introduction, but rather "related dimensions" that are joined inseparably. This emphasis on space-time as the fourth dimension is reinforced by the Manifesto's inclusion of artists such as Calder and Moholy-Nagy, whose sculptures exemplify Einstein's and Minkowski's conceptions through their incorporation of movement. Although not mentioned explicitly in the document, other modern artists working across a range of mediums were also engaging with this new dimension through their art, such as the Swiss-American photographer Herbert Matter, who used stroboscopic technology to create arresting photographs that capture the wake of motion outlined by a figure's movement in time (figure 0.3).

This catalog is the first publication devoted to critical writing on Dimensionism. It opens with Oliver Botar's essay "Charles Sirató and the Dimensionist Manifesto," which masterfully reconstructs the creation of the Dimensionist Manifesto. Covering Sirató's formative early career as a poet in Budapest and his knowledge of science, Botar situates the artist and the Manifesto in relation to Einstein's theory of relativity and its fourth dimension of space-time, as well as advances in other scientific fields including biology and mathematics. He documents Sirató's move to Paris, where he encountered the poetry, painting, and sculpture of the avant-garde and decided that Dimensionism was already present in the work of many advanced artists.[12] Sirató's Dimensionist Manifesto sought to unify the arts by distilling this organic movement and calling attention to it. Botar's essay details how various artists, including a number that did not end up signing the document, came to participate in its planning, creation, and

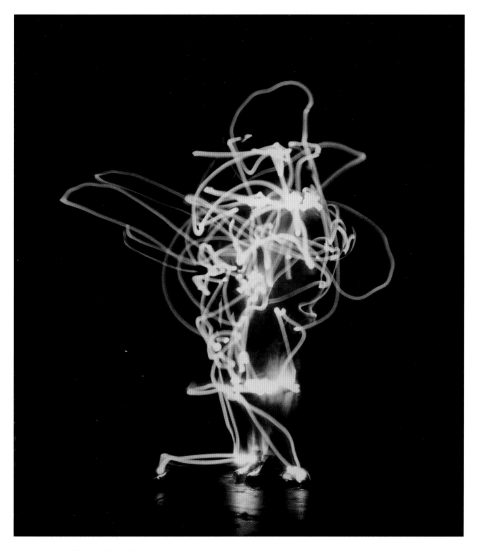

0.3 Herbert Matter, *Man Dressing*, 1944.
Photograph. 11 × 14 inches (28 × 35.6 cm).
Stanford University Libraries, Stanford,
California.

dissemination. The sources of this essay include Sirató's own 1966 text on the subject, the "History of the Dimensionist Manifesto," as well as an interview that Botar conducted with Sirató in 1980, five weeks before the artist's death. The "History of the Dimensionist Manifesto" offers a remarkable window onto a historical moment of encounter among artists, illuminating their highly self-conscious artistic responses to rapidly changing conceptions of the material world and of humans' agency within it. This primary document serves both as an interpretive aid and a significant common

ancestor for a network of international artists, providing detailed accounts of how key artists learned of the Manifesto and engaged with its ideals. Published for the first time in English in the appendix to this catalog, this significant and extensive manuscript will be a vital resource for future research on this topic.

As both Sirató's and Botar's texts demonstrate, Dimensionist artists approached these new scientific concepts through their varying understandings of new and old science, as well as different personal beliefs and artistic motives. While some artists such as Alexander Calder had specialized knowledge in engineering, physics, and science more generally, many more had been introduced to these ideas through nonscientific avenues.[13] One example is the painter Ben Nicholson, a Christian Scientist whose interest in modern physics and astronomy was informed by his faith, in particular the work of the Cambridge astrophysicist and devout Quaker Sir Arthur Eddington, whose popular writing and lectures contained pronounced echoes of the writings of the Christian Science founder Mary Baker Eddy.[14] In an attempt to accommodate this diverse group of artists, the Manifesto sought to stay "liberal in conception" and allow for a "wide range of nuance."[15] It provided its signees the opportunity to include a concise clarifying statement on their art in its "Mosaic" section, which was printed on the Manifesto's verso. In this document Duchamp, for instance, who had an interest in higher spatial dimensions that predated the understanding of the fourth dimension as space-time, provides a brief explanation of his involvement in the Manifesto, writing of his "use of movement in the plane for the creation of forms in space: *Rotoreliefs*."[16] He refers here to the series of works he had produced in 1935 that feature a flat two-dimensional disc with a spiral design that, when set in rotary motion, invokes the presence of a wobbly cylindrical volume that appears to expand and contract. Based on the optical illusion created by the kinetic manipulation of the spiral, the work appears to transport a two-dimensional circle into a three-dimensional object that moves in four-dimensional space-time.

However, as Linda Henderson explains in her essay in this volume, while Duchamp's *Rotoreliefs* may have satisfied the Dimensionist Manifesto's call for art to occupy four-dimensional space-time, the *Rotoreliefs* actually reflect Duchamp's pre-Einsteinian interest in using motion to generate a higher-dimensional space, revealing how twentieth-century artists had multiple understandings of the fourth dimension. In "The Dimensionist Manifesto and the Multivalent Fourth Dimension in 1936: Sirató, Delaunay, Duchamp, Kandinsky, and Prampolini," Henderson draws, like Botar, on Sirató's "History of the Dimensionist Manifesto" and its detailed recollections of how artists such as Duchamp, Robert Delaunay (figure 0.4), Kandinsky (figure 0.5), and Enrico Prampolini came to sign the document. She shows how the relative ages of the original signers may have played a role in their approach to science, with older artists tending to contemplate relativity alongside earlier scientific concepts such as higher mathematical dimensions, ether, or vibrations. As such, Henderson's essay reveals a complex engagement between the arts and sciences in the modern era in which science served as a stimulus that was absorbed by artists through their preexisting conceptions and motivations and consequently reflected a gamut of understandings.

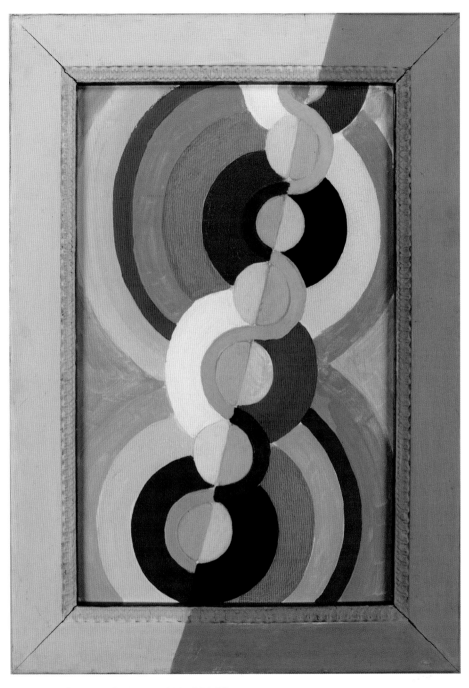

0.4 Robert Delaunay, *Rythme*, c. 1932–1937. Oil on artist board. 29¾ × 21 × 1⅛ inches (75.6 × 53.3 × 2.9 cm). Frances Lehman Loeb Art Center, Vassar College, Poughkeepsie, New York; bequest of Gladys K. Delmas, class of 1935 (1992.15.27).

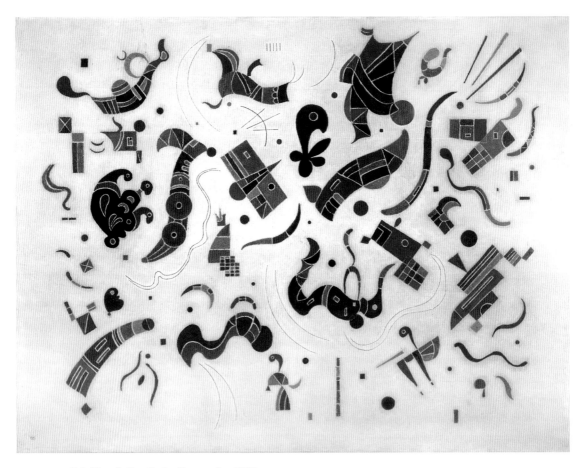

0.5 Wassily Kandinsky, *Succession*, 1935. Oil on canvas. 31⅞ × 39⅜ inches (81 × 100 cm). The Phillips Collection, Washington, DC; acquired 1944.

Soon after Sirató wrote his Dimensionist Manifesto he also began to collect photographs of Dimensionist artworks for his First Dimensionist Album, which he continued to do in the 1960s when writing his "History of the Dimensionist Manifesto."[17] These images reflect the broad range of scientific advances from which artists were drawing inspiration, from the irregular biomorphic forms of microbial organisms as revealed in new scientific photography and films (figure 0.6) to the dynamic stars and planets of the macrocosm (figure 0.7). What is further noteworthy about these images is that Sirató himself apparently did not restrict Dimensionist art to the endorsers of the Manifesto, nor to the date of the Manifesto (1936), nor to artwork created in Paris or in Europe. His photographs represent a range of artwork from the early twentieth century through the 1960s, produced by artists throughout Europe, the United States, and South America, thereby confirming his assertions in the "History of the Dimensionist

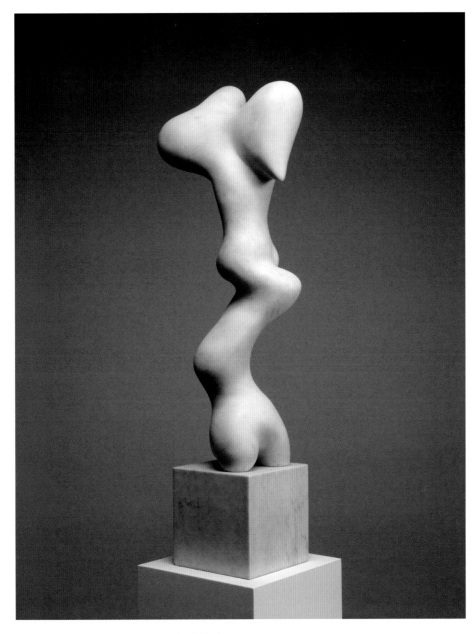

0.6 Jean Arp, *Growth*, 1938. Marble. 31⅝ inches
(80.3 cm) high. The Solomon R. Guggenheim
Museum, New York (53.1359).

Manifesto" that Dimensionism was from its inception an international movement.[18] Artists of this era were increasingly global, and as geopolitical earthquakes shook Europe in the early twentieth century, a number took up residence in the United States, including Marcel Duchamp, Max Ernst, Naum Gabo, Frederick Kann, André Masson, Roberto Matta, Herbert Matter, László Moholy-Nagy, Wolfgang Paalen, and Yves Tanguy.

0.7 Nina Negri, *Flight (Envol)*, n.d. Print. 15.7 × 12.6 inches (40 × 32 cm). Musée National d'Art Moderne, Centre Georges Pompidou, Paris.

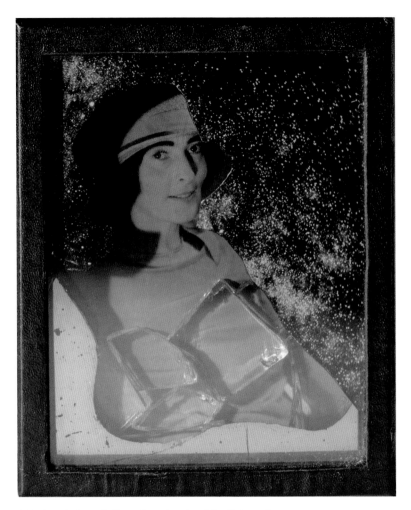

0.8 Joseph Cornell, *"Imperious Jewelry of the Universe"
(Lunar Baedecker): Portrait of Mina Loy, Daguerreotype-
Object,* 1938. Assemblage with silvered glass, glass shards,
cut-out printed illustration, gelatin silver print, and other
materials. 5 3/16 × 4 3/16 × 1 inches (13.2 × 10.6 × 2.5 cm).
Photograph by Man Ray. Philadelphia Museum of Art,
Philadelphia; 125th Anniversary Acquisition. The Lynne
and Harold Honickman Gift of the Julien Levy Collection,
2001 (2001.62.3).

My essay in this catalog, "From Macrocosm to Microcosm: Examining the Role of Modern Science in American Art," establishes the important role of the art-science exchange in the United States and examines how new abstract conceptions of space provided by science were envisioned in the realms of the macrocosm and microcosm. For instance, Einstein's general theory of relativity became more than just an abstract concept in the popular photographs of the 1919 and 1925 total solar eclipse, which proved an important postulate in Einstein's theory by documenting the bending of starlight as it traveled through space. Einstein's abstract theory introduced this new perception of the cosmos, in which the mass of a cosmic body exerts an immense gravitational pull that makes the celestial landscape curved, irregular, or otherwise non-Euclidean. The essay shows how the image of the eclipse and this warped cosmic space inspired many artists working in the United States and how advances in U.S. telescope design further informed the visual vocabulary of their work (figure 0.8). At the same time, technological advances in microscopy, and the related developments in photography and film, allowed both scientists and artists to focus on the microcosmic world, connecting the life cycles of the tiniest organisms to those of stars and planets that make up the sprawl of the universe.

The book concludes with an essay by Gavin Parkinson, "Revolutions in Art and Science: Cubism, Quantum Mechanics, and Art History." Building upon the author's previous publications on artists of the 1930s such as Roberto Matta (figure 0.9) and Wolfgang Paalen and their engagement with the new physics of quantum mechanics, this essay reveals that artists were not the only participants in the art-science exchange in the early twentieth century. Parkinson documents how art critics, for example, based their analyses of the work of Cubist artists such as Pablo Picasso (figure 0.10) and Georges Braque on the new physics of quantum mechanics, creating a dialogue between Cubism and quantum physics that until this point had been unknown to the field of art history. His essay, along with this publication as a whole, demonstrates how some of the most influential and famous works of art cannot be understood fully unless they are contextualized within the modern social and scientific upheavals that shaped them.

While most of us today have heard of Einstein's theory of relativity, few are aware of the degree to which the twentieth century introduced new realities beyond human perception though its advances spanning mathematics and astronomy. So it is with Dimensionism. The ideas it embodied had a profound impact on modern art, and yet it has been largely forgotten. *Dimensionism: Modern Art in the Age of Einstein* aims to make visible the immense richness and diversity of the physical forms created by artists in response to the complex new ideas that informed the scientific revolution in the modern era. The goal of both the exhibition and this catalog is to enrich our understanding of modern masters such as Arp, Calder, Cornell, Moholy-Nagy, and Taeuber-Arp while inspiring a revision of the narrative of twentieth-century modern art as a whole. Without a consideration of how scientific developments shaped many artists' aspirations in this era and later, any study of the period will remain two-dimensional indeed.

0.9 Roberto Matta, *The Onyx of Electra*,
1944. Oil on canvas. 50⅛ × 72 inches (127.3 ×
182.9 cm). Museum of Modern Art, New York;
Anonymous fund (963.1979).

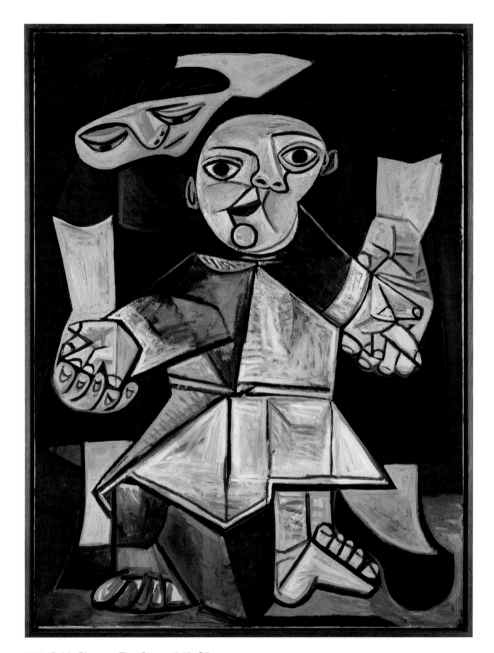

0.10 Pablo Picasso, *First Steps*, 1943. Oil on canvas. 51¼ × 38¼ inches (130.2 × 97.1 cm). Yale University Art Gallery, New Haven; Gift of Stephen Carlton Clark, B.A. 1903 (1958.27).

1 CHARLES SIRATÓ AND THE DIMENSIONIST MANIFESTO

Oliver A. I. Botar

To the memory of Árpád Mezei (1902–1998)

CHARLES SIRATÓ AND DIMENSIONISM

At the end of May 1936, the poet Charles Sirató published his Dimensionist Manifesto (*Manifeste Dimensioniste*) in Paris (figure 1.1).[1] It was signed by, among others, Pierre Albert-Birot, Hans Arp, Camille Bryen, Alexander Calder, César Domela, Robert Delaunay, Sonia Delaunay, Marcel Duchamp, Luis Fernández, Wassily Kandinsky, Katarzyna Kobro, László Moholy-Nagy, Ben Nicholson, Francis Picabia, Enrico Prampolini, and Sophie Taeuber-Arp (figures 1.2, 1.3, 1.4; for English translations see appendix). The Manifesto struck a chord in the art and literary world of the time and, drawing together members of both the Surrealist and recently disbanded Abstraction-Création groups, it was a rare rallying point for the interwar Parisian avant-garde. In it Sirató and his close associates both observed and promoted a kind of dimensional inflation in the arts to reflect and correspond with the advancement in perception they believed was under way as a result of Albert Einstein's conception of special relativity and Hermann Minkowski's related formulation of the space-time continuum. Thus, Sirató wrote of poetry's shift from the linear (unidimensional) to the planar (two dimensional), of painting from the planar to the three dimensional (i.e., the relief), and of sculpture from three dimensions to four, which he defined as its incorporation of kinetics, setting the stage for an immaterial type of multisensorial art, its "vaporization."

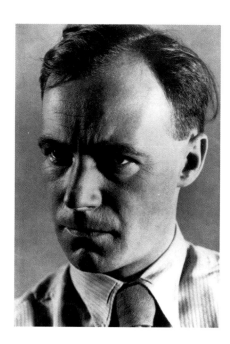

1.1 Photographer unknown, portrait of Charles Sirató, Paris, 1936. From the archive of Oliver Botar.

1.2 Charles Sirató, Dimensionist Manifesto, loose-leaf insert intended for the first issue of the unrealized journal *La Revue N + 1* (published by José Corti, Paris, June 1936).

Despite Sirató's invocation in the Manifesto of the Einsteinian-Minkowskian conception of space-time based on "non-Euclidean" geometries, Linda Henderson's essay in this volume explains how the very formulation "N + 1" reflects a multi-variant understanding of the fourth dimension.[2] While Sirató's understanding of the new science may not have been fully up to date, he at least tried to inform himself of the science, and he certainly saw himself as one who possessed a scientific understanding of the physics rather than a merely intuitive one. In the Manifesto Sirató characterized Dimensionism as "a general movement in the arts begun unconsciously by Cubism and Futurism." Basing his work on observations of contemporary art, Sirató conceived of the Manifesto as a means of making conscious this intuition of the *Weltanschauung* shift brought on by Einstein and Minkowski. Through such a bringing-to-consciousness Sirató hoped to establish Dimensionism as a program for artistic production.[3]

Basing the Manifesto on his compatriot Árpád Mezei's syncretic and eccentric combination of Bergsonian-Spenglerian biologistic and Minkowskian ideas, Sirató managed to formulate a text that was simple, descriptive, and prescriptive. It was also vague enough in its science so that it seemed to offer scientific legitimation to an approach to art at odds with the group that most of the signers saw as their rivals — the Paris Surrealists. In 1936 Sirató began compiling the *Premier album Dimensioniste* (First Dimensionist Album), a "photographic anthology of the works of dimensionist artists" — in other words, a kind of *musée imaginaire* of artworks that, in his view,

Prix : 1 fr.50

MANIFESTE DIMENSIONISTE

ch. sirato

Librairie José Corti
6, rue de Clichy. Paris 9ᵉ

Le dimensionisme est un mouvement général des arts, commencé inconsciemment par le cubisme et le futurisme, — élaboré et développé depuis continuellement par tous les peuples de la civilisation occidentale.

Aujourd'hui l'essence et la théorie de ce grand mouvement éclatent avec une évidence absolue.

A l'origine du dimensionisme se situent également les nouvelles idées d'espace-temps de l'esprit européen (répandues plus particulièrement par les théories d'Einstein) — ainsi que les récentes données techniques de notre époque.

Le besoin absolu d'évoluer — instinct irréductible — qui fait que les formes mortes et les essences expirées sont devenues la proie des seuls dilettantes, oblige les avant-gardes à marcher vers l'inconnu.

Nous sommes obligés d'admettre — contrairement à la thèse classique — que l'Espace et le Temps ne sont plus des catégories différentes, mais suivant la conception non-euclidienne : des dimensions cohérentes, et ainsi toutes les anciennes limites et frontières des arts disparaissent.

Cette nouvelle idéologie a provoqué un véritable séisme et ensuite un glissement de terrain dans le système conventionnel des arts. L'ensemble de ces phénomènes, nous le désignons par le terme : « DIMENSIONISME ». /Tendance ou Principe du Dimensionisme. Formule : « N + 1 ». (Formule découverte dans la théorie du Planisme et généralisée ensuite, en réduisant sur une loi commune les manifestations apparemment les plus chaotiques et inexplicables de notre époque d'art.) /

ANIMES PAR UNE NOUVELLE CONCEPTION DU MONDE, LES ARTS, DANS UNE FERMENTATION COLLECTIVE (Interpénétration des Arts) SE SONT MIS EN MOUVEMENT ET CHACUN D'EUX A EVOLUE AVEC UNE DIMENSION NOUVELLE. CHACUN D'EUX A TROUVE UNE FORME D'EXPRESSION INHERENTE A LA DIMENSION SUPPLEMENTAIRE, OBJECTIVANT LES LOURDES CONSEQUENCES SPIRITUELLES DE CE CHANGEMENT FONDAMENTAL.

Ainsi la tendance dimensioniste a contraint :

I. la Littérature à sortir de la ligne et à passer dans le plan.
Calligrammes. Typogrammes. Planisme
(préplanisme) Poèmes Electriques.

II. la Peinture à quitter le plan et à occuper l'espace.
Peinture dans l'Espace. « Konstruktivisme »
 Constructions Spatiales.
 Compositions Poly-Matérielles.

III. la Sculpture à abandonner l'espace fermé, immobile et mort, c'est-à-dire l'espace à trois dimensions d'Euclide, — pour asservir à l'expression artistique l'espace à quatre dimensions de Minkovsky.

D'abord la sculpture « pleine » (sculpture classique) s'éventra et en introduisant en elle-même le « manque » sculpté et calculé de l'espace intérieur — et puis le mouvement — se transforme en :
Sculpture Creuse.
Sculpture Ouverte.
Sculpture Mobile.
Objets Motorisés.

Ensuite doit venir la création d'un art absolument nouveau :
L'Art Cosmique
(Vaporisation de la Sculpture
Théâtre Synos-Sens, dénominations provisoires). La conquête totale par l'art de l'espace à quatre dimensions /un « Vacuum Artis » jusqu'ici/. La matière rigide est abolie et remplacée par les matériaux gazéifiés. L'homme au lieu de regarder des objets d'art, devient lui-même le centre et le sujet de la création et la création consiste en des effets sensoriels dirigés dans un espace cosmique fermé.

Voilà dans son texte le plus restreint le principe du dimensionisme. Déductif vers le passé. Inductif vers le futur. Vivant pour le présent.

BEN NICHOLSON (Londres).
ALEXANDRE CALDER (New-York).
VINCENT HUIDOBRO (Santiago du Chili).
KAKABADZE (Tiflis).
KOBRO (Varsovie).
JOAN MIRO (Barcelone).
LADISLAS MOHOLY-NAGY (Londres).
ANTONIO PEDRO (Lisbonne).

HANS ARP - PIERRE ALBERT-BIROT - CAMILLE BRYEN - ROBERT DELAUNAY - CESAR DOMELA - MARCEL DUCHAMP - WASSILY KANDINSKY - FREDERICK KANN - ERVAND KOTCHAR - NINA NEGRI - MARIO NISSIM - FRANCIS PICABIA - ENRICO PRAMPOLINI - PRINNER - SIRI RATHSMAN - CHARLES SIRATO - SONIA DELAUNAY - TAEUBER-ARP.

Feuille détachée de " LA REVUE N+1 " 1936. Paris. 25 rue Vavin.

MOSAIQUE

Le changement fondamental de notre conception du monde, transmutation profonde, d'où résulte la grande révolution formelle des arts, réside dans l'absolue négation du matérialisme et du spiritualisme pur. Le résultat de ce changement est l'avènement de l'idée synthétique dans laquelle esprit et matière forment un seul processus.
En art l'esprit est la source la matière (forme) est l'expression.

Kandinsky.

Les pas traînants du piéton : les lettres ∞ la littérature linéaire. Les voitures sur les routes, les trains rapides : les lignes précipitées ∞ la littérature à deux dimensions.
Pourquoi je fais de la superposition dans la peinture ? Parce qu'on n'en a jamais fait jusqu'ici.

Picabia.

La contraction longitudinale de l'espace pictural.

Louis Férnandez.

Compositions Poly-matérielles — la joie contemporaine de la création du monde.

Pamprolini.

L'homme ailé : la Peinture dans l'Espace.
C'est ma plus grande satisfaction d'avoir ventilé le cerveau d'Euclide : Sculpture Ouverte.

Kotchar.

Le fait qu'il existe un nouveau mode d'expression de l'art plastique, qui diffère du mode traditionnel, est à mon avis la preuve suffisante pour le justifier. La Vie évolue sans cesse, n'obéissant qu'à sa propre loi fondamentale, mystérieuse, d'après laquelle elle se renouvelle perpétuellement.

Kann.

J'insiste sur l'extrême importance des préoccupations spécialement psychiques, qui ont permis la voie vers la poésie, à son tour, d'évoluer vers la forme automatique.
Après cette dernière étape, l'expression poétique tend vers des réalisations à plusieurs dimensions.
Je considère les objets surréalistes comme une expression poétique à trois dimensions. Il me semble évident, que ce chemin conduit à une Nouvelle Réalité et qu'il ne saurait rien avoir à faire avec les confusions qu'entraînent les mots d'Art concrets et abstraits.

Arp.

La Peinture Occidentale a conquis symboliquement l'espace (la profondeur par la perspective) depuis la Renaissance. Le Cubisme a rejeté cette conquête. Il a réoccupé la surface. La Peinture Abstraite a rigoureusement gardé ce résultat du Cubisme, en se simplifiant toujours.
Quand les peintres abstraits voient qu'il n'y a plus rien à faire dans une surface à deux dimensions, la Peinture doit ou bien mourir sur le dernier carré de Mondrian, ou bien accepter la seule possibilité vivante, c'est-à-dire prendre la troisième dimension : évoluer dans l'espace. Conquérir réellement l'espace à trois dimensions.

Kotchar-Nissim.

Une Nouvelle Réalité s'impose en dehors de tous les Réalismes connus; ni perspective, ni euclidienne, ni claire-obscure. Matériaux nouveaux. Couleurs dans le sens de non-imitation. La lumière électrique comme rythmes. Le rythme comme sujet.
L'architecture étant monumentale, cette nouvelle expression y trouve sa place en faisant vivre les surfaces et les vides. Seule une architecture polychrome et non-décorative peut devenir dynamique et plastique en rapport avec cet art actuel.

Delaunay.

Peinture ? Le Plan est mort. Les objets, aujourd'hui, aspirent à crever la toile. La Peinture poursuit donc chaque jour son effort de libération : c'est ainsi qu'elle s'affirme fidèle à sa tradition.

Nissim.

Rotation, forme de vie des Univers. Forme de vie inconnue de l'art. Utilisation des mouvements dans le plan, pour la création des formes dans l'espace : Rotoreliefs.

Duchamp.

Dans le vide universel la création poétique invente les nouvelles dimensions du plaisir. Je voudrais comme poème inventer un animal vivant d'un règne inconnu.

Bryen.

L'homme « unité et entité biologiques » le seul fondement qui nous reste pour un art entièrement nouveau. Fusion de la musique et de l'art cosmique. Qu'on le veuille ou non, cette revalorisation de l'homme comme centre de création s'imposera.

Sirato.

Sens profond du Dimensionisme : la Révolution Biologique.

Sirato-Bryen.

Les formes d'art sont des matérialisations d'un état d'esprit. La grande Révolution de forme, qui se prépare depuis le commencement de notre siècle est le résultat organique du changement fondamental de notre conception du monde.
Le Manifeste laisse la possibilité de développer d'une façon plus détaillée tous les problèmes qu'il soulève, dans notre Revue par les artistes eux-mêmes, et dans le livre « Les Arts et les Artistes non-euclidiens » par Ch. Sirato.

Les Signataires.

LE DIMENSIONISME

n'est pas un mouvement voulu, créé, ou dirigé; c'est une evolution qui depuis longtemps existait sous forme latente. Le Manifeste est en réalité une constatation générale, déduite des œuvres de certains artistes avancés, et, en même temps, un élargissement des idées initiales dérivées de la littérature à deux dimensions.

C'est la première fois qu'un Exposé de 60 lignes a pu réunir dans un temps aussi bref (deux mois environ) l'approbation unanime et spontanée de 25 artistes, les plus remarquables de tous les pays.

Cela prouve que notre Exposé est une prise de conscience. Nous avons mis à jour une vérité — et sans nos recherches antérieures personne n'aurait pu l'exprimer avec autant de précision.

Le Manifeste Dimensioniste est largement conçu. De l'Interprétation des Arts jusqu'à l'Art Cosmique il comporte une gamme complète de nuances. Les œuvres des signataires sont, toutes, saturées d'esprit dimensioniste. D'ailleurs nous n'avons invité à nous approuver que les artistes dont la valeur dimensioniste clairement rayonnait et qui possédaient d'avance des places bien établies dans le développement futur de nos théories.

NOTRE MANIFESTE EST UN DEPART.

" LA REVUE N + 1 "

POUR LES ARTS NON-EUCLIDIENS

Le livre où le principe du Dimensionisme était découvert, qui apporte les premières bases de la théorie non-euclidienne des arts :

ch. sirato
LE PLANISME
(la littérature à deux dimensions)

I^re Partie . La théorie du Planisme.
II^me Partie . Les poèmes planistes.

(Nous attirons particulièrement l'attention sur le chapitre V. : La décomposition de la Littérature. Introduction du Planisme selon les nouvelles idées d'espace-temps d'Einstein et Minkovsky)
PLAN-POEMES . ELECTRO-PLAN-POEMES.
Matérialisations absolument nouvelles de la pensée poétique.
Appareil-Ballade. Roman-Brique etc.

Edition de la Nouvelle Réalité. Demandez le prospectus à la librairie TSCHANN 84, Bd. du Montparnasse Paris

NOS LIVRES EN PREPARATION :

Ch. Sirato : « Les arts et les artistes non euclidiens ». Une nouvelle conception expliquant les artistes les plus avancés, avec documents et analyses des œuvres.

Ch. Sirato : « La Vaporisation de la Sculpture ». Création d'un art futur, qui naît sous nos yeux, but de l'évolution, suprême résultat synthétique d'une héroïque poésie.

Album Dimensioniste Anthologie photographique d'œuvres des artistes dimensionistes.

C. Bryen : « 5 objets poétiques » photographiés par Raoul Michelet.

E. Kotchar : La Peinture dans l'Espace.

J. Van Heeckeren : Roman Gothique.

Madame Jeanne Bucher et Madame Cuttoli ont présenté dans leur galerie, 9 ter, boulevard du Montparnasse, du 4 au 14 mars, quelques œuvres récentes de Francis Picabia.

L'exposition Arp, Kandinsky, Taeuber-Arp. a eu lieu à la Galerie Pierre, 2, rue des Beaux-Arts, du 2 au 4 mai.

Aux Quatre-Chemins, 99, boulevard Raspail, des œuvres de Ferren, Mead, Negri, Prinner, Rathsman ont été exposées du 10 au 25 mars.

« Regain », centre d'information des tendances nouvelles des arts contemporains Président : Gaston Diehl, 8, rue Monge.

« Orbes », revue aux tendances dimensionistes. Directeur : Jacques-Henri Lévesque, Saint-Cloud, 21, rue de l'Eglise.

Le Dadaïsme à la Sorbonne. La conférence de J.-H. Lévesque sur le Dadaïsme a eu lieu le 6 mai à l'Amphithéâtre Guizot.

Pour votre phonographe, faites tourner les « Rotoreliefs ». — En vente chez tous les libraires.

L'Imprimerie des 2 Artisans, 18, rue Ernest-Cresson, Paris-14^e est l'imprimerie des Artistes.

LA POESIE A DEUX DIMENSIONS. — PEINTURE DANS L'ESPACE. « KONSTRUKTIVISME ». CONSTRUCTIONS SPACIALES. COMPOSITIONS FOLY-MATERIELLES. — SCULPTURE CREUSE. — SCULPTURE OUVERTE. SCULPTURE MOBILE. OBJETS MOTORISES.

ACTIVITÉ

Après la parution de la première édition française, notre Manifeste paraîtra simultanément en plusieurs langues étrangères. Chacune de ces éditions comportera la photographie de l'artiste représentant le mouvement dimensioniste dans son pays. Exemple : l'édition pour l'Amérique du Sud aura le portrait de Huidobro; celle de la Russie le portrait de Kakabadze; celle du Portugal le portrait de Pedro, etc. Ces éditions spéciales seront identiques à l'édition originale française, à l'exception de la seconde page dont le texte du milieu sera remplacé par l'une de ces photographies.
En agissant ainsi, nous avons voulu accentuer la tendance internationale de notre mouvement. Nous avons voulu associer, poussés toujours par le sens social, que nos théories touchent le plus grand nombre d'artistes, que nos manifestes dénoncent des facteurs vivants partout où il s'agit de l'Evolution.

Le premier numéro de « La Revue N + 1 » sortira en Octobre.
Nos livres annoncés paraîtront tous les quatre mois.
Notre première Exposition aura lieu en automne.

NOUS INVITONS TOUS LES ARTISTES, D'ACCORD AVEC NOS IDEES EXPRIMEES DANS LE MANIFESTE, A COLLABORER AVEC NOUS.
QU'ILS DONNENT LEUR ADHESION, QU'ILS ENVOIENT LES PHOTOS DE LEURS ŒUVRES, POUR QUE NOUS PUISSIONS LES PUBLIER DANS NOTRE REVUE.
QU'ILS PARTICIPENT A NOTRE EXPOSITION.
QU'ILS PROPAGENT — EN DEHORS DE NOTRE ORGANISATION INTERNATIONALE — NOS MANIFESTES, NOS IDEES, NOS ŒUVRES.

Secrétaire-Général : Mario NISSIM, 165.Bd. Montparnasse Paris
Le Gérant : R. BERTELÉ.

LA PREMIERE EXPOSITION INTERNATIONALE DU DIMENSIONISME

Paris - Automne - 1936

Sera l'Exposition la plus moderne de ces dernières années.

Elle réunira les œuvres des dimensionistes et celles des artistes aux tendances dimensionistes.

Arp - Calder - Delaunay - Domela - Duchamp - Fernandez - Ferren - Gabo - Gonzalez - Kandinsky - Kann - Kobro - Lipchitz - Kotchar - Marcoussis - Mead - Michelet - Miro - Moholy-Nagy - Negri - Nissim - Pevsner - Picabia - Picasso - Prampolini - Prinner - Rathsman - Sonia Delaunay - Taeuber-Arp - Kakabadze.
Bollinger - A. Birot - Bryen - Huidobro - Lévesque - Van Heeckeren - Pedro - Sirato.

Pour tout renseignement s'adresser à la Rédaction (25, rue Vavin).

IMPR. DES 2 ARTISANS, 18, rue Ernest-Cresson, Paris (XIV^e)

1.3 Verso of the Dimensionist Manifesto, with "Mosaique," "Activité," and other texts. Loose-leaf insert intended for the first issue of the unrealized journal *La Revue N + 1*.

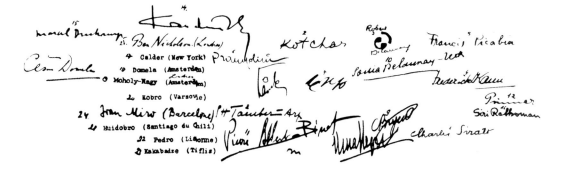

1.4 Signatures of the endorsers of the Dimensionist Manifesto. Image from the cover of Charles Sirató, *A vizöntő-kor hajnalán* [At the dawn of the Age of Aquarius] (Budapest: Szépirodalmi, 1969).

manifested the Dimensionist turn in artistic production. This imaginary museum was to be actualized in a planned "Première Exposition International du Dimensionisme" (First International Dimensionist Exhibition) in the fall of that year.[4] Circumstances intervened, however, and as we will see, Sirató suddenly had to return to Budapest. Posterity has not been kind to Sirató and his project; the Manifesto is so brief, so little was known about its author (who was unable to return to Paris first because of the war, then because of postwar conditions, and finally because of the Iron Curtain), that the exhibition was never realized, the album did not appear until its publication by Artpool and Magyar Műhely Kiadó in Budapest in 2010, and the Dimensionist project was largely forgotten. When it was invoked at all, the references were brief and somewhat derisory. For example, Maria Lluïsa Borràs referred to it as "the refuge of a motley avant-garde including artists of widely varying types, [which] may be regarded as a declaration of principles against the realism then obtaining in France and against the Nazi repression … echoes of which were already making themselves heard in Paris."[5] Enrico Crispolti's evaluation of it as "a typical expression of the syncretism and deductivism of the historical avant-garde of the first generation" is particularly telling.[6] In 1983 Henderson characterized the Manifesto most accurately as "a generalized echo of earlier beliefs, recast in the terminology of space-time."[7] Ironically, as she points out in her essay in this volume, it is the Surrealists who today are better acknowledged for their engagement and grasp of Einstein's theory of relativity, despite Sirató's close cooperation with the Surrealist poet Camille Bryen on the text of the Manifesto.

Who was Charles Sirató? Despite interest expressed by Gladys Fabre, Crispolti, and Henderson, to date nothing of substance has appeared on this *inconnu* in a language other than Hungarian.[8] Indeed, even in Hungarian, until the publication of a Hungarian translation of the Manifesto from the original French in 2010 (*A Dimenzionista*

Manifesztum története), the writings on Sirató (with the exception of Júlia Szabó's entry in a 1985 history of Hungarian interwar art) have focused on his literary production. The Manifesto, however, was first and foremost a manifesto of the fine arts, and I examine Sirató here as an art theorist. This essay builds on the work of Szabó and Tamás Áczél, and is also based on Sirató's own writings as well as the comments he made in an interview I conducted with him five weeks before his death on New Year's Day 1980. I also wish to begin the historicization of two widespread and influential aspects of avant-garde artistic theory closely related to fourth dimension studies: the topos of "dimensional inflation" and the theme of perceptual expansion.

CHARLES SIRATÓ: THE EARLY YEARS IN HUNGARY

Károly Tamkó Sirató was at various times a law student, poet, fourth dimension enthusiast, aesthetic theorist, yoga instructor, photojournalist, translator, children's author, and advertising copywriter. His interest in mass culture, physics, and biology, his enthusiasm for aesthetic innovation, his love of children's "authenticity," and his determination to heal himself after the failure of mainstream medicine to do so are all markers of twentieth-century alternatives to conventional thinking. He was born at Ujvidék (now Novi Sad) in 1905 in a region of southern Hungary attached to Serbia in 1920. His father, the son and grandson of Calvinist ministers, was the municipal doctor at Pusztaföldvár, a village in the agricultural southeastern county of Békés, where Sirató spent his childhood years. At Mezőtúr Calvinist Gymnasium Sirató benefited from a rigorous education. He excelled at his studies and displayed an aptitude for poetry by the age of nine. Encouraged by his teachers, he published his first volume of poetry at sixteen. While still a young man Sirató exchanged Calvinism for Buddhist and anarchist perspectives.[9]

After *gimnázium* Sirató studied law in Budapest to please his family. While this had the advantage of landing him in the capital, in 1922 Budapest was no longer the locus of cultural ferment it had been before the war, as most members of the artistic avant-garde had followed their publisher and impresario, Lajos Kassák, into exile after the collapse of the short-lived Soviet Republic of 1919. Still, the three elements of Sirató's mature worldview – an avant-garde aesthetic, a biologism suffused by *Lebensphilosophie*,[10] and the Einsteinian-Minkowskian conception of the fourth dimension – were all readily available in artistic contexts during the early twenties.

Thus Sirató began to read publications coming in from Vienna such as Kassák's journal *MA* (Today) and Kassák and Moholy-Nagy's 1922 anthology *Új művészek könyve* (Book of new artists), in which he was inspired by Kassák's *képversek* (picture poems) and the artistic products of the international avant-garde.[11] Exposure to Futurism and Dadaism shocked Sirató into the realization that an artistic revolution was under way.[12] In the issues of *MA* appearing between 1920 and 1925 Sirató would have read, in addition to Kassák's and Erwin Enders's concrete poetry, Kassák's "Képarchitektúra" manifesto, which called for the picture to "step into the third dimension."[13] He

would have seen, in good-quality reproductions, the reliefs, sculpture, and film images of Kurt Schwitters, Oskar Schlemmer, Willy Baumeister, Gert Caden, Hans Arp, Alexander Archipenko, Moholy-Nagy, Viking Eggeling, Hans Richter, Theo van Doesburg, the Russian Constructivists, and others, which challenged the two-dimensional format of painting and the static standard of sculpture and imagery, or both. He would also have read Raoul Hausmann's series of articles on "Optophonetics" speculating on the development of our perceptual abilities; El Lissitzky's "Proun," which would have introduced Sirató to "dimensional inflationary" ideas; "The Direction of Art" by the Lyon avant-gardist Émile Malespine, in which he might have first encountered Minkowski's formulation "N + 1" within an aesthetic context; and F. T. Marinetti's perceptual expansionist "tactile theater." Sirató would also have encountered pertinent views put forth in articles by van Doesburg, Schwitters, Prampolini, Moholy-Nagy, and others.[14]

If Sirató had obtained the 1922 issues of the Viennese-Hungarian journal *Egység* (Unity), he would have encountered not only Russian Constructivist texts and images, but also Kazimir Malevich's 1919 preface to *Suprematism, 34 Drawings*, in which he proposes the introduction of the "fifth dimension" into art, and Naum Gabo and Antoine Pevsner's Realistic Manifesto, one of the most important postwar documents to call for an art produced with an awareness of space-time rather than an occult "fourth dimension." This was also – after Boccioni – the earliest manifesto to call for kineticism in sculpture.[15]

Sirató was also involved with the modernist literary journal *Magyar Írás* (Hungarian writing), a conduit to international avant-garde movements produced in Budapest during the twenties.[16] While a forum for international modernist manifestos, the journal also reflected a local orientation toward biocentrism characteristic of early twentieth-century Central Europe, featuring the work of *Lebensphilosophen*, neo-Vitalists, Monists, and biologistic thinkers such as Friedrich Nietzsche, Arthur Schopenhauer, Henri Bergson, Ernst Mach, and Sigmund Freud – as well as the theories of Einstein.[17] This combination – the new physics of Einstein and biologism, the pervasive fin-de-siècle *Weltanschauung* that privileged biology among the sciences and applied its concepts and methodologies such as evolution and "survival of the fittest" to other spheres of knowledge – was one that would prove decisive for Sirató's intellectual development.

Another crucial element in Sirató's early intellectual development was *Is* (Also), the speculative art journal produced in Budapest in 1924–1925 by a team including his later friend, the autodidact philosopher, art theorist, and psychologist Árpád Mezei (figures 1.5, 1.6, 1.7).[18] Mezei's "Forma" (Form), published in the first issue, seems to have been important in pointing out to Sirató the aesthetic implications of Minkowski's definition of the fourth dimension as space-time within a context of the widely held understanding of time in the durational, Bergsonian sense: "Our most general conceptions demonstrate adequately that the various categories of reality strive toward states within one or another dimension, and so we may take up the bi-directional possibility of existence as tendencies toward stationery extension and extensionless

motion."[19] Here it seems as though Mezei is attempting to situate Bergsonian "exten-sionless motion" within Minkowskian "stationary extension," better understood as the "Block-Universe" conception of time that had "stopped," frozen in space, so to speak. It is notable that Mezei's understanding of this binary is not one of "either/or," but rather of "and," of "bi-directional possibility." Mezei's preference for perceiving the world as "extensionless motion," as far as art-making goes, represented a position that formed a basis for points 3 and 4 of the Dimensionist Manifesto concerning the kineticization of sculpture and the "vaporization" (a kind of "extensionless motion") of art itself. Mezei's refusal to have to choose between Bergson and Minkowski led him to intuit a desubstantiation of reality,[20] which had implications for both perception and creative production:

> It is clear that within the [predetermined] dimensions of our perceptual organs it is not only the transitory forms of things that appear – they can in fact be shifted, which, as we have seen is impossible with respect to the thing itself; rather, new realizations of liminal values [*határértékmegvalósulások*] might appear. In essence, every sensation entering into consciousness demands extension and if a new form entering into the dimension of a sensory organ in use spatializes completely, the artwork is constituted; those individuals who are capable of such a pure real-ization of the spatial tendency we term "artists." ... The analogy of Minkowski's more-than-three-dimensionally constructed worldview is clearly recognizable [in artworks]; axiomatically, the artwork is the realization of realizations in [a system of] dimensional increases.[21]

It is this system of Minkowskian dimensional increases that Sirató would formu-late in the Dimensionist Manifesto more than a decade later. Mezei's Bergsonian-Minkowskian slogan – repeated in *Is* – was "Humanity, as a race, is now closed in its spatialization. Let us demand process rather than accommodation within the life of the 'ideal.'"[22] It is the "process" of the perceptual accommodation to the new worldview engendered by the Einsteinian-Minkowskian "direction" of dimensional reality that Sirató would "demand" to see expressed in the fine arts. Thus, not only did Mezei (and, as we shall see, Oswald Spengler) spur Sirató to think about changes in the arts, but Mezei's texts were for Sirató crucial sources that inspired him to think about the muta-bility of perception within a matrix of a potentially endless series of dimensions.[23] Sirató followed Mezei in realizing that what the artists were actually doing at the time was expanding the limits of media from one Euclidean dimension to another.

In his own creative work Sirató was engaged with the production of concrete poetry involving dimensional increases and new technologies. Not encountering – he claimed – Apollinaire's *Calligrammes* (1918) until 1929, he wrote his first "Planar Poem" in Budapest around 1925, under the influence of Kassák's *képvers* (picture poem) practice.[24] In 1928 he published the Glogoist Manifesto in his book *Papírember* (Paper man), in which he defined the *síkvers* (planar poem) and two-dimensional prose.[25] In

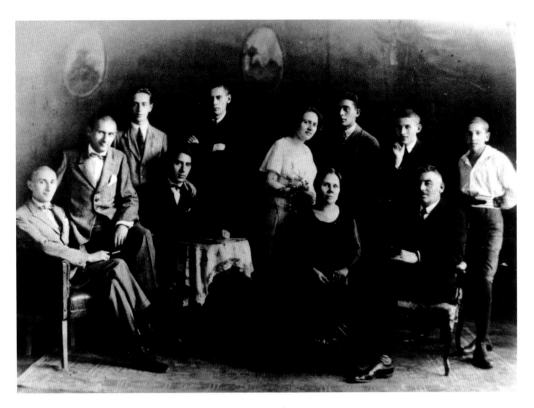

1.5 Unknown photographer, the Mezei parents (seated at right) and their nine children, Budapest, 1920. Árpád is the tallest, dressed in black, standing behind the table. His brother Imre is the boy to his left. From the archives of Árpád Mezei. Image courtesy of Dr. Mihály Mezei.

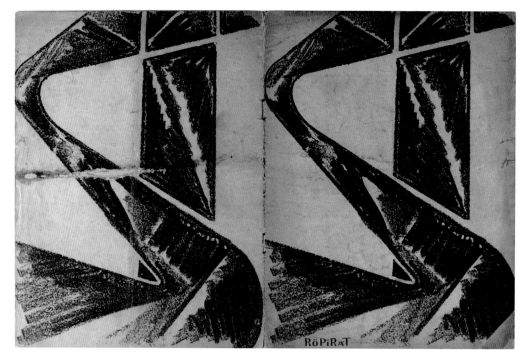

1.6 Hugó Scheiber, cover of *Is* [Also], no. 1 (Budapest 1924). Photograph of Árpád Mezei's copy, archives of Oliver Botar.

1.7 Introductory page of *Is* [Also], no. 1 (Budapest 1924), with "Forma" [Form] by Árpád Mezei. Photograph of Árpád Mezei's copy, archives of Oliver Botar.

IS KULTURA CIVILIZÁCIÓ IS

Magyarország, 1924.

1. szám.

Forma.

Induljunk ki a létezés anyagi formájának törvényszerüségeiből. Legáltalánosabb tulajdonsága a kiterjedés, eloszlása ezen belül különösen a tapintás adatai szerint nem egyenlő. Az egyenlőtlenség továbbmozgatása a tiszta intellektus és határolt alkalmazásaiban határértékben az oszthatóság. A felosztás alapeleme az egység, amelyhez az ujrafelépitéshez szükséges minőségek utólagosan járulnának. A tudomány ezeknek számát egyeseknek a többiekből függvényszerüen előállithatóságával állandóan csökkentette a ma fölvett egyetlen alapminőségig, a teljesen számszerü mozgásokkal. A homogén egység kizárólag fölvétel, mert a kiterjedés két tetszőleges része mint egység szükségszerüen egymáson kivül van s ezáltal kölcsönhatásuk lehetősége kizáródik, ami pedig közvetlenül észlelhető tényszerüség. Az egymásrahatás kapcsolódás s ha a kapcsolódást tendenciaként fölvéve végső következményeig folytatjuk, a hatóelemek határértékben mint tiszta áthatás külön létezni megszünnek s csak maga a kölcsönhatás marad meg. Anyagi jelentésben: a kiterjedés két tetszőlegesen fölvett része között lévő helyek a hatóelemekkel egylényegüek, a hatás ugyanazon anyag, mint a hatás. Ha a fölvett két rész egyikének hatása az időben megszünik, ezzel a hatásviszony maga szünt meg s igy ez nem csupán megmaradás, hanem folyamatosság. Ez a tiszta időbeliség a hatók és a hatás összeesése folytán az anyagra teljességben vonatkozik.

Példának vehetjük az eíektrodinamika egy feltevését, amely szerint az egységként felvett elektron teste mozgása folytán egy meghatározott kifejezéssel arányosan összehuzódik. Tiszta fizikai elgondolás, amelyben a test egyetlen minőség, a sebesség és összehuzódás mint mozgások pedig teljesen megszámolhatók. A mozdulatlanság mint a sebességhatás megszünésének exisztenciális léte gömb, a mozdulatlan elektron, ami a sebesség hatása alatt elliptikusan ellaposodik. Az ellaposodás materializálja a sebességhatás és a testellenállás összegeződését, amik ily módon teljességgel benne vannak és belőle leolvashatók. A megvalósultsági alak természetesen a hatóerők folytonos változásainak függvénye, de ha keresztmetszetet állitunk elő ezeknek folyamatosságában, a kapott alak összehuzódottsága az aktuális hatásösszefüggés téri formája, a hatóelemek léte a mozdulatlanságban. Általánosságban tehát a realitás a hatóerők időbeli létének kölcsönhatása és ezek öszszegeződésének téri megvalósultsága. A létezés két körülménydimenziójának határértékeiből az időbeli teljesen kiterjedéstelen és formátlan, a térbeli tiszta kiterjedés és teljességgel forma. Egy hatásösszefüggés elhelyeződése az egyikben vagy másikban a föltevés

szerint a lényegen nem változtatna, a kérdéses összefüggés mivoltától is függetlenül. Részletezve: egy anyagi valóságelem időbeli létezésének csökkenése térbeli létezésének növekedését jelenti, végső következményként pedig a valóságelem tiszta kiterjedéssé válását. Ez a kiterjedés most már teljesen homogén és felszine alatt semmi változás nem történik. A valóságelem fölvetten töredék az egyetemes hatásban és igy a kiterjedésben is az, homogén tömege tehát hirtelen megszakad és a további térrel szemben elhatárolódik. Az elhatárolódás folytonos felszint ad, ami mint egységforma a valóságelem hatáslétezése töredékeségével analóg, pontosabban ugyanennek téri létezése. Egy ilyen hipotézis a valóságra vonatkoztatva több folyamatelgondolás lehetősége között választhat, vegyük a Minkowski-féle négyméretü világot például: a realitás számunkra egy háromdimenziós térbeni mozgás, azonban elgondolható mint mozdulatlan forma egy olyan négydimenziós térben, ahol az idő mint negyedik koordináta szerepel.

Mindenesetre legáltalánosabb ismereteink is eléggé megmutatják, hogy a valóság különböző kategóriái inkább az egyik vagy másik dimenzióban való létezésre törekszenek, s igy a létezés kétirányu lehetőségét felvehetjük mint tendenciákat a mozdulatlan kiterjedés és a kiterjedéstelen mozgások felé. A valóságban csak akkor válhatik egy tendencia exisztenciálisan létezővé, ha az adott realitás önmaga válik a tendencia megvalósulásának testévé s igy megadja a létezéshez szükséges kvalitást; idő, tér és létező minőség egyaránt abstrakciók. Igy az egyik tendencia tiszta megvalósulása apriorisztikusan a másik teljes eltünését jelenti. A létező világ például a maga egy pillanatban megadottnak elgondolt teljességében nem tériesülhet, miután az időben tartás alapvetően beletartozik, ez mind törvényszerüség megvalósitható formában (mint ahogy a jelenkor müvészetében meg is történt), azonban a törvényszerüséghez hozzátartozik a hatékony érvényesség, ami a tériesülés által megszünik. A metafizika feladata a világ tényleges irányainak kimutatása, minket itt kizárólag a forma, tehát a téri tendencia megvalósultsága érdekel, függetlenül attól, amit ez esetleg megszüntet. A felosztásban függetlenitsük először a tériesülést mint tendenciát a forma határértékével és keressük a benne megjelenő kategóriákat.

Első példánkban fölvettük az anyag egy töredékét, aminek feltételezett formája az elektronnak mint hatásösszefüggésnek egyes elemeit teljesen megvalósitja az érintőként létező térben, az elemek mozgásának függvényeként. Szükségszerüen befejezetlen, mert az anyag egészének hatását nem tartalmazhatja

point 2 of the Glogoist Manifesto he writes, "Glogoism rejects 'book-seeing' and replaces it with 'pictorial seeing.' Rather than as a fabric of depressingly unilinear, formless lines, it regards the page as a territory in which the placement of sentences and words gains a constructive significance." In point 6 Sirató – paralleling an idea by Blaise Cendrars – proposes the *villanyvers* (electric poem) for electric signboards as a "new mass art," anticipating Jenny Holzer's and others' use of such signboards as an artistic medium as well as his own later calls for a dematerialized art.[26] In *Paris* of 1936 (adapted from the original "Budapest" of 1928) the metropolis (just as in Fritz Lang's film *Metropolis* of 1927) is presented as a Moloch-like system that leads the artist inexorably to compromise or death (figure A.5). *Introduction to the Novel-Brick* of 1930 presents Sirató's two-dimensional conception of the prose narrative, in which the second dimension varies the mood or health of the characters. In *L'histoire d'une nuit* of 1936 (*The Story of a Night*) the text is arranged within segments of concentric circular bands, which make possible the simultaneous presentation of different narrative outcomes of an erotic encounter on a Paris-Berlin train trip (figure 1.8).[27]

After completing his legal studies Sirató conducted his scientific and philosophical education on his own during 1928–1929 in Debrecen. Sirató cites the writings of Bergson, Einstein, Minkowski, and Hendrik Lorentz as his sources on the question of space-time, which led him to the hyperbolic geometry of the Russian mathematician Nikolai Lobachevsky and the Translyvanian-Hungarian mathematician János Bólyai. Sirató emphasized 1905 – the date of his own birth and that of the twentieth-century avant-garde – as the year Einstein published his results on the relativity of space, time, and motion in his special theory of relativity.[28] In 1929 Sirató's reading of these authors moved him to the realization that a new *Weltanschauung* was emerging as a result of these innovations in philosophy, mathematics, and physics. As the former Budapest Technical University lecturer Károly Czukor, the first popularizer of relativity theory in Hungarian, wrote in September of 1920, "If we may call the seemingly stable concepts of the old physics a 'worldview,' then we may bravely state that relativity theory thoroughly changes our physical worldview, and does not even spare everyday concepts such as space and time."[29] Sirató cites Bergson's *Durée et simultanéité* (Duration and simultaneity) (1922) as a means by which – following Bergson's own problematic attempts to do so – he was able to synthesize the concept of space-time with creative evolution, though he encountered a similar synthesis in Mezei's writings.[30] Also, it was through the new physics and non-Euclidean geometry that Sirató remembers being guided to the "historical morphology" of Spengler, who explicitly linked the development of mathematics and art in *Der Untergang des Abendlandes* (*The Decline of the West*): "The mathematic, then, is an art. As such it has its styles and style-periods. It is not ... unalterable, but subject like every art to unnoticed changes from epoch to epoch. The development of the great arts ought never to be treated without a ... sideglance at contemporary mathematics." But most importantly, the work clarified for Sirató the relativity of historical development; all artistic value is context specific.[31]

1.8 Charles Sirató, "L'histoire d'une nuit (nouvelle planiste synchro-simultané)," published in János Fajó, ed., *Le Planisme 1936/Planizmus 1936* (Budapest: Pesti Mühely, 1981). Collection of Oliver Botar.

In 1928 Sirató decided to leave Hungary, prompted by the hostile reception his *Papírember* had received in the local press. An unexpected inheritance enabled him to move to Paris in late August of 1930. Like the painters Lajos Tihanyi, Anton (Anna) Prinner, and Sigismund Kolos-Vary, the sculptors Josef Csáky, Sándor Grossman, and Étienne Béothy, and the photographers André Kertész and Brassaï, Sirató soon established himself at the Hungarians' table of the Café du Dôme (figure 1.9).[32] Like other Hungarian photographers such as Éva Besnyő, Brassaï, Robert Capa, Kertész, Moholy-Nagy, and Martin Munkácsy, Sirató was able to survive by working for a Hungarian-owned photojournalist agency. Though the job proved to be his undoing, it afforded him the security he needed to carry out his work while he was in Paris, and it even allowed him to take annual vacations at home.

While no coherent Surrealist movement emerged in Budapest during the 1920s, Sirató had read Surrealist poetry in *MA* and *Magyar Írás*, and during his year in Debrecen he had systematically studied French avant-garde literature, from Symbolism to Surrealism, with his friend István Nemes, a student of French literature fresh from Paris. Indeed, in his 1935 article on French Surrealism published in the Budapest journal *Literatura*, Sirató referred to himself and to three others as "major representatives of Hungarian Surrealist poetry."[33] Once in Paris he remembered viewing all the exhibitions, both abstract and Surrealist, and his article indicates a thorough knowledge and understanding of the Parisian Surrealist scene.[34] He took to translating Surrealist writing into Hungarian, including the work of his close friend and roommate Camille Bryen, through whom he came into direct contact with second-generation Surrealists and young critic-artists such as Jean van Heeckeren and Jacques-Henri Lévesque, editor of *Orbes*.[35]

During the time of Sirató's and Bryen's friendship in the mid-thirties, Bryen's Surrealist activity was at its height; he had his first show of automatist drawings and collages in May of 1934 and another the following summer. Sirató described Bryen as the "most extreme representative of automatism," and indeed hundreds of undated drawings survive from this period, some of them executed on Café du Dôme stationery.[36] Bryen also created many *objets à fonctionnement* (functional objects) employing "automatic" processes, and on February 26, 1934, he lectured on automatism to psychology students at the Sorbonne.[37] The following year Bryen began projects with the photographer Raoul Michelet (alias Ubac); he is credited with having invented "tachiste" painting in 1936, and his second Sorbonne lecture, "L'aventure des objets" (The adventure of objects) was published as a booklet illustrated with photographs by Michelet in 1937.[38]

Not surprisingly, it was the destabilization of the object, a byproduct of "automatism," that was at the core of Sirató's interest in Surrealism. In his 1935 article Sirató observed that "in Surrealist vision nothing holds things and objects together in the order and with the characteristics we are accustomed to which render them recognizable here on earth. Nature has *fallen apart* and so is freely reassembleable; more

1.9 André Kertész, Hungarians at the Café du Dôme, with Lajos Tihanyi (at the right end of the group standing) and Vilmos Aba-Novák (at far right, with portfolio), Paris, 1926. André and Elizabeth Kertész Foundation, New York.

precisely, it can be associated freely into a ... system which we call the 'artwork'" (italics in original). Such a "vaporization" of the object (as he put it in the Dimensionist Manifesto) opened the way for its reformulation in another dimension. Sirató understood Surrealism to be "a movement conducive to completely new aesthetic judgements ... [that] engenders an inexorable striving toward the absolutely new." For him this was "Surrealism's most attractive aspect." But Surrealism contained for him another, perhaps even more crucial, component. Moving now into the vocabulary of Spenglerian biologism, he writes that Surrealism "expresses an absolute and deep-rooted dissatisfaction with the extant. Perhaps [it expresses] a blind indication of a deeper biological revolution." Since, from the biologistic perspective, everything – including the rise of Surrealism – is explicable in biological terms, Sirató explained the rise of Surrealism as an expression of a revolution in perception, which is by its nature a biologically based process. This would account for Sirató's statement that though Surrealist practice is destructive of traditional poetic, pictorial, and sculptural forms, "from the biological point of view, dying is as perfect a moment as is birth."[39] At this point, rather than specific aesthetic results, it was Surrealism's biologically determined destructiveness of forms – one that initiates an inexorable process toward vaporization – as well as its *Vorwärtsdrang* (push forward), that attracted Sirató the most. Indeed, in a 1976 interview with Ilona Bánki, as in his manuscript "A Dimenzionista Manifesztum története" (History of the Dimensionist Manifesto), with the exception of the Surrealist *objet*, Sirató expressed ambivalence toward specific manifestations of Surrealist art and literature.

So, it was after seeing one of Joan Miró's *sculptures-objets* (sculpture-objects) that Sirató was jolted into the realization that a process of self-destruction and self-critique was being undertaken in the field of sculpture. In 1965, expanding on a paragraph in his 1935 article on Surrealism, he recalled that

> One evening on the way home from the [Café du] Dôme, I stop in my tracks before the display window of a gallery on the Boulevard Raspail. In it I see a rotten board about 1.5 meters high and about 35 centimeters wide, with a rusty iron hoop at one end, a long bird's feather inserted in it. Velvet pedestal. Inscribed:
>
> Joan Miró: Sculpture
>
> I was shocked. After a short while I gathered my wits and smiled. "So this too is sculpture! It ridicules itself!!! Its own materials and role. As it should!"[40]

Miró was not the only artist expanding the traditional bounds of sculpture. Besides being exposed to Bryen's *objets à fonctionnement*, Sirató would have encountered a host of sculptural experiments in the French capital. It was around the time that he arrived there in 1930 that Enrico Prampolini began producing his *Compositions poly-matérielles* (polymaterial compositions) in Paris. After experimenting with mobiles from

1930, Calder was by 1931 developing his first motorized kinetic sculptures, and Duchamp continued work in Paris on his kinetic *Rotoreliefs*, an edition of which was released in 1935.[41] Sirató also would have known through reproduction, by reputation, and perhaps through personal experience Moholy-Nagy's *Lichtrequisit einer electrischen Bühne* (Light prop for an electric stage), later known as the *Light-Space Modulator*, the first prototype for which was completed in 1930, in time to be shown in Moholy-Nagy's theater section of the German Werkbund's contribution to the Exposition des Arts décoratifs in Paris during that summer. Sirató may have caught Moholy-Nagy's stage prop on display before the exhibition closed.[42] Had he missed it, he would have heard of it in detail from Kertész, who met with Moholy-Nagy and photographed the mechanism.[43]

In 1933 Sirató began attending the Cercle François Villon, a club funded by a charity that provided meals for artists and writers. This is where he met figures such as Robert Delaunay and Arp, who became his associates and advisors, as well as Piet Mondrian.[44] At the time, Delaunay was working on his *art murale* (wall art), employing materials such as plaster, casein, mosaic, cork, sand, and cement.[45] Through his conversations with Delaunay and Bryen—and also through speaking with Prinner at the Café du Dôme and seeing his works at his studio—Sirató came to the view that not only was sculpture questioning its own means, but also painting was attempting to cease being "painting."[46] This development was manifested as well in the reliefs being made by Taeuber-Arp and Arp, the latter of which he had seen in *MA* in the early twenties and that Arp continued to produce and exhibit in Paris. Domela had been producing relief sculptures since 1928, and after he moved to Paris in 1933 he exhibited them regularly. Indeed, Sirató first encountered—and was deeply impressed by—Domela's work in an exhibition at the Galerie Pierre in 1934.[47] It is also likely that Sirató viewed the reliefs of the Bohemian-American artist and Dôme regular Frederick Kann at the 1934 Salon de l'Abstraction-Création, and while Picabia was producing paintings in his notorious realist style in 1935, he sometimes applied objects to their surfaces.[48]

Sirató's experiences with avant-garde painting and sculpture in Paris, his own experiments in Hungary and France in the realm of "planar poetry" and the "novel-brick," his readings in philosophy, the new physics, and geometry, as well as his innate synthetic tendencies encouraged him to construct a wider theoretical framework for these observations. As he wrote in 1966, "From the start of my Paris stay the cloudy awareness lived in me that … the fact that I moved the means of expression up one dimension in literature … is … equivalent to the revolution in physics that led our world-views from three-dimensional Euclidean space to the four-dimensional space-time continuum. The idea occurred to me, 'what role might the other arts play in this contemporary process?'"[49] At the end of his 1935 article on Surrealism Sirató asks, "What comes after Surrealism?" His answer: "The path of avant-garde artists leads forward, through Surrealism … to contemporary forms unimaginable to those infected with today's aesthetic conceptions, toward different media and absolutely new forms of art, concealed before us in their lively richness and free combinations, but under no circumstances toward the flea market of the past."[50] What Sirató needed at this point

was a catalyst that would steer him toward the formulation of his ideas on an art of the future, and this he found in Robert Delaunay. When Sirató told Delaunay around 1935 of his experience with Miró's *sculpture-objet* and about his literary experiments, Delaunay asked for a translation of the Glogoist Manifesto. Sirató complied, enlisting the assistance of Bryen and the journalist Julien Moreau to translate it (now renamed the "Manifeste Planiste") along with his Planar Poems (figures 1.10, 1.11).[51]

After seeing the translations, Robert Delaunay invited Sirató to the Closerie des Lilas for one of the regular Thursday evening get-togethers that he and Sonia Delaunay had maintained since the days of Apollinaire, a pioneer of popular artistic conceptions of the fourth dimension. Sirató remembers that upon seeing the poems Robert Delaunay said "Sirató! We need you!" — a surprising development given Delaunay's lack

TABLE DES MATIERES

I.

1. — Manifeste Planiste.
2 — La Grammaire du Plan.
3. — Le rôle du Planisme dans la littérature universelle.
4. — Le Préplanisme : Blaise Cendrars, Baudoin,
 Apollinaire, Pierre Albert-Birot, Huidobro,
 Francis Picabia,
 Kandinski, Mahlevich, Joan Miro.
5. — La décomposition de la Littérature (Introduction du Planisme selon les nouvelles théories d'espace-temps d'Einstein et Minkovsky.)

II.

Les Poèmes Planistes
(exécutés en une, deux et trois couleurs)

op. I — Violon d'eau à sept places
 ou La Mythologie du Puits (poème surréo-planiste).
op. II — Appareil Ballade.
op. III — Le Divorce.
op. IV — Paris (poème électrique).
op. V — Drame rouge-noir horizontal.
op. VI — Le Suicide (poème sans parole).
op. VII — L'Histoire d'une Nuit
 (nouvelle planiste synchro-simultanée).
op. VIII — L'épopée de l'Homme.
op. IX — Autoportrait.
op. X — La Vie de Bernard dans le Roman-Brique
 (roman système à quatre dimensions).

A détacher suivant le pointillé et
 1) ...à remettre contre le reçu à notre représentant.
 2) ...à remettre contre le reçu à l'éditeur, **84, Bd du Mont-**
 parnasse, Librairie Tschann.
 3) ...à retourner avec un chèque, mandat du montant de l'édition choisie à l'éditeur (N° de chèque-postal Paris 1361-61) et votre reçu vous sera envoyé dans les vingt-quatre heures.

IMP. LANTOS FRERES ET MASSON, 86 FAUB SAINT-DENIS. PROV 69-95

charles sirato

LE PLANISME
la décomposition de la littérature

Edition de la Nouvelle Réalité
Librairie Tschann, 84, bd. du Montparnasse, Paris (6').

1.10 Charles Sirató, preorder promotional brochure for *Le Planisme: La décomposition de la littérature* (Paris: Éditions de la Nouvelle Réalité, 1936). Collection of Oliver Botar.

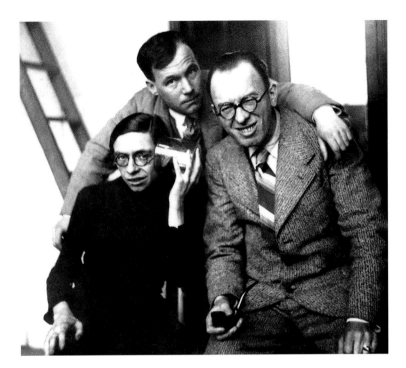

1.11 Charles Sirató (at center, employing a self-timer), Camille Bryen, and Julien Moreau, 7 rue Ledion, Paris XIV, early 1936. Silver gelatin print. After Károly Tamkó Sirató, "Korforduló," *Új Írás*, no. 2 (February 1971): 123.

of enthusiasm for fourth-dimension theories earlier in the century.[52] Delaunay's prior concerns with respect to the occult overtones of certain fourth-dimension discussions may have been allayed by the gloss of science in Sirató's theorizing. Delaunay then introduced Sirató to Ervand Kochar, the ethnically Armenian artist from Tblisi, Georgia, who, following in the footsteps of Archipenko, Gabo, and Pablo Picasso, had been engaged since 1925 in a project synthesizing painting and sculpture that the Armenian referred to as "peinture dans l'espace" (painting in space).[53]

In these works Kochar used materials such as leather, glass, metal, and wood to build complex multiplanar constructions on the surfaces of which he painted images suggesting the human form in a figurative-surrealist manner related to contemporary work by Georges Braque, Picasso, Salvador Dalí, and Georges Valmier. Kochar also experimented with what he – and after him, Sirató – termed *sculptures-ouvertes* (open sculptures), whose interior spaces were opened up to break down their mass. Sirató remembers that "when Kochar saw and read the French texts of my planar poems, and when he heard me reading the compilation of my old texts I entitled 'Poetry in the Plane,' he embraced me and kissed me. Sirató! We are doing the same thing! He sat

me in a taxi and took me to his studio where he showed me his 'painting-bushes' on tables, his 'picture-shrubs,' and he read his manifesto 'Peinture dans l'espace.'"[54] Kochar then sliced up drawings on cardboard and reassembled them as sketches for works. As the *pièce de résistance*, he pulled back a curtain and showed Sirató his *sculpture-ouverte* portrait bust of his fellow Georgian, Josef Stalin![55] At this point Sirató told Kochar about his research into space-time and relativity and the implications it had for artistic production. "And then," recalls Sirató, "in the breaking dawn, we ... felt in its complete reality the fact that we were the warriors of a new age in the process of being born!" This intense contact with an artist thinking along the same lines as he was in his poetry, this moment of synthesis, was the nudge Sirató needed to take the final step in formulating a theory linking dimensional inflation and contemporary artistic development.

Robert Delaunay had also suggested to Sirató that he go to see an exhibition of the work of César Domela, then on display at the Galerie Pierre. When, impressed by this show, Sirató visited Domela, showed him his "Manifeste Planiste" and poems, and declared that they were doing the same things in different media, Domela was "surprised" but agreed with him that he *truly had developed from painting to construction* (italics in the original). Sirató remembers that they then agreed to – temporarily – refer to this new trend as "general planism" (*általános planizmus*), and they decided to "collect artists working in a similar spirit, produce our program and launch our movement." At this point Domela wrote Sirató a letter of introduction to his friends, which is how Sirató came to visit Naum Gabo and discover his spatial constructions, and how – in line with the ideas expressed in the Planist Manifesto – they had developed from painting.[56]

After this, according to Sirató, he, Kochar, Robert Delaunay, Domela, and Bryen came to meet informally to begin discussing this "new" artistic tendency (*tendance*). Sirató felt it essential at this point to employ a more appropriate name for it, and he came up with the term "Dimensionisme." He remembers discussing this proposed name with Domela, Pierre Albert-Birot, and Mme Apollinaire at a Boulevard Raspail café in June of 1934, to the approval of all present.[57] News of the movement spread in Montparnasse, and at the request of the art critic Gaston Diehl, head of the artists' group Regain, the group organized a presentation and discussion of it at a Montparnasse café.[58] Amid the discussions surrounding the movement, the members of the group concluded that it was crucial to formulate its tenets in a text. Since Sirató was the only one with a (seeming) theoretical grasp of the science, the others entrusted him with formulating the theory. Sirató next composed the long manuscript in Hungarian that would form the basis for the *Premier album Dimensioniste*, partly over a three-week period in a space his friend Constant Cachera had secured for him in a château at Paillencourt in Normandy. Back in Paris, Sirató, Kochar, Delaunay, Bryen, and Domela decided to organize the "universal Dimensionist revolution of the arts." For this, however, a pithy manifesto was needed, the writing of which was again entrusted to Sirató. He drafted the Manifesto in French with Moreau's help, and Bryen refined

the language. Afterward he vetted it with Kochar and Delaunay (Domela had left for an extended stay in Holland).[59]

Sirató attempted to keep the Manifesto as simple and direct as possible, and as Henderson points out in her essay in this volume, this probably aided the group in garnering the signatures they did. As we have seen, however, this concision gives the impression that the Manifesto was based on a simple understanding of Minkowski and Einstein. While it is difficult to gauge Sirató's command of the material from such a short text, his single statement on the theory of space-time that appears in paragraph 5 is correct as far as it goes, and he was unequivocal concerning the basis of the Manifesto in geometry and physics. He stated from the outset that the scientific and mathematical theory on which the artistic movement was based was brought to consciousness in it. To this end, he cites Einstein and Minkowski (the latter in the addendum) in the first, French version inserted by Sophie Taeuber-Arp and Domela into *Plastique* in 1937, while he mentions both Einstein and Bólyai in the second (Hungarian) variant. This passage pinpoints the origin of the term "N + 1": "That which is given as movement, as an event in a space of any number of dimensions (n), may be represented as a form in a space having an additional dimension (n + 1)." From this it is apparent not only that Sirató employed this formula as a signifier of a dimensional inflation, but also that—because this was a manifesto of art—he wished to place the emphasis on the *form* that the "movement" or "event" took.

While Sirató does not cite all of his sources, it was Spengler's biologistic linking of the development of mathematics and the arts that formed the basis for his arguments in the first paragraph concerning "unconscious" artistic developments, and he was also inspired by both Mezei's and Hausmann's speculations on the adaptation of Minkowski's ideas to art. In the fourth paragraph Sirató invokes Bergson's category of creative evolution when he writes of evolution as "the instinct that breaks through all barriers." A statement titled "Le Dimensionisme" drafted by Sirató on the verso of the first edition of the Manifesto states that "the Manifesto is in reality a general ascertainment deduced from the works of certain advanced artists" (see appendix). Here Sirató takes the neo-Vitalist, "psycho-biological" view that the "pioneers of creative art" produced their Dimensionist works instinctively, presumably driven by the *élan vital*, a point also driven home in "Mosaïque" (Mosaic) (figure 1.3), a collection of comments that appeared as an addendum on the verso side of the first edition of the Manifesto in which Sirató and Bryen jointly declare that the "deep sense of Dimensionism" is "the Biological Revolution."[60]

Besides the influence of philosophy, biologism, science, and mathematics, the effect that 1920s aesthetic theory had on Sirató is also apparent in the Manifesto. The "dimensional inflationary" sense of Sirató's basic schema, which he attributes to Minkowski's "N + 1" formula, derives from the textual tradition developed by Lissitzky, Kandinsky, Mikhail Matiushin, Prampolini, and Moholy-Nagy, which portrayed artistic products as bursting out of their given formats and "penetrating into" the next dimension. While Kandinsky titled his 1926 Bauhaus volume *Point and Line to Plane*, Moholy-Nagy

specifically developed this idea in a text that evidently formed the basis for point 3 of the Manifesto, in which Sirató writes of "the five stages of development of sculpture": the blocked-out, modeled, perforated, equipoised, and kinetic. "The legible meaning of this development" he continues, "may be summarized as: from mass to lightening of weight, from static treatment to movement." He goes on to locate this trend in various media: "A similar quest for expression by subduing or lightening the material is to be found ... in painting: from coloured pigment to light ... ; in music: from instrumental tones to spheric tones ... ; in poetry: from expression of thoughts to expression of feeling ... ; in architecture: ... from restricted inner space to absolute space."[61]

Among most of the artists who articulated the dimensional inflationary topos in the teens, the idea – as Henderson has suggested in *The Fourth Dimension* – was grounded more firmly in the hyperspace philosophy of J. M. Hinton and P. D. Ouspensky than in Einstein's general theory of relativity. This is not so clearly the case with Moholy-Nagy, however, even though it has been suggested that he read Ouspensky.[62] And it is Moholy-Nagy's speculations on a dematerialized art of light made in his books *Malerei, Photographie, Film* (1925) and *Von Material zu Architektur* (1929), as well as the synaesthetic tradition, which form the basis for Sirató's articulation of his proposed "Cosmic Art." In 1926 Moholy-Nagy described the use of colored light as an artistic medium: "projected/reflected displays of fluid coloured light; liquid, immaterial suspensions; transparent colorfalls in luminescent swathes; the vibration of space with iridescent light emulsions."[63] By focusing on the symbolic import of light through the wielding of its creative potential, Moholy-Nagy displayed his understanding that for Einstein light was more important than either space or time: that it "seems ... to be the very *source* of space and time,"[64] that it was a kind of measure of all things, the only possible constant or fixed point in the universe. Moholy-Nagy wrote: "We must 'paint' colors with glowing, oscillating, prismatic light, instead of with pigments. This will allow us again to approach a new conception of space."[65] Alain Findeli's summary of his thinking in this regard is precise: Moholy-Nagy wished, he says, "to get rid of any material intermediary [as] ... mere '*technological detours*,' in order to paint directly with light ... and thus make almost totally transparent the space/time between the flash of an idea and its materialization" (italics in original).[66]

Moholy-Nagy's emphasis on movement implied his understanding that movement, or speed – the speed of light, in fact – was the medium of exchange between matter and energy; it was the means to "transform" space into time and time into space, the mode of "conveyance" along Minkowski's space-time continuum. In adopting Moholy-Nagy's sculptural program of an evolution toward a "dematerialized" or "vaporized" art of light and movement, Sirató implicitly indicated his understanding of Moholy-Nagy's appropriation of Minkowski's epoch-making realization, even if, as Moholy-Nagy's wife, the photographer Lucia Moholy put it, "the combination 'Space-time continuum' presented itself spontaneously, without our having studied Minkowski."[67]

By early 1936 Hans Arp, one of the most important relief artists, was aware and supportive of the group's efforts and plans to initiate a "Dimensionist" movement. Of

him Sirató wrote, "Not only was he Dimensionism's newest pioneer warrior, but he became practically the indispensable soul and inspiration of the movement."[68] In his contribution to "Mosaic," Arp insisted, perhaps as a countermeasure to an overemphasis on the purely scientific, that the "automatic" and the "poetic" were also important in the attainment of a dimensionist art. Still, according to Sirató's memory, Arp's reaction to the draft Manifesto was that it "produced just as natural an order in the chaotic wilderness of post-1905 avant-garde efforts, as [Dmitrii] Mendeleev's periodic table had created in the realm of previously chaotic atomic weights."[69]

Also active in the Dimensionist movement were Antonio Pedro, the painter, poet, critic, and central figure of the Portuguese avant-garde, and Kochar's associate, the Greek-Jewish painter-sculptor Mario Nissim. In the insert to the planned journal *La Revue N + 1* Nissim is identified as "secretary-general" of the Dimensionist movement (on this see below), and Sirató remembers him hosting a party for the signatories of the Manifesto, although I have been unable to find further information on him.[70] The Cape Verde-born Pedro, an independently wealthy man, began publishing poetry in 1926, and in 1934–1935 lived in Paris, where he studied art history with Henri Focillon and began painting. Pedro characterized his *15 poèmes au hasard* (15 random poems), published in 1935 and exhibited the following year in Lisbon, as "dimensional poems" (*poèmes dimensionnels*), and he published "Le Planisme," an essay by Sirató that would appear, along with "Le Dimensionisme," on the verso of the Manifesto, in his journal *Fradique* in Lisbon after his return from Paris early in 1936.[71]

At this point, Kochar, Robert Delaunay, and Arp assisted Sirató in assembling a list of names of people they agreed to approach to sign the Manifesto. Despite disputes between Kochar and Sirató about the names to be included, a final list was eventually drafted, and they set out to collect signatures for their "universal" manifesto. According to Sirató they accomplished this in four to five weeks, probably around March and April of 1936.[72] The text of Sirató's explanatory essay, "Le Dimensionisme," makes it clear that while they were generous in their judgment as to what might constitute "dimensionist" art, they "invited only those artists to approve of us, whose work clearly exudes dimensionist value, and who already in advance had well-established positions in the future development of our theories." In other words, with some exceptions, they went looking for well-known sympathizers. It was due to Delaunay's and Arp's prestige in the Parisian art world—as well as Arp's, Domela's, and Bryen's connections—that a range of signatories such as this one was assembled, and Mezei recounts that "it is fairly well-known that everyone invited to sign Károly Sirató's Dimensionist Manifesto did so." The only exception, according to Mezei—and it was a crucial one—was Albert Gleizes, who felt that some issues had to be clarified before he could sign. Given Gleizes's prominence in prewar discussions of the fourth dimension, one can well imagine that Mezei's claim that this refusal disappointed Sirató is accurate.[73] Sirató does not address the other important omission from this list of signatories: Naum Gabo. This must remain the object of further research. Had Theo van Doesburg still been alive, he might also have resisted signing the Manifesto, as it was, to a certain extent, constructed on the ruins

of his "Abstraction-Création" project, and he usually liked to exercise control over any initiative he participated in. Given Sirató's epiphanic experience with Miró's *sculpture-objet*, it is not surprising that though he failed to receive a reply from the artist to his request, Sirató "elected" the Catalan artist to be an honorary Dimensionist and signed for him (figure 1.4).[74]

Among Sirató's personal friends and associates the list included Prinner, Bryen, Nissim, and Pedro. Sirató also wrote to Moholy-Nagy, who suggested that Sirató take full responsibility and full credit for the Manifesto by being the only one to sign it. This was not Sirató's intention, however, and Moholy-Nagy nevertheless expressed strong support for the venture. Early that summer, he visited Sirató in Paris and gave him a copy of the unique issue of František Kalivoda's Brno journal *Telehor* devoted to Moholy-Nagy's work, a volume that includes versions of the very texts so influential on Sirató's development of the dimensionally inflationary conception of the Manifesto. A copy of the "Dimensionist" issue of the journal *Plastique*, meanwhile, is still to be found in the archives of Hattula Moholy-Nagy, the artist's daughter.[75]

In 1966 Sirató described Duchamp as "formally and intellectually perhaps the most Dimensionist of all the creators" who signed the Manifesto. This is an apt description, for, as Linda Henderson has demonstrated, "unlike other early twentieth-century artists ... Duchamp actually engaged in four-dimensional geometry, creating his own playful mathematics in his notes for *The Large Glass*."[76] Arp offered to show Duchamp the Manifesto, which he received with great interest and approval. Indeed, Duchamp looked Sirató up at his hotel soon afterward, where – as Sirató remembers it – he "congratulated me warmly for the discovery of the Dimensionist theory and the manifesto's wording, of which he emphasized its simplicity and precision." Sirató remembers Duchamp "repeatedly emphasizing" that "*he felt that his own tendencies had been completely explained, supported and logically legitimized by my text* and the Dimensionist tendency. *It was in a state suffused with the optimism and assuredness of the certain victory of this tendency, that he looked to the future*" (italics in the original). To no other signatory does Sirató attribute such high praise of the Manifesto, a noteworthy aspect of his detailed account of the text's signing process. Duchamp signed his name, as Sirató puts it, "left of Kandinsky, outward, in a completely new direction, practically tangentially to those of the other signatories." Duchamp, in turn, indicated his respect for Sirató by giving him a number of photographs and drawings of his works, a photograph of himself with the dedication "Cadeau de Marcel Duchamp à Charles Sirato, en 1936, à l'occasion de la signature du Manifeste Dimensioniste" (Gift from Marcel Duchamp to Charles Sirató in 1936, on the occasion of the signing of the Dimensionist Manifesto") and a dedicated a copy of his *12 Rotoreliefs* (1935 edition).[77] Sirató advertised the *Rotoreliefs* in the first edition of the Manifesto: "Sur votre phonograph, faites tourner les 'Rotoreliefs' – en vente chez tous les libraires" (make the *Rotoreliefs* turn on your phonograph – on sale at all bookshops). There is little doubt that Sirató, having seen the *Rotoreliefs* in action, would have understood their

significance, not primarily as kinetic works of art, but rather as works that made visible a kind of hidden (fourth) dimension of space arising out of circular (spiral) movement.

Ultimately, a significant number of the members of the Abstraction-Création group signed or approved Manifesto: Robert Delaunay, Sonia Delaunay, Arp, Taeuber-Arp, Domela, Kann, Calder, Nicholson, Kandinsky, Kobro, and Prampolini.[78] Domela signed for the London-based Nicholson. Kochar signed for Kobro in Warsaw and for his countryman David Kakabadze of Tblisi. Also signing was Picabia, who had been interested in the fourth dimension during the prewar years, and other, more obscure Parisian expatriates such as the Argentinean-Italian graphic artist Nina Negri and the Swedish painter Siri Rathsman.[79] Sirató signed for one of his poetic models, the Chilean avant-garde poet Vincente Huidobro, who was slated to translate the Manifesto into Spanish.[80] Along with Arp, Bryen, Sirató, Picabia, Pedro, and Huidobro, the literary component of the Dimensionists included van Heeckeren, Lévesque, and the Simultaneist French poet and editor Pierre Albert, although the latter two did not sign the Manifesto but were scheduled to take part in the exhibition.[81] The roster of signatories was therefore impressive, although many artists producing reliefs and multimedia sculpture and exhibiting in Paris with the Abstraction-Création group were conspicuously missing.[82]

One afternoon in the early spring of 1936 Sirató, having sent Kandinsky a copy of the Manifesto in advance, visited the artist at his home on the banks of the Seine for the actual signing. Sirató later remembered this event as "one of the most beautiful and memorable two and a half hours of my life." While approving the Manifesto's text, Kandinsky asked to add an addendum under his own name. Here he stated his Monist position, advocating, rather than a "pure" spiritualism or materialism, a synthesis between matter and spirit.[83] This contribution inspired the solicitation of comments from others that appeared in "Mosaic."

Reading this "texte du milieu" (inserted text), as they refer to the back page of the Manifesto, one is struck by the excitement of its plans, by its self-consciousness as the initiation of a movement as ambitious as the Surrealist project launched by André Breton twelve years earlier. It announced that the First International Dimensionist Exhibition, scheduled for the fall of 1936, would be "the most modern exhibition of the last years and would include the works of the Dimensionists and those of artists of dimensionist tendencies," including "two-dimensional poetry, *peinture dans l'espace*, Constructivism, spatial constructions, *constructions poly-matérielles*, lacunose sculpture [i.e., sculpture with perforations], *sculpture-ouverte*, mobile sculpture, and motorized sculpture." In a plan for the exhibition cited by Júlia Szabó, Sirató indicated that the show would include the concrete and typographically innovative poetry and layouts of Apollinaire, Kassák, and Vladimir Mayakovsky; "pre-planist" (Moholy-Nagy, Marinetti, Malevich) and "planist" (Sirató, James Joyce) literary production; Surrealist objects by Arp, Dalí, Man Ray, Max Ernst, and Alberto Giacometti; "spatial constructions" by Miró, Kobro, Moholy-Nagy, Picasso, and Prinner; and *sculptures-ouvertes* as well as kinetic sculptures by Calder, Duchamp, and Moholy-Nagy.[84] Non-signatories to

be exhibited included Gabo, Julio González, Jacques Lipshitz, Louis Marcoussis, Michelet, and Pevsner. Also announced on the verso of the Manifesto was the publication of Sirató's *Le Planisme: La décomposition de la littérature* (Planism: The decomposition of literature), as well as a plan for future publications that included Bryen's *5 objets poétiques* (5 poetic objects), with photographs by Michelet, and Kochar's *La peinture dans l'espace* (Painting in space), as well as three planned volumes by Sirató: *Les arts et les artistes non euclidiens* (Non-Euclidean arts and artists), the *Album Dimensioniste*, and *La vaporisation de la sculpture* (The vaporization of sculpture).[85] In addition, plans were announced to publish the Dimensionist Manifesto in various countries, beginning with a Portuguese edition to be produced by Pedro, a Spanish-langugue one by Chilean poet Huidobro, and a Russian one by Kakabadze. A list of current events and products relevant to Dimensionism included exhibitions by Picabia, Arp, Kandinsky, Taeuber-Arp, Ferron, Mead, Negri, Prinner, and Rathsman; Lévesque's Dada lecture at the Sorbonne and his journal *Orbes*; "Regain," an "information center of new tendencies in the contemporary arts" led by Gaston Diehl; and, as mentioned, Duchamp's *Rotoreliefs*. Finally, a call was made for relevant material for the exhibition and for *La Revue N + 1*, the first issue of which was scheduled to appear in October 1936. Sirató's lecture on the "Manifeste Planiste" was scheduled for Robert Delaunay's "Salon de l'Art Mural" of June 28, 1936 (figure 1.12). Sirató remembers Arp calling what must have been a May 1936 meeting of Arp, Delaunay, Kochar, and Domela — the members of the original group who had begun meeting in 1934 and by now were in effect the executive committee of the Dimensionist movement — at which Arp enumerated their achievements and plans. Because of his rapidly deteriorating health, Sirató was unable to be present, but, in anticipation of his full recovery, he was elected to be the movement's "secretary-general." After overseeing the publication of the Manifesto as a flyer intended for inclusion in the planned *La Revue N + 1*, Sirató, finally recognizing his physical limitations, and with Arp's and Delaunay's approval, asked Nissim to take over.[86]

CONCLUSION: THE INFLUENCE OF THE MANIFESTO AND ITS LEGACY

Almost none of these projects were realized. While the insert to the first issue of *La Revue N + 1* appeared with the Manifesto and the "Mosaic" addendum at the end of May 1936, the journal itself did not. Though Taeuber-Arp and Domela republished the Manifesto as a loose-leaf insert in their journal *Plastique*,[87] the Portuguese, Russian, and Spanish editions did not appear. Apart from *Le Planisme*, Sirató's ambitious publishing program remained in the manuscript stage, though Bryen's and Michelet's book appeared the following year as *L'aventure des objets* (The adventure of objects). The exhibition plans came to nothing.

The reasons for this narrowing of the Dimensionist project were various. The lack of a financial backer delayed some of the plans. Most crucially, however, Dimensionism lost its principal organizers precisely at the moment when it was poised to take off. On assignment for his photo agency in 1935, Sirató caught a cold that developed into

Salon de l'Art Mural

64 bis, rue La Boëtie

Dimanche 30 juin, à 22 heures, Grand Bal de L'Art Mural.

RÉUNIONS du Vendredi 28 Juin

17 h. Conférence du peintre **A. Gleizes:** « Tradition et peinture murale ».

21 h. Causerie de **M. Jean Cassou.**

22 h. Présentation de la Poésie Murale. Lecture du Manifeste Planiste de **Charles Sirato.**

23 h. Causerie-débat sur les projets de l'Association l'Art Mural, par le peintre **Saint-Maur.**

24 h. **Distribution des Prix et Bourses** par le Comité d'Encouragement.

Il sera perçu 2 frs par personne pour la constitution des bourses de voyages, distribuées le soir-même.

1.12 Invitation to the "Salon de l'art murale" for June 28 [n.d.; 1936], Paris. Including planned lectures by Charles Sirató on his "Manifeste Planiste" and by Albert Gleizes. Collection of M. Szarvassy, New York.

influenza, and he never fully recovered. Then he fell victim to a mysterious debilitating inflammatory illness resembling what today might be diagnosed as chronic fatigue syndrome. To compound his problems, shortly before the appearance of the Manifesto, when Sirató was already quite ill, the Stalinist Kochar moved home to Tblisi in Soviet Georgia. At this point Sirató could hardly walk and the conclusion was inevitable; he had to return to his family for long-term medical treatment. Sirató remembers with bitterness the dawn of June 2, 1936, just four days after the appearance of the Manifesto as a flyer, and only three weeks before his lecture at the Salon de l'Art Mural – the moment of his arrival on the international art scene – when Bryen and Moreau took him to the Gare de l'Est and sat him in the coach of the Orient Express en route to Budapest.[88]

The dependence of the movement's organizers on Sirató for his ability to discuss art in terms of scientific theory turned out to be one of the principal factors contributing to Dimensionism's collapse after Sirató's exit. Robert Delaunay, Arp, and Domela lacked an aptitude for the theoretical intricacies of the new physics, according to Sirató. Without Sirató and Kochar as its main organizers, and without Sirató's knowledge of the theory of space-time (however out of date), Dimensionism was unable to maintain its momentum, and it faded away during the years of peace left to Paris. Meanwhile, Sirató was being treated aggressively in Budapest at various hospitals. Finally, responding to the newly introduced medication Prontosil, he recovered, and immediately planned his return to Paris. This was during the summer of 1939, and by September 1, the war had erupted. But Sirató had still not given up his ambition to return to Paris. The war, particularly the Siege of Budapest in the winter of 1944–1945, affected his health adversely, however, and by the time he recovered again, mainly through his adoption of the practice of yogic breathing, it was 1951, the high point of the Stalinist regime in Budapest, and travel abroad was again out of the question (figure A.9).[89]

Despite Sirató's inability to return to Paris and the movement's disintegration, the Dimensionist Manifesto likely exercised a powerful, though indirect, effect on the art world. While this is a topic awaiting further study, I might point to a few possibilities. Given Charles Biederman's presence in Paris shortly after the Manifesto appeared, and given the fact that his concept of the "Structurist" relief was developed after 1936, one can assume that the Manifesto played a role in the development of his book *Art as the Evolution of Visual Knowledge* (1948), on painting's inexorable development toward three-dimensional relief sculpture – even if Biederman does not refer to it in his book – and consequently on postwar Structurism. Stephen Peterson suggests that Sirató's Manifesto affected the development of Lucio Fontana's postwar aesthetics and thus the influential "Manifiesto Blanco" (White Manifesto) and "Movimento spaziale" (Spatialist movement).[90] The exhibition may not have been realized, but in 1937 van Heeckeren and Lévesque organized a show of Dimensionist character at the bar La Cachette in Paris, with canvases by Picabia and Duchamp, Duchamp's *Rotoreliefs*, collages by Bryen, and drawings by the two organizers.[91] Since Bryen is credited with helping to

found both Tachisme and Art Informel, it is certainly worth examining these movements in this context. Crispolti and Fabre claim that the suggestions/predictions of the Manifesto were not fully taken up until the golden age of kinetic sculpture in the 1950s and 1960s, and Sirató himself later referred to Victor Vasarely and Nicholas Schöffer in this respect.[92] The development of holographic art and virtual reality are further realizations of Sirató's and Moholy-Nagy's prediction.[93]

By the mid-1960s, when Hungary was finally reopening itself to international artistic currents, Sirató had been isolated for decades. While working on the manuscript for the First Dimensionist Album he wrote, "Wishing to evaluate the results of Arp's prediction that it would take a century for *Dimensionism* to run its course, I decided to survey … artworks created over the past 30 years, i.e., since 1936. To my surprise I realized that [they] … justified the Manifesto's development. … Indeed these years indicated the victory of *Dimensionism*, of non-Euclidean art."[94] But Sirató never recovered from his disappointment at not having been able to guide the development of an inevitably "Dimensionist" art through the organization, coordination, and theorization he felt it required to remain coherent. "This would have been my calling," he declared, but "sadly no one stepped into my place. And so the artistic chaos was not reduced one iota."[95]

2 THE DIMENSIONIST MANIFESTO AND THE MULTIVALENT FOURTH DIMENSION IN 1936: SIRATÓ, DELAUNAY, DUCHAMP, KANDINSKY, AND PRAMPOLINI

Linda Dalrymple Henderson

An exhibition devoted to the 1936 Dimensionist Manifesto (*Manifeste Dimensioniste*) some eighty years after it was written offers an unusual chance to consider the status of the popular "fourth dimension" of space, so central for many artists in the early twentieth century, and of ideas of dimensionality more generally among modern artists in the 1930s.[1] The Manifesto, written by the Hungarian poet Charles Tamkó Sirató, argued that each medium should move up a dimension, with literature spreading to the plane and painting moving to three-dimensional space. Sculpture should then leave behind "closed, immobile space" to express "Minkowski's four-dimensional space" (space-time) and, beyond that, even "vaporize" in a new form of "Cosmic Art."[2] With its eighteen signatories in Paris and eight signers from abroad, the Dimensionist Manifesto provides valuable insights into the history of modern art in this period of transition, including previously unnoted aspects of continuity between the pre-World War I and postwar periods. In addition, reexamining the Manifesto and its signatories allows us to reflect on the understanding of contemporary science in this period, as the world of Einstein and space-time increasingly challenged the earlier focus of the public and artists alike on the spatial "fourth dimension" and on the ether of space that had characterized pre-relativity physics.[3]

The new world of relativity theory, first publicized in the wake of the 1919 eclipse expedition that confirmed one of Einstein's postulates, appears at the beginning of the Manifesto. There Sirató writes of "the new ideas of space-time of the European spirit" (propagated particularly in the theories of Einstein)" as one of the key roots of "Dimensionism."[4] Yet by couching the Manifesto in terms of the larger issues of dimensional progression and related artistic transformations, Sirató made it possible for the majority of the signers – who were not engaged with Einstein and relativity theory – to add their names. The "Mosaic" of signed statements appended to the Manifesto by Sirató himself and ten artists (Wassily Kandinsky, Francis Picabia, Louis Fernandez, Enrico Prampolini, Frederick Kann, Hans Arp, Robert Delaunay, Mario Nissim, Marcel Duchamp, Camille Bryen) is a particularly useful tool for helping discern the reactions to the Dimensionist Manifesto by various artists and what they wished to clarify or emphasize to be able to add their support. In addition to addressing key elements of the Manifesto, this essay considers, in particular, the responses of four signers of the "Mosaic": Marcel Duchamp, the early twentieth-century artist who had been most fully engaged with four-dimensional geometry and space before and during World War I; two pioneers of totally abstract painting, Robert Delaunay and Wassily Kandinsky, neither of whom had manifested a public interest in the prewar spatial fourth dimension, but on whom new information sheds light; and the second-generation Italian Futurist Enrico Prampolini, whose interests may have matched most fully the range of ideas expressed in the Manifesto and who was, himself, a probable source for some of Sirató's ideas.

Oliver Botar's essay in this volume masterfully reconstructs Sirató's bringing together of members of the avant-garde in Paris around the Dimensionist Manifesto project, drawing on the poet's until-now untranslated 1966 history of the endeavor.[5] Equally importantly, through his interviews with Sirató and his friend, the Hungarian theorist and later chronicler of Surrealism Árpád Mezei, Botar recovered and preserved the intellectual background for the Manifesto's theme of "dimensional inflation."[6] According to Botar, it was the Budapest journal *Is*, in which Mezei was involved, that in 1924–1925 first introduced Sirató to ideas of dimensionality in the context of Hermann Minkowski's 1908 formulation of a four-dimensional space-time continuum that Einstein would later adopt as the framework for his general theory of relativity of 1915. In an essay in the journal, quoted by Botar, Mezei had written that "the analogy of Minkowski's more-than-three-dimensionally constructed world view is clearly recognizable [in artworks]; axiomatically, the artwork is the realization of realizations in [a system of] dimensional increases."[7] In the cultural history of the spatial fourth dimension, the popularization of relativity theory after 1919 had gradually replaced the generally accepted view of the fourth dimension as space with a focus on time as a fourth dimension in a continuum fusing three dimensions of space and one of time.[8] That was the view that artists such as Sirató's countryman László Moholy-Nagy and the Russian Naum Gabo adopted in the early 1920s as they incorporated time and motion into works of "kinetic" art.[9] And such a focus on movement appears in section 3 of the Manifesto with its references to "movement," "Mobile Sculpture," and "Motorized Objects."

Yet in its reference to "dimensional increases," Mezei's discussion also demonstrates his specific interest in additional spatial dimensions, and that theme would become even more central for Sirató. Although Minkowski had declared time to be the fourth dimension, now inextricably linked to space, he had thought of his space-time continuum as a geometrical four-dimensional "absolute world," in which time was subsumed within space.[10] Mezei makes clear his understanding of these two ways of thinking about Minkowski's space-time in his references to "stationary extension" (emphasis on space) and the "extensionless motion" (emphasis on time), which would underlie kinetic art.[11] Mezei specifically connected the augmenting of perception with the process of spatialization or increasing spatial dimensions that would subsequently support the broader theme of the Dimensionist Manifesto: "In essence, every sensation entering into consciousness demands extension and if a new form entering into the dimension of a sensory organ in use spatializes completely, the artwork is constituted; those individuals who are capable of such a pure realization of the spatial tendency we term 'artists.'"[12] Here, as Botar has argued, there is an underlying sense of progressive perceptual evolution manifested in new understandings of space, which was grounded for both Mezei and Sirató in the writings of Oswald Spengler and Henri Bergson.[13] Spengler, for example, had argued for the close connection between ideas of geometry or space and particular cultural moments, declaring in *The Decline of West* (1918), "From now on, we shall consider the *kind of extension as the prime symbol of a Culture.*"[14]

Born in 1905, Sirató was exactly the right age in the 1920s to dive enthusiastically into reading about the new relativity theory in the literature that proliferated on the subject in that decade. Botar notes that while Sirató was still in Budapest in 1928–1929, after he completed his study of law, he read texts on or by Einstein, Minkowski, and Hendrik Lorenz, as well as Bergson and Spengler. According to Botar, he also encountered information about the nineteenth-century pioneers of curved non-Euclidean geometries, Nikolai Lobachevsky and the Hungarian János Bólyai.[15] However, as much as Sirató touted "non-Euclidean geometry" in the Dimensionist Manifesto and related writings, there is no mention in the manifesto of G. F. B. Riemann, whose geometry of irregular curvature was the non-Euclidean geometry of general relativity. As formulated by Einstein, gravity was the result of the irregular, non-Euclidean warping of space-time by the masses of bodies.[16] Instead, with his focus on Minkowski, whose space-time continuum of 1908 was not curved, Sirató actually used the term "non-Euclidean" to signify his primary interest – extra dimensions of space, or space-time, not the curved geometries of Lobachevsky, Bólyai, or Riemann. As he wrote in 1966, he saw the move of each art form up one dimension as "equivalent to the revolution in physics that led our world views from three-dimensional Euclidean space to the four-dimensional space-time continuum."[17] In 1936 Sirató had designated the planned journal *La Revue N + 1* as "FOR THE NON-EUCLIDEAN ARTS,"[18] extending his nonstandard usage of "non-Euclidean" in the Manifesto.

With his birth year matching that of Einstein's publication of the special theory of relativity, Sirató felt a kinship with the new age of Einstein and Minkowski and embraced the radical shift in world views that relativity represented, as Botar has established. Whatever the depth of Sirató's knowledge of physics, it would hardly have mattered for most of the best-known signers of the Manifesto who were much older artists and not invested in relativity theory in any way (i.e., the "Mosaic" signatories noted previously as well as the Paris signers Hans Arp and Sophie Taueber Arp, Sonia Delaunay, César Domela, and Pierre-Albert Birot).[19] Indeed, the age of artists in 1919 as Einstein and his revolutionary ideas burst upon the world of popular culture is a critical indicator of their probable reaction to the new paradigm that suddenly swept aside the spatial fourth dimension in favor of time as well as the space-filling ether, long understood as the necessary medium for wave vibrations. Although ten years Sirató's senior, Moholy-Nagy was also the right age in 1919 (twenty-four) to embrace the new paradigm, as was another signer of the Manifesto, Alexander Calder, who was twenty-one that year and actually studying physics as part of his training as an engineer. Prampolini, born in 1894 and a year older than Moholy-Nagy, was also young enough to adapt to the new science as he developed his theories in the 1920s, although, as we shall see, he remained far more loyal to his Futurist roots and the prewar ideas of Kandinsky. Born in 1866, Kandinsky was fifty-three in 1919, and his world view, focused on vibrations in the ether, was certainly not going to change. His insistence on adding a statement to the Manifesto, inaugurating the "Mosaic" project, is understandable in this context.[20] Likewise, Duchamp and Robert Delaunay were born in 1887 and 1885, respectively, and were also grounded in the pre-World War I era of the spatial fourth dimension and ether physics.[21]

Having developed his theory of "Planism" in poetry in Hungary, Sirató had come to Paris in 1930 and soon connected with Robert Delaunay, Arp, and Ervand Kotchar, along with Domela and Bryen. The close friends Delaunay and Arp would be particularly important to Sirató as he worked on his project, and they came to serve as a kind of "executive committee" for the movement.[22] In the face of Surrealism, which had emerged in the 1920s as the one unified movement in Paris, abstract artists by the 1930s were in need of a means to unify and promote their styles of painting cohesively. Two main groups advocating abstract art, some of whose members would subsequently sign the Manifesto, had been founded earlier in the decade: Cercle et Carré (1929–1930) and Abstraction-Création (1931–1936). Arp, Sophie Taeuber-Arp, Kandinsky, and Prampolini had been members of the much smaller Cercle et Carré, founded by the critic Michel Seuphor and the artists Joaquin Torres-Garcia and Pierre Daura in 1931.[23] Abstraction-Création had counted among its members a number of Manifesto signatories: Robert Delaunay, Sonia Delaunay, Arp, Tauber-Arp, Kandinsky, Prampolini, Domela, Calder, Moholy-Nagy, and Ben Nicholson.[24] Notes in the archive of Pierra Daura make clear the quandary faced by artists united primarily by their opposition to Surrealism. As Daura recorded of one of the early organizational meetings for Cercle

et Carré: "What purpose does the group pursue? Construct what? For whom? Why? etc. etc."[25] Sirató's theme of dimensional augmentation could unite a wide range of poets and artists, and the link to Minkowskian space-time and Einstein gave the movement a gloss of contemporary science. Citing the "absolute need to evolve" that "obliges the avant-garde to march toward the unknown," Sirató argued convincingly for the movement's relevance and even inevitability from the Manifesto's very first line.

Despite his friend Camille Bryen's participation in Surrealism (as well as Arp's association with the movement), Sirató considered Dimensionism a move beyond Surrealism – as well as Cubism and Futurism.[26] Ironically, though, some of the Surrealists themselves had actively engaged both relativity theory and non-Euclidean geometry, the latter in part through their reading of Gaston Bachelard's *Le nouvel esprit scientifique* (The New Scientific Spirit) (1934), with its discussion of Lobachevsky and Bólyai.[27] Bachelard likewise drew on non-Euclidean geometry in his 1936 essay "Surrationalism," which celebrated a "revolution of reason" and specifically mentioned Surrealism.[28] Salvador Dalí had discussed non-Euclidean geometry and the theories of Einstein in his 1935 book *La conquête de l'irrationel* (The conquest of the irrational), and the Surrealist founder André Breton referred to both non-Euclidean geometry and Bachelard's "surrationalism" in his 1936 essay "Crise de l'objet" (The crisis of the object).[29] What appealed to the Surrealists – and Marcel Duchamp before them – was the iconoclastic challenge of consistent non-Euclidean geometries to the status of Euclid's axioms as absolute truths.[30] Thus, in Paris in 1936 there would have been competing usages of the term "non-Euclidean," with quite different intentions on the part of Sirató, for whom it signified additional dimensions, and the Surrealists, who emphasized the revolutionary philosophical import of these curved geometries.

If the close association of the term "non-Euclidean" with Surrealism was one irony surrounding the Manifesto, the other was that, while Sirató acknowledged in the Manifesto that Dimensionism had "been commenced unconsciously by Cubism and Futurism,"[31] he was likely unaware of the degree to which the popular spatial fourth dimension had played a conscious role for Cubist artists. Even if he had read Guillaume Apollinaire's references to the "fourth dimension" in his 1913 *Les peintres cubistes*, the general understanding of the term "fourth dimension" was increasingly shifting to its definition as time in relativity theory, obscuring its earlier central role in Cubist theory.[32] As Sirató worked with Robert Delaunay to spread Dimensionism, including inviting Duchamp to sign the Manifesto, he also would not have been aware that these two artists had actually been in the same circle of Puteaux Cubists for whom the fourth dimension was a major concern. Indeed, along with Delaunay's good friend the painter Jean Metzinger, Delaunay and Duchamp had been involved in separate discussions on the fourth dimension with the insurance actuary Maurice Princet.[33] While Duchamp would go on to explore four-dimensional geometry and make the concept central to his major work *The Bride Stripped Bare by Her Bachelors, Even (The Large Glass)* of 1915–1923, Delaunay would never incorporate the idea into his published artistic theories, which by

1912 centered on color and light. But Sirató's project would certainly have reminded Delaunay of those earlier discussions. And, as will be discussed, new information from the Delaunay archive suggests that it was not only his change in style during 1912 that may have led to his deliberately distancing himself from the notion, but also disagreements with Metzinger and Albert Gleizes in advance of their December 1912 book, *Du Cubisme*.

Interest in the possibility that space might actually have four dimensions, with our familiar world functioning as a section of that truer reality, had developed out of mathematics in the 1870s. E. A. Abbott's *Flatland: A Romance of Many Dimensions* of 1884 was the first major popularization of the idea, which came to be a prominent theme in culture between the 1880s and 1920.[34] The discovery of the X-ray in 1895, which demonstrated scientifically that the human eye sees only a fraction of the electromagnetic spectrum (visible light), made it impossible to deny the existence of a higher dimension simply because it could not be seen. The result was a widespread sense that an invisible metareality existed just beyond the reach of human perception and suggested that artists might intuit this more complex reality. A plate from Claude Bragdon's 1913 *A Primer of Higher Space (The Fourth Dimension)* (figure 2.1) sets forth the mathematical progression of dimensional forms generated as each is moved perpendicular to itself – creating exactly the phenomenon Sirató used as the basis of Dimensionism. The difference here is Bragdon's mathematical continuation of the process to the four-dimensional hypercube, or "tesseract," versus Sirató's adoption of time/movement and the "vaporization" of sculpture. Importantly, however, as Bragdon indicates, it is movement that generates each higher spatial dimension, and in the literature on the spatial fourth dimension time and motion were thus given a role as a *means* to produce the next higher spatial end.[35]

Such space-generating motion had been an important part of Cubist theory, as painters found new support for rejecting three-dimensional Renaissance perspective and pursuing, on the model of the writings of the geometer Henri Poincaré, "tactile and motor sensations."[36] As Metzinger wrote of the Cubist technique in 1911, "They have allowed themselves to move round the object, in order to give ... a concrete representation of it, made up of several successive aspects. Formerly a picture took possession of space, now it reigns also in time [*la durée*]."[37] Robert Delaunay's *Eiffel Tower* series of 1910–1911 (figure 2.2) exemplifies this approach, in which multiple viewpoints of the tower are juxtaposed and fused to suggest a cumulative process of perception, just as Poincaré had suggested that one could take multiple views of a higher-dimensional object and combine them to gain an intuition of its form.

THE GENERATION OF CORRESPONDING FIGURES IN ONE-, TWO-, THREE-, AND FOUR-SPACE.

FIG.1.

THE LINE: A 1-SPACE FIGURE GENERATED BY THE MOVEMENT OF A POINT, CONTAINING AN INFINITE NUMBER OF POINTS, AND 2 FORM ITS BOUNDARIES

FIG.2.

THE SQUARE: A 2-SPACE FIGURE GENERATED BY THE MOVEMENT OF A LINE IN A DIRECTION PERPENDICULAR TO ITSELF TO A DISTANCE EQUAL TO ITS OWN LENGTH IT CONTAINS AN INFINITE NUMBER OF LINES, AND IS BOUNDED BY 4 LINES AND 4 POINTS.

FIG.3

THE CUBE: A 3-SPACE FIGURE OR "SOLID." GENERATED BY THE MOVEMENT OF A SQUARE, IN A DIRECTION PERPENDICULAR TO ITS OWN PLANE, TO A DISTANCE EQUAL TO THE LENGTH OF THE SQUARE THE CUBE CONTAINS AN INFINITE NUMBER OF PLANES (SQUARES) AND IS BOUNDED BY 6 SURFACES, 12 LINES AND 8 POINTS

FIG.4

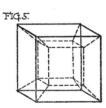

FIG.5.

THE TESSERACT, OR TETRA-HYPERCUBE: A 4-SPACE FIGURE GENERATED BY THE MOVEMENT OF A CUBE IN THE DIRECTION (TO US UNIMAGINABLE) OF THE 4TH DIMENSION. THIS MOVEMENT IS EXTENDED TO A DISTANCE EQUAL TO ONE EDGE OF THE CUBE AND ITS DIRECTION IS PERPENDICULAR TO ALL OUR 3 DIMENSIONS AS EACH OF THESE 3 IS PERPENDICULAR TO THE OTHERS. THE TESSERACT CONTAINS AN INFINITE NUMBER OF FINITE 3-SPACES (CUBES) AND IS BOUNDED BY 8 CUBES, 24 SQUARES, 32 LINES AND 16 POINTS.

NOTE: FIGURE 4 IS A SYMBOLIC REPRESENTATION ONLY—A SORT OF DIAGRAM—SUGGESTING SOME RELATIONS WE CAN PREDICATE OF THE TESSERACT. FIGURE 5 IS A REPRESENTATION DRAWN ON A DIFFERENT PRINCIPLE IN ORDER TO BRING OUT A DIFFERENT SET OF RELATIONS.

PLATE 1

2.1 Claude Bragdon, "The Generation of Corresponding Figures in One-, Two-, Three-, and Four-Space" from *A Primer of Higher Space (The Fourth Dimension)* (Rochester, NY: Manas Press, 1913).

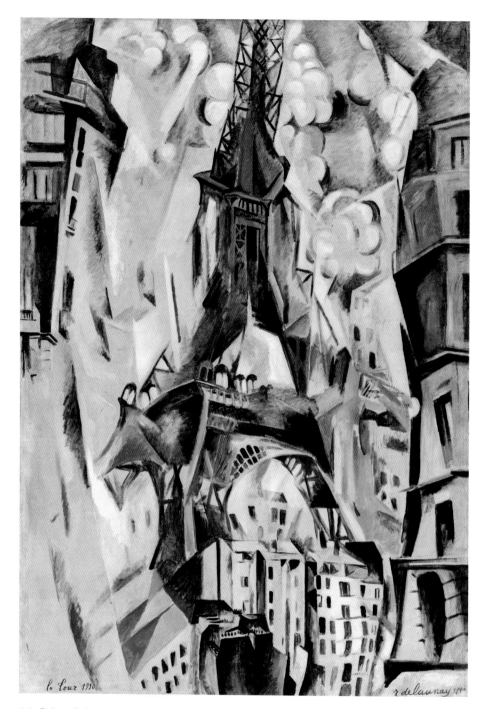

2.2 Robert Delaunay, *Eiffel Tower*, 1911. Oil on canvas.
79½ × 54½ inches (202 × 138.4 cm). The Solomon
R. Guggenheim Museum, New York; Solomon R.
Guggenheim Founding Collection, By gift (37.463).

Robert Delaunay's public silence on the fourth dimension has kept scholars from discussing the *Eiffel Tower* paintings in these terms, but letters from the painter's American friend Samuel Halpert make clear the degree to which the mathematician Maurice Princet was a key part of the milieu around the artist. In a letter to Delaunay of August 24, 1911, Halpert added the note, "Bonjour à Metzinger et au mathématicien."[38] In March 1912 Halpert wrote again, "It is bizarre that I have forgotten the name of the "mathematician" of Montmartre who came rather often to your place. He is part of my best memories, of friendship and chess." Clearly, disagreements had developed between Delaunay and Metzinger by this time, since Halpert in the same letter asks to be remembered to him, despite "all the discussions."[39] And tellingly, during that same month Princet's short text on Delaunay for his joint exhibition with Marie Laurencin at the Galerie Barbazanges included no mention of the fourth dimension.[40] When Halpert wrote again in December 1912 that he had been reading *Du Cubisme*, he noted, "I see that they have taken care to omit Le Fauconnier and you. Why?"[41] Delaunay's style had moved definitively away from Cubism during the summer of 1912 when he commenced his *Simultaneous Windows* series, in which pure color and light replaced any concern with form.[42] Dissociating himself from Metzinger and Gleizes also meant deliberately distancing himself from any association with their brand of Cubism and the fourth dimension.[43] That choice on Delaunay's part was echoed in a manuscript from the early 1920s by one of the artist's friends, the Spanish poet Guillermo de Torre, which describes Delaunay as "fleeing ... the fourth dimension and its plastic equivalents" and "discover[ing] a more evident reality: the depth of color."[44]

Although Delaunay had broken with Metzinger and Gleizes by 1912, he and Gleizes became close in later years when they could see more commonalities in their artistic goals.[45] They both became members of Abstraction-Création, and in 1933 Gleizes produced a manuscript about Delaunay that was to have been published by Abstraction-Création but never appeared. In that text Gleizes wrote of Delaunay's art in language that echoed Cubist writing: "Not of space in itself, not of time in itself, but space and time."[46] In 1933, however, these terms had a new context, the space-time world of Minkowski, and Gleizes would seem to have been a logical recruit for Sirató's Dimensionist Manifesto. As Botar notes in his essay, however, Gleizes did not join his friend Delaunay in signing, saying he felt there were issues that needed to be clarified.[47] In fact, in this period Gleizes's art theory was centered on the theme of vibrations (echoing earlier interest in ether vibrations), and he was deeply interested in the new physics of Louis de Broglie, who interpreted electrons as having the properties of both particles and waves. Gleizes was sending copies of his essays to de Broglie (with no response), but he was likely unwilling to commit to the Einstein-Minkowski relativity model on which Sirató grounded Dimensionism.[48]

What Sirató's project offered Delaunay was a celebration of the way in which his painting now used sculptural relief, raising it to the third dimension — leaving behind the Cubists' pursuit of higher-dimensional realities that he had rejected. In a December

1917 letter to the Barcelona journal *Vell i nou*, Delaunay had declared his opposition to "perspective, geometry, chiaro-scuro."[49] In 1936 he converted that general opposition to "geometry" to an opposition to the "Euclidean." Thus, his "Mosaic" statement celebrates "a New Reality [that] imposes itself outside all known Realisms; neither perspectival nor Euclidean nor chiaro-scuro. New materials. Colors in the nonimitative sense. Electric light as rhythm. Rhythm as subject."[50] Both Delaunay and his wife, Sonia Delaunay, had a longstanding interest in electricity as well as color as vibrating electromagnetic waves, along with the Hertzian waves of wireless telegraphy/radio being broadcast from the Eiffel Tower.[51] Such concerns could now be highlighted as avant-garde themes in the context of Dimensionism.

MARCEL DUCHAMP

In contrast to Robert Delaunay, Duchamp took his discussions with Princet to heart, embracing four-dimensional space and becoming the most knowledgeable artist on the subject in the pre-World War I era. Indeed, Duchamp recognized the iconoclasm of both four-dimensional geometry and the curved non-Euclidean geometries, which he also actively engaged in works such as his *3 Standard Stoppages* of 1913–1914 (Museum of Modern Art, New York), to be discussed further.[52] Beginning in 1912, Duchamp wrote extensive notes responding to the new geometries and popular ideas about the fourth dimension as he prepared for the creation of the *Large Glass* (figure 2.3).[53] In the "playful physics" of the *Glass*, a technoscientific allegory of quest by the Bachelors in the lower realm for the Bride above, Duchamp sought to create unbridgeable contrasts between its lower and upper halves.[54] Thus he defined the realm of the Bride in the upper half as four-dimensional, immeasurable, and free of gravity and perspective versus the constraining Bachelors' domain below, which is ruled by three-dimensional perspective, measure, and gravity. In his notes on the fourth dimension, Duchamp speculated on tactile sensations, cuts and continua, mirrors, and virtual images as ways to make the Bride's space four-dimensional. In the end, without techniques such as computer graphics, which would become available much later in the century, Duchamp reverted to the idea of shadows, a common trope in the literature on the fourth dimension. He thus suggested that the Bride was a two-dimensional compression on glass of a three-dimensional Bride, who was the shadow of the four-dimensional Bride.[55]

In 1936, however, Sirató would have known none of this. The *Large Glass* was in the private collection of Katherine Dreier in Connecticut and was to be repaired that year by Duchamp after it cracked during return shipment to Dreier from the Société Anonyme's 1926–1927 exhibition in Brooklyn. The *Green Box* collection of seventy-nine notes for the *Glass*, which Duchamp had published in facsimile in 1934, had included only one subtle allusion to the fourth dimension. With the idea itself in such a transition in meaning after the rise of Einstein, the artist held back his notes on the fourth dimension, releasing them only three decades later, in his 1966 *White Box*. Thus in 1936 Duchamp's art, in Sirató's eyes, consisted primarily of his more recent

2.3 Marcel Duchamp, *The Bride Stripped Bare by Her Bachelors, Even (The Large Glass)*, 1915–1923. Oil, varnish, lead wire, lead foil, mirror silvering, and dust on two glass panels, as originally executed. 109¼ × 70 × 3⅜ inches (277.5 × 177.8 × 8.6 cm). Philadelphia Museum of Art, Philadelphia; Bequest of Katherine S. Dreier, 1952 (1952.98.1).

production involving motion such as the *Rotoreliefs*, and these works suited Sirató's needs perfectly. As he wrote in his 1966 "History of the Dimensionist Manifesto," Duchamp's "two-dimensional forms were transformed into moving three-dimensional elements by being rotated." Most crucially for Sirató, "What Duchamp did with these works was to introduce a new element – movement – and even more than that – rotation and cyclical movement – into the realm of completely fixed and static arts, i.e., he enriched the realm of artistic effect by the most non-Euclidean aspect."[56] For Sirató, Duchamp's work fit perfectly into the Dimensionist Manifesto's section 3 as "Mobile Sculpture" and "Motorized Objects."

Yet Duchamp's primary interest was not in motion or time itself: for him, as for other advocates of the spatial fourth dimension, movement was simply a means to generate higher-dimensional space. And he made that clear as part of his statement in the appended "Mosaic" text: "Use of movement in the plane for the creation of form in space: Rotoreliefs."[57] In his 1966 historical account Sirató declared Duchamp "the most Dimensionist of all the signees," and that was truer than Sirató could have known.[58] Not only had Duchamp been a serious student of the spatial fourth dimension, he was also the one artist-signer of the Manifesto who had engaged actual non-Euclidean geometries (as opposed to Sirató's loose usage of the term to mean "N + 1"). In his *3 Standard Stoppages* Duchamp had dropped a string from the height of a meter to create three alternative, curved, non-Euclidean "meters."[59] Gluing the threads to black canvas, he simultaneously found a way to "draw" an impersonal line, just as he would glue lead wire onto the surface of the *Glass* to define its forms. And he would use the configurations of the *3 Standard Stoppages* to create the Capillary Tubes connecting the Nine Malic Molds/Bachelors in the lower left corner of the *Glass.*

Writing in the 1960s, Sirató described Duchamp as "a giant of modern art" and an "epoch-making, hugely important pioneering artist."[60] In 1936 Duchamp had not yet achieved this recognition in the art world, so Sirató's encouragement was undoubtedly meaningful for him. He had been laboring on the subject of dimensional change for more than two decades, and Sirató provided a theory and rationale for the subject that had become a major theme of his artistic career and that he would continue to explore. Indeed, it was in 1937 that Duchamp began making notes on the concept he termed *inframince*, or infrathin, by which he meant liminal changes from one dimensional state to another in the everyday world (e.g., "Filing – polishing ... sandpaper ... rubbing down lacquer / often these operations reach the infrathin").[61] Although he never engaged relativity theory, its popularity and the fact that the *3 Standard Stoppages* were, in fact, a demonstration of the irregular, Riemannian curvature of the space-time continuum must have given him some private delight. Indeed, Duchamp seems to have slyly pointed up his awareness of curved, non-Euclidean geometries in the 1942 *First Papers of Surrealism* exhibition installation. There he filled the space with his curvilinear web of *Sixteen Miles of String* (actually one mile) and hung his painting *Network of Stoppages*, based on the *3 Standard Stoppages* in a gesture only his closest friends probably recognized.[62]

Kandinsky, like Robert Delaunay, was not an artist associated with the fourth dimension in his period of greatest artistic invention in the years before World War I, nor in the 1920s. The two painters, who admired each other's works and corresponded, shared a dislike of the lack of color in the Cubism of Picasso and Braque.[63] Moreover, Kandinsky was opposed to "geometric" modes of composition, as he wrote to Arnold Schoenberg in January 1911, preferring an "anti-geometric, antilogical" approach to painterly construction and harmony.[64] Kandinsky studiously avoided any reference to the fourth dimension in his voluminous writings, including *On the Spiritual in Art* (1911) and *Point and Line to Plane* (1925), even after he himself had adopted a geometric style in the later decade. Only in 1930 would an inkling of a change in his view of the fourth dimension come in a letter to the art historian Will Grohmann: "The circle ... is the synthesis of the greatest oppositions. It combines the concentric and the excentric in a single form, and in equilibrium. Of the three primary forms [triangle, square, circle], it points most clearly to the fourth dimension."[65]

Although Kandinsky had avoided the geometrical fourth dimension of Cubism, he was certainly well aware of other of its significations that went well beyond geometry per se, such as its links to idealist higher realities and evolving consciousness as well as its embrace by Theosophists such as C. W. Leadbeater.[66] The artist had cited J. C. F. Zöllner, author of *Transcendental Physics* (1878), in his 1911 *On the Spiritual in Art*, and he owned copies of the Berlin spiritualist periodical *Die Uebersinnliche Welt* (The Suprasensory World), in which the fourth dimension was a frequent topic.[67] Zöllner's experiments with the medium Henry Slade had convinced him of the reality of higher dimensions in the 1880s, and he continued to be closely associated with the topic in Germany.[68] More importantly, the Theosophist/Anthroposophist Rudolf Steiner, whose lectures and writings were crucial for Kandinsky, regularly commenced his lectures on gaining higher consciousness by pointing to that "wise man" Charles Howard Hinton, the British hyperspace philosopher, and his practical exercises for learning how to visualize the fourth dimension.[69] Yet at this stage the associations with Cubism must have been too strong for Kandinsky, even if Apollinaire celebrated the term "fourth dimension" as a "utopian expression," reflecting its larger function as what Bruce Clarke has termed a "matrix of millennial expectations."[70]

Of course, with the popularization of Einstein and relativity theory, such visionary associations of the term were increasingly marginalized, particularly at the Bauhaus as Moholy-Nagy arrived and embraced the new world of space-time and kinetic art.[71] Moholy-Nagy replaced the Expressionist painter Johannes Itten in 1923, marking a change in orientation at the Bauhaus that paralleled the shift in interpretations of the fourth dimension and the vibratory ether of space that had been central to Kandinsky's conception of his painting.[72] He would have found little interest in the new temporal fourth dimension of relativity theory, but we now know that Itten had a copy of Bragdon's *Primer of Higher Space (The Fourth Dimension)* in Weimar in 1920.[73] Kandinsky likely saw the text, and there he would have discovered Bragdon's discussion of the

concept's philosophical dimensions – so sympathetic to his own views. His 1930 comment to Grohmann suggests that Kandinsky had come to see the earlier spatial fourth dimension as a sign of transcendent meaning in the face of the mathematical abstraction of relativity theory and its temporal fourth dimension. Typical of the changing mood of the international avant-garde by the 1920s was the 1922 declaration by Theo van Doesburg, Hans Richter, and El Lissitzky following the Düsseldorf Congress of the International Union of Progressive Artists that "art has ceased to be a means for unraveling cosmic mysteries."[74] For Kandinsky, by contrast, art would never lose its transcendent qualities.

Even though Sirató approached Kandinsky to sign a manifesto that touted the new arts as a response to the four-dimensional space-time world of Minkowski, the concluding elements of section 3 of the text of the Dimensionist Manifesto paralleled Kandinsky's own interests – particularly on the subject of sculpture transformed into a "Cosmic Art" characterized by the "Vaporization of Sculpture," "Syno-Sense Theater," and "gaseous materials." Kandinsky's commitment to synesthesia and experimental theater work in the pre-World War I years had led to experiments such as *The Yellow Sound*, a play whose action was to have been accomplished largely by means of colored lighting, as he described it in the 1912 *Blaue Reiter Almanach*.[75] His 1911 painting *Impression 3 (Concert)* (figure 2.4) presents a similar realm of dematerialized color, experienced by Kandinsky in response to hearing a concert of Schoenberg's music. As Kandinsky explained in his essay "On Stage Composition," "When the artist finds the appropriate means, it is a material form of his soul's vibrations," and "if the method is appropriate, it causes an almost identical vibration in the soul of the audience."[76] Whether in theater or in painting, Kandinsky's works expressed their meaning through wave vibrations in the ether, and the effect was that of dematerialized matter and "gaseous materials." As Kandinsky told Sirató, he had written a similar text in Moscow in 1915, titled "Synthetic Art," and the poet asked the artist for a copy of his text.[77] Indeed, the synergy between Sirató's and Kandinsky's ideas may have been created in part through the Kandinsky-inspired writings of another signer of the Dimensionist Manifesto, Enrico Prampolini, as will be discussed.

Although Kandinsky would have agreed with Sirató's ultimate vision of Dimensionist art, the painter insisted on adding a statement before he would sign the Manifesto – surely to counteract the document's overt relativity theory orientation. In his "Mosaic" addendum to the Manifesto, Kandinsky asserted his deep-seated philosophical beliefs about the relationship of spirit and matter. In his view, "the fundamental change in our conception of the world" that has produced "the great formal revolution in the arts" was the result not of the emergence of Minkowski's space-time world but of "the absolute negation of materialism" and the emergence of "pure spiritualism." According to Kandinsky, "The result of this change is the advent of the synthetic idea in which spirit and matter form a single process."[78] Here was an echo of the painter's longstanding interpretation of spirit and matter as degrees on a continuum, with matter as condensed spirit and spirit as refined matter.[79] This was a worldview characteristic

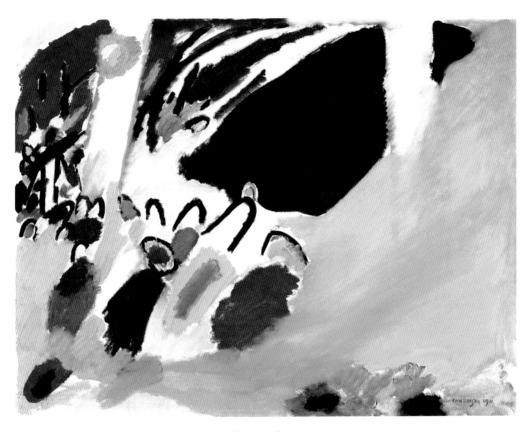

2.4 Wassily Kandinsky, *Impression III (Concert)*, 1911.
Oil on canvas. 30.5 × 39.4 inches (77.5 × 100.0 cm).
Städtische Galerie im Lenbachhaus, Munich.

of the prewar era, supported by the fluid understanding of the relationship between matter and ether, which was often discussed as the source of matter (e.g., the "electron theory" of matter to which Kandinsky refers) and the receptacle for particles of dematerializing matter emitted by radioactive substances.[80] But it was a model that also lived on in the era of relativity theory in a variety of ways. The vibrating ether was central, for example, in the 1927 reprint of Maurice Boucher's 1903 book *L'hyperespace: Le temps, la matière, et l'énergie* (Hyperspace: Time, matter, and energy), which had proposed (before Minkowski) that "l'Espace-Temps à 4 dimensions" (space-time has 4 dimensions) filled with ether and infinite in its extent.[81] While Kandinsky hardly needed such support for his long-held view, sources like Boucher and other French books on the ether kept the topic accessible after the "triumph" of relativity theory after 1919.[82] And, like Kandinsky's theories, many of Prampolini's artistic ideas were also rooted in the realm of vibrating "atmosphere" or ether central to the pre-World War I era.[83]

ENRICO PRAMPOLINI

Prampolini was very likely a critical source for the views about Cosmic Art and the future of sculpture that Sirató set forth in the Dimensionist Manifesto. Sirató mentions Prampolini only briefly in his 1966 "History of the Dimensionist Manifesto," but his comments are significant: "The sixth signee was Enrico Prampolini, whom I had held in high esteem for a long time because of his research-type works that were published in *Hungarian Writing* and [Lajos] Kassák's periodicals. I think we met in the Café Dôme. He fully agreed with the Manifesto and signed it immediately."[84] Although not well known today, Prampolini was a high-profile signer of the Manifesto. While his "Mosaic" statement, "Polymaterial Compositions: contemporary joy in the creation of the world,"[85] emphasized only his current use of mixed materials in his paintings, Prampolini's earlier writings and his embrace of Kandinsky's ideas make clear that he would have identified closely with the Manifesto's concluding themes and was likely a stimulus for some of them. And Sirató's interest in Futurism had been longstanding: "By the time I was seventeen ... I was drawn to the world of the Futurists," he declares in his history of the evolution of his Planist poetry.[86]

Living primarily in Paris between 1925 and 1937, Prampolini had been a prominent international figure and advocate of Futurism in the later 1910s and 1920s, linked to Dada and to the international Constructivist avant-garde in Germany, including the Bauhaus, as well as to De Stijl and to French Purism.[87] From 1917 to 1925 he edited the Rome-based avant-garde journal *Noi*, and particularly in the context of his theater-related work he was invited to exhibit widely across Europe, including at the 1924 International Exhibition of New Theater Techniques in Vienna and the 1926 International Theater Exposition in New York, sponsored by the *Little Review*.[88] Prampolini wrote multiple Futurist texts and manifestos, including "Futurist Stage Design" (1915), which appeared in French translation in Berlin in 1922 and which Sirató read as "Scène

Dinamique Futuriste" in the "Music and Theater Number" of the Hungarian journal *MA* in 1924.[89] That same year Prampolini published "The Futurist Scenic Atmosphere: Technical Manifesto" in a theater-themed issue of *Noi*, a text that subsequently appeared in 1926 in the *Little Review*'s special catalog number as "The Magnetic Theatre and the Futuristic Scenic Atmosphere."[90] Sirató surely knew this text as well, since its theme of dimensional progression resonates with the Dimensionist Manifesto. By the time Prampolini signed the Manifesto in 1936, he was involved in the Italian painting movement of "Aeropittura," founded in 1929, in which the cosmic and spiritual themes suggested in his 1924 theater essay were now linked to flight. And he was pursuing his "Poly-Material Compositions," which he tied specifically to the goal of spiritualizing matter.[91]

Prampolini's visionary 1915 "Futurist Stage Design" essay reflects the impact of Kandinsky's ideas on the possibility of a vibratory synesthetic theater of colored light, which were known in Italy through the *Blaue Reiter Almanach*.[92] Aware as well of Umberto Boccioni's interest in paintings becoming "whirling musical compositions of enormous colored gases,"[93] Prampolini emphasizes electrical technology as well:

> The stage will no longer have a colored backdrop, *but a colorless electromechanical architecture, enlivened by chromatic waves from a source of light*, produced by electric reflectors with colored filters attached and coordinated in accordance with the mood demanded by every dramatic action. ...
>
> In the epoch that Futurism can bring about, we will see the dynamic and luminous architectural structures onstage emitting colorful gleams which ... will ineluctably awaken new impressions, new emotive values in the spectator. Quivering and luminous forms (produced by electrical currents + colored gases) will be unleashed in dynamic writhings, genuine *gas-actors* will replace real actors in the theater of the unknown.[94]

This was the text Sirató read in *MA* in 1924, so suggestive of the dematerialization of art forms and the new "Synos-Sense Theater" he would later celebrate at the conclusion of the Manifesto: "Rigid matter is abolished and replaced by gaseous materials."[95] Indeed, in a fall 1913 text Prampolini had proposed a new form of "Sculpture of Colors and Total Sculpture,"[96] and earlier that year he had published "Chromophony: The Color of Sounds," responding likewise to Kandinsky's ideas, including the prominent theme of vibration.[97] Whatever Sirató's reading on this subject may have been, such ideas remained central for him, since his own "Mosaic" statement would equate "cosmic art" with the "fusion of music and sculpture."[98]

While Prampolini had been interested in the ideas of the mechanical and electromechanical stage sets that were developing in Germany and Russia, the context in which his essay appeared in *MA*, he subsequently broke with these Constructivist approaches. He had spoken at the 1922 Congress of the International Union of Progressive Artists in Dusseldorf, and he had reacted negatively to the post-conference

statement by Van Doesburg, Lissitzky, and Richter, noted earlier, that had denounced art as a "means for unveiling cosmic mysteries."[99] In 1924 he returned overtly to themes closer to Kandinsky's, suggesting in "Spiritual Architecture" that the Futurists had opened the way to "new spiritual landscapes of the cosmic soul."[100] And in his 1924 "Futuristic Scenic Atmosphere" manifesto, Prampolini specifically rejects Constructivist theater, declaring, "The magnetic theater wants to surround watching humanity with a new atmosphere and a new spirituality in order to protect it against the *esthetic materialism* which dominates the realm of theatrical interpretation."[101] Thus, he proposes a new "poly-dimensional scenic space" (figure 2.5), the result of stage design's progress through successive dimensions (two-dimensional "sceno-synthesis" and three-dimensional "sceno-plastic") to an ultimate four-dimensional "sceno-dynamic" phase. Free of actors, a moving set would be filled with vibrating colored light and sound:

> *four dimensional scenic setting*—predominance of the architectonic element of space – intervention of rhythmical movement, as a dynamic element necessary to the unity and to the simultaneous development of the environment and of the theatrical action – *abolition of painted scenery*—*luminous architecture of chromatic space* – polydimensional and poly-expressive scenic action – *dynamic abstraction*—*space*—[102]

Prampolini's fourth-dimensional focus also seems to nod to Einstein in his declaration that new "futuristic stage reform ... frames its scenic conception in Time and Space, that it considers the measure of time and the dimension of space."[103] Yet his final discussion of the "poly-expressive and magnetic theater" demonstrates a fusion of the scientific and spiritual worthy of Kandinsky and Sirató.[104] According to Prampolini, this new theatrical form relies on the "magnetic power of suggestion" and, in conjunction with his moving, mechanical set, the synesthetic use of sound (specifically, the human voice) and colored lights can create "a *mechanical rite* expressive of the eternal transcendence of matter, a magical revelation of a scientific and spiritual mystery."[105]

Prampolini's goals became even more specifically cosmic in the context of the visionary Aeropittura movement of Futurism's second phase, in which earlier associations of the spatial fourth dimension with infinity and escaping gravity now found new relevance in the context of flight. Referring both to the "simultaneity of time-space" and "perspective polydimensionality," Prampolini wrote for the 1931 *Futurist Exhibition of Aeropainting and Scenography* in Milan: "I believe that to reach the highest goals of a new extra-terrestrial spirituality, we must go beyond the transfiguration of seeming reality, even in the contingency of our own plastic developments, and aim at the absolute equilibrium of the infinite and there generate the latent images of a new world of cosmic realities."[106] He might well have referred to his Aeropittura activity in his "Mosaic" statement, but the strongly nationalist associations of the movement, as Aeropittura artists created murals for Fascist buildings, may have militated against

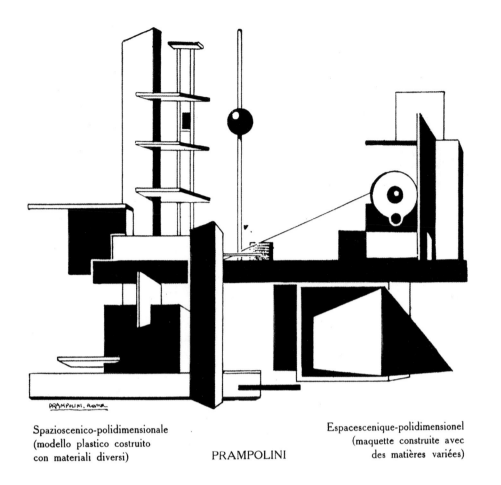

Spazioscenico-polidimensionale
(modello plastico costruito
con materiali diversi)

PRAMPOLINI

Espacescenique-polidimensionel
(maquette construite avec
des matières variées)

2.5 Enrico Prampolini, "Poly-dimensional Scenic Space," 1925, from *Noi*, 2nd ser., nos. 10–11–12 (1925).

that.[107] Instead, Prampolini focused solely on his "Poly-Material Compositions," which fit more comfortably into an international art movement. But here his goals remained equally spiritual, as he explained in a 1934 essay: "To spiritualize matter and orchestrate it harmoniously on spatial surfaces, to exalt the human visions of our epoch with the living and direct contrast of materials themselves: such is the suggestive and representative power of materials."[108]

Prampolini had, in fact, exhibited examples of Aeropittura in Paris in April 1935 in the exhibition *Futurisme et aéropeinture* at the Galerie Bernheim-Jeune, an exhibition that is said to have impressed Robert Delaunay.[109] The catalog for that exhibition reprinted Prampolini's 1931 essay, which had also included the suggestive comments:

"The painting emigrates from the surface, and the picture emigrates from the frame. Sculpture emigrates from the plastic block and the auxiliary planes."[110] For Sirató, the Italian artist was the Dimensionist par excellence: his art and theories matched virtually all of Sirató's dimensional artistic categories, including an awareness of the space-time world of Minkowski. Early on, Prampolini's writings on theater had offered the young poet an image of dematerialized artworks that ultimately could stand as a counterpart to his own expansion of the medium of poetry to the plane in his Planism. Sirató's 1966 discussion in his "History of the Dimensionist Manifesto" of his own speculation on a "five-sensed theater" in the late 1920s confirms the impact of experimental theater on the evolution of his ideas, and it thus stood as a "readymade" endpoint for a system of dimensional evolution.[111] Stimulated by Mezei's ideas on progressive spatialization in the context of Spengler and relativity theory, Sirató, once he was in Paris, found the transitional stages for a coherent system when he discovered forms of painting that added relief elements and sculpture transformed by new kinetic elements. In a prescient suggestion of the immersive installation art that would come decades later, Sirató concluded the Dimensionist Manifesto by proposing that the viewer, "instead of looking at works of art," would "become the center and subject of creation," with "creation consist[ing] in sensorial effects directed in a closed cosmic space."[112] Placing the spectator "in the center of the picture" had been a key goal of the Futurism that had attracted Sirató in his youth.[113] The continued stimulation provided by Prampolini's writings, as well as the ideas of Kandinsky as absorbed by Prampolini, had pushed Sirató's thinking in the direction of the cosmic aspects of the fourth dimension, complementing the scientific rationale for Dimensionism announced at the beginning of the Manifesto.

1936–1960S

Although Sirató's failing health tragically took him back to Hungary in 1936, and the ambitious plans for the Dimensionist movement never progressed beyond the Manifesto's second publication in the journal *Plastique*, edited by Sophie Taueber-Arp and Domela, there was a remarkable resurgence of such ideas in the 1960s.[114] In his 1966 history Sirató recounts receiving the third edition of the Dimensionist Manifesto, published by the periodical *Morphemes* in Paris in 1965.[115] What he did not know was that in the spring of that year a group of artists in New York, known as the Park Place Gallery group, had staged an exhibition they titled *4D* at the John Daniels Gallery.[116] And just as in 1936, the term "fourth dimension" functioned in a variety of ways for these artists, bringing together individuals around a theme that could be interpreted quite differently by each artist. Thus, for the sculptor Mark di Suvero, "4D" signified the space-time world of Einstein as embodied in the kinetic sculpture that had become dominant in the 1950s, particularly as promulgated in Moholy-Nagy's *Vision of Motion* of 1947. "I am a child of Einstein … I cannot see space without time," di Suvero stated in regard to his monumental sculptures with their moving components.[117] For Peter Forakis and Dean Fleming, it was the largely forgotten spatial fourth dimension with its

geometrical and mystical associations that offered important new inspiration. In 1957 Forakis had discovered a copy of *Tertium organum* (1911) by the Russian mystic philosopher P. D. Ouspensky as well as books by Bragdon in a sale of the books of California artist Adaline Kent; these texts were revelations in the world of the temporal fourth dimension in the 1950s.[118] Forakis embraced Bragdon's geometrical drawings as models for sculpture, and Fleming responded to Ouspensky's belief in the possibility of escaping three-dimensional logic and achieving four-dimensional "cosmic consciousness," just as Kazimir Malevich had sought to do in his Suprematist works of the 1910s.[119] Associated as well with escaping from gravity in outer space, the "4D" appealed to Forrest Myers and Leo Valledor in this context, along with the theories of Buckminster Fuller, whose lectures helped resuscitate the spatial significance of the term in the world of Einstein.[120]

Duchamp himself must have sensed the renewed cultural interest in the geometrical fourth dimension by the 1960s and finally published his speculations on the subject, which had been so central to the *Large Glass*.[121] He and Sirató were no longer in contact, but if they had been they might have celebrated together the resurgence of interest in an idea so important to both of them. As Sirató sensed at the time of his work on the *Dimensionist Album I* in 1966, this renewal of interest was indeed stimulated in part by "the Atomic Age, the SPACE AGE – creat[ing] art that suits its needs."[122] Lucio Fontana's movement of Spatialism, which was anticipated by the Dimensionist Manifesto, provided a context for continued European interest in the fourth dimension in the Space Age of the 1950s and 1960s, as Stephen Petersen has argued convincingly.[123] Subsequently, other developments beginning in the 1970s, including the emergence both of computer graphics and of string theory in physics, with its discussions of ten- and eleven-dimensional universes, would further contribute to renewed public focus on higher dimensions of space.[124] Today, in the era of virtual reality and immersive installation art, we have come much closer to the realization of the "furthest future of Dimensionism" that Sirató had suggested to Robert Delaunay in 1935 would require "75–100 years."[125] One need only enter an installation by Olafur Eliasson, such as his 2010 *Your Blind Movement*, in which a visitor is immersed in fog-filled spaces of varying colors, to experience the very "creation consist[ing] of sensorial effects directed in a closed cosmic space" that Sirató celebrated at the end of the Dimensionist Manifesto.[126] And Eliasson, whose projects have engaged dimensionality directly, is far from the only artist today drawn in this direction.[127] The multivalent fourth dimension is proving to be a theme as stimulating for artists in the twenty-first century as it was for Sirató and his colleagues in the twentieth.

3 FROM MACROCOSM TO MICROCOSM: EXAMINING THE ROLE OF MODERN SCIENCE IN AMERICAN ART

Vanja V. Malloy

On January 24, 1925, many Americans had a unique opportunity to see cosmic space as Einstein's general theory of relativity proposed it: curved, irregular, warped, or otherwise non-Euclidean. Thousands of people lined the streets of upper Manhattan and other urban areas and gazed at the sky that afternoon, where for a mere minute the sun was cast in blackness and a golden halo enveloped its circular form (figure 3.1). The light from this halo was not coming from the sun – which was completely shadowed by the moon – but was in fact produced by neighboring stars whose light traveled the curved paths of cosmic space surrounding the sun. This bent starlight gave visual evidence of the warped celestial space created by the sun's enormous mass. Peering at the sky with the unaided eye, even the lay observer was able to find visual confirmation of a key postulate of Einstein's general theory of relativity that scientists had not been able to prove experimentally: that the strong gravitational pulls of large masses warp their surrounding space.

Alexander Calder was one of the many thousands of New Yorkers who viewed the eclipse, and later that year he produced a painting of the celestial phenomenon that he had observed from the steps of Columbia University.[1] Six years earlier the astrophysicists Arthur Eddington and Charles Rundle Davidson of the Royal Observatory in

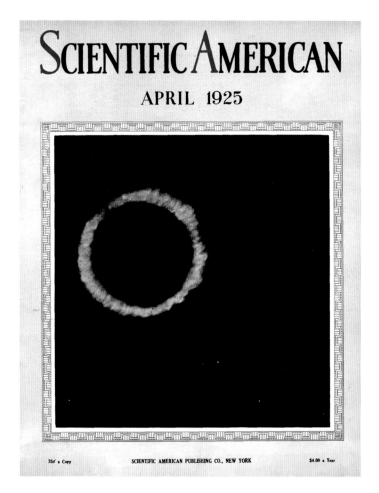

3.1 Photograph of the total solar eclipse of January 24, 1925, cover of *Scientific American*, April 1925.

Greenwich, England, had traveled, respectively, to the island of Principe (off the west coast of Africa) and to Sobral, Brazil, to photograph the total solar eclipse of 1919.[2] While the 1919 expedition is credited with bringing Einstein and his celebrated theory into the mainstream, it was the 1925 occurrence that allowed a record number of Americans to witness this new conception of space with their own eyes, and that provoked an insatiable appetite for this new science in U.S. popular culture.[3] *Scientific American*, for example, covered the event in full, publishing a map of where the eclipse had been best visible (figure 3.2) alongside essays explaining the science behind it, and popular demand even spurred a special motion picture of the event (figure 3.3).[4] To a fascinated U.S. audience, the eclipse demonstrated that completely new conceptions of space revealed themselves just beyond the limits of everyday human perception.

The Solar Eclipse

The shaded strip on this map shows where the eclipse will be total. At the center of the strip the totality will last about two minutes

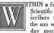

WITHIN a few days after this issue of the Scientific American reaches our subscribers the long-heralded eclipse of the sun will be on. The date is Saturday morning, January 24. A time table for the period of totality is printed here.

If you live in or near the zone of totality, within which zone the sun's light will be entirely cut off for two minutes or less, and if you are at all interested in doing scientific work yourself, you have doubtless planned long before this just what observations you will carry out.

A number of cooperative investigations, all of them possible without extensive training or complicated equipment, are engaging the efforts of thousands of interested persons in the eclipse area. One of these is the determination of the exact position of the edge of the shadow path, as requested by the American Astronomical Society. The coupon for reporting the results of these observations, as

The Time Table

This table gives the approximate time of the beginning of totality as calculated for a number of cities in and near the shadow.

All times are given in Eastern Standard Time. For places that use Central Standard Time, the local times will be one hour earlier.

	Beginning of Totality	Duration of Totality in Minutes
Duluth, Minn.	9:02 A.M.	0.4
Iron Mountain, Mich.	9:03 A.M.	1.7
Bellaire, Mich.	9:04 A.M.	1.9
Stratford, Canada	9:05 A.M.	1.8
Buffalo, N. Y.	9:06 A.M.	1.8
Warsaw, N. Y.	9:07 A.M.	1.9
Hornell, N. Y.	9:08 A.M.	1.4
Ithaca, N. Y.	9:09 A.M.	1.8
New York City (northern part)	9:10 A.M.	.5
Poughkeepsie, N. Y.	9:11 A.M.	1.9
New Haven, Conn.	9:12 A.M.	2.0
Montauk Point, L. I.	9:12 A.M.	2.0

described in detail in our January, 1925, issue, is reprinted in the present issue on page 139.

Another investigation is that of radio transmission during the eclipse, as arranged by the Scientific American with the collaboration of several broadcasting stations and a large group of radio listeners who have registered with us.

This, too, was described in detail in our January, 1925, issue and similar descriptions have appeared in many newspapers in the eclipse zone.

If you have not seen these descriptions and if it is still not too late for you to arrange to help, get a copy of our January issue at a library or book store, or telegraph us to send you our eclipse pages.

The map and time table on this page will show you when and where to begin your observations.

If you make observations of any kind relating to the eclipse send your report to the Editor of the Scientific American, 233 Broadway, New York City. We will see that they reach the proper agency.

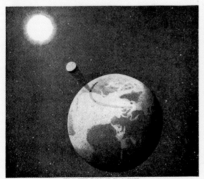

HOW THE ECLIPSE IS CAUSED

The moon gets between the sun and the earth, casting a complete shadow which moves along a narrow strip as the earth revolves

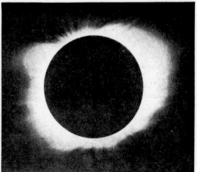

WHAT THE ECLIPSED SUN LOOKS LIKE

Around the black disk of the moon is the marvelous fringe of light or "corona" that astronomers will travel miles to see

3.2 Coverage of the total solar eclipse of 1925, including a map of where it was best visible and a photograph of the event, *Scientific American*, February 1925.

Carpenter-Goldman Laboratories, Inc.

Prize for Criticism of Eclipse Motion Picture
An Announcement of a Contest Which We Hope All Our Readers Will Join

DURING the eclipse the Scientific American party, at Easthampton, Long Island, made a complete motion picture record of the sun. A strip of this film, showing the corona during totality, is reproduced above.

This record was made, originally, for scientific purposes only. But since the eclipse we have had so many requests for this film that we have decided to prepare a special motion picture dealing with the entire event. This picture is now in preparation under the direction of the well-known motion picture experts, Mr. Arthur Carpenter and Mr. F. L. Goldman. It will probably be ready for release in the theatres even before this issue is on sale.

Profits to Go to Astronomy

The picture is not a commercial enterprise. In return for much assistance from the scientific professions, we have agreed that any profits earned by the picture shall go to the American Astronomical Society for scientific purposes.

The film will show, not only the eclipse itself, but all the scientific investigations which were carried out. There will be views of astronomers operating the instruments in the great observatories; of the scientists aboard the airship Los Angeles; of the multitudinous preparations made long before the eclipse; of the radio investigations and of the results obtained from them.

Special models of the earth and moon have been

Carpenter-Goldman Laboratories, Inc.
MAKING AN ANIMATED DRAWING
Mr. Goldman is photographing one of the series of animated diagrams showing how the eclipse affected the reception of radio programs

built in order to show just how an eclipse occurs.

Every available bit of scientific information has been collected for this unusual effort to show a scientific event correctly and interestingly on the silver screen. Some of America's most distinguished scientists are giving us full and gratuitous cooperation.

There is something *you* can do. The problem of

presenting scientific fact by motion pictures is a pressing one. Properly used, the movies may be a great means of popular education. We are anxious to discover how this can be done. Is the eclipse film a step in the right direction or is it not?

Accordingly, if you have seen this film, sit down and write us a letter about it. Tell us what parts of it you thought good; what parts you thought bad. Tell us, too, whether you think we are on the right track toward the use of films in scientific education. What subject, if any, ought we to attempt next? It is not necessary to see the film. We will send you on request an illustrated synopsis of it. You can write your criticisms from this.

One Hundred Dollar Prize

Just to make it a little more interesting for you we are offering a prize. For the most helpful letter of criticism, written along the above lines and mailed to us before July 1, 1925, we will give a prize of one hundred dollars in cash. There are no conditions except that helpful suggestions will be rated higher than mere objections. Our Editors will be the judges. We cannot agree to enter into correspondence about this contest. If you want the receipt of your letter to be acknowledged, enclose a reply postcard. Address: Movie Contest Editor, the Scientific American, Woolworth Building, New York, N. Y.

Even if you do not care about the hundred-dollar prize, send us your letter of criticism anyway. We want to know what to do. You can help us to decide.

Carpenter-Goldman Laboratories, Inc.
HOW THE MOTION PICTURE RECORD WAS MADE
This photograph, taken at Easthampton during the eclipse, shows the making of the actual motion picture. This camera was operated continuously for over two hours in order to show all phases of the eclipse

Carpenter-Goldman Laboratories, Inc.
SHOWING THE MOTION OF THE EARTH AND MOON
A model of the earth and a small ball to represent the moon have been used to produce a remarkable motion picture scene showing the relative motions of these bodies and the exact way in which eclipses happen

3.3 Strip of film showing the solar eclipse of January 24, 1925, *Scientific American*, April 1925.

While the eclipse provided viewers from all walks of life with a glimmer of this cosmic realm, it was also one of the many phenomena challenging artists to apply their unique creative minds to the new scientific reality of the twentieth century. In the United States they could take advantage of a wide range of visual resources documenting this new science, from photographs of microbial organisms and molecular structures of a crystal, to simulated journeys through space in newly constructed planetariums. What is of interest to this essay is how the United States at mid-century was a site of interdisciplinary exchange for modern art and science, uniting a widely varied group of international artists who drew inspiration from the new discoveries on both the macrocosmic and microcosmic levels.

EINSTEIN'S SPECIAL THEORY OF RELATIVITY

As the 1919 and 1925 eclipses demonstrated, Einstein's famous theory of relativity provided us with a new outlook on the cosmic macrocosm, redefining the fourth dimension as space-time and engendering a new vision of cosmic space. A discussion of the influence of relativity in the arts, however, benefits from a differentiation between its two theories – the 1905 special theory of relativity and the 1915 general theory of relativity, which built upon special relativity to include gravitation. By demonstrating the gravitational pulls of cosmic bodies, the total eclipse embodies general relativity. However, the earlier special relativity, particularly as it was clarified in 1908 by Hermann Minkowski and his notion of four-dimensional space-time, plays a dominant role in the Dimensionist Manifesto – a key focus of this volume as a whole.[5] As the opening paragraph of the Manifesto states, "space and time are no longer separate categories" but rather "related dimensions" that are inseparably joined. Several of Charles Sirató's statements in his "History of the Dimensionist Manifesto" support this conclusion, since he repeatedly references 1905 as the year of Dimensionism's birth.[6] This essay, therefore, will first examine the engagement between artists and Einstein's 1905 theory of relativity.

The special theory of relativity resulted in the mass-energy equivalence formula ($E = mc^2$), which placed a new importance on the speed of light as a universal constant, in a universe that was increasingly shown to be anything but constant. In his essay in this volume Oliver Botar discusses, for example, the influence of Einstein's special relativity on László Moholy-Nagy's use of light. Moholy-Nagy's *Light Prop for an Electric Stage* (1930) (figure 3.4), which later became known as the *Light-Space Modulator,* was originally intended as a prop for a film that would depict moving patterns of reflected light, but it ultimately became known as a sculpture in its own right.[7] Making use of light projection technology, the object casts colored light onto its surroundings and creates the appearance of abstract and disembodied motion. The work, Botar argues, fulfills the Dimensionist Manifesto's mission to create a new "cosmic" art in which sculpture becomes "vaporized" in the fourth dimension by implementing light to disembody the object from its physical form. Indeed, Moholy-Nagy had met with

Einstein in 1924 to ask the scientist to write a book on relativity for the Bauhaus, and after Einstein declined Moholy-Nagy himself delineated the spatial and temporal implications of relativity in his books *The New Vision* (1928) and *Vision in Motion* (1947).[8]

Both of these publications were highly influential in their advocacy of an interrelationship between art and science. *Vision in Motion* in particular reached a broad U.S. audience, especially a younger generation of art students. Devoting an entire section of the book to what he titles "Space-Time Problems," Moholy-Nagy draws attention to the term popularized by special relativity, arguing that while "artists and laymen seldom have the mathematical knowledge to visualize in scientific formulae," relativity had introduced a "new dynamic and kinetic existence freed from the static, fixed framework of the past."[9] He discusses the notion of "space-time" as a distinctly modern conception of space as "inseparably intertwined" with time and therefore of critical importance to new art. Since Moholy-Nagy was living in Chicago by 1937, the book presents numerous examples of U.S. artists who were engaged with the new physical realities revealed by science. One example was the Swiss-American artist Herbert Matter, whose stroboscopic photographs were based on the new technique of electronic stroboscopic lighting invented in 1931 by Harold Eugene Edgerton at the Massachusetts Institute of Technology.[10] Producing one flash with many powerful yet incredibly short bursts of light, this method precisely captures a body's path in motion and allows the photographer, Matter noted, to record "what the human eye fails to discern. … Our vision is quickened, our plastic conception enriched."[11] Matter's photographs can also be seen as representing a dilation of time through their depiction of slowed-down movement, alluding in this way to special relativity and its demonstration of the inconstancy of time. *Vision in Motion* features several examples of Matter's stroboscopic photographs, ranging from a figure captured in mid-stride (figure 3.5) to the dynamic path of motion employed by Alexander Calder's kinetic mobile sculptures. Many other artists working in the United States engaged with these ideas, such as Isamu Noguchi, whose 1944 sculpture $E = mc^2$ (figure 3.6) takes Einstein's famous formula as its title.

Attempts to understand special relativity and space-time also gave birth to the spatial delineation of the "light cone," a shape that resembles an hourglass and that depicts, through its mapping of the two coordinates of time (t) and space (x), the observer's relation to the past (the lower cone), the future (the upper cone), and the present (the midpoint where the tips meet).[12] The object, in a sense, explicates the travel of a flash of light, or indeed the movement of any moving body (whose path is described as a "world-line"), since only an impossible velocity faster than the speed of light would permit access to areas beyond this realm. The image of the light cone, which was an essential element in Minkowski's delineation of the fourth dimension, captured the imagination of numerous critics and philosophers, particularly because of the profound questions about determinism and free will that it provoked. As the popular science writer and astrophysicist James Jeans explained in his 1943 book *Physics and Philosophy*,

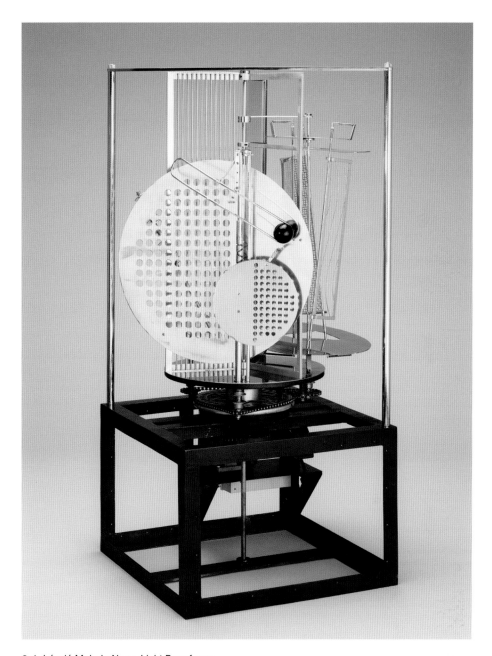

3.4 László Moholy-Nagy, *Light Prop for an Electric Stage (Light-Space Modulator)*, 1930. Aluminum, steel, nickel-plated brass, other metals, plastic, wood, and electric motor. 59½ × 27½ × 27½ inches (151.1 × 69.9 × 69.9 cm). Harvard Art Museums/Busch-Reisinger Museum, Gift of Sibyl Moholy-Nagy (BR 56.5).

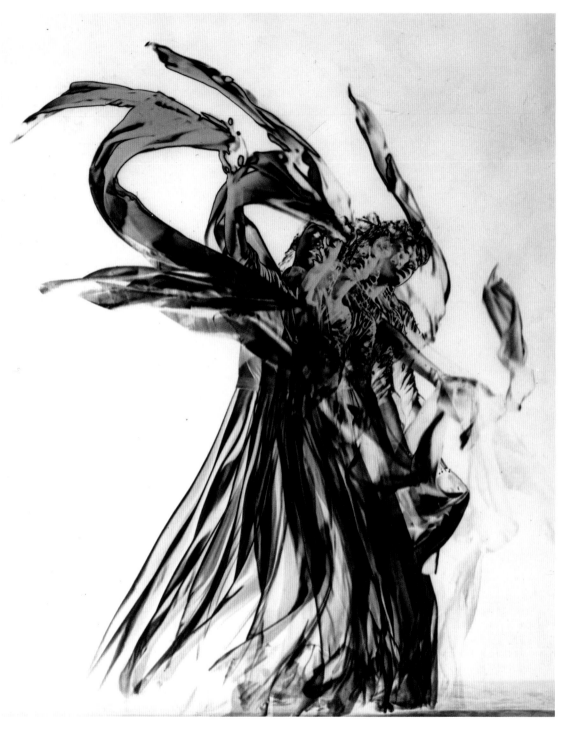

3.5 Herbert Matter, *Mercedes Matter Dancing*, 1937.
Photograph. 5½ × 4½ inches (14 × 11.4 cm). Stanford
University Libraries, Stanford, California.

3.6 Isamu Noguchi, $E = mc^2$, 1944. Papier-mâché.
13⅝ × 11¾ × 10 inches (34.6 × 29.8 × 25.4 cm). The
Isamu Noguchi Foundation and Garden Museum,
New York.

the question of causality has assumed a new aspect. We can no longer say that the past creates the present. ... All we can say is that the world-lines of all objects in the universe follow the simple pattern already described. If these world-lines have a real existence in a real continuum, the whole history of the universe, future as well as past, is already irrevocably fixed. If on the other hand the world-lines are merely constructions we draw for ourselves, to help visualize the pattern of events, then it is as easy to extend these world-lines from our already completed past into our future as it is to carry on the weaving of a fabric when the pattern is already set in the loom. In either case the future is unalterable, and inescapable determinism reigns.[13]

By the 1930s the form of the light cone, with its implicit reference to Einstein's special relativity and the metaphysical questioning it provoked, could be found in a range of American artworks. One example is Patrick Sullivan's 1938 painting *The Fourth Dimension* (figure 3.7), in which the form of the light cone is placed prominently in the center of the composition and the beams of light projecting from it allude to the indivisible coordinates of time and space. A figure on the left of the painting stands with his back to the viewer, facing the cosmic landscape, with his wrist chained to the ground. The same figure appears again on the right side of the painting, still chained and now lying dead, with a ghost rising from his body. Both the title of the painting and its content suggest that the artist was contemplating the philosophical queries born out of Einstein's special relativity, particularly the contrast between humankind's destined lifespan on Earth and the far greater unknown timeline of the universe.

EINSTEIN'S GENERAL THEORY OF RELATIVITY AND NON-EUCLIDEAN SPACE

As the growing population of scientifically literate observers in the United States understood, the warped space made visible by the 1919 and 1925 solar eclipses served to confirm Einstein's general theory of relativity, which expanded on special relativity by incorporating the effects of gravity on matter, space, and time and proposed, therefore, a new way of thinking about the relations among these phenomena. One of general relativity's postulates concerns the relationship between gravity and a non-Euclidean curvature of four-dimensional space-time—a phenomenon that is not noticeable from the perspective of Earth but that nevertheless exists in outer space. Thus a key difference between Newtonian physics and general relativity is the latter's cosmology, whose truths revealed themselves in the warped space made visible by a total eclipse. From the perspective of general relativity, the universe takes on completely new dimensions; because of the curvature of space, parallel lines no longer need to be parallel, and the three angles of a triangle are not required to add up to 180 degrees. The impact of this new theory on modern thought was immense in both the sciences and humanities.

3.7 Patrick Sullivan, *The Fourth Dimension*, 1938. Oil on canvas. 24¼ × 30¼ inches (61.5 × 76.6 cm). Museum of Modern Art, New York; The Sidney and Harriet Janis Collection (656.1967).

Although the dominant scientific narrative of the Dimensionist Manifesto is based on special relativity, it does refer to the contributions of János Bólyai, a Hungarian mathematician whose 1832 paper, "Absolute Science of Space," was the first publication to demonstrate the possibility of non-Euclidean space. Georg Friedrich Bernhard Riemann developed this idea further in 1854 by proposing, via differential geometry, the existence of an alternative curved space, which he believed could exhibit irregular properties and consequently stretch, contract, or otherwise deform an object moving through it. However, as Linda Henderson explains in her essay in this volume, Sirató's use of the term "non-Euclidean" in the Dimensionist Manifesto and his related writings was a nonstandard one, suggesting the spatial expansion of an artwork (N +1) rather than the Riemannian geometry of general relativity. His concept of the "non-Euclidean," in other words, seems more closely aligned with earlier conceptions of higher spatial dimensions than with curved geometry, although his slightly vague or inaccurate language may have been deliberate. It remains unclear, in other words, if it was based in a misunderstanding of relativity, or if it was a calculated attempt to keep the Manifesto "liberal in conception" so that it would accommodate a diverse group of artists, including those who were expressly concerned with the pre-Einsteinian conceptions of higher spatial dimensions.[14]

Regardless of Sirató's motive, general relativity can still be seen to inform a range of artwork by Dimensionist artists. For instance, Henderson points out that in Duchamp's 1942 exhibition *Papers of Surrealism* in New York City, the artist evoked a non-Euclidean space through the curvilinear webs of his *16 Miles of String* installation. By the time the Dimensionist Manifesto was created in 1936, the widely publicized photographs from the 1919 and 1925 eclipses had been accorded an iconic status in U.S. popular culture, and discussions of general relativity continued to appear in magazines and newspapers, as well as in pulp fiction and comics.[15] References to the total eclipse can be found in the work of artists who signed the Dimensionist Manifesto, including Ben Nicholson, Calder, and Duchamp (who in fact titled one of his 1935 *Rotoreliefs* "Eclipse Totale" [figure 3.8]). But the image of the eclipse is perhaps even more pronounced in the work of other modern artists. Joseph Cornell (figure 3.9), for example, incorporated film footage of the eclipse into the finale of his 1936 film *Rose Hobart*, and he alludes to this same cosmic image in his 1939 abstract mixed media work *Object* (figure 3.10). A number of artists working in the United States also evoked the warped, curved space of general relativity in their cosmically evocative artworks, such as Moholy-Nagy's 1942 sculpture *Space Modulation with Highlights* (figure 3.11), Herbert Bayer's 1942–1944 painting *Celestial Spaces* (figure 3.12), and Calder's drawings and paintings from the 1940s and beyond. General relativity's creation of warped space through a cosmic body's gravitational pull encouraged the exploration of how these cosmic bodies engage in spatial relationships with one another, and provided a new context for the spatial relationships explored in Isamu Noguchi's series of cosmic landscapes, such as *Yellow Landscape* (1943) (figure 3.13).

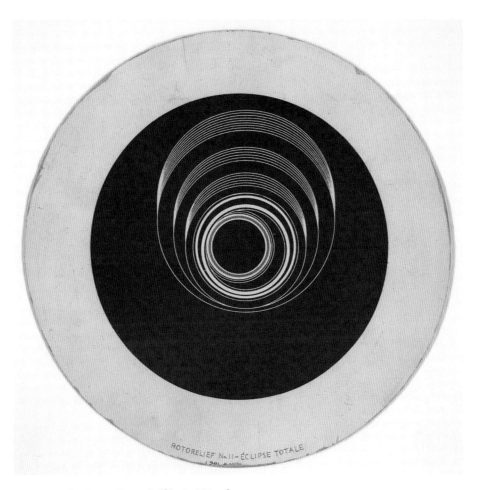

ROTORELIEF No. 11 – ÉCLIPSE TOTALE

3.8 Marcel Duchamp, *Rotorelief [Optical Discs]*,
1935. Paper disc printed on each side with offset
color lithography in circular holder consisting of
two plastic rings. 7⅞ inches (20 cm). Yale University
Art Gallery, New Haven; Gift of Collection Société
Anonyme.

3.9 Joseph Cornell, *Frances Pernas M.M.A.*, n.d.. Collage. 9 × 7 inches (22.9 × 17.8 cm). Smithsonian American Art Museum, Washington, DC; Gift of the Joseph and Robert Cornell Memorial Foundation (1991.155.290).

3.10 Joseph Cornell, *Object*, 1939. Mixed media. 7⅛ × 4¾ × 1⁄16 inches (18.1 × 12.1 × 2.7 cm). Wadsworth Atheneum Museum of Art, Hartford, CT; The Douglas Tracy Smith and Dorothy Potter Smith Fund (2003.10.1).

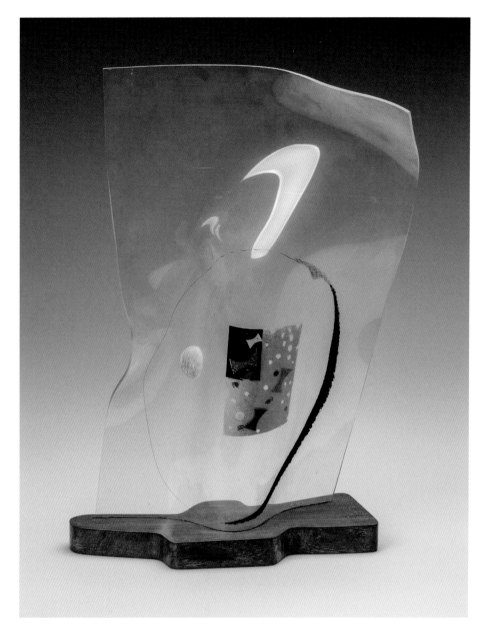

3.11 László Moholy-Nagy, *Space Modulation with Highlights*, 1942. Acrylic, paint, and wood. 17 × 11¹¹⁄₁₆ × 6⁵⁄₁₆ inches (43.2 × 29.8 × 15.9 cm). Museum of Art, Rhode Island School of Design, Providence, Rhode Island; Gift of Mr. and Mrs. John Gilbert Dean (75.119).

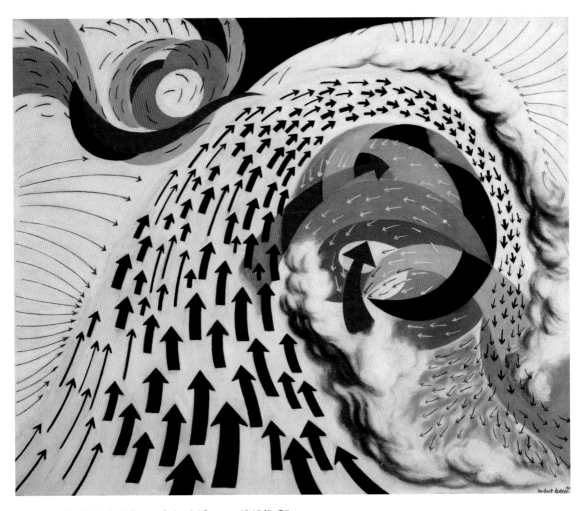

3.12 Herbert Bayer, *Celestial Spaces*, 1942/5. Oil on canvas. 25 × 30 inches (63.5 × 76.2 cm). Denver Art Museum, Denver; Herbert Bayer Collection and Archive.

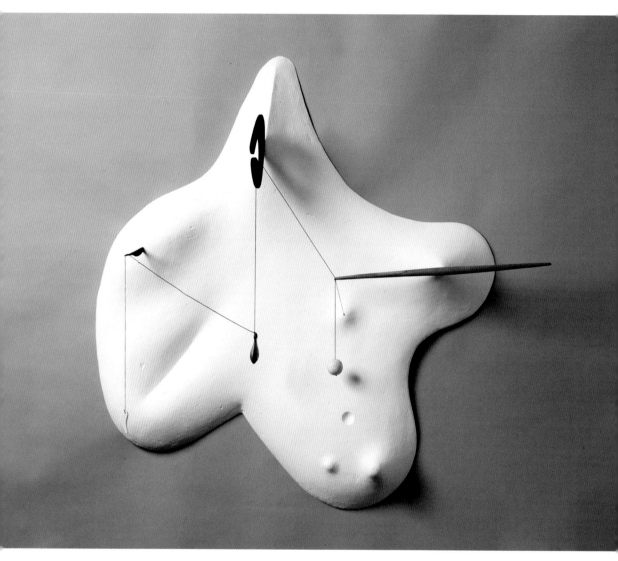

3.13 Isamu Noguchi, *Yellow Landscape*, 1943
(partially reconstructed, 1995). 30½ × 32⅝ ×
6¾ inches (77.5 × 82.9 × 17.1 cm). Magnesite,
wood, string, metal fishing weight. The Isamu
Noguchi Foundation and Garden Museum,
New York.

While general relativity reconfigured our perception of cosmic space, technical innovations in lens design and engineering opened up new vistas of the cosmos, in the process revising previously held assumptions about stars. For instance, for millennia the vast distance of stars from Earth had resulted in the popular misconception that stars are fixed or static.[16] With advanced lenses and metallic reflectors, new telescopes revealed that stars are in fact moving at unthinkably fast speeds and in every possible direction.[17] These devices further enabled a study of stellar temperatures and color spectrums, which showed that stars are gaseous throughout, and undergo a life cycle that mimics our own stages of birth, growth, and death.[18] Powerful new telescopes further revealed that moving stars exhibit spectral lines caused by the Doppler effect. This information was used to prove the existence of many new galaxies in addition to our own Milky Way and thus the existence of a vastly larger and more complex cosmos than ever previously imagined.[19]

Like the coverage of the eclipse, this new information was communicated to a general audience through regular articles in popular sources such as *Scientific American*. From 1900 to 1943 the magazine published an essay in each issue by the astronomer Henry Norris Russell on current topics in astronomy, and throughout the century it featured numerous instructional articles on hobbyists who were building their own personal telescopes with inexpensive materials.[20] This national fascination with astronomy was enhanced in part by the leading position of the United States in telescope technology and the subsequent propagation of telescopically produced photographs, which brought remote stars to the purview of both astronomers and the general public. The period was marked by a prolific flood of awe-inspiring photographs of the cosmos (figure 3.14) that quickly became ubiquitous in magazines, books, and newspapers and which, by replacing lithographs and engravings, offered the viewer a more direct encounter with otherwise inaccessible realms. This powerful cosmic imagery emphasizing the sheer vastness of outer space also served as the inspiration for the artwork of a variety of artists from this era, including the astronomical drawings, collages, and boxes by Cornell and the photography of Man Ray, such as *Électricité* (1931) (figure 3.15).

In addition, just as integration of movement into art was surely seen as a response to Einstein's space-time, it also echoed the revisionist understanding of the newly dynamic cosmos.[21] Making use of mechanics and light projection to portray an infinite space filled with numerous kinetic cosmic bodies, modern planetariums built in the United States in the early twentieth century provided visitors with scientifically accurate models that reflected current theories in astronomy while also explaining and visually presenting its audience with the colors, forms, movements, and spatial properties of the cosmos. Another visualization was provided by the 1939 World's Fair in New York City, which was titled "The World of Tomorrow" and featured two astronomy exhibitions organized by the American Museum of Natural History and the Hayden Planetarium, including a "Theater of Time and Space" which simulated a journey for audiences through the distant galaxies of the cosmos.[22] This vision of cosmic

VANJA V. MALLOY

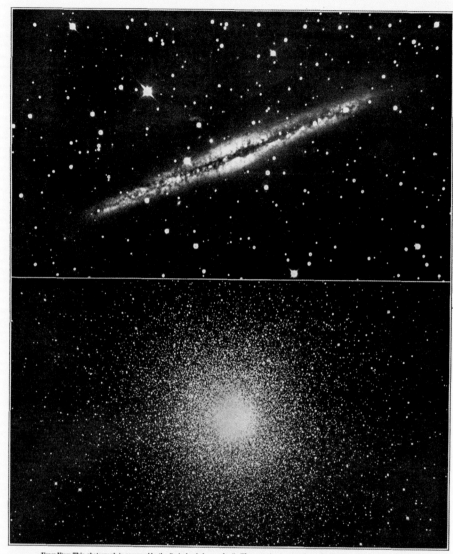

Upper View: This photograph is presumably the "spiral nebula on edge." The quotation is taken from the Mt. Wilson catalogue statement
Lower View: The great globular cluster, one of the greatest objects in the heavens

3.14 Photographs taken from the Mt. Wilson catalogue and published in *Scientific American*, July 16, 1921.

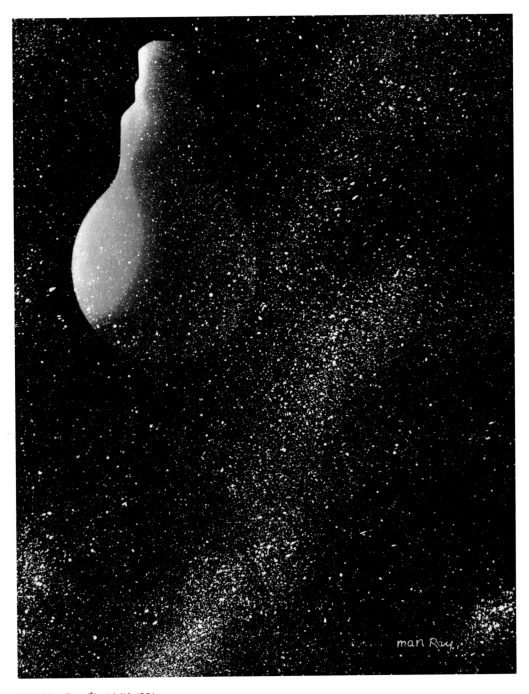

3.15 Man Ray, *Électricité*, 1931.
Photogravure. 10¼ × 8 inches (26 × 20.5
cm). Smithsonian American Art Museum,
Washington, DC; Museum purchase
(1976.84.2).

dynamism provided the backdrop for a range of experimentations with kinetic art, encompassing not only works by Dimensionist artists such as Moholy-Nagy and Calder, but also lesser-known experimentations by artists such as Cornell, who created his kinetic and cosmically suggestive *Untitled (Disc Mobiles)* (figure 3.16) around the time of the 1939 World's Fair.

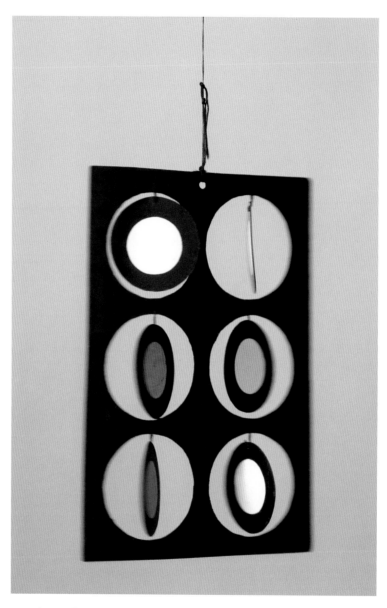

3.16 Joseph Cornell, *Untitled (Disc Mobile)*, 1939–1940. Paint and paper on paperboard and string. 9¼ × 6½ × 2¼ inches (23.7 × 16.6 × 5.7 cm). Smithsonian American Art Museum, Washington, DC; Gift of Mr. and Mrs. John A. Benton (1978.95.7).

Just as advances in telescopes revolutionized our perception of the cosmos, so too, advances in microscopes made possible a wealth of photographs documenting strange new microbial environments. Filmmakers also made use of these new technologies to create scientific documentaries offering viewers an immersive experience of microscopic realms, aquatic life, and other previously unobservable natural phenomena.[23] A number of artists who were directly involved with the creation of the Dimensionist Manifesto cited the influence of these images on their art. For instance, the curvilinear, biomorphic shapes used by European artists such as Jean Arp and Wassily Kandinsky allude to the cellular structures and globular forms of single-cell organisms.[24] Similarly, as Henry Moore explains in his 1936 book *Unit One: The Modern Movement in English Architecture, Painting, and Sculpture*, the development of his curved, open forms was influenced by his viewing of both telescopic and microscopic images.[25] The interrelationship of art and science was also a topic of interest to the 1937 book *Circle: International Survey of Constructive Art*, which includes the essay "Art and the Scientist" by the famous crystallographer J. D. Bernal.[26] Naum Gabo—whom Sirató credited as influential to the development of the Dimensionist Manifesto but who never signed the document—included his stringed sculptures in this publication (figure 3.17). While they do not represent the growth of microbial organisms, their open composition and geometric structure echo the new microrealm made visible by X-ray crystallography, which exposed the empty, geometric substructure of crystals and was later used to reveal the molecular compositions of many more materials, including the structure of DNA.

In the 1940s Gabo immigrated to the United States, where he continued to create his stringed sculptures and where many other artists were also responding to the new space of the microworld. For instance, in 1937 Herbert Matter used the camera lens to capture the curved forms of the cellular amoeba, which alters its shape by extending and retracting its pseudopods (figure 3.18). Similar influences can be found in Joseph Breitenbach's 1949 photograph of a swirling pattern on a petri dish, which appeared in Moholy-Nagy's book *Vision in Motion* with the following extended caption:

Joseph Breitenbach, 1940 / Photograph of fragrance of a coffee bean. Patterns of fragrances are obtained by extending the very small amount of matter of which fragrance consists of as a very thin (monomolecular) layer. The thickness of this layer is 1/1,000,000 mm, which means: if enlarged to the thickness of a sheet of paper, the thickness of the paper itself enlarged at the same degree would be higher than the Empire State building. The shapes develop in time and the forming of richer and richer abstract patterns may be observed and photographed. Generally the layman believes that every odor has its specific pattern, just as there is a name for every color. This is not at all the case. Very complicated phenomena caused by molecular structure, surface tension and electro-dynamical charges are involved. Besides, the odors we are used to looking upon as primary sensations of olfaction are highly complicated mixtures of a dozen and more odorant compounds.[27]

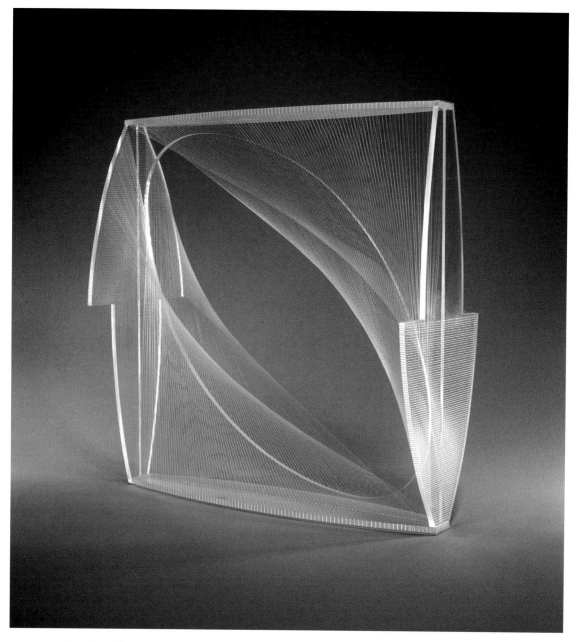

3.17 Naum Gabo, *Linear Construction in Space*, 1942–1943 (enlargement c. 1957–1958). Plexiglas with nylon microfilament. 24¾ × 24¾ × 9½ inches (62.9 × 62.9 × 24.1 cm). Nasher Sculpture Center, Dallas; Raymond and Patsy Nasher Collection (NC.1985.A.12).

3.18 Herbert Matter, *Amoeba Forms*, 1937. Photograph. 8 × 15 inches (20.3 × 38.1 cm). Stanford University Libraries, Stanford, California.

Here Moholy-Nagy highlights how Breitenbach's art, in partnership with science and technology, reveals striking new physical realities that are invisible to the naked eye. This idea is also present in the work of the California artist Helen Lundenberg, who had studied biology and astronomy in her youth.[28] Lundeberg's 1937 painting *Microcosm and Macrocosm* (figure 3.19) shows the artist herself reflecting upon globular forms that can be read simultaneously as both cosmic and microbic. In this way, this new science was encouraging a new interconnected vision of the universe, in which the macrocosm was understood as paralleling the life cycles and dynamism of the microcosm, and with both extremes defined by a state of constant change driven by the generative forces of nature.

Dimensionism thus embodied an expansive movement of modern artists that was not restricted to the Manifesto's signees, or a certain geographic area, or even to one mode of science. It is no wonder, in fact, that advances in modern science had an international impact and an equally international artistic response. An examination of the exchanges between art and science in the twentieth century asks us to consider, in effect, how much our understanding of physical nature and natural forces changed in this era, and how advances in science engendered a wealth of new visual vocabularies, realities, and philosophical debates. These scientific revolutions were both humbling and inspiring, challenging artists to change with the times and create a new art that reflects upon our imperfect and incomplete understanding of the cosmos—a vast and dynamic universe that presents us with mysteries at every locus on the macroworld/microworld spectrum.

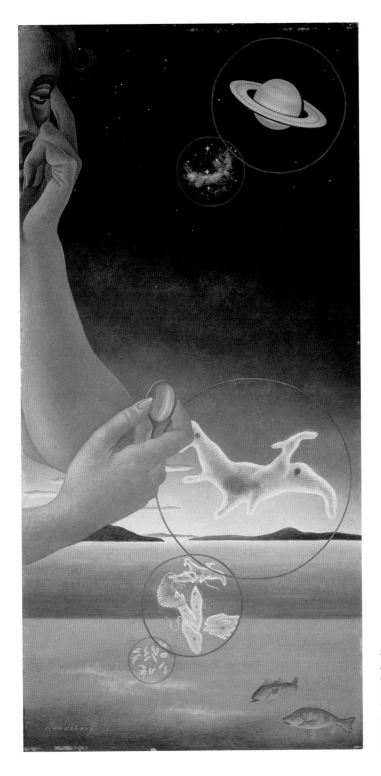

3.19 Helen Lundeberg,
Microcosm and Macrocosm, 1937.
Oil on Masonite. 37 × 19½ inches
(94 × 49.5 cm). Los Angeles
County Museum of Art, Los
Angeles; Purchased with funds
provided by Mr. and Mrs. Robert
B. Honeyman, Jr. (M.2003.50).

4 REVOLUTIONS IN ART AND SCIENCE: CUBISM, QUANTUM MECHANICS, AND ART HISTORY

Gavin Parkinson

One of the topics in intellectual history that has been raised over the last twenty years in research on Cubism and Pablo Picasso is what has been termed the "Cubism-relativity myth." Discredited once and for all by Linda Dalrymple Henderson and further undermined by the posthumous publications of Meyer Schapiro, the supposed connection between Picasso's art and Albert Einstein's theory of relativity was made by several scholars in the 1940s and 1950s, among them the historian and critic Sigfried Giedion and the art historian Erwin Panofsky.[1] Given the chronological trajectory of the theory of relativity – the publication of the special theory in 1905 and the general theory in 1915–1916, and their wider reception from 1919 on – it is not particularly surprising that historians would seek to organize and affirm its link with Picasso's pioneering work of about the same period. According to this argument, a painting such as Picasso's *The Poet*, 1911 (figure 4.1) is a synthesis of different observers, occupying different frames of reference – Einstein's term for individual coordinates of space and time that are relative to one another – viewing a moving object. Henderson has shown that such views retrospectively and mistakenly bracket Cubist painting with the fourth dimension as time, as it is in relativity, thus obscuring the actual cultural notion to which Picasso and the Cubists were responding and contributing, in which the fourth dimension was spatial.

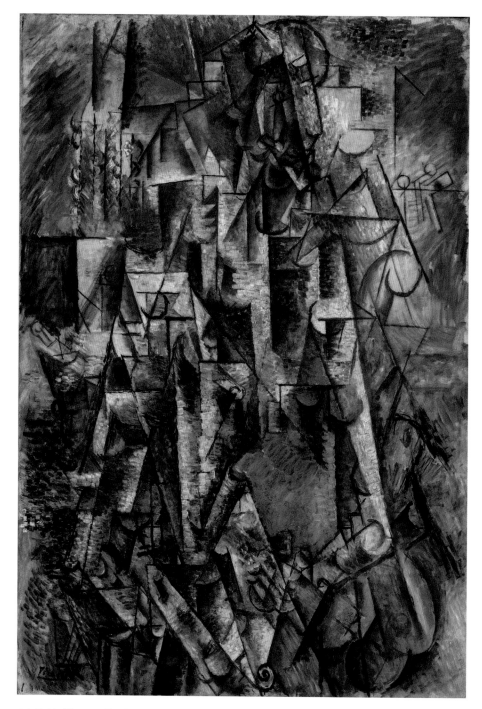

4.1 Pablo Picasso, *The Poet*, 1911. Oil on linen.
51⅝ × 35¼ inches (131.2 × 89.5 cm). The Solomon
R. Guggenheim Foundation, Peggy Guggenheim
Collection, Venice (76.2553.1).

The Picasso-Einstein link is a kind of historian's fantasy, rather like those completist theories asserting that Marcel Duchamp's entire oeuvre can be read as an alchemical text. A perfectly good and perhaps even informative film or novel could be made of an encounter between Duchamp and, say, James Joyce, or one between Picasso and Einstein, for that matter. But historians turning over the bits, parts, and fragments of the past are constantly aware of a void eroded by time, which is inevitably unsatisfactory to the human consciousness that yearns for the coherence, consistency, and finality of a conventional storyline or plot. The best we can do, perhaps, is string together a flimsy narrative bridge over all the parts. They never met; they did meet but we do not know what was said; forgotten details; lost letters; absence; misunderstandings and miscommunication; gaps of all kinds: the mess of ordinary life, in other words, which rationalist art history selects from, emphasizing and deleting bits here and there, arranging and narrating the past as a story that makes sense.

This, then, is the historian's predicament, and it is one to which Cubism speaks directly, in fact. Cubism takes literally the metaphor of the "window onto the world" that implied clarity and nature for pre-twentieth-century painting only so that it could smudge, crack, and score—in short, metaphorically damage—it and draw attention to that window at the expense of what lay supposedly "beyond" it. Very tightly knit compositions of the most opaque period of Cubism, such as Georges Braque's *Clarinet and Bottle of Rum on a Mantelpiece* (1911) (figure 4.2), assemble complex, compound objects with tangible qualities placed very close against the picture plane, comprising sometimes unrecognizable, half-recognizable, at times even recognizable part components: a bottle, its label, a musical instrument, possibly a piece of a musical score, details of architecture, furniture, and fabric. Yet there is nothing painted "whole" in the monocularcentric manner by which objects had been traditionally rendered in the visual arts. The "whole" is one of bits, parts, portions, pieces, as though perception is being rendered through a disjointed experience of glimpsing rather than of sustained looking.

From here, it is a short step to the suggestion that it is not entirely seeing or the subject's visual experience that is at issue in Cubism; it is as much about the operation of memory with all its flaws, as the capacity that allows the subject to call up what has been witnessed by vision but also felt. In this way of conceiving it, Cubist painting is the visual rendering of phenomena as a corollary of the ways it has been experienced. It is an art that rejects the claim of naturalism and forms of realism to recapitulate what has been experienced as a spatially and temporally unbroken whole in the way of Gustave Caillebotte, let us say. Cubism represents the activity of the mind as a witness, with all its partial recollection, hesitancy, undecidedness, and repetition, and that is why it can serve as a kind of model of what might be called the "historian's predicament."

If Cubism can be thought of as an attempt to render the flaws of personal or historical memory, we can return to physics to see how the style pioneered by Picasso and Georges Braque was once thought of as a pictorial parallel to the problems of

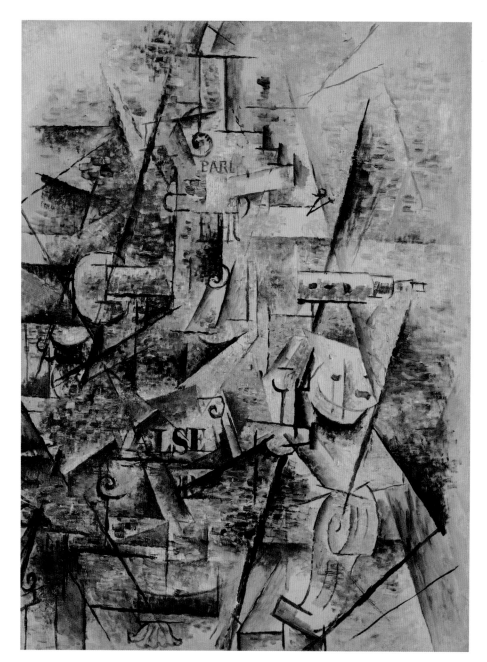

4.2 Georges Braque, *Clarinet and Bottle of Rum on a Mantelpiece*, 1911. Oil on canvas. 31.9 × 23.6 inches (81 × 60 cm). Tate Modern, London; Purchased with assistance from a special government grant and with assistance from the Art Fund 1978.

incompleteness and visualization found in quantum mechanics. The historical para-phrase situates the origins of quantum mechanics at 1900, the year in which Max Planck, a professor of physics at the University of Berlin, discovered that energy emis-sion and absorption (heat, for instance) take place not smoothly and continuously, as dictated by the view of nature inherited from the classical physics of Isaac Newton and James Clerk Maxwell, but discontinuously, in pulses or packets of energy: that is, in discrete measurable units, or "quanta."[2] Planck's momentous discovery led initially to the quantization of light in 1905 by Einstein, who proposed that light is composed not of waves, as taught by classical electromagnetic theory, but of quanta. Like Planck, Einstein was bothered by the resistance of the "old" physical theory to the "new," later writing, "my attempts ... to adapt the theoretical foundation of physics to this knowledge failed completely."[3]

The validity of Newtonian mechanics was questioned further in 1913 by Niels Bohr, often seen as the father of quantum mechanics, who hypothesized from Planck's intu-ition of the discontinuous nature of radiation that activity within the atom is similarly characterized by "breaks."[4] Just as the absorption and emission of radiation are par-celed out in quanta, so, Bohr claimed, electrons cannot move in just any conceivable orbits but are located on allowed orbits, or "stationary states," of specific value, corre-sponding with energy states between which they can jump as the atom absorbs or emits chunks of energy, or quanta. Again, these results could not be squared with classical theory. Years later, Einstein wrote of this experience in the language of epis-temological breaks and anti-foundationalism: "It was as if the ground had been pulled out from under one, with no firm foundation to be seen anywhere, upon which one could have built."[5]

These discoveries between 1900 and 1913 are usually designated as the "old quantum theory," which offered a set of ideas that reached fruition during the 1920s in the work of a generation of physicists eager to break with the beliefs and attitudes of their elders. For the young Werner Heisenberg, the leading figure of what became known as "boys' physics," the ongoing problem for physicists for the duration of what he later termed "the preparatory years" of quantum mechanics (1922–1924) was the continuing obligation to utilize classical laws alongside the muddled and incomplete, yet irrefutable glimmers of quantum logic, and despite their uncomfortable awareness of the incompatibility between the two.[6] Heisenberg became convinced that previous theories of the quantum had not received precise confirmation from experimental data because scientists were hampered by the outdated baggage of classical imagery, lan-guage, and concepts. He concluded that he would arrive at an overarching quantum theory only by dispensing with the imagery of electrons and all other "perceptual" aids and models. Heisenberg went on to make his major discoveries following his sweeping rejection of things called "electrons" on paths called "orbits," which he now viewed as misleading descriptive analogies or visualizations of the behavior of nature at the most fundamental level. Instead, he attended to the numerical associations between energy states of the atom, developing in the summer of 1925 a noncommutative, tabular

4.3 Photograph of physicists at Solvay Conference, Brussels, October 1927.

mathematics, now known as matrix mechanics, which allowed for the description of pairs of states of the atom.

The most quoted outcome of his use of matrix mechanics is Heisenberg's "Uncertainty Principle," which links the paired concepts of "momentum" and "position" to the very conditions of observation. When either of those two properties is measured, the result includes the effect of light hitting the electron to enable observation. The greater the accuracy of the measurement of one property, the less accurate is the measurement of its partner. If momentum and position could not now be measured with precision, then the epistemology inherited from Newtonian-Kantian causality—insisting on the universe as a teleological mechanism, the future states of which could in theory be predicted from the measurement of momentum and position of particles—was now obsolete. In 1927 the twenty-five-year-old Heisenberg confidently brought an epoch in philosophy to a close with his conclusion that the "invalidity of the law of causality is definitely established by quantum mechanics" (figure 4.3).[7]

Revolutionary for physics and philosophy, quantum mechanical acausality was aired close to Surrealism as early as 1929 in the second number of Georges Bataille and Carl Einstein's journal *Documents*. In an essay titled "Crise de la causalité" [Crisis of causation], the philosopher of science Hans Reichenbach, presumably on the invitation of Einstein,[8] provided a mini-history of the notion of causality from the Greeks through Galileo, Newton, and Laplace, underlining its overriding importance for engineering and mechanical systems: "No engineer would ever try to construct or repair a machine according to any other principles than those of causality."[9] Biology, too, was now utterly indebted to causality, but it was physics, "the most exact of the natural sciences" ["la plus exacte des sciences de la nature"] that had in previous times put to rest all objections to causality.[10] However, as we saw, quantum mechanics had now led physicists such as Heisenberg to reject causality as invalid in the description of subatomic phenomena, and it was to this revolution in science that Reichenbach referred in *Documents*:

> It is only over the last few years that one could speak of a veritable crisis in the conception of causality, when physicists themselves began to doubt seriously the precision of natural phenomena. Their doubts have forced them to renounce quite methodically the idea of causality in the mechanical explanation of the interior of the atom.[11]

Reichenbach's text ends with a plea to philosophy to adapt to the new discoveries about the behavior of matter.

The acausality of Heisenbergian mathematical positivism — that is, the limits set by the observer's inseparability from the object of observation — was further advertised in this same second issue of *Documents* in an article by Carl Einstein himself, "André Masson: An Ethnological Study," which appeared, not coincidentally, next door to Reichenbach's in the journal.[12] Here Einstein concocted an interpretation of the painter's work that begins in a coalition of Planck's discontinuous packets of energy quanta and Heisenberg's acausality. Arguing for the revolutionary achievements of contemporary artists over the conservatism of the writers of the time, he claimed that the artist's harnessing of "hallucinatory forces will effect a breach in the order of mechanical processes; they will introduce chunks of 'a-causality' into this reality that had hitherto absurdly been considered as unified."[13] Einstein wrote in these terms of the viewers of Masson's work in a way reminiscent of those used by Heisenberg and others to describe the role of the observer in contemporary physics: "The subject is no longer on the periphery of the construction. ... The object is no longer regarded as an interruption of the optical process. The motif has become an immediate psychological function."[14] Einstein's "ethnological study" of Masson asserts a shared vision between the physicist in quantum mechanics, who is inseparable from the phenomena he observes, and the onlooker of ritual in tribal cultures, "inciting identification with animals, ancestors and so on," which is what he claimed Masson's "mythic" and "totemic" canvases also achieve.[15]

With reference to quantum mechanics and also psychoanalysis, Carl Einstein went on to develop a language of breaks, ruptures, breaches, fragmentations, aporia, and discontinuities, which we would now associate with the language of poststructuralism and postmodernism, to elucidate the shattered appearance of Cubist painting. In his 1934 monograph *Georges Braque*, Einstein argued that the Cubists' breakup of forms in their paintings (see figure 4.4) corresponds to "a rent between human beings and the conventional conception of the world, a reconstruction of the structure of sight."[16] Within what he called "this rupture of continuity" ["cette rupture de la continuité"] one could find, Einstein believed, a new reality, "breaking the fatal chain of unitary causality" ["brisent la chaîne fatale de la causalité unitaire"].[17] He went on to argue in *Georges Braque* that Cubism is evidence of what we would now call a "paradigm shift," a revolutionary break rather than an evolutionary development in the history of art:

> If one wanted to arrive at a new understanding of and a new form for man and the universe, it was important above all to break the banal image of reality, to break, thus, oneself, with conventional history. This enterprise was risked by several poets and men of science, as it was by two Cubists whose boldness amounted to a historical event of the highest importance.[18]
>
> Quantum theory tore apart the unitary continuity of the universe, and ultimately cast grave doubt on causality, the heart and soul of all former science. The conscious I is today no more than a simple façade, ready to founder on the spontaneous act. … So-called Cubism is a perfectly normal phenomenon in a general conception of things undergoing radical transformation.[19]

Interpreting the obscurity and fragmentation of the Cubist canvas as a condition of the loss of the unified, objective observer that was wrought by quantum mechanics and the emergence of a "divided self" in psychoanalysis, Einstein's *Georges Braque* waves farewell to humanism, asserting that "the end of a 'stable' and circumscribed subject is equivalent to an elimination of the anthropocentric standpoint"[20] and that "the belief in a hermetic I, of its definitive figuration, must be abandoned."[21]

An argument close to Einstein's but with specific reference to Picasso was offered around the same time by Henri-Charles Puech, an orientalist and historian of comparative religion, folklore, and ancient philosophy who became editor of the *Revue de l'histoire des religions* [Religious history review].[22] Puech published a few articles in *Documents*, and he remained in contact with Bataille into the postwar period, although his precise intellectual relationships with Einstein and Bataille have yet to be assessed by historians.[23]

One of his articles in *Documents*, "Picasso et la représentation" [Picasso and representation], appeared in the special "Picasso" issue in 1930.[24] The beginning of the text was positioned in the review alongside the larger-than-life-size, flat, bitty, discontinuous, and difficult-to-read *Three Musicians* (now in the Philadelphia Museum of Art) (figure 4.5), in which the mustachioed figures, while relatively distinguishable, seem

4.4 George Braque, *Homage to J. S. Bach*, Winter
1911–1912. Oil on canvas. 21¼ × 28¾ inches (54 × 73
cm). Museum of Modern Art, New York; The Sidney and
Harriet Janis Collection, acquired through the Nelson
A. Rockefeller Bequest Fund and the Richard S. Zeisler
Bequest (both by exchange) and anonymous promised
gift, 2008 (544.2008).

melded along with the local domestic accoutrements into a patchwork of irregular, angular, and straight-edged segments. Also reproduced were other 1920s figure paintings enacting Picasso's transition from late Cubism to a style utilizing distortion and metamorphosis more recognizable from Surrealism. These paintings, such as the 1927 tableau now in Toronto, *Seated Woman* (figure 4.6), show, by contrast, an apparent awareness of the elegant, rhythmic loops and curls of Masson's automatic drawings. Puech's argument concerns the crisis of representation created by and evident in both modern art and modern science. He maintained that the world we see, experience, and interpret is no longer the one known to science, which, he says,

> recoils more and more from all *visualization*. We'll have to measure one day the scope of this remark through verification of all the manifestations of modern science or of modern art, to give ourselves a very accurate account of the ruin of the idea of *visualization* as the essential characteristic of our time, giving to us our *style*, and extrapolate finally from this new state of things and of the mind all the disruption that it implies.[25]

Pointing to the limits of the "rationalism" of his day, Puech complains of the lingering legacy of mimetism in what he calls the tendency to confuse "to understand" [*comprendre*] with "to visualize" [*se représenter*].[26] He believed that "the primary concern of the oeuvre of Picasso has been … to deliver painting from the too-human obsession with visualization which would seem, moreover, to be essentially attached to its domain [the domain of painting]; to expand pictorial form previously defined by the correlation of sensations arising from the eye and from the hand."[27]

In the same way that Heisenberg's matrix mechanics offers a kind of summary of – or, better, a version or abstraction of – activity at the subatomic level, thereby recognizing in mathematics an autonomy and aesthetics separate from what it describes, Puech's Picasso detached painting from traditional mimetic models of representation and in doing so gave painting back to itself. For Puech, the "modern aesthetic" in physics and art was one of representation through signification, not reproduction. A painting by Picasso is "a thing of *signification*" ["une chose *significative*"], he argued, and Picasso's paintings are charged through this process as "*magic objects*" ["*objets magiques*"].[28] Physics, unexpectedly, then, offers an alternative path to magic.

Shortly after Carl Einstein's book on Braque appeared, Puech published a similar argument, this time in the Surrealist-dominated review *Minotaure*, titled "Signification et représentation" [Signification and representation]. Puech wrote:

> The most recent developments in physics seem not to allow representation to rediscover "invariants" *this side* of apparent reality in the form of *content*. Solids dissolve and are reconstituted as fluids, matter as radiation, particles as "wave packets." The exact delineation of reality gives way to a vaguer consideration of unities more or less arbitrarily defined: strict determinism vanishes before a calculation of probabilities trying hard to come to terms with chance.[29]

4.5 Pablo Picasso, *Three Musicians*, 1921. Oil on
canvas. 80½ × 74⅛ inches (204.5 × 188.3 cm.).
Philadelphia Museum of Art, Philadelphia; A. E.
Gallatin Collection, 1952 (1952.61.96).

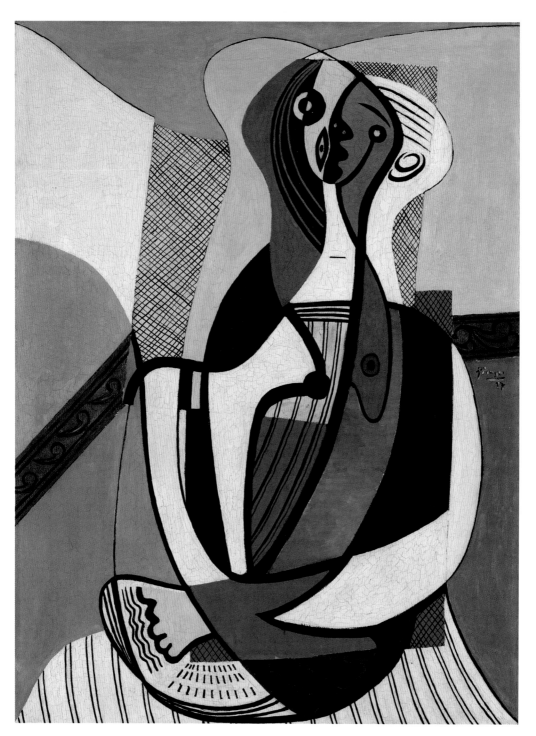

4.6 Pablo Picasso, *Seated Woman*, 1926–1927. Oil on canvas. 51.5 × 38.5 inches (130.8 × 97.8 cm). Art Gallery of Ontario, Toronto.

With its affirmation of what might be called the underlying "formlessness" of visible phenomena, modern physics, Puech explained, narrows the field of naturalistic representational possibilities. He went on to say that a similar case arises from propositions put forth by both psychoanalysis and existentialism, which also deny the possibility of any "objective" presentation of "reality." The image in painting, he wrote, repeating the conclusions of his Picasso article in *Documents*, should no longer be compared to "a more or less idealized copy, but to a magic object or a mental *symbol.*"[30]

There are overlapping institutional milieus that help explain Georges Bataille's own growing interest in physics from 1929. As well as being a contributor to Bataille's *Documents* and the Surrealists' *Minotaure*, Puech was from that year Director of Studies at the École Pratique des Hautes Études, which is where the legendary seminar on Hegel took place that changed the course of twentieth-century French philosophy. It is well known that the seminar was led from 1933 to 1939 by Alexandre Kojève and included such attendees as Bataille, Pierre Klossowski, Jacques Lacan, Maurice Merleau-Ponty, and Raymond Queneau. What is less widely understood is that the seminar was initiated (in 1926) by the historian and philosopher of science Alexandre Koyré, and that Kojève's first two publications were on quantum mechanics.

Koyré and Puech were two of the three editors of the journal *Recherches philosophiques* [Philosophical research], which published, among others, Bataille, Roger Caillois, René Daumal, and Klossowski in its six numbers that appeared annually between 1932 and 1937. In 1934, the year of Carl Einstein's *Georges Braque*, the editorial board was joined by the philosopher of science Gaston Bachelard, who also coined the term "coupure épistémologique" [epistemological break] in that year. Prefiguring the antinarrative, counter-Enlightenment metaphors and concepts of postmodernism and poststructuralism – of breaks, ruptures, breaches, aporia, obscurity, fragmentation, discontinuity – Bachelard's epistemological break was originally meant to theorize the crisis in knowledge that Albert Einstein articulated, whereby new discoveries, just like those of quantum mechanics, seem to contradict the whole basis of knowledge – the entire foundation out of which they emerged. The affinity between the notion of an epistemological break and the view of Cubism expressed by Carl Einstein in *Georges Braque* – of an artistic revolution that wished "to break the banal image of reality, to break ... with conventional history" – surely demonstrates either Carl Einstein's reading of Bachelard, or the existence of a common language that the two also shared with Puech, made available by new developments in the philosophy of science.

Ultimately the epistemological break that was theorized in philosophy after the discoveries of relativity and quantum mechanics, initially evident in Surrealism and swiftly brought into the domain of art writing by Carl Einstein and Puech, would be reformulated as a key component of postwar French theory by Georges Canguilhem, Louis Althusser, Michel Foucault, and others; this widely discussed development is by now long-established in standard histories of French structuralism and twentieth-century philosophy.[31] According to Foucault, the lesson of Bachelard's concept is that "the

problem is no longer one of traditions, of tracing a line, but one of division, of limits; it is no longer one of lasting foundations, but one of transformations that serve as new foundations, the rebuilding of foundations."[32]

Over the last two decades, the art historian Christopher Green has developed a language of "architecture" and "vertigo" derived largely from Bataille to discuss both Bataille's and Einstein's interpretation of Picasso's paintings in *Documents* and beyond.[33] He argues that Picasso's view of his own work was one of "discontinuity and contradiction," which jarred with "the principle of continuity and cohesion" that guided Christian Zervos's chronological and sequential organization of the Picasso *oeuvre* catalog.[34] For Green, this is shown already in the ways Picasso exhibited his work in private and public, which demonstrates, for him, an acceptance of inner and outer contradiction. Green argues that it was an attitude shared by Picasso's friend Michel Leiris and also by *Documents,* where Picasso's work was shown as "a succession of shocks," as "disruption," where "different figuration emerges to open a gap," comparisons are "pulled apart by differences," "the connections never threaten to override the discontinuities," and "a collage of texts ... supports a collage of reproductions."[35]

Green adopted Bataille's *informe* [formless] to characterize a situation, especially in Cubism, in which the vertiginous is constantly faced by the architectural. As Bataille famously wrote in 1929, "For academics to be happy, the universe would have to take on form. The whole of philosophy has no other goal: to provide a frock coat for what is, a mathematical frock coat."[36] That term *informe* is deeply embedded in all of the scientific contexts in which I have situated Cubism in this essay. Such a formulation recalls Heisenberg's rigging out of the unvisualizable, unthinkable, unreachable behavior of matter in the garb of matrix mechanics two years earlier. A few years later Bataille drew again on the philosophy emerging from the new physics in his essay "The Labyrinth" (1936), whose argument is based on the role of the indeterminate electron in substantializing the "being" of the atom: "A particular being not only acts as an element of a formless [*informe*] and structureless whole," he wrote, "but also as a peripheral element orbiting around a nucleus where being hardens."[37] Published in the fifth number of *Recherches philosophiques*, Bataille's discussion of being and sufficiency in "The Labyrinth" leans heavily on the new nonconcept of the electron as indeterminate until observed as wave or particle — a line of inquiry inspired by Paul Langevin's short introduction to particle physics, *La Notion de corpuscules et d'atomes* [The concept of corpuscles and atoms (1934)] to which Bataille refers in a footnote.[38] In the context of the physics and philosophy of the 1930s, *informe* is an anti-essentialist, anti-epistemological term; as Heisenberg would have said of the electron, once it is represented by thought, it is misrepresented.

The argument presented here about the critical languages developed to discuss Cubism and Picasso has obvious similarities to those imparted by other scholars. The only difference is the way in which I have tried to place both Cubism and commentary on it in the 1920s and 1930s in a scientific context, inflected at times by psychoanalysis. But this is a significant difference; although psychoanalytic methodology has many

adherents in art history, the science of the twentieth century is known to far fewer, in spite of the extraordinary impact science had on that century and continues to have on our lives.[39] In returning science and the philosophy of science to the writing on Picasso, Braque, and Cubism, the terms of the critical commentary are clarified and the work itself is enriched.

PLATES

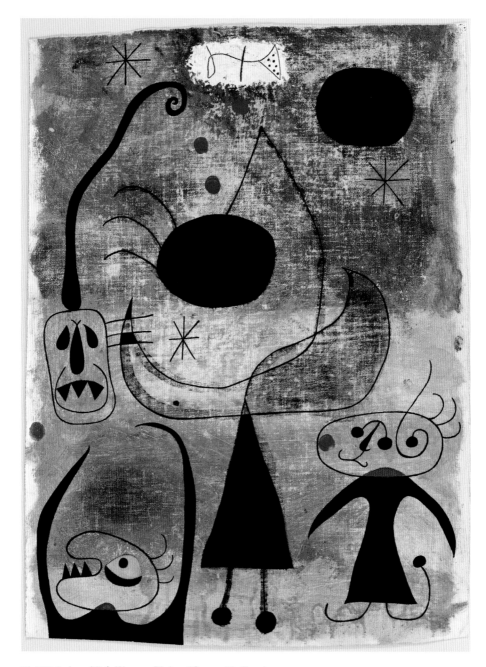

PLATE 1 Joan Miró, *Women, Bird and Serpent in Front of the Sun*, 1944. Oil on canvas. 19 11/16 × 15 1/8 inches (50 × 38.5 cm). Allen Memorial Art Museum, Oberlin College, Oberlin, Ohio; Gift of Joseph and Enid Bissett, 1962 (1962.42).

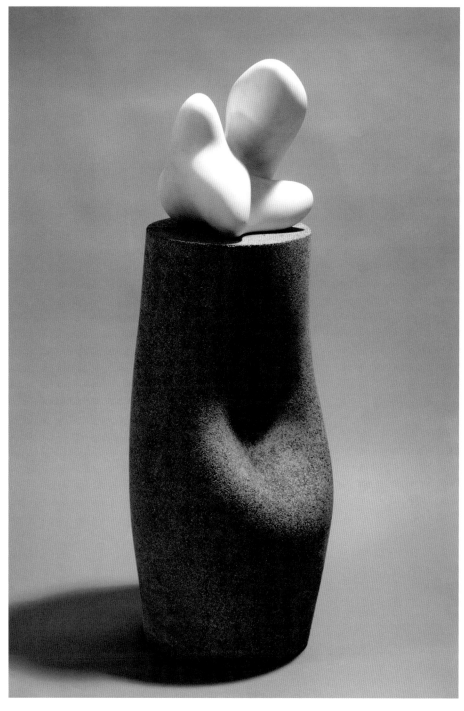

PLATE 2 Jean Arp, *Mirr*, 1936 (base 1950). Marble.
6⅞ × 8⅝ × 6 inches (17.5 × 21.9 × 15.3 cm). National
Gallery of Art, Washington, DC; Gift of Mr. and Mrs.
Burton Tremaine (1977.75.6).

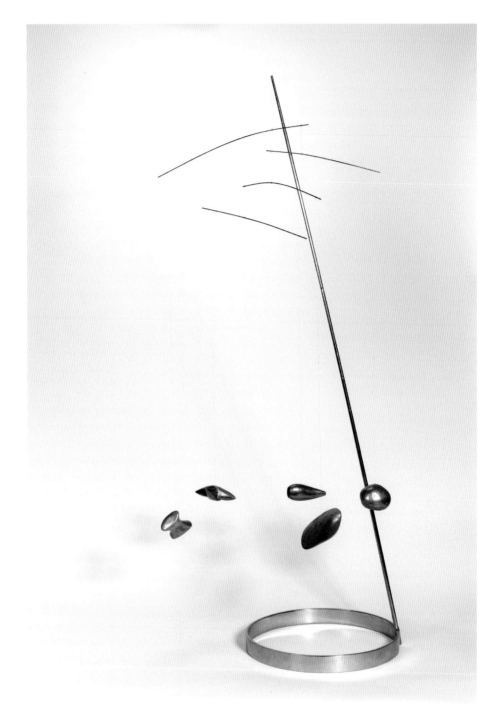

PLATE 3 Alexander Calder, *Mobile*, 1934. Nickel-plated wood, wire, and steel. 42½ × 11⅞ inches (107.95 × 30.1625 cm). Smith College Art Museum, Northampton, Massachusetts; Museum purchase (1935:11-1).

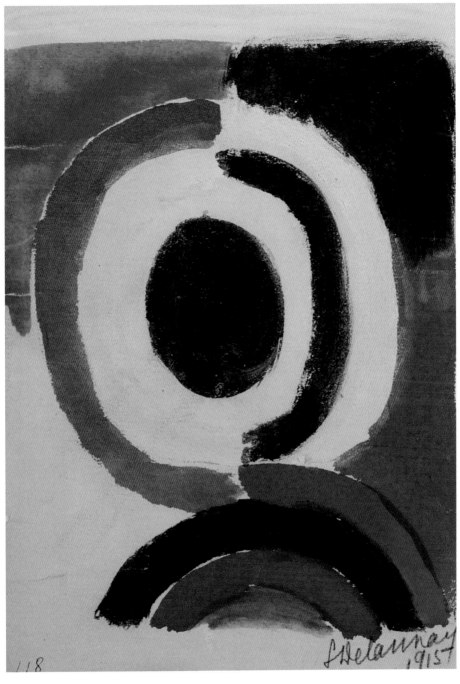

PLATE 4 Sonia Delaunay, *Disque*, 1915.
Gouache on paper. 9¾ × 7¾ inches (24.8 ×
19.7 cm). Mead Art Museum, Amherst College,
Amherst, Massachusetts; Gift of Thomas P.
Whitney (Class of 1937) (2001.03).

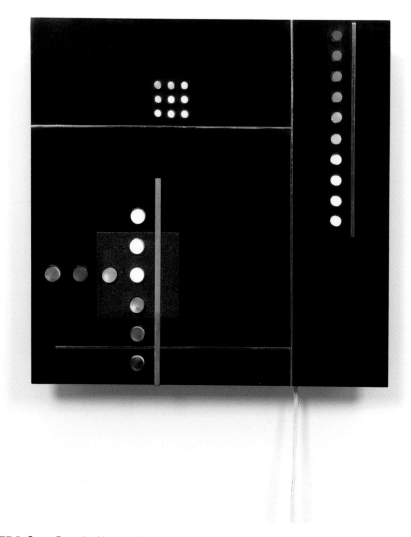

PLATE 5 Cesar Domela, *Abstract Construction*, 1930. Steel, brass, and glass. 19¾ × 19¾ × 3½ inches (50.2 × 50.2 × 8.9 cm). Wadsworth Atheneum Museum of Art, Hartford, Connecticut; Purchased through the gift of James Junius Goodwin (1936.16).

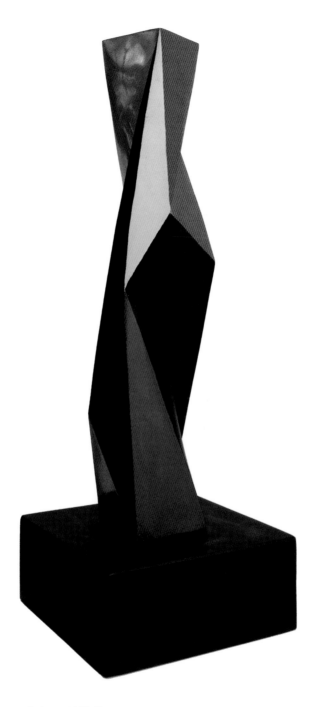

PLATE 6 Anton Prinner, *Colonne*, 1932. Bronze
polychrome. 16.1 × 7.1 × 7.1 inches (41 × 18 ×
18 cm). Mead Art Museum, Amherst College,
Amherst, Massachusetts.

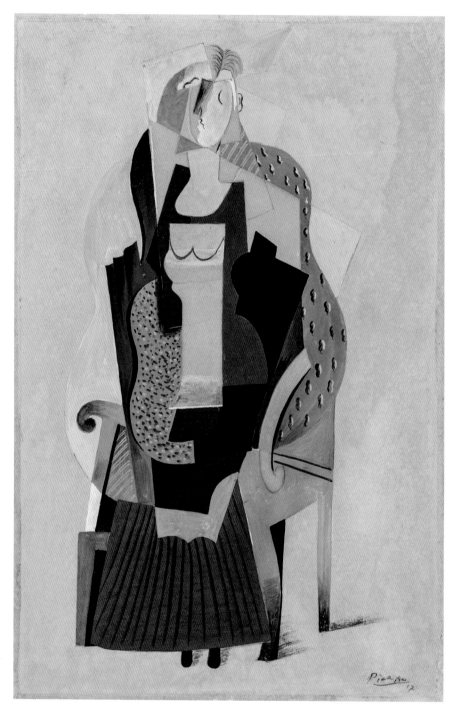

PLATE 7 Pablo Picasso, *Young Girl in an Armchair*, 1917. Graphite and gouache on wove paper. 12⅝ × 8⁵⁄₁₆ inches (32.1 × 21.1 cm). Speed Art Museum, Louisville, Kentucky; Purchase, Museum Art Fund (1962.9).

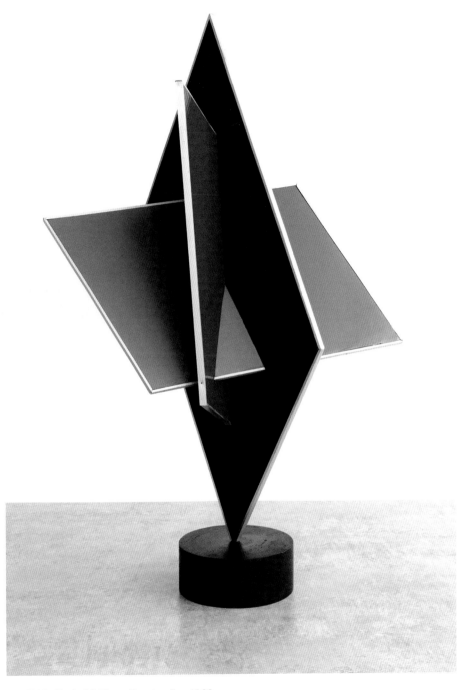

PLATE 8 Frederick Kann, *Construction*, 1928–1935. Painted wood construction. 43 1/16 × 29 × 19 inches (109.4 × 71.1 × 48.3 cm). Courtesy of Michael Rosenfeld Gallery LLC, New York, NY.

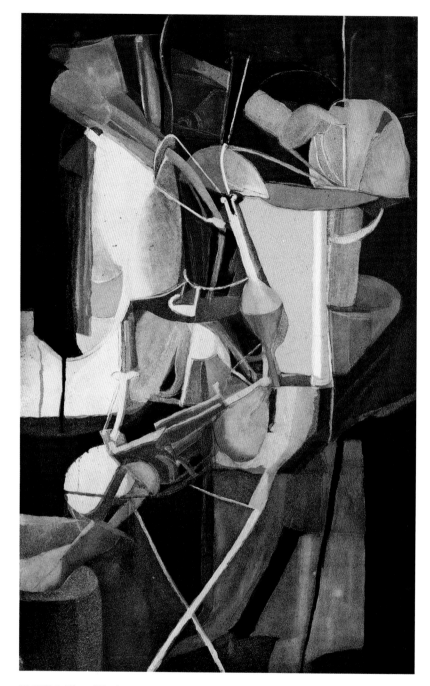

PLATE 9 Marcel Duchamp and Jacques Villon, *La Mariée [The Bride]*, 1934. Color aquatint on cream wove paper. 25¹¹⁄₁₆ × 19¹¹⁄₁₆ inches (65.2 × 50 cm). Mount Holyoke College Art Museum, South Hadley, Massachusetts; Gift of David and Renee Conforte McKee (Class of 1962) (2003.24.2).

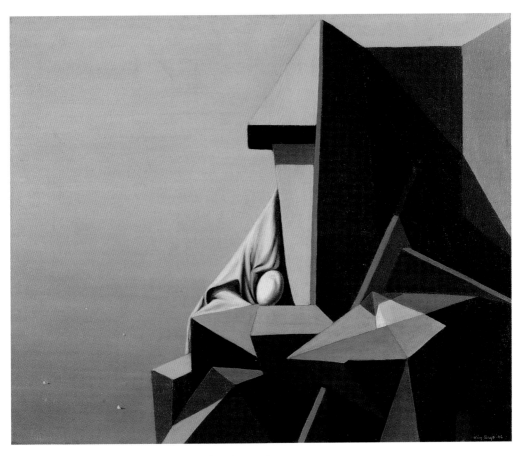

PLATE 10 Kay Sage, *From Another Approach*,
1944. Oil on canvas. 15 × 18 inches (38.1 × 45.7 cm).
Collection of Walker Art Center, Minneapolis; Gift of
the Estate of Kay Sage Tanguy, 1964 (1964.45).

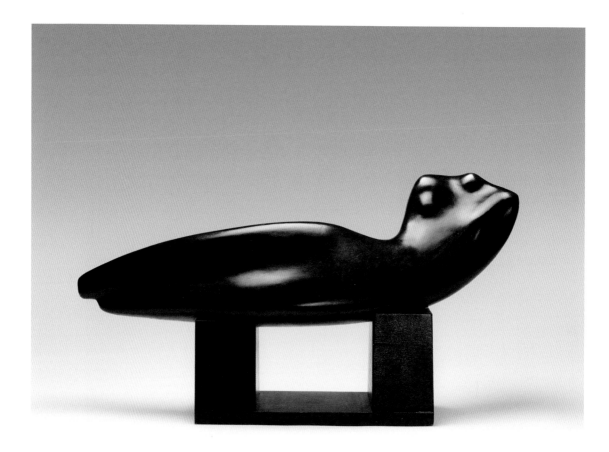

PLATE 11 Alexander Archipenko, *Torso in Space*, 1936. Bronze on wood base. 8 × 28 × 7 inches (20.3 × 71.1 × 17.8 cm). Mead Art Museum, Amherst College, Amherst, Massachusetts; Gift of Julia A. Whitney Foundation (2001.601).

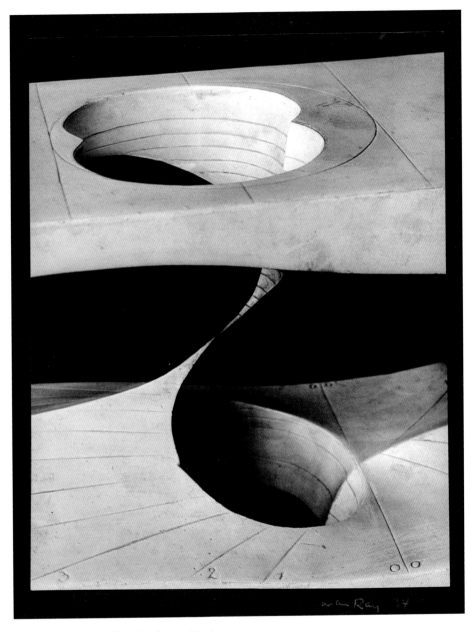

PLATE 12 Man Ray, *Equation, Poincaré Inst., Paris*, 1934. Gelatin silver print. 11¹³⁄₁₆ × 9³⁄₁₆ inches (30 × 23.3 cm). The J. Paul Getty Museum, Los Angeles.

PLATE 13 Man Ray, *Untitled (Mathematical Object),* 1934–1935. Gelatin silver print. 11¾ × 9½ inches (29.8 × 24.1 cm). The Phillips Collection, Washington, DC; Gift of Wendy Grossman and Francis Naumann, 2015.

PLATE 14 Ervand Kochar, *Head*, 1933. Plaster. 17.7
× 16.5 × 8.7 inches (45 × 42 × 22 cm). Ervand Kochar
Museum, Yerevan, Armenia.

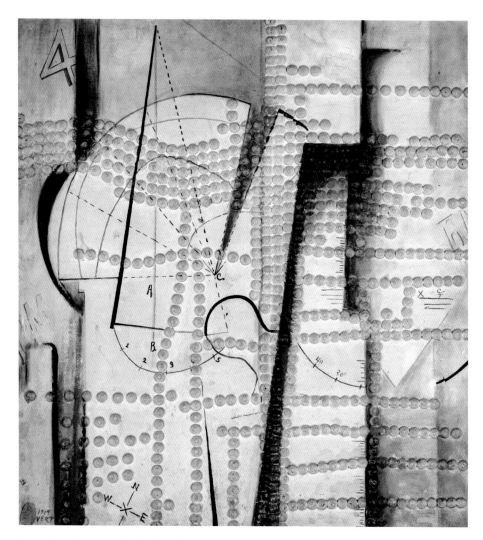

PLATE 15 John Covert, *Time*, 1919. Oil, carpet tacks,
possibly tempera on commercial pierced wood, covered
on both sides in cardboard. 24 × 24 inches (61 × 61 cm).
Yale University Art Gallery, New Haven; Gift of Collection
Société Anonyme (1941.412).

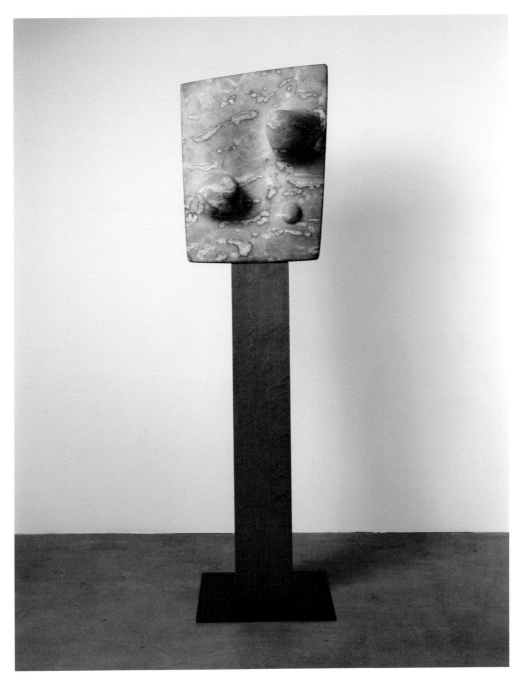

PLATE 16 Isamu Noguchi, *Time Lock*, 1944–1945.
Languedoc marble. 26¼ × 20½ × 15¾ inches (66.7
× 52.1 × 40 cm). Courtesy of The Isamu Noguchi
Foundation and Garden Museum, New York.

PLATE 17 Harold Edgerton, *Milk Drop Coronet*,
1936. Gelatin silver print. 20 × 16 inches
(50.8 × 40.64 cm). Smith College Art Museum,
Northampton, Massachusetts; Gift of Lynn
Hecht Schafran, class of 1962 (2003:43-1f).

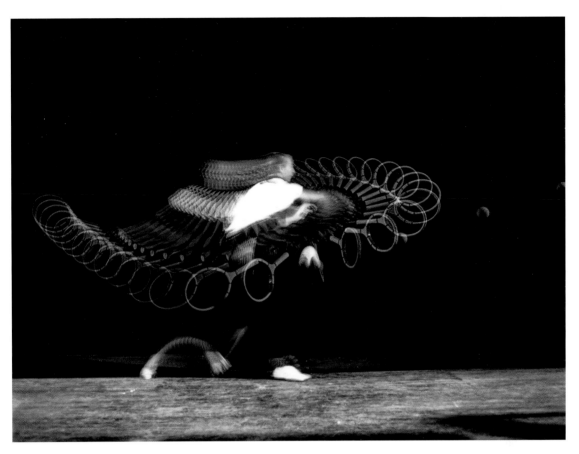

PLATE 18 Harold Edgerton, *Jenny Tuckey,
Tennis Multiflash*, 1938. Gelatin silver print. 11 ×
14 inches (27.9 × 35.6 cm). Mead Art Museum,
Amherst College, Amherst, Massachusetts;
Bequest of Richard Templeton (Class of 1931)
(1989.55).

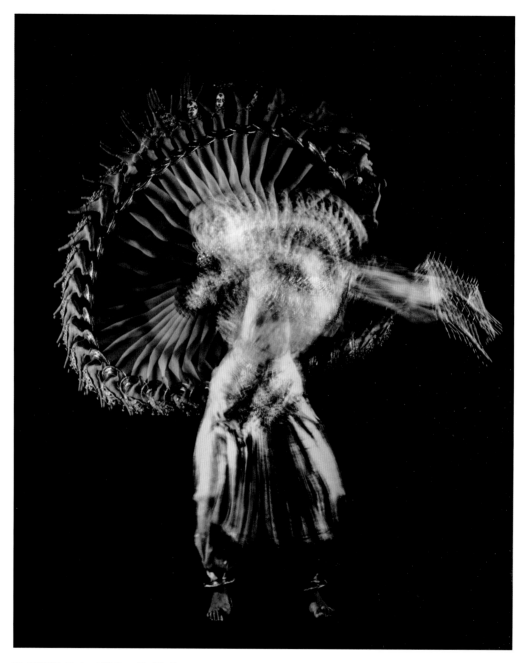

PLATE 19 Herbert Matter, *East Indian Dancer; Pravina*, 1937. Photograph. 11 × 14 inches (27.9 × 35.6 cm). Stanford University Libraries, Stanford, California.

PLATE 20 Herbert Matter, *Light Drawing*, 1943.
Photograph. 16 × 20 inches (40.6 × 50.8 cm).
Stanford University Libraries, Stanford, California.

PLATE 21 Robert Delaunay, *Rhythme sans fin*, 1934. Gouache on canvas. 80.3 × 18.1 inches (204 × 46 cm). Private collection, Paris.

PLATE 22 Ben Nicholson, *abstract composition,*
1939 (also known as *from painting 1936).*
Lithograph printed in color on paper. 25⅞ × 32⅛
inches (65.7 × 81.6 cm). Smith College Art Museum,
Northampton, Massachusetts; Museum purchase
(1950:49).

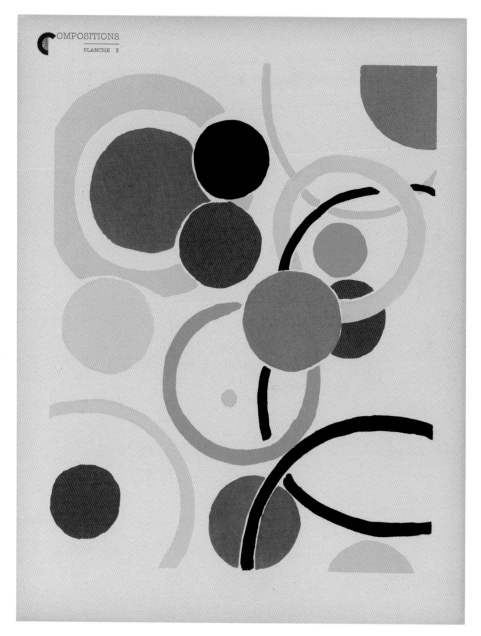

PLATE 23 Sonia Delaunay-Terk, *Plate 2 from the portfolio "Compositions, Colors, Ideas,"* 1930. Color stencil (pochoir). 12 11/16 × 9 5/8 inches (32.2 × 24.4 cm). The Baltimore Museum of Art; Friends of Art Fund (BMA 1997.152.2).

PLATE 24 Sophie Taeuber-Arp, *Composition with Circles and Semi-Circles*, 1935. Oil on canvas. 19⅞ × 25⅝ inches (50.48 × 65.08 cm). Albright-Knox Art Gallery, Buffalo; Charles Clifton Fund, 1969.

PLATE 25 Joan Miró, *Untitled*, 1937. Oil on matboard and mounted on Masonite. 19¼ × 25¼ inches (48.9 × 64.1 cm). Yale University Art Gallery, New Haven; Gift of Paul Rand (1974.29.2).

PLATE 26 Alexander Calder, *Two Spheres*, 1931.
Wood, wire, and paint, with motor. 21½ × 11 inches
(54.6 × 27.9 cm). Calder Foundation, New York;
Promised Gift of Holton Rower.

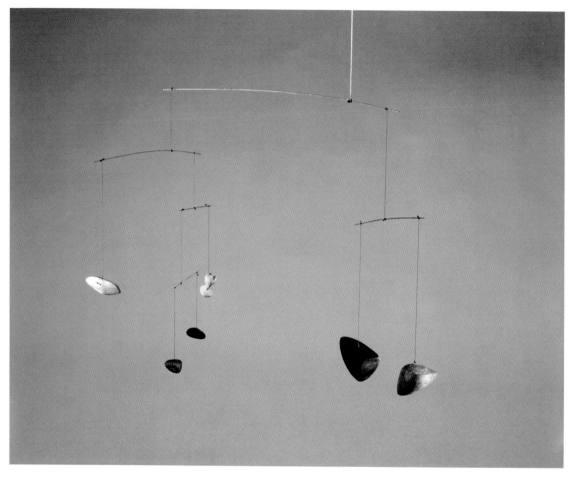

PLATE 27 Alexander Calder, *Little Wooden Mobile*,
c. 1943. Wood, wire, and string. 17¾ × 24 × 4⅝ inches
(45.1 × 61 × 11.7 cm). Calder Foundation, New York.

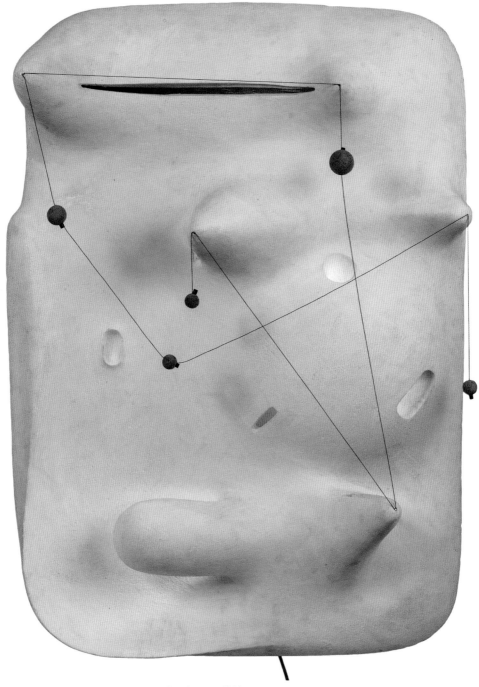

PLATE 28 Isamu Noguchi, *Lunar Landscape*, 1943.
Magnesite cement, electric lights, colored acetate
sheets, cork, and string. 35 × 25¼ × 7 inches (88.9 ×
64.1 × 17.8 cm). Crystal Bridges Museum of American
Art, Bentonville, Arkansas (2006.101).

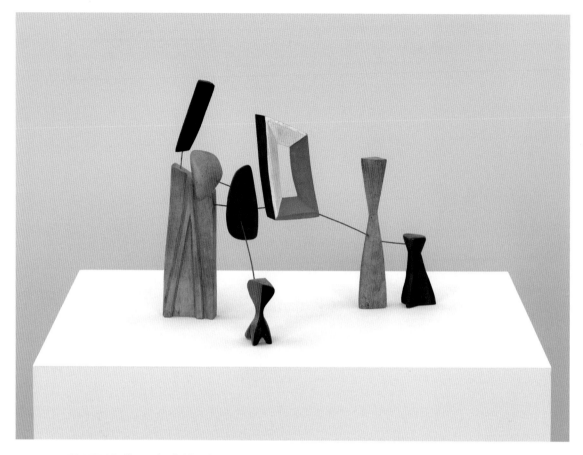

PLATE 29 Alexander Calder, *Constellation with Quadrilateral*, 1943. Painted wood and steel wire. 15 × 15½ × 10⅛ inches (38.1 × 39.4 × 25.7 cm). Whitney Museum of American Art, New York; Purchase, with funds from the Howard and Jean Lipman Foundation, Inc. in honor of the Museum's 50th Anniversary (80.28.1).

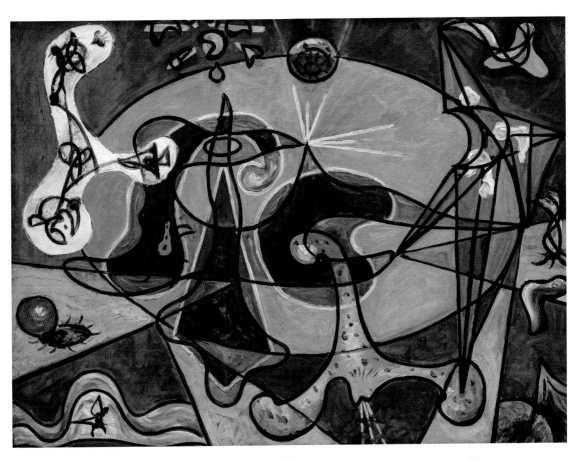

PLATE 30 Gordon Onslow Ford, *Escape*, 1939. Oil on canvas. 30 × 40 inches (76.2 × 101.6 cm). Courtesy of Weinstein Gallery, San Francisco.

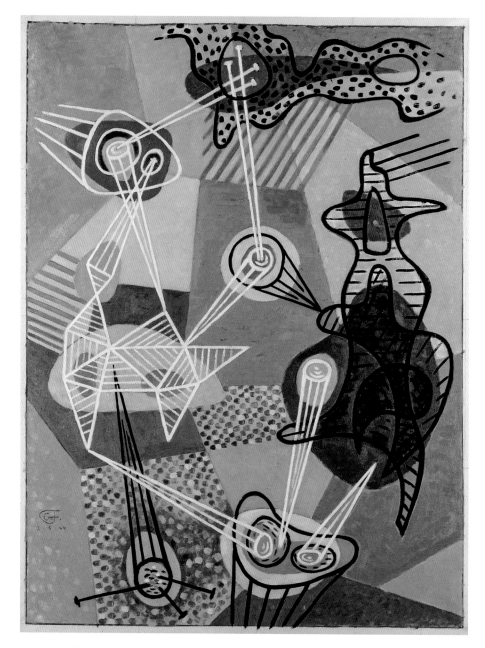

PLATE 31 Gordon Onslow Ford, *The Dialogue of Circle Makers*, 1944. Oil on canvas. 46⅛ × 35 inches (117.2 × 88.9 cm). Courtesy of Weinstein Gallery, San Francisco.

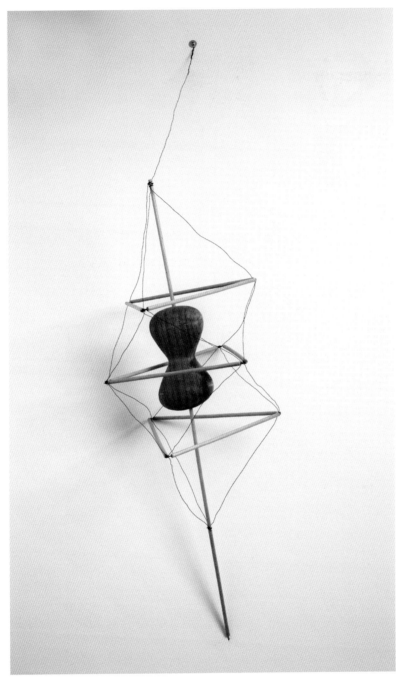

PLATE 32 Isamu Noguchi, *Bucky*, 1943. Wood and wire. 40 × 13 × 13 inches (101.6 × 33 × 33 cm). Courtesy of The Isamu Noguchi Foundation and Garden Museum, New York.

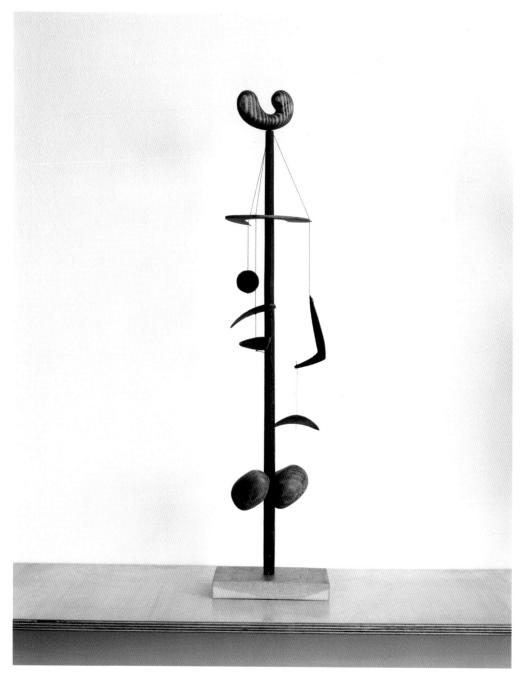

PLATE 33 Isamu Noguchi, *Untitled*, c. 1943 (partially reconstructed, 1995). Wood, string. 23¼ × 5⅜ × 3½ inches (59.1 × 13.7 × 8.9 cm). Courtesy of The Isamu Noguchi Foundation and Garden Museum, New York.

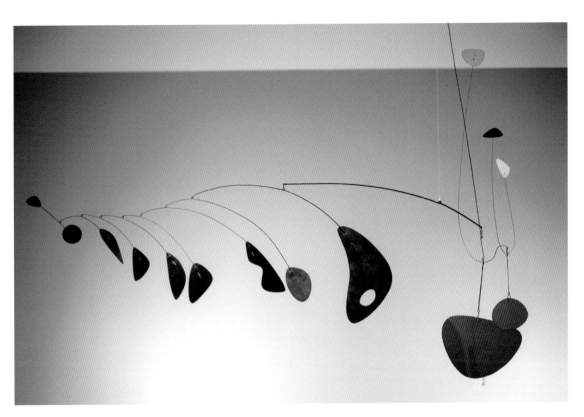

PLATE 34 Alexander Calder, *Study for Lobster Trap and Fish Tail*, 1937–1938. Painted sheet iron and wire. 55 inches (139.7 cm). Davis Museum, Wellesley College, Wellesley, Massachusetts; Gift of John McAndrew (1958.24).

PLATE 35 Helen Lundeberg, *Self Portrait*, 1944. Oil
on canvas. 17 × 28 inches (43.2 × 71.1 cm). Zimmerli
Art Museum, Rutgers University, New Brunswick,
New Jersey; Gift of The Lorser Feitelson and Helen
Lundeberg Feitelson Arts Foundation.

PLATE 36 Dorothea Tanning, *The Truth about Comets*, 1945.
Oil on canvas. 24 × 24 inches (61 × 61 cm). Crystal Bridges
Museum of American Art, Bentonville, Arkansas (2014.24).

PLATE 37 Isamu Noguchi, *Lunar Infant*, 1944. Magnesite, wood, electric components. 22 × 16 × 16 inches (55.9 × 40.6 × 40.6 cm). Courtesy of The Isamu Noguchi Foundation and Garden Museum, New York.

PLATE 38 André Masson, *Les Comètes*, 1943. Tempera
and sand on canvas. 14 × 11¼ inches (35.6 × 28.6 cm).
Frances Lehman Loeb Art Center, Vassar College,
Poughkeepsie, New York; Bequest of Gladys K. Delmas,
class of 1935 (1992.15.27).

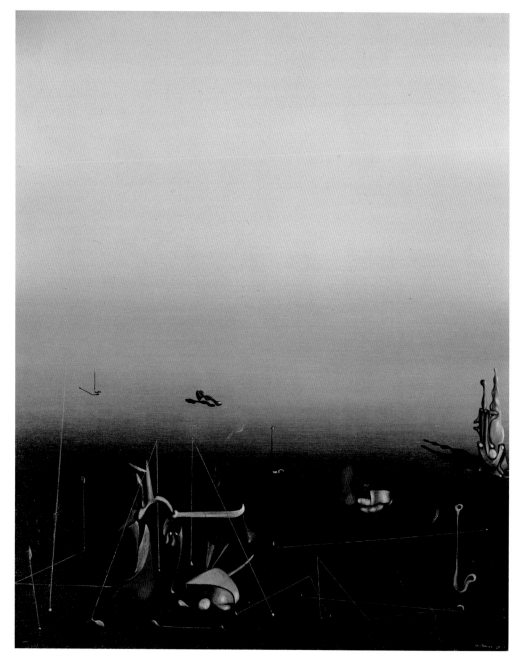

PLATE 39 Yves Tanguy, *Movements and Acts*, 1937. Oil on canvas. 25½ × 20¾ inches (64.77 × 52.705 cm). Smith College Art Museum, Northampton, Massachusetts; Gift of the estate of Kay Sage Tanguy (1964:45).

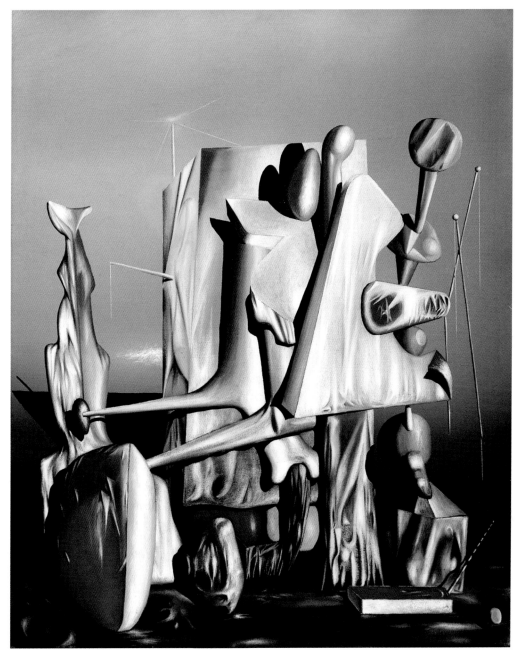

PLATE 40 Yves Tanguy, *Equivocal Colors*, 1943.
Oil on canvas. 20 × 16 inches (50.8 × 40.6 cm).
Williams College Museum of Art, Williamstown,
Massachusetts; Gift of the Lynes Family
Collection (99.5).

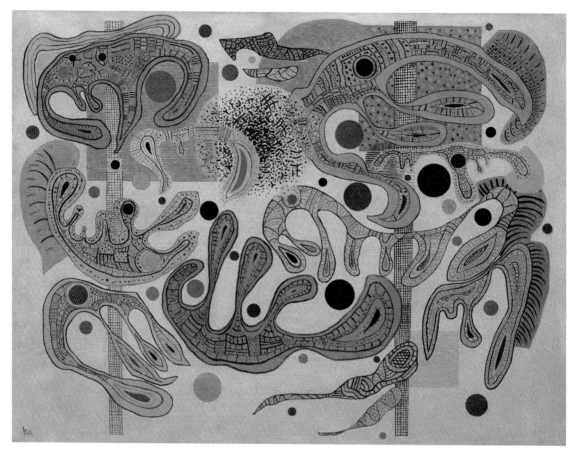

PLATE 41 Wassily Kandinsky, *Capricious Forms*,
July 1937. Oil on canvas, 35 × 45¾ inches (88.9
× 116.3 cm). Solomon R. Guggenheim Museum,
New York; Solomon R. Guggenheim Founding
Collection (45.977).

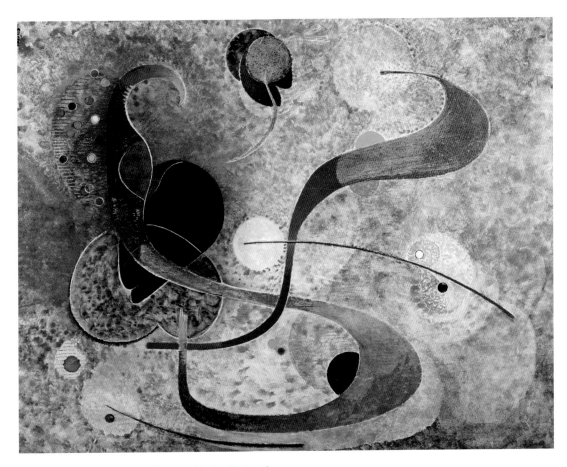

PLATE 42 Will Henry Stevens, *Marine Abstraction*, 1944. Oil on board. 27 × 21 inches (68.6 × 53.3 cm). Los Angeles County Museum of Art, Los Angeles; Bequest of Fannie and Alan Leslie (M.2006.73.13).

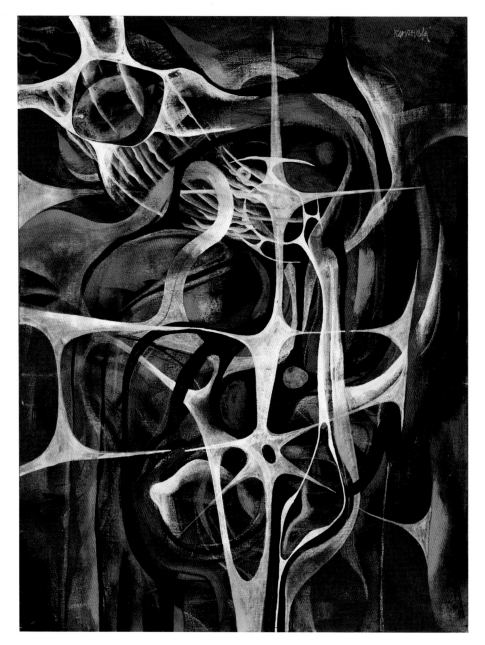

PLATE 43 Gerome Kamrowski, *Membrane, No. 239*, 1942–1943. Oil and pastel on canvas. 40 × 30 in. (101.6 × 76.2 cm). Los Angeles County Museum of Art, Los Angeles; Bequest of Fannie and Alan Leslie (M.2006.73.14).

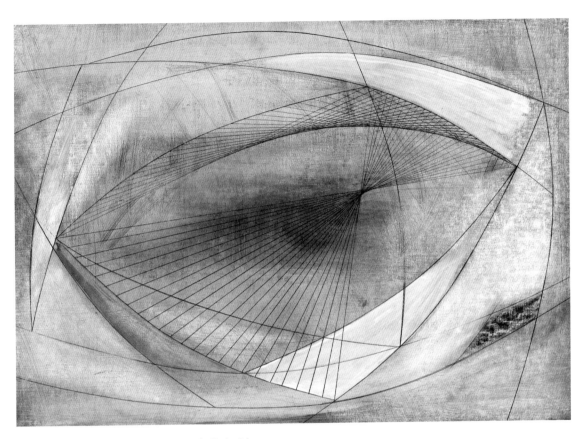

PLATE 44 Barbara Hepworth, *Project for Wood and Strings, Trezion II*, 1959. Oil, gesso, and pencil on board. 14⅞ × 21⅛ inches (37.8 × 53.7 cm). Mead Art Museum, Amherst College, Amherst, Massachusetts; Gift of Richard S. Zeisler (Class of 1937) (1960.1).

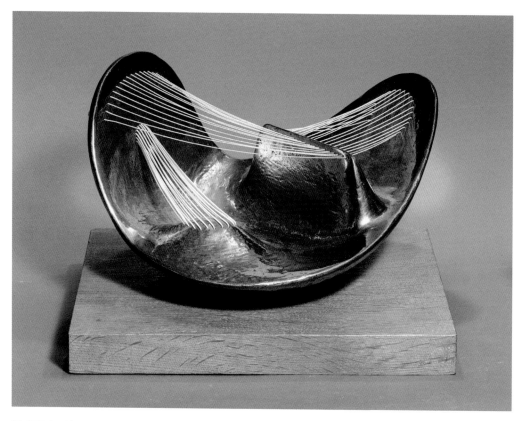

PLATE 45 Henry Moore, *Stringed Figure*, 1938.
Bronze and string, 9¾ × 14 1/16 × 12 inches (24.8 ×
35.7 × 30.5 cm). Mead Art Museum, Amherst College,
Amherst, Massachusetts; Gift of Bertram H. Bloch,
Class of 1933 (1972.55).

PLATE 46 Naum Gabo, *Vertical Construction No. 2
(The Waterfall)*, 1965–1966. Bronze with stainless-
steel spring wire. 81 inches high (205.7 cm). Mead Art
Museum, Amherst College, Amherst, Massachusetts;
Gift of the Julia A. Whitney Foundation (2001.600).

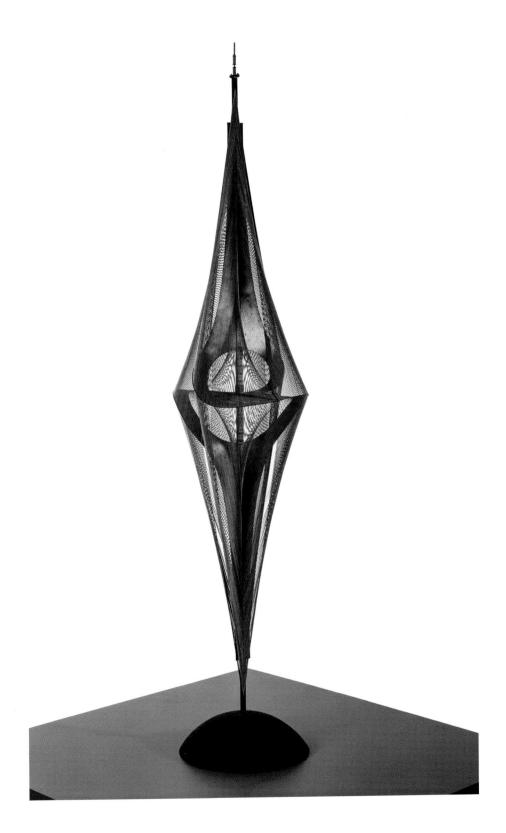

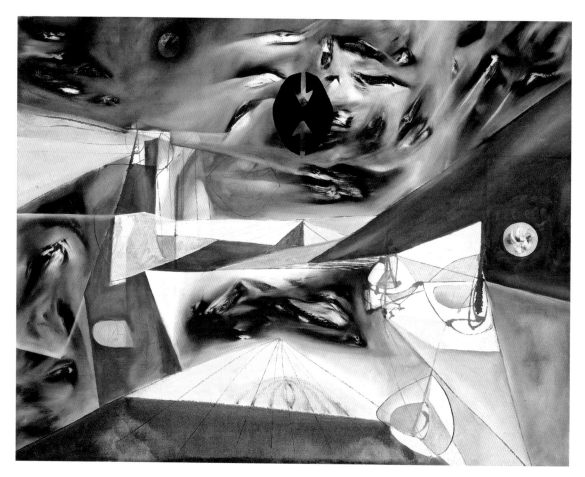

PLATE 47 Roberto Matta, *Genesis*, 1942. Oil on canvas. 28 × 36 inches (71.1 × 91.4 cm). National Gallery of Art, Washington, DC; Gift of Mr. and Mrs. Burton Tremaine (1971.87.6).

PLATE 48 Wolfgang Paalen, *Les Cosmogones*, 1944.
Oil on canvas. 96 × 93 inches (243.8 × 236.2 cm).
Courtesy of Weinstein Gallery, San Francisco.

PLATE 49 Dorothea Tanning, *Midi et Demi (Half Past Noon)*, 1956–1957. Oil on canvas. 51⅜ × 64 inches (130.5 × 162.6 cm). Courtesy of the Pennsylvania Academy of the Fine Arts, Philadelphia; Joseph E. Temple Fund (2010.5).

APPENDIX: THE HISTORY OF THE DIMENSIONIST MANIFESTO, AND RELATED TEXTS

Charles Tamko Sirató

EDITOR'S NOTE

Thirty years after the Dimensionist Manifesto was signed, Charles Tamko Sirató wrote a manuscript detailing the history of Dimensionism – its early formation in his poetry, the Manifesto's publication as a flyer in 1936, its reception that same year by artists in Paris and abroad, the insertion of copies of this same flyer into *Plastique* no. 2 (1937), and the publication of a second edition in 1965. He also published an edition of the Manifesto in Hungarian, with slight changes from the French original, in 1969. As his overview, or table of contents, of the manuscript indicates, Sirató intended his text to be part of a larger "album" that would include the text of the Manifesto along with a set of statements from many of the Manifesto's signers that he referred to as "Mosaique," and that was originally printed on the verso of the 1936 flyer. The album was also meant to include selections from Sirató's poetry and other writings, as well as a large collection of images documenting artwork created in the Dimensionist spirit dating from the 1910s through the 1960s. Unfortunately, Sirató's efforts met with disappointment when he failed to secure a publisher, and the project languished. In 2010 the Artpool Art Research Center in Budapest under the direction of Júlia Klaniczay, in collaboration with Magyar Műhely Kiadó (Hungarian Atelier Publishing), published Sirató's

manuscript in its original Hungarian, making available a text that has become a critical resource for the study of Dimensionism.[1] In particular, the book reflects a massive effort to reconstruct Sirató's planned illustrations for his "album," and includes many of the original photographic negatives he compiled for this project.[2] While the publishers acknowledge that the illustration section of the publication is incomplete, as not all of Sirató's images could be located, the book offers a wonderful visual record of how he tracked the development of Dimensionist art over the course of several decades.

What follows are translations of key components of his planned "album," including its overview, the Dimensionist Manifesto proper, and the first English translation of Sirató's "History of the Dimensionist Manifesto." We trust that these will be a useful resource for students and scholars of Dimensionism. The translation of the "History of the Dimensionist Manifesto" was produced in cooperation with Artpool and based on their Hungarian publication which in turn was based on Sirató's 1974 edited version of the original 1966 manuscript, a transcript of which can be found in the manuscripts section of the Library of the Hungarian Academy of Sciences. The original French (1936) and later Hungarian (1969) versions of the Dimensionist Manifesto included here were translated by Oliver Botar. Translation of the overview and of the "History of the Dimensionist Manifesto" from the original Hungarian was undertaken by Krisztina Sarkady-Hart. In most cases the formatting of the original text (e.g., words and phrases italicized or in boldface, or written with idiosyncratic spacing) was retained in order to preserve, as much as possible, the flavor of the original. Júlia Klaniczay of Artpool Art Research Center was extremely helpful throughout this process, providing assistance in the translation process and sharing original research material. Copyediting in English was undertaken by Ella Kusnetz. Every attempt was made to stay as close to the original manuscript as possible, and necessary edits to the original text are documented in square brackets and in footnotes. In particular, due to the challenges of translating poetry accurately, this publication does not include Sirató's supplemental appendix of poetry, and it also omits his intended section of illustrations. However, we hope that the many wonderful images in this catalog by Dimensionist artists will serve to illustrate Sirató's own vision of the expansive breadth of Dimensionism in the arts.

This album consists of the following parts:

A) The Text of the Dimensionist Manifesto

Excerpts from the texts of the Mosaic and the flyer for the first edition

B) The History of the Dimensionist Manifesto

1. The emergence of Planism in Hungary

2. How the theory of Dimensionism developed from Planism in Paris

3. Who signed the Dimensionist Manifesto and in what order

4. The first edition of the Dimensionist Manifesto: Paris, 1936

5. The second edition of the Dimensionist Manifesto: Paris – New York, 1937

6. The third edition of the Dimensionist Manifesto: Paris, 1965

7. Dimensionist Album I, 1966

C) Illustrations [Reconstruction]

Non-Euclidean Art I (art derived from literature)

Non-Euclidean Art II (art derived from painting)

Non-Euclidean Art III (static art derived from sculpture)

Non-Euclidean Art IV (art derived from the vaporization of sculpture; "cosmic art," "matter-music," "total-sensory," etc.)

Appendix

Egy éjszaka története [The Story of a Night (linear version)]

Bevezetés a Regénytéglába [Introduction to the Novel-Brick]

Bernát élete a regénytéglában [Bernard's Life in the Novel-Brick]

Additions to the texts, addendum

The Art of Fraction-Words (Manifesto)

Intermezzo / Start / Cry

Modern Masterpieces

CHARLES TAMKO SIRATÓ

THE DIMENSIONIST MANIFESTO[4]

Paris, 1936

Dimensionism is a general movement of the arts. Its unconscious origins reaching back to Cubism and Futurism, it has been continuously elaborated and developed since then by all the peoples of Western civilization.

Today the essence and theory of this great movement bursts with absolute self-evidence.

Equally at the origin of Dimensionism are the European spirit's new conceptions of space-time (promulgated most particularly by Einstein's theories) and the recent technical givens of our age.

The absolute need to evolve, an irreducible instinct, has sent the avant-garde on their way toward the unknown, leaving dead forms and exhausted essences as prey for less demanding artists.

We must accept – contrary to the classical conception – that Space and Time are no longer separate categories, but rather that they are related dimensions in the sense of the non-Euclidean conception, and thus all the old limits and boundaries of the arts d i s a p p e a r.

This new ideology has elicited a veritable earthquake and subsequent landslide in the conventional artistic system. We designate the totality of relevant artistic phenomena by the term "DIMENSIONISM." / Tendency or Principle of Dimensionism. Its formula: "N + 1." (A formula discovered in Planist theory and then generalized, reducing to a common law the seemingly chaotic and inexplicable artistic phenomena of our age.)

ANIMATED BY A NEW CONCEPTION OF THE WORLD, THE ARTS, IN COLLECTIVE FERMENTATION (their interpenetration)

HAVE BEEN SET INTO MOTION

AND EACH HAS ABSORBED A NEW DIMENSION.

EACH HAS FOUND A NEW FORM OF EXPRESSION INHERENT TO THE NEXT DIMENSION, OBJECTIFYING THE WEIGHTY INTELLECTUAL CONSEQUENCES OF THIS FUNDAMENTAL CHANGE.

Thus, the Dimensionist tendency has led to:

I. …L i t e r a t u r e leaving the line and entering the plane.

 Calligrammes. Typograms. P l a n i s m .

 (preplanism) Electric Poems.

II. …P a i n t i n g quitting the plane and entering space.

 Painting in space "Constructivism"

 Spatial Constructions.

 Poly-Material Constructions.

III. …S c u l p t u r e stepping out of closed, immobile, dead forms, that is, out of forms conceived of in three-dimensional Euclidean space – in order to appropriate for artistic expression Minkowski's four-dimensional space.

It has been, above all, "solid" sculpture (classical sculpture) that has opened itself up, first to inner space, then to movement, and is transformed into:

Perforated Sculpture.

Open Sculpture.

Mobile Sculpture.

Motorized Objects.

And after this a completely new art form will develop:

Cosmic Art

(The Vaporization of Sculpture,

Synos-Sense Theater, provisional denominations.) The artistic conquest of four-dimensional space / to date an artistic vacuum /. Rigid matter is abolished and replaced by vaporized materials. Instead of looking at objects of art, the person becomes the center and the subject of creation, and creation consists of sensorial effects operating in a closed cosmic space.

This is how one would most concisely summarize the essence of Dimensionism: Deductive with respect to the past. Inductive with respect to the future. Alive in the present.

[The following artists signed the DIMENSIONIST MANIFESTO in Paris in 1936:]

Hans Arp

Francis Picabia

Wassily Kandinsky

Robert Delaunay

Marcel Duchamp

Enrico Prampolini

César Domela

Camille Bryen

Sonia Delaunay-Terk

Sophie Taeuber-Arp

Ervand Kochar

Pierre Albert-Birot

Frederick Kann

Anton Prinner

Mario Nissim

Nina Negri

Siri Rathsman

Charles Sirató

[The following foreign endorsements appeared in the first (*movemental*) edition of the Manifesto:]

Ben Nicholson (London)

Alexander Calder (New York)

Vincente Huidobro (Santiago de Chile)

David Kakabadze (Tblisi)

Katarzyna Kobro (Warsaw)

Joan Miró (Barcelona)

László Moholy-Nagy (London)

Antonio Pedro (Lisbon)

M O S A I C[5]

The fundamental change in our worldview, the profound transmutation which results in the great formal revolution of the arts, resides in the absolute negation of materialism and of pure spiritualism. The result of this change is the advent of the synthetic idea in which spirit and matter constitute a single process.

In art, spirit is the source, while matter (form) is the expression.

— Kandinsky.

The pedestrian's shuffling gait: letters = linear literature. Cars on the roads, fast trains: accelerated lines = literature in two dimensions.

Why do I practice superposition in painting? Because it has not been done so up until now.

— Picabia.

The longitudinal contraction of pictorial space.

— Louis Fernandez.

Polymaterial Compositions — the contemporary joy in the creation of the world.

— Prampolini.

The winged man: Painting in Space

It is my greatest satisfaction to have ventilated Euclid's brain: *Sculpture-Ouverte*

— Kochar.

The fact that a new mode of expression exists in the plastic arts which differs from the traditional one is in my opinion sufficient proof to justify it. Life evolves unceasingly, obeying only its own mysterious fundamental law, according to which it renews itself perpetually.

— Kann.

I insist on the utmost importance of the particularly psychological preoccupations which have permitted poetry, on its part, to evolve toward the automatic poem.

After this last stage, poetic expression tends toward realizations in many dimensions.

I consider Surrealist objects to be poetic expressions in three dimensions. It seems evident to me, that this road leads to a New Reality and that it could not have anything to do with the confusions engendered by concrete and abstract art terms.

— Arp.

Western painting has symbolically conquered space (depth using perspective) since the Renaissance. Cubism has rejected this conquest. It has reoccupied the surface. Abstract art, by forever simplifying itself, has rigorously maintained this result of Cubism.

When the abstract painters see that there is nothing more to do within a two-dimensional surface, Painting must either die on Mondrian's last square or accept the only living possibility, that is say, to grasp the third dimension: evolve in space. To really conquer three-dimensional space.

— Kochar and Nissim.

A New Reality imposes itself outside of all known Realisms; neither perspectival nor Euclidean nor chiaroscuro. New materials. Colors in the non-imitative sense. Electric light as rhythm. Rhythm as subject.

Architecture being dimensional, this new expression takes its place in it by bringing surfaces and voids alive. Only a polychrome and non-decorative architecture can become dynamic and plastic in conjunction with this contemporary art.

— Delaunay.

Painting? The plane is dead. Today objects wish to break through the canvas. Every day, then, painting pursues its attempt at liberation: this is how it declares itself true to its tradition.

— Nissim.

Rotation, life form of Universes. A life form unknown to art. Use of movement in the plane for the creation of forms in space: Rotoreliefs.

— Duchamp.

In the universal void poetic creation invents the new dimensions of pleasure. I wish to invent, as a poem, a live animal of an unknown kingdom.

– Bryen.

Mankind "biological unit and entity" the only basis left to us for an entirely new art. Fusion of music and sculpture: cosmic art. Whether we want it or not, this revalorization of mankind as a center of creation will impose itself.

– Sirató.

The deep meaning of Dimensionism: the Biological Revolution.

– Sirató and Bryen.

The forms of art are materializations of a spiritual state. The great Revolution of form, which has been developing since the start of our century, is the organic result of a fundamental change in our conception of the world.

The Manifesto allows for the possibility of developing in a more detailed way all of the problems it raises; in our *Revue* by the artists themselves, and by Charles Sirató in his book *Les Arts et les Artistes non-euclidiens*.

The Signatories

DIMENSIONISM

is not a willed movement, created or directed; it is an evolution which has existed in a latent form for a long time. The Manifesto is in reality a general ascertainment deduced from the works of certain advanced artists, and, at the same time, an enlargement of the initial ideas derived from two-dimensional literature.

This is the first time that a Statement of 60 lines has been able to assemble in such a short time (around two months) the unanimous and spontaneous approbation of 25 artists, the most remarkable of all the countries.

This proves that our Statement is an awakening of consciousness/conscience [*une prise de conscience*]. We have brought to the light of day a truth – and without our background research no one would have been able to explain it with as much precision.

The Dimensionist Manifesto is liberal in conception. From the interpretation of the arts to Cosmic Art, it allows for a wide range of nuance. The works of the signatories are, all of them, saturated by the Dimensionist spirit. On the other hand, we have invited only those artists to approve of us, whose work clearly exudes Dimensionist value, and who already in advance had well-established positions in the future development of our theories.

OUR MANIFESTO IS A DEPARTURE.

LA REVUE N + 1

FOR THE NON-EUCLIDEAN ARTS

ACTIVITÉ

After the appearance of the first French edition, our manifesto will appear simultaneously in several foreign languages. Each of these editions will include a photograph of the artist representing the Dimensionist Movement in their country. For example the South American edition will include Huidobro's portrait; that of Russia the portrait of Kakabadze; that of Portugal the portrait of Pedro, etc. These special editions will be identical to the original French edition with the exception of the second page in which the text at center will be replaced by one of these photographs.

In proceeding this way, we wished to accentuate the international tendency of our movement. Ever compelled by the social sense, we have wished that our theories should reach the largest number of artists, that our ideas should become living factors everywhere that there is the possibility of evolution.

The first issue of *Le Revue N + 1* appears in October.

Our announced books will appear every four months.

Our first Exhibition will take place in the fall.

WE INVITE ALL THE ARTISTS IN ACCORD WITH OUR IDEAS EXPRESSED IN THE MANIFESTO TO COLLABORATE WITH US.

THAT THEY JOIN US, THAT THEY SEND US PHOTOS OF THEIR WORKS, WHICH WE WOULD BE ABLE TO PUBLISH IN OUR JOURNAL.

THAT THEY PARTICIPATE IN OUR EXHIBITION. THAT THEY PROPAGATE – OUTSIDE OF OUR INTERNATIONAL ORGANIZATION – OUR MANIFESTOS, OUR IDEAS, OUR WORKS.

THE DIMENSIONIST MANIFESTO[6]

Paris, 1936

Dimensionism is one of the living and leading examples of the *Kunstwollen* of our age. Its unconscious origins reach back to Cubism and Futurism. Nearly every cultured nation of modern civilization has been working on its development since that time.

It is the essence and theory of this *great, universal, and synoptic* artistic movement which is made conscious in our manifesto.

It is, on the one hand, the modern spirit's completely new conception of space and time (the development of which, in geometry, mathematics, and physics – from Bólyai through Einstein – is ongoing in our days), and on the other, the technical givens of our age, that have called Dimensionism to life.

Evolution, the instinct that breaks through all barriers, has sent the pioneers of creative art on their way toward completely new realms, leaving older forms and exhausted essences as prey for less demanding artists!

We must accept the fact that space and time are not separate categories – absolutes in opposition to one another – as was earlier believed and taken for granted, but rather that they are related dimensions in the sense of the non-Euclidean conception. By intuiting this fact, or by making it our own through conscious means, all the old borders and barriers of the arts suddenly disappear.

This new ideology has elicited a veritable earthquake, a landslide, in the old artistic system. We designate the totality of relevant artistic phenomena by the term "Dimensionism." (The formula "N + 1" expresses the Dimensionist development of the arts. It was through Planism, the theory of two-dimensional literature, that we noted its relevance to the arts. We generalized its application in order that we might attribute – in the most natural way possible – the seemingly chaotic, unsystematic, and inexplicable artistic phenomena of our age to *one single common law*.)

ANIMATED BY A NEW FEELING FOR THE WORLD, THE ARTS – IN COLLECTIVE FERMENTATION (Their Interpenetration) – HAVE BEEN SET INTO MOTION, AND EACH HAS ABSORBED A NEW DIMENSION, EACH HAS FOUND A NEW FORM OF EXPRESSION INHERENT IN THE NEXT DIMENSION (N + 1), opening the way to the weighty spiritual/intellectual consequence of this fundamental change.

The Dimensionist tendency has led to:

I. *Literature leaving the line and entering the plane*: *Calligrammes*, Typograms, Planism, Electric Poems.

II. *Painting leaving the plane and entering space*: *Peinture dans l'espace. Compositions Poly-matérielles*, Constructivism. Spatial constructions. Surrealist objects.

III. *Sculpture stepping out of closed, immobile forms* (i.e., out of forms conceived of in Euclidean space), *in order that it appropriate for artistic expression Minkowski's four-dimensional space.*

It has been, above all, "solid sculpture" that has opened itself up, first to inner space, and then to movement; this is the sequence of developments: Perforated sculpture; *sculpture-ouverte*, Mobile sculpture; Kinetic sculpture.

IV. And after this a completely new art form will develop: Cosmic Art. The *Vaporization* of Sculpture: "*matter-music.*" The artistic conquest of four-dimensional space, which to date has been completely art-free. The human being, rather than regarding the art object from the exterior, becomes the center and five-sensed [*öt-érzékszervü*] subject of the artwork, which operates within a closed and completely controlled cosmic space.

This is how one would most concisely summarize the essence of Dimensionism: Deductive with respect to the past. Inductive with respect to the future. Alive in the present.

The following artists signed the DIMENSIONIST MANIFESTO in Paris in 1936:

Hans Arp

Francis Picabia

Wassily Kandinsky

Robert Delaunay

Marcel Duchamp

Enrico Prampolini

César Domela

Camille Bryen

Sonia Delaunay-Terk

Sophie Taeuber-Arp

Ervand Kochar

Pierre Albert-Birot

Frederick Kann

Anton Prinner

Mario Nissim

Nina Negri

Siri Rathsman

Charles Sirató

The following foreign endorsements appeared in the first (*mouvement*) edition of the manifesto:

Ben Nicholson (London)

Alexander Calder (New York)

Vincente Huidobro (Santiago de Chile)

David Kakabadzé (Tblisi)

Katarzyna Kobro (Warsaw)

Joan Miró (Barcelona)

László Moholy-Nagy (London)

Antonio Pedro (Lisbon)

THE CONCEPT FOR THE FIRST INTERNATIONAL DIMENSIONIST EXHIBITION[7]

Non-Euclidean Art I

CALLIGRAMS, VISUAL POEMS: Apollinaire, Bryen, Kassák, Pedro, Huidobro, Sirató

PREPLANSM: Blaise Cendrars, Jean van Heckeren, Huidobro, Kandinsky, Lévesque, Malevics [Malevich], Marinetti, Prampolini, Joan Miró, Moholy-Nagy, Picabia, Picasso, Joyce

TYPOGRAMS: Pierre Albert-Birot, Pedro, Marinetti, Kassák, Mayakovsky

PLANISM: Charles Sirató, James Joyce

Non-Euclidean Art II

PAINTING IN SPACE: Francis Picabia, Ervand Kochar

SURREALIST OBJECTS: Arp, André Breton, Salvador Dalí, Man Ray, Max Ernst, Giacometti etc., etc.

CONSTRUCTIVISM: Gabo, Pevsner, Lissitzky etc., etc.

SPATIAL CONSTRUCTIONS: Taeuber-Arp, Robert Delaunay, Sonia Delaunay-Terk[8] Cesar Domela, Ferren, Gonzalez, Frederick Kann, Kakabadze, Kobro, Miró, Moholy-Nagy, Ben Nicholson, Mario Nissim, Picasso, Prinner, etc.

POLYMATERIAL COMPOSITIONS: Nina Negri, Siri Rathsman, Prampolini, and many others

Non-Euclidean Art III

HOLLOW, CARVED-OUT SCULPTURE: Marcoussis, Laurent, Lipchitz, Moore, Zadkine, etc.

OPEN SCULPTURE: Ervand Kochar

MOBILE SCULPTURE: Giacometti, Calder, etc.

KINETIC SCULPTURE: Calder, Duchamp, Moholy-Nagy, etc.

MOTORIZED OBJECTS: Calder, Duchamp

About the completely new art resulting from the vaporization of sculpture, which is called

Non-Euclidean Art IV

Lectures (readings):

SIRATÓ: The Five-Sensed Theater. The Matter-Music Theater (study, Budapest, 1928; Paris, 1936).

CALDER: Cosmic Sculpture (New York, 1930).

MOHOLY-NAGY: Total Theater (Berlin, 1927).

KANDINSKY: Synthetic Art (Moscow, 1915).

HOW DID THE THEORY OF DIMENSIONISM DEVELOP AND HOW WAS THE DIMENSIONIST MANIFESTO CREATED?[9]

I. Planism: The Development of Planism in Hungary

I spent my childhood in the Great Hungarian Plain (Alföld), in the village of Pusztaföld-vár in Békés County, so my first ever experience was that of the *Hungarian Puszta: the flatlands.*

Our village was surrounded by a vast farmland region, and my father, who was the village doctor, was often summoned to patients living in the tiny farms. He would often take me along, and during the slow, bumpy rides on a peasant cart I would gaze into the endless flatlands that were diverse in their geometrical formations: the snow-covered or the sun-drenched plains. This was the greatest joy and the most lasting and defining memory of my childhood. The endless plain was lined in every direction by paths; lines of acacia and poplar trees marched along the road, and the small farmsteads were like junctions, centers of gravity, condensations in the middle of the squares, and in the yards of the farmsteads the high sweep-poles of the wells moved up and down like tolling bells. This kind of well sweeps can only be seen in the Hungarian Alföld or in regions to the east of it. All this was carved into my memory for life.

I attended secondary school in the Alföld too – in Szeged, Hódmezővásárhely, and Mezőtúr – where this experience of the plains, the plain/planar-impression, deepened and became enriched even further. I was twelve when I realized that I was able to write far more scathing satirical poems than my classmates, and I discovered to my great surprise that I was able to compose parodies for well-known verses, and even improvise stanzas with ease.

Since that time I regularly read – almost studied – poems. After reading the poets available at the secondary school library I soon turned to the living moderns, and I was only fifteen when I was utterly under the influence of the greatest living Hungarian poet, Endre Ady, and this can be clearly felt in my first volume of poetry, titled *In the Spring of Life*, published when I was a sixteen-year-old in secondary school.

By the time I was seventeen, however, I was drawn to the world of the Futurists. Regarding my spiritual/intellectual makeup, let me just say that I was absolutely unwilling to embrace the concepts and dogmas of the Reformed secondary school I attended, and a kind of restlessness urged me to find my own tenets, which are better suited to my character.

I soon found harmony in Buddhism, after which I felt the "truths" of the Sophist to be real, and in the end "absolute anarchism" became my basic spiritual/intellectual scheme, which *at the time, in 1920, perfectly corresponded to the presentiment of "Dadaism."* (So I can say without exaggeration that I was in sync with Europe! Even more than that!)

After graduating from secondary school I moved to Budapest, and it was in the avant-garde periodicals (Kassák's periodicals, the periodical of Árpád Mezei and Imre Pán, IS [Too], etc.) where I found everything that captured my imagination that was

naturally averse to the past. At the age of seventeen, in the secondary school of Mezőtúr, *driven by an instinct I felt natural, it was my ambition to challenge the thus far existing limits of poetic expression* and express *more* with words *than just ideas*.

In Budapest, in 1924, I wrote the first line of poetry that satisfied my imagination that was yearning for something new: it was a poem with a visual effect titled *The Cross of Poets*, whose four short lines followed by three long and another fourteen short lines actually formed a cross. In my next experiment, in my poem titled *Memory of Three Minutes in Song*, I wanted to express the lines of a woman's foot through the musical regulation of the volume of uttering the word "stockings," or by using the "cubic content of the word" (as I described it at the time). The poem went like this:

> pianissimo: stockings
> crescendo: stockings
> più crescendo: stockings
> decrescendo: stockings
> piano: stockings

At this time, Lajos Kassák, who was living in Vienna, published one new experimental periodical after the next including typograms, poems incorporating typography to create a visual effect. Of these, the one that had the greatest influence on me was his eye-catching work titled *Flowers*, whose square-circle-acute angle composition (but especially the acute angle shooting up high), evoked the unforgettable memory of my childhood: the image of the well sweep and the plains associated with it.

These images gave rise to ever broader and deeper resonances of the past in me, and one day I composed my first specifically "visual poem," to which I gave the title: *Well in the Puszta*.[10]

The first version of *Well in the Puszta* was lost, along with many of my manuscripts, during my rather stormy life full of ups and downs, and I cannot reconstruct these sentences from memory, except for the last line, which went like this: "My old man, you won't need water for long!"

Later on I found this text with its logical and grammatically almost "spoon-fed" form being of no interest, and I replaced the "sentences" of the visual poem with syllabic verse. The poem was then translated into French in this form. I even changed the title, and so it became a Surrealist work:

> *Water Violin with Seven Positions*
>
> *or*
>
> *The Mythology of the Well.*

VÍZHEGEDŰ HÉT ÜLLÉSSEL

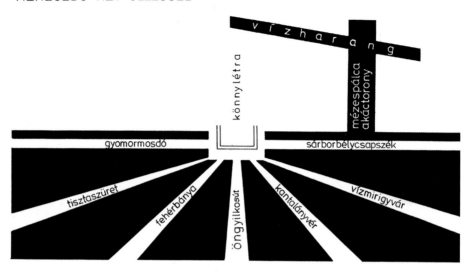

A.1 Charles Sirató, *Water Violin with Seven Positions* [Violon d'eau à sept places], 1925. Image courtesy of Artpool Art Research Center, Budapest.

In the circle of my poet-friends we had heated debates about poetry, its essence and its genres. The ballad was a special favorite of ours. Hungarian literary theory provides an excellent definition of the ballad which is a gift for aesthetes: "a tragedy related in song." We analyzed this definition for a long time.[11]

In my opinion the main thing is: a fast development of a tragedy, like lightning. I did not know any such ballad, which I referred to as a "fast ballad" at the time. It was around 1924–25 that the first electric posters appeared in the streets of the world's biggest cities, including Budapest. The sentences in these posters lit up and went out one after the other, both in three- and two-dimensional form. Immersed in the world of our ballad debates, I wrote a fast ballad. It had a conventional form "composed within the line," and it sounded like this:

Simple Ballad

The woman who has dropped her petals has daughters
daughters with white backs have sons
sons with fists like axes have lovers
lovers with smooth shoulders have desires
The desires set out in the night to roam about
the lovers with smooth shoulders set out to love in the night
the sons with fists like axes set out to kill in the night
the daughters with white backs set out to bury in the night
The woman cries and turns white.

I soon realized that this poem in this form was not interesting enough, not comprehensible enough, and above all: not fast enough! I worked on it some more and realized this: if I take this story, which consists of nine sentences in its linear form, and contract it into a single sentence consisting of four subjects and four predicates, and I use numbers to indicate the connections between the subjects and the predicates, and then *I lend the poem the visual form that it fashions for itself* and I indicate the direction of the tragic, balladistic fall of the plot with a large black arrow, I can significantly intensify the ballad's pace of development and hence its tragedy.

Using this method I composed the *Visual Ballad*, and I myself was the most surprised when it was ready. I did not really know myself where this would lead, but I clearly felt that the poem was better, denser, faster, more tragic, and I thought much more "comprehensible" than it was in its "skimpy and simple" form. Needless to say, it was also more original. My friends and fellow poets looked at my new creation in silent shock. None of them had ever seen anything like this before. None of them were able to define the genre of this thing. Eventually I added a caption: "Numero-kinetic construction," or to be more precise: *poem-apparatus put in motion by numbers*.

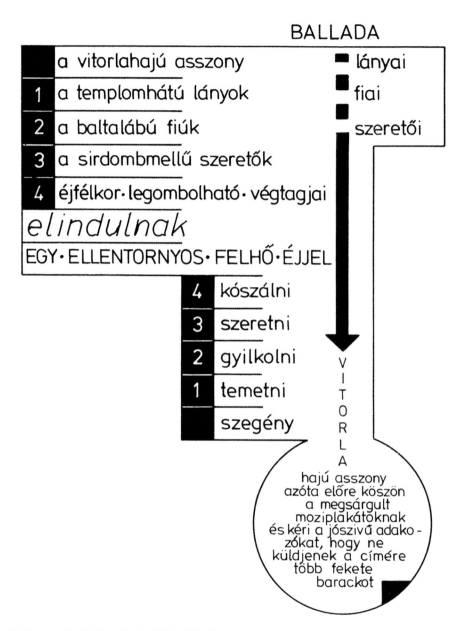

A.2 Charles Sirató, *Visual Ballad / Ballad Machine*
[Vizuális Ballada / Ballada-gép], 1926. Image courtesy
of Artpool Art Research Center, Budapest.

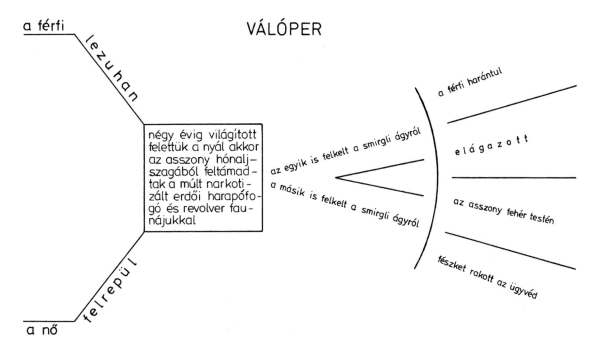

A.3 Charles Sirató, *Divorce,* 1929–1936. Image courtesy of Artpool Art Research Center, Budapest.

As far as I was concerned, I was really happy with my own work, especially with the speed of the ballad's development. I immediately imagined it as an electric poster: first it happens slowly, at the pace of reading. Then it will accelerate, and in the end it will be just flashing, flashing! It could even reach the speed of 100–150 flashes per minute.

It was like a machine! A *Ballad Machine*! (And that is what the title was translated into in French.) A faster-paced ballad than this would have actually been difficult not only to find, but even to imagine.

Around this time, in 1926–27, my simple "poems within the line" were published in Tivadar Raith's periodical titled *Magyar Írás* [Hungarian writing]. The periodical's assistant editor lived opposite the dormitory in Liliom Street, and I, then a third-year law student, often went to see him and helped him in the editor's office. It was in this period that I wrote my third visual poem, titled *Divorce*.

This poem was an improvement on the previous two, since while the first one was a *completely static* depiction, like the pattern poems of ancient Alexandrian poets or even the calligrams and typograms of Apollinaire and Kassák, and the movement in the second one, let me put it this way: "rolled on number-bearings," in this third one

there was a *movement of events driven by the line*. I immediately noticed this difference and I regarded this third poem as a "planar poem." It was this poem that actually made me realize what I was doing: *I was transforming literature into a planar form of expression*.

A basic impetus for my method was the growing number of moving electric posters in the streets. The first electric newspaper with its racing lines was installed in Budapest's most beautiful square, called Octagon, and we happily read the events of world history racing across the top of the walls. In cinemas, the wars that broke out and escalated in various corners of the world as well as reports from the war fronts were illustrated using two-dimensional, black-and-white, shadowed "moving maps" with geometric shapes pushing forward. *Arrows showing directions* assumed increasing importance in these moving maps and *also started appearing everywhere in the streets*, partly to indicate the directions of traffic and location of parking lots, and partly to denote other notions related to traffic. Under the influence of all this, I composed my first veritable electric poem in 1927, titled *Budapest*, which was translated into French as *Paris*. In those days, there was abject poverty in Hungary. Like so many of my fellow-sufferers, I was living a life of desperation at a student camp, working as a private tutor, barely getting by, facing a harsh reality in a world of canteens and charitable campaigns.

Despite the circumstances, my peers, who lived in the dormitory in Liliom Street, were almost without exception right-wingers, following the controlled public opinion. I and a few others, most of them artists, were unable to accept these right-wing sentiments—and remained leftists, undoubtedly influenced by the leading authors of world literature in that period.

My electric poem titled *Budapest* was conceived in this experience of destitution and the hope in a left-wing solution. In this poem I showed the social structure of a capitalist metropolis, with the dynamic portrayal of the inspectors recruited from the proletariat eager to destroy the capitalist "superstructure" at any moment.

My work made a great impact. I showed it to many people, and even those who did not agree with the poem's explosive tendency starting from the bottom and spreading upward praised it as a well-conceived, well-composed, and first-class work of excellent execution. Even in its initial form—i.e., not played electrically but sketched or drawn on paper and functioning as a *musical score*—it was highly effective thanks to its *architectural monumentality* and its contrapuntal dynamics, the latter being clearly manifest in its structural solidity. My poem was passed from hand to hand, circulated in photocopies, and it had a big influence on everyone who understood it. It had the power of artistic propaganda.

So I already had four works of a new type which I could barely call "poems," but planar poems at best, although I was not exactly clear about what a "planar poem" was about; I only had an inkling about the events that had led up to its emergence, i.e., visual poetry and visuality, and how they were related to the new technological developments of the age.

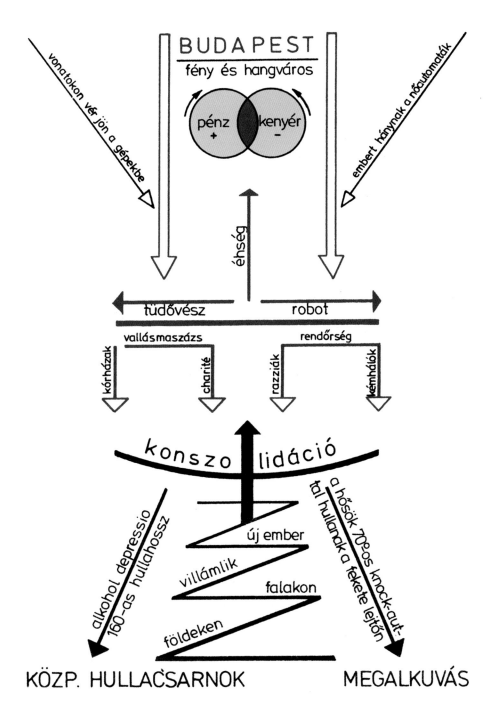

A.4 Charles Sirató, *Budapest*, 1927.
Image courtesy of Artpool Art Research
Center, Budapest.

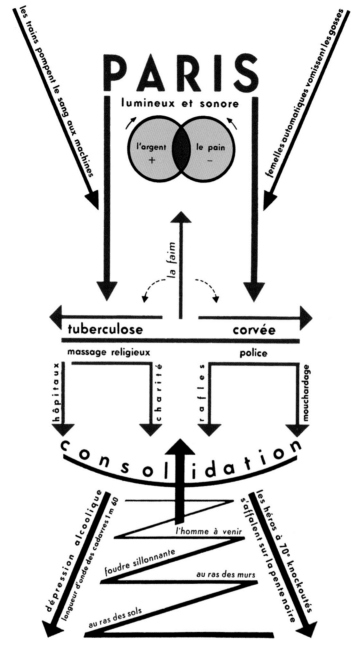

A.5 Charles Sirató, *Paris*, 1936. Image courtesy of Artpool Art Research Center, Budapest.

After the increasing success of *Budapest* and the more thorough examination of my four "works," *I realized that I had accomplished something completely new*. I actually had created a new "ism." A new direction in poetry.

I needed to give a name to this new direction and elaborate its attributes. I thought that the word "visualism" would not distinguish it enough from other directions and it did not express enough either. I did not dare use the term "planar poetry," because of the synonymous meaning of the words for "plane" and "flat" in the Hungarian language.

I wanted to give an extremely eccentric name to this "ism" I had created. In those days I spent a lot of time studying Slavic philology. The word for "speak" in Old Slavic is *glogao*. New poems were also new forms of expression. I invented a new form of speaking. I can no longer recall what my exact reasons were, but I started out from the verb *glogao* = speak and called my new "ism" *Glogoism*. It sounded eccentric enough. Nobody really knew what it meant. Nobody understood Old Slavic in Hungary anymore, and only very few studied Slavic philology. After I had named the new "ism," I needed to elaborate it and its theory needed to be presented. It took me a few days to write the

Glogoist Manifesto

which had 7 points and went like this:

Glogoism

(P l a n a r p o e t r y) (E l e c t r i c p o e t r y)

1. We decompose and compose. In Hungary Kassák was the first to break lines out of the horizontal. This opening-up led to the culmination of

a n e w w a y o f a r t i s t i c r e p r e s e n t a t i o n.

2. Glogoism breaks away from "book vision" and replaces it with "pictorial vision." In Glogoism paper is not seen as a depressingly monodirectional mass of shapeless lines, but rather as a realm where sentences and words can be arranged in a constructively meaningful way.

3. Thus far poems had existed in an absolutely paper-blank space; they had no chance to exist optically. But poems live in letters: i.e., in the two-dimensional plane. Thus, Glogoism primarily emphasizes the

t w o - d i m e n s i o n a l i t y o f p o e m s.

Glogoist poems are not written down but

a r e b u i l t.

4. Glogoism organizes the abstract time-art of literature in real two-dimensional art (t h r e e - d i m e n s i o n a l p o e t r y). Following the laws of physics, the construction of Glogoist visual poems is executed by way of geometrical (figural) projection. It attaches the optical aesthetics of poetry to its acoustic aesthetics.

5. Hence, Glogoism is a more accomplished form of expression of what happens in a poem at an optical and phonetic level. Its constructional element-type is: the l i n e – s e n t e n c e. Lines in Glogoist poems are not decorations but organic components: r a i l s o f m e a n i n g, the f i r e w a l l o f w o r d s.

6. The form taken by Glogoist poetry addressing the masses is called

e l e c t r i c p o e t r y.

In the same way that music was given a new form of communication with the invention of the radio, billboards are the new form of communication for poetry. However, while the so-called radio art will only slowly develop, Glogoism already exists in the form of billboard art, since

p l a n a r p o e t r y a n d e l e c t r i c p o e t r y

are built on the same theoretical foundation.

Billboards that project phonetic masses in time provide a 200 percent space for presenting planar poetry: the two-dimensional lines they bear transform into spatial elements in the realm of time.

7. Manifest in Glogoism is the special art of the future

The poetry of technology – that of billboards, electric posters

Glogoism is the new mass art

In the Glogoist Manifesto I undoubtedly defined and explained the essence of planar poems – as confirmed by "the brain trust" of my immediate circle of friends; it was clear that *I had successfully laid the theoretical foundation for my experiments and new type of compositions*. In my view of global literary and fine art trends, I regarded even these first four branches of planar poetry as a *literary manifestation of Constructivism*, the important trend that emerged at the same time in Eastern Europe and mainly in Russia and Poland. Now that I reread my Glogoist Manifesto I have no doubt in my mind about the truth of that statement ("[Glogoist poems] are built"!). However, back in those days my vision was limited by the smaller-minded reality of the Ferencváros district of Budapest and did not allow me to have an adequate knowledge of global trends; that is the reason I only made a reference to Kassák, who was the most active Constructivist in Hungary.

But now I showed my Glogoist poems and read the manifesto in a wider literary circle, stirring heated debates and at times kicking up a storm.

Of course these planar poems only formed a part of my literary activity, since at no other time did I churn out more *poems within the line* – or poems "*enslaved by the line*" to use a *terminus technicus* – than in those days. My poems were published in the literary periodicals of the time (*Magyar Írás*, *Nyugat* [West]), and in the dailies, too. Because of my age, I belonged to the third generation of artists after Endre Ady in Hungarian literature; the members of the first were Kassák and his contemporaries, those of the second included József Erdélyi, Gyula Illyés, Lőrinc Szabó, etc., and the artists of the third generation were born around 1905: Attila József, Ferenc Pintér, Odön Palasovszky, and many others.

If we say that Endre Ady and his poetic revolution brought [Charles] Baudelaire's Impressionism and Symbolism to Hungary – albeit with a 50-year delay – it is appropriate to say that thanks to Kassák, current-day literature and art erupted onto the Hungarian intellectual scene: the struggle of "isms." In the milieu of the early 1920s dominated by an aristocratic–small bourgeois mentality, the second generation, led by József Erdélyi, diverged from the European path of development and assumed a kind of *narodnik*-type "peasant-folk" direction. However, we, i.e., some of the writers of the third generation, did not turn back, but instead are trying to develop the European trends in our own way.

This group of writers was led by the editor of *Hungarian Writing*, Tivadar Raith – instead of Kassák, who was living in Vienna. While Kassák was a noncompromising, independent writer with a fighter's mentality, Raith was a government official, a teacher living on a salary, and literature was merely a side hobby for him. For fear of losing his job he was rather careful, too, when he was "fighting" for the newly emerging literature.

When compiling the material for my new volume of poetry, I added the Glogoist Manifesto and my four planar poems after my Expressionist, Dadaist, and Surrealist poems as an appendix, and I took everything to Tivadar Raith. While looking through the works, Raith – who already knew one or two of my planar poems – stared at me in shock when he got to the Glogoist works (even though he had previously published several of the poems included there in his periodical).

"You can't be serious about these!" he said as he pulled the six sheets out of the pile.

"Why not?"

"These can't be published. They will think we are mad!"

"You are mad!" I answered. "Why would anyone think we are mad now? After Dada?! When Europe is flooded with the craziest artistic ideas!"

"That's Europe," he responded calmly. "But this here is Hungary."

"So what? *We'll take over Europe*!"

"That's out of the question. I will only publish the volume without Glogoism. I cannot afford to have people laugh at my publications."

And how right he was! Everything has a limit. I was devastated. All this coming from the "leader of the European trend," the editor of an avant-garde periodical. I was flabbergasted.

"I am more than happy to publish it without Glogoism. It will make a fine volume."

I had no choice but to agree to have Glogoism scrapped. And as I was walking home, I spotted an apparently new book in the shop window of a book dealer, perhaps published on that day: Ödön Palasovszky: *PUNALUA*. [The author and the title appeared in] a large yellow circle, [and the first letter of the title] was presented in lower case with a long stem, laid out in a modern Bauhaus-like style. The whole front cover was impressive, giving me a feeling of hope. I had to buy it then and there. And I read it in one sitting.[13] The whole thing had ingenious original typography; it had a Chorus, Sounds, Cries … Just like a huge Dadaist symphony … I still remember the profound impression that book had on me. I was ecstatic. I was beside myself with frantic joy. Finally, something good and new!

I rushed back to Raith the next day. I slammed *Punalua* on the table and said:

"Am I mad? That's what you told me! So what is this here?"

Tivadar Raith was not familiar with the newly published volume, but no sooner had he glanced at it than he said with a wave of his hand:

"But this is Ödönke (Little Ödön)! The Arch Madman!!! Is this who you compare yourself to? He will be carted off to the asylum soon!

"I don't want to be like him," I replied, "but if this book was published … *Punalua*? What is *Punalua*? Heave-ho – *Punalua* … well, then why couldn't my planar poems be published? *Especially since planar poems are clear and understandable!*

This time Raith was flabbergasted.

"I absolutely insist that my planar poems be included in the volume," I said in a resolute tone. And you can remain Hungary, but I will be Europe!

I took the volume, put it in my briefcase, and left Tivadar Raith's office.

I recomposed the collection of poems, supplemented it, and drew the Glogoist poems again; I carefully typed the poems in three copies and even gave a new title to the volume: *Paper Man*, after the new opening poem. I sent the first copy to *Békéscsaba*, to Andor Tevan, who had already published a few modern books of poetry around that time, including one by Tibor Déry. I received his reply ten days later: interesting, original, novel poems that will undoubtedly sell, so Tevan Publisher can publish them for a modest assurance fee. Complaints – none.

I received a telegram from the printer, who was already doing the typesetting: "The typesetting process got stuck when we got to Glogoism. Please come and see us immediately!" As it turned out, the printing of the planar poems proved to be far more challenging than they had anticipated. The printer finally recommended that I draw the pieces more precisely and that I have plates produced for their printing, the latter of which I was only able to have done in Budapest, together with the cover design. During my visit to the printer in Békéscsaba there was a rather awkward scene, which nevertheless speaks volumes about how things were in Hungary at the time. The staff, both in the editor's office and the printer's, received me with great respect as a revolutionary poet, but the director, Andor Tevan, admitted that while they felt utter admiration for me, they actually did not understand even one word of Glogoism. He asked me to explain it to him at least … tête-a-tête … in person. …

Then I read out the manifesto to him, slowly and expressively, and immediately after that I also read out the four planar poems, articulating them rhythmically and showing him how the lines were constructed. Then he understood. But then that was the problem. Once he had fully understood my electric poem titled *Budapest*, the "figure" and text, which he had previously looked at with amazement, [now disturbed him]; he said:

"But Mister Sirató, this is blatantly agitation against society! True, it is done artistically and innovatively, but it surely is agitation! Even more than that: communist propaganda."

"Please do not look at it like that. Not from this perspective. Think about it in this way: all this is fact and reality! The current social structure of Budapest is exactly as it is in my poem."

"It might be so, but I am the director and owner of a printing house. I cannot afford to publish poems like this. I would be locked up for it."

It was impossible to calm him down. He was afraid and with good reason, I must admit. In the Hungary of that time, in 1928, there were legal consequences for anything that raised even the slightest suspicion. Since most of the book was already typeset, he did not completely refuse to publish it, but he took no responsibility as a publisher and especially did not want to take any financial risks with the project. That is why, in the printed work, Tevan Printing House was named as the responsible entity instead of Tevan Publisher.

The four planar poems and the Glogoist manifesto were printed in spring 1928 as an appendix to *Paper Man* – and caused a rather big scandal. The "domestic" press of the Horthy regime launched a harsh attack against it. And not only did the left-wing press show no willingness to offer even the least support, it did not even sympathize with it.

The most notorious conservative periodical, *Budapesti Hírlap* [Budapest Gazette] – in which the decrying and stigmatization of modern literary trends was virtually a "tradition" – wrote the following in its lead article – in the same "prestigious" section in which Endre Ady was regularly attacked – in its issue dated June 20, 1928:

"A New Hungarian 'Book of Poetry'"

To the kind attention of the prosecutor's office!

In his work titled *Genius and Madness* Lombroso, the famous professor of psychiatry, published a whole selection of poems written by psychiatric patients in his care – the article began – ... the paper man is not a genius ... yet he is allowed to write poems as he pleases, without being put in a straitjacket. ...

The article, which was several columns long, ended like this: "Today, when we have laws specifically applicable to sacrilege, blasphemy, and immorality, I regard it as

a wonderful thing that this book is circulated for free. ... Let me cordially place my copy at the disposal of the prosecutor's office."

Although a social democratic paper, *Transl* [People's voice] admitted that the volume had adopted a proletarian worldview, it also expressed its complete lack of understanding regarding the new attributes of the volume.

I received the most supportive critique in *Nyugat* (in the issue dated June 16, 1928): "... original talent ..., unharnessed, fresh personality," but regrettably, the critic [Gyula Illyés] disapproved of the part which I personally found the most important. "We are certain that one of these days Charles Sirató might arrive at this realm (that of pure, mature/composed poetry), since he is in possession of the only *laisser-passer* required for entry to such a place: talent. But – let me give you some advice as a friend – leave your vagabond's cloak at the entrance." The author probably used the term "vagabond's cloak" to refer to Glogoism, although later [Illyés] arrived at a different opinion: *after his study tour in Europe* he published long accounts of the global victory of the avant-garde, [and] Gyula Illyés considered himself an avant-garde artist.

The fiercest attack on me was launched by a tabloid newspaper, titled *8 Órai Újság* [8 O'Clock News]: "Where is the prosecutor? Why does he not confiscate this? Now! Immediately! Instantly!" "Rotten vegetable! Stomach-turning!" they wrote in their spiteful commentary.

I was shocked to see such an absolutely malevolent reception. I could not understand how there could be such a huge gap between my worldview and that of the leading intellectuals of Hungarian culture.

The repeated reference to the prosecutor's office was especially surprising to me. The main reason the case did not actually end up in court was probably the fact that I was legally a resident in Budapest, but *Paper Man* was published in Békéscsaba, whose official prosecutor's office was in the town of Gyula. And in those days prosecutors in the countryside did not tend to read papers much. In any case, *Paper Man* was hugely successful in more congenial literary circles.

[Poets and writers] who had grown accustomed to and had begun "to believe in me" and my poems – as well as a few leading critics – reassured me: I was on the right path. Despite my holding Gyula Illyés in the greatest esteem (and he, actually, was the one critic who offered some praise to my book), I had no intention of returning to "pure literature," i.e., to aspire to be "locally recognized" in Hungary. On the contrary! I was fuelled by the *desire for something entirely new* to the extent that I firmly believed that planar poetry marked out the direction for future development; so I wrote newer and newer and more and more important planar poems.

In this period, which I would describe as the "golden age of my planar poetry," I broke away with increasing certainty from the kind of poetry that was confined by line-time. It was becoming clear to me that planar poetry had absorbed linear poetry in its entirety and dialectically: it had forced even its influences into the background. Nevertheless, I was eagerly following the developments in the periodicals, especially *Nyugat* [West] and *Napkelet* [Orient], and every time I felt reassured because my conclusion was always the same: "There are no geniuses! No geniuses! There is nothing new in literature!"

The emergence of a new Ady or Baudelaire would have thrown my aspirations of planar poetry into a completely different context. (I felt that would never happen, but since, by definition, anything is possible in art and literature, I needed to constantly keep an eye on the entire realm of world literature.)

I was turning more and more eagerly to the recent periods of French poetry and the artistic revolutions that broke out in 1905 and after. Other poets, in the course of their artistic development, had at times felt that they had reached the end of their poetry, that they had exhausted their potential. In contrast, the better I became at planar poetry, the more reassured I felt that I was not reaching the end of my own poetry, but rather the end of "poetry" per se! "Poetry that exists in line-time." There were especially three planar works that made me feel that it was not possible to go any further, as in effect everything had been said: one of these was my planar novel titled *The Story of a Night*, which I wrote in 1929, when Hugó Scheiber persuaded a friend of ours, Gyula Hincz, to travel to Berlin to see Hervart Walden, who was the editor of the Expressionist art journal *Sturm*. This planar novel completely decomposed and frayed the previous form of literary rendering. The second work was titled *An Epic Poem About Man*, and was a concise work that I could describe as a "map of humanity" and which left absolutely no chance for any further possible forms of expression. The third opus was *Bernard's Life in the Novel-Brick*, which was no longer a planar composition but rather a literary *block of possibilities* consisting of several overlaid planes. After completing these three works I felt that I had nothing else left to do in "literature." Literature – "was finished"! The Dadaists were right: "literature was *fuit*"! Now, in 1965, this idea does not sound shocking anymore, since we have already seen several manifestations of how literature disintegrated and was finished and how these newer and newer forms and diverse genres – for example the anti-novel, the meta-novel, the card-novel, the liquid opera, the sonette mosaic – brought fame to a great many writers who were taking delight in the process of literature's death.

We eventually resigned ourselves to it, and there was nothing we could do. But back in 1929, when I arrived at this idea through planar poetry during a most natural process, and I myself was artistically taking pleasure in it, this discovery was the greatest surprise for me. I could barely believe it myself. And I began to study the avant-garde trends starting from 1905 in the most meticulous way in order to find out if I had come to the right conclusion. I lived in Debrecen at the time, and together with István Nemes, a friend of mine who had studied French and Hungarian at the university and who had recently returned home from Paris, I analyzed the new French poetry starting from [Stéphane] Mallarmé in the greatest depth. It was during my discussions with Nemes that I realized with utmost certainty that *European literature had nothing to express in poetry after Dadaism and Surrealism.* That was my basic contention based on my own poetry, and now I applied it to the whole of European literature. *The logical nothing that forms the content of Surrealist poems* – and here I mainly had Benjamin Péret in mind, whom I regarded in 1929 as the greatest European poet – *is exactly what European culture had to say in this age.* In other words, in Surrealism, poetry only

existed in its form: in the line and in time. And *planar poetry* had "set it free" from even these constraints by shifting expression into two-dimensional space. By doing that it had *"buried" literature*, i.e., had put an end to old literature – which was *the negative side* of what had happened – but *it had also developed the opportunity for a completely new form of expression*, i.e., had taken literature out of the rut it was in – *which was the positive side.*

It was then that I "wrote" my poem cycle titled *Modern Masterpieces*, in which I – dare I say even now – found a productive solution, which in the given situation could be seen as slightly humorous: I bound together four blank sheets of paper, and in the Preface written on the four blank sheets I expounded that then, in 1929, when the "poetic message" of European culture – as defined by Spengler – had been reduced to nothing, it would be a great waste to express this "nothing" in words, to force it into letters and lines, and it would be much simpler to bring it before the readers in its pure form, as white paper. The four white sheets were the modern and genuine master-pieces of those days. And I was the only real, great European poet! Through this pro-cess I also invented a transitional form of expression, which I believed had a profound power of proof: it was "*Alternativism*," or "*the art of fraction-words.*"

This literary trend I invented was the following: I expressed the key words of a given poem by producing several variations, fine-tuning it – as if the poem had not yet been completed – and I added a note saying "unwanted parts to be deleted," calling on the readers to shape the poem as perfectly as he or she could according to his or her own mental and intellectual world by crossing out parts and even signing the poem as my co-author; *in every variation the poem still remained completely self-identical.*

Not long ago, in 1964 I think, a young French writer ([J. M. G.] Le Clézio) received a literary prize for a novel in which he used a method similar to my Alternativism and he became world famous![14] The difference between my and his method was simply that he left some blank sections in his work, where the reader was able to add words of his or her choosing. This could not have been done in Alternativism, because then the work *could not have remained self-identical in every variation.* However, in my *Modern Masterpieces* I found an absolute solution that surpassed this. Readers were encour-aged to write on the blank sheets! Whoever wanted to. And whatever they wanted.

This approach was seen as so bizarre in the suffocating conservativism of Hun-gary at the time, and the then prevailing destructive attitude became such a part of me, too, that I myself did not see much chance that these two new trends would take off (especially being the author of planar poems!), and apart from sharing them with my friends, I did not consider publishing either *Modern Masterpieces* or my works created using Alternativism.

At the same time, I took them very seriously as far as myself and my own poetry were concerned: *I stopped writing linear poetry in 1930! And I did not return to it for thirty years, until 1960!*

I clearly felt that poetry was finished and my complete breaking away from litera-ture was not a spontaneous, bizarre idea on my part but *a necessary consequence of a*

A.6 Charles Sirató, *One Night's Story*
[Egy éjszaka története], 1929. Image courtesy
of Artpool Art Research Center, Budapest.

A.7 Charles Sirató, *Epic Poem about Man* [Eposz az emberről], 1929. Photograph Kieselbach Archives.

profound and integral process of development. I moved more and more in the direction of planar poetry, and I felt more and more comprehensively that it was the modern manifestation of the reality of art. I was curious *what place art could have at all in the history of human thought, and what role art could have if there ever would be a new art.* I also wanted to penetrate more into the essence of all art forms.

Looking back, in retrospect, at the period that signified a turning point in my development, I might seem to be oversimplifying things, but this is actually how it happened: my poetry was mainly composed of *visual and conceptual elements.* After the publication of *Paper Man,* when I "stopped doing poetry" and I turned to conducting a more in-depth analysis of planar poetry, these two kinds of elements became separate in my thinking: the visual elements grew into a hugely powerful photo-ambition in me – I wanted to be a photographic artist and I tried to use photography to visualize the most bizarre ideas – while I satisfied my conceptual needs by conducting an overall intellectual/spiritual reexamination. I primarily studied the history of philosophy from antiquity to the present day, which was followed by analysis of aesthetics, art history, and all the related disciplines, and then came biology, etc. I read everything and more, whatever I managed to get hold of, and there was no one in the Déri Museum library in Debrecen more studious and impassioned than me. *I mainly wanted to understand the place, role, and essence of planar poetry, and to find its coordinates somehow in the history of mankind's development and that of our age.*

It was clear to me that I had shifted "temporal" art or literature into a "spatial" form of expression. So in reading philosophy I was mainly interested in the *questions of space and time.* After [Immanuel] Kant's a priori concepts I soon got to [Henri] Bergson's creative anthropomorphic theory of development, and then to the non-Euclidean geometries, Minkowski and Einstein, *the complete elimination of the concept of absolute time,* this immense change that completely transformed our way of thinking. It was after I had read Bergson's *Durée et Simultanéité* [Duration and simultaneity] – in which he analyzes and explains Minkowski's transformation – that I understood what planar art was in a contemporary sense, and what actually happened to literature in my two-dimensional poems. Digesting, intellectually processing, and structuring this concept was not easy for me and no doubt took me a long time. Thoughts that emerged during these readings had to take root in me, they had to mature. In any case, by that time the process of the complete dissolution of one-dimensional, temporal literature, which I called literature "within the line," had become clear and perfectly understandable. To put it differently: as our way of thinking shifted from the Euclidean to the non-Euclidean worldview, literature gradually lost its *privilege of being the exclusive expression,* and having fulfilled the judgment passed on it by the Dadaists in regard to its form, it ceased to exist – in its old meaning! *With the downfall of the concept of absolute time the concept of literature based upon it also expired!* And this statement was confirmed by the literary developments of the time as far back as in 1929!!

It seemed clear to me by then that "literature per se" had reached its end. I turned my attention, therefore, to literature and its historical role.

It was at this time that I got to [Oswald] Spengler in my philosophical studies. I ordered both volumes of *Untergang des Abendlandes* [The Decline of the West] and studied them for months. I could not care less about Spengler's pessimism, but the morphology of his philosophy of history and the new approach it represented, its new concepts and the way in which it modified our old notions – all of which I accepted – helped me tremendously in shaping my thinking. For example, I found his idea of cultures as units of the highest-level abstraction completely acceptable; by then it was something history offered us on a plate anyway. In connection with this, the blindly human-centered concept of the "eternally human" and of the "eternal" also had to be eliminated. Hence, we should not talk about painting, sculpture, and literature "per se," but only about "Greek literature," "Chinese literature," or "European literature." And the same applies to all the other branches of art, too.

I concluded from the above, with a sense of assurance, that it was not in fact "literature per se" that had been eliminated in Europe between 1919 and 1929 through Dadaism to Planism, but only "European literature." Thus, no "eternal human value" was lost for good because such a value had never even existed and would probably never exist in the future. It was European literature that had reached the phase of natural decline (which is inherent in every life form) only to be replaced by new manifestations of culture and new art formations, because after all, all art is the imperative essence of culture! I even took Spengler's concept a step further when I began to analyze the nature and concept of "art" in areas outside cultures discussed by Spengler, such as "primitive" societies.

I realized that humanity in general, and even Spengler himself, "instinctively" included phenomena in the concept of "art" that had absolutely no relation to today's "art concept" and only provided ample ground for confusion and additional misunderstanding.

I had no other option but to set up my own classification and draw clear lines to create an unambiguous situation.

In regard to their *objective, essence, and function*, three completely different arts must be distinguished – I wrote in the draft of my book titled *The Relativity of the Arts*.

Alpha art: *directly aimed at gaining power*. Included here are all the *magical, power-mediating manifestations* of animism such as cave drawings, cultic depictions, jantras, mantras, etc., reflecting the mentality of "primitive" societies.

The function of "Alpha art" is not to delight people, which is rather the function of today's art, so the starting point for "assessing" a cave drawing is not its aesthetic quality but whether the hunter in question managed to kill the depicted reindeer or not. If he did, the drawing was good. If not, it was bad. For this reason, these manifestations should mainly and primarily be preserved by military history museums and could be included in fine art museums in regard to their "grave-robbing" function at best. (And yet, what do we see? In several prominent works the history of "painting" begins with cave drawings, which I must protest against most vehemently!)

Beta art: the art of gaining power indirectly. Included here are the *religious manifestations* at the stage of Spenglerian cultures, which, similarly to alpha art, are not aimed at bringing delight but at influencing the "divine powers" to attain certain goals. Prayer-themes, embodiments of religious powers, gifts of gratitude, and anathemata: These are significantly closer to what we mean by art today but are still not identical with it.

Gamma art: works with an aesthetic aim. It emerged after beta art had run cold and was further developed into gamma art at the civilization stage of Spenglerian cultures (i.e., in the declining phase of culture). *All of today's aesthetics developed around the end of the 18th century* (even though the word had already been used in Greek philosophy). Despite this, *we project our basic concepts of art and the value of artworks into the past and the future* – as *psycho-hallucinations*, I would say, since they do not run into any obstacles either in the positive or negative direction (this resulting from a deficiency in our thinking that is based on the anthropomorphic Euclidean concept of thread-time) – and we talk about "eternal art"; and whenever we make a declaration about art we "feel" the two endpoints as being part of plus and minus infinity! Hence, this "eternal-hallucination" and its foundations diametrically opposed to reality *serve as the most fertile ground for false consciousness.*

I definitely felt that there was a huge task ahead of me, or more accurately, ahead of someone, to create a kind of art that is in line with today's reality but also to clarify the basic concepts of "art"! Returning to my starting point, what we have here is not the disintegration of "European literature" but simply its "aesthetic part," whose exclusive aim is to entertain and delight, i.e., the disintegration of gamma literature!

Therefore, this disintegration of literature does not affect:

1. "Eternal" literature, as it simply does not exist but is only an illusory concept: a psycho-hallucination;

2. Religious literature, psalms, devotional songs, satire, etc., in other words, beta literature, which also includes propaganda literature, advertisements, commercials, etc.;

3. Alpha literature, i.e., mantras, magic spells, magic songs, etc.;

4. The gamma literature of other peoples, namely the folk and national genres of Chinese, Japanese, Arabic, Persian, and Negro literature;

5. And in general, all the literature that has any other primary function in addition to "bringing aesthetic delight," for example, an educational function, thus, it does not affect socialist realist literature either! (Nor children's literature!)

Greatly satisfied with the results I arrived at, I recorded them among the series of notes I was making for my planned works; I also regularly added elaborated sections to these notebooks.

I did not feel guilty of being a destructive barbarian at all! The specifically "constructive" character of my planar poems would have served as a most definite argument to the contrary. And it was not my fault that burials form part of life and production as much as births do.

The work I was working on included both elements, therefore, my notes were divided into two parts:

I. The end of the old.

II. The beginning of the new.

A clear testament to and proof of my definite anticipation of the emergence of a new culture and a new society was my planar poem titled *Self-portrait 1930*.

While pursuing my studies of history, philosophy, and aesthetics, I never took my eyes off the ongoing Hungarian and French literary developments, and I was able to receive the latest books published on the French book market thanks to the help of my friend István Nemes. I was reading Marcel Raymond's *De Baudelaire au Surréalisme* [From Baudelaire to Surrealism] about the development of the most modern literature with the greatest excitement. In his book, Raymond divides French poetry into chapters,

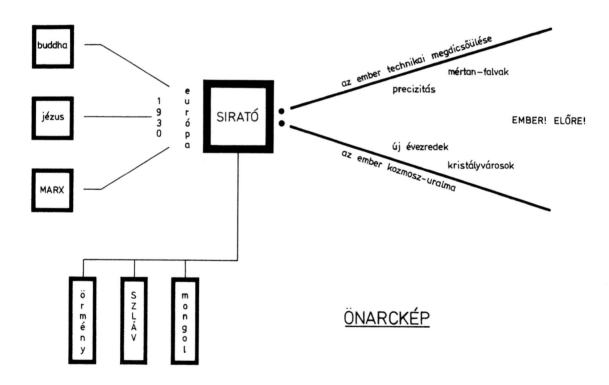

A.8 Charles Sirató, *Self-portrait* [Autoportrait], 1930. Image courtesy of Artpool Art Research Center, Budapest.

and says the following about the Apollinaire – Beauduin trend [i.e., Nicolas Beauduin], which he treats as an autonomous, indivisible intellectual/spiritual realm: "This chapter cannot yet be ended. The potential for further developments can be felt here. Something is yet to come."

I had already decided a long time before that I was not going to stay in Hungary, and I was hoping to find the path of my further development in Paris, which had been so popular with Hungarian poets since Ady; in any case, this decision was also explained by the Hungarian reception of my planar poems, and as I had already completed my preparatory studies to a large degree and I was able to assess more or less the integral relationship my planar poems had with the changing times, I traveled to Paris in summer 1930 with the aim of settling there for good.

I wrote this in one of my farewell poems, perhaps with slightly excessive immodesty:

They left a place open for me in World Literature
you can find it István Nemes
on pages 288–289 of
Marcel Raymond: De Baudelaire au Surréalisme.

Thinking back to it, I had little reason for such overconfidence and immodesty, since I set out on the path of my new life with only 500 pengős in my pocket, which at the time was enough to get by on for even two and a half weeks.

II. How the Theory of Dimensionism Developed from Planism in Paris

I arrived in Paris in late August in 1930.

The place I arrived at was not unfamiliar, as I had many friends who had been living here for some years, and I was pretty familiar with the French artistic developments from the periodicals I read regularly.

I will write down in detail how I managed to sustain myself in Paris for six years another time perhaps. Suffice it to say here that I did everything that provided a source of income for "étudians" in those days. Then I soon found a job in my own profession, as a photographer, but making a living, combined with my art studies and the organizational work I had to do later, undoubtedly strained me greatly. I had not been used to such immense physical exertion, even though my passion and willpower allowed me to stretch my physical capacity to the limits.

During the early period of my years in Paris I received the most help from Sándor Groszmann, a Hungarian sculptor, and his wife, Márta. I knew Groszmann from the time when I was a member of a company of artists meeting in Liliom Street. He loved my poems, so much so that he had them translated into French, and he strongly recommended that I introduce myself into the Parisian scene with these linear poems. However, he was not at all impressed with my planar poems, and I did not find that unusual as he was "only a sculptor" in every sense of the term.

Café du Dôme, on the corner of Boulevard Montparnasse and Boulevard Raspail, was the "center of the art world," as some described it very aptly. Artists living in Paris fell into three main categories: those who were already successful – they were sitting around on the right-hand side terrace of Café du Dôme, which was more expensive; those who were aiming at becoming successful and had already achieved some kind of material success – they were sitting on the corner terrace reaching to Boulevard Raspail, where the cheapest order, a "café crème" was 2 francs; and those who did not even have as much as 2 francs – they were walking up and down on the pavement in front of the two terraces, eagerly observing who was sitting on one or the other and keenly watching the new people who appeared among the pedestrians.

From the third day of my arrival I worked in Paris virtually without a break, so I roughly managed to cover my costs, and I escaped the fate of the "walkers" and immediately landed in the 2-franc category, joining Groszmann and his company, the regular members of which included the sculptor József Csáky, the painter [Lajos] Tihanyi, and many other famous Hungarian artists. After a rather long period of time I spent trying to become familiar with Paris and the artists of Café du Dôme and to improve my command of the French language, I slowly made myself at home in France, a country I loved from the first moment.

Even considering this milieu, Groszmann's circle was extremely conservative for me; Groszmann and Csáky were both adherents of "solid sculpture" and its traditional forms, and I was feeling increasingly uncomfortable in their midst, but did my best to resign myself to their uninspiring mentality. I was walking down Boulevard Raspail one morning and I noticed the following figure in a shop window: on a small horizontal board there was a long decaying vertical board with a rusty iron ring at its top end, and it had a long thin white feather pinned into it like a collar. I kept looking at this figure and I could not make anything of it, either with my unsuspecting Central European eye or my daring mind.

And then I caught sight of an inscription on the bottom board:

Joan Miró: Sculpture

Then the meaning of the inscription shot through me like lightning: this is a sculpture! Or more accurately, a mock sculpture. The present symbol of sculpture in the old sense and also setting out on a new path. Yes: this is what sculpture is today – a decaying board, a discarded rusty iron ring, and a weathered feather! I myself had had that feeling for so long but it felt so strange that I did not dare say it out loud. But not only did Joan Miró state it, he even expressed his opinion, and how brilliantly! He created a new kind of artwork in which he used completely new, ordinary, and everyday materials instead of stone, marble, and other classic raw materials!

What I saw had a profound effect on me and I felt like dancing, jumping for joy right then and there on the wide pavement of Boulevard Raspail. But I had to control myself as there were pedestrians around; I stepped under a doorway and leaned against the

wall, almost dizzy with it all, and after five months of being in France it suddenly dawned on me why I had come to Paris ... *For this!* To find the continuation! After poetry had become futile, after painting had reached a crisis and sculpture decaying ... – to find the new, modern forms, if they exist at all!

I visited my unproductive Hungarian friends – who I felt were "stuck in a rut" and were fading away, and I zealously spent all my spare time – now, here in Paris – studying original documents about the artistic revolutions from 1905, and the present state of the arts in general.

The phrase "all my spare time" is to be understood rather elastically, since there were months when I was caught up in working on another subject or working out new ways of securing a living for myself, so I was unable to deal with my areas of research. Nevertheless, they were alive in my mind and I strove to focus my mind around them, which was the direction my natural course of development was taking anyway.

For example, I will never forget how I reached the end of my ambitions of "photographic art."

I regularly went to see exhibitions, mostly modern shows of course. Once I was at a Man Ray exhibition and as I was looking at the photographs of this American artist, and taken by them completely, I gradually recognized my own ideas in them, and when I saw his *Double Venus*, I stopped in front of it standing riveted to the earth and I cried out: "I did this!" or to be more precise: "I would've done it exactly the same way." It was like an epiphany: all the ideas I had in me as potentials have been realized by the greatest photographer of all time, Man Ray, and with a brilliant technique too! I succumbed to logic and had to be consistent: it made no sense for me to try to succeed in so many areas of art, especially the ones in which I did not look very hopeful. So I finally put an end to my ambitions of being a photographic artist and from then on I only did photography to earn money – I took portraits and produced images used in news reports.

In those days Paris was overtaken by the Surrealists: one came across their works everywhere, from shop windows to exhibitions, private homes, and periodicals. Although I liked them and some of their ideas surprised and excited me (e.g., Surrealist objects, collages, and sculptures of the most bizarre combinations, etc.), yet I instinctively felt that they represented the course of future development only in part.

In regard to their prestige and the frequency of their appearance, the Surrealists were followed by the Abstract painters and sculptors. They came on the scene in ever-growing numbers and they often had joint exhibitions with the Surrealists, despite the fact that the difference between their worldviews was loud and clear through their works and it made the overall effect of the exhibitions a bit too "exotic."

I was keenly interested in Abstract art. I felt: the course of development ran here, through [these artists].

In those days Constructivist artists only rarely made an appearance in Paris. The term "Constructivism" did not mean much for artists in Paris, and perhaps it was not dynamic enough either, yet I was the most interested in this development. *I was amazed at their works and I was able to identify with them fully and completely.* I kept

marveling at their amazing "matter-joy-orgies"; each work of theirs was a celebration of glass, metal, and plastic, and I was amazed by their works in which space was dissected, constructed anew, and taken possession of.

Seeing these works brought me great joy and excitement, even though at the time I didn't have the slightest clue that the spatial art of the Constructivists and my planar poems had something in common. I was simply amazed but could not yet see their place in the development process of the new art. (And that has generally been the case ever since.)

I encountered a very surprising thing at the exhibitions: the "wilder" and "more daring" a work was, the more I liked it. And to my greatest surprise, although they were not regarded as being the most valuable pieces, a special prize was awarded to these works, called "*Prix d'encouragement*" [Prize of encouragement], recognizing the boldness of the given artist and encouraging him or her to continue to be daring. Then I realized that *it was in France's interest to embark upon the path of artistic progress and development*, and that it was probably even profitable to the country: it was *great business,* so to speak! (I still cannot get my head round why certain other countries cannot see it this way.)

I traveled in many regions of France thanks to the wide range of jobs I undertook, and the primacy of the conception of world-changing European thought could be sensed across the French countryside. I often stopped and looked at the churches in the small villages. And I generally am not a fan of Christian churches! However, the perfection, beauty, and harmony they exuded made me feel that that particular style came into being right here. *It was created right here!* It was all the more obvious to me because I had seen so many churches in other parts of Europe that were mere secondary or tertiary copies made with sweat. You could see that those buildings were not inspired by a thought or "world-feeling" that had the power to conceive a style. Their builders were simply given a template and the command "make it look like this," and by slavishly following the command they actually built churches that "looked like that"!

It was this *primacy of thought* that could be sensed in many of the exhibition venues in Paris at the time! Undoubtedly the European spirit, a new, modern "world-will," was fermenting. Something was waiting to be created, but at the time none of us knew exactly what that would be. What is more, we had not the slightest idea what this world-will was striving toward. We only felt that it was going toward a realm that no human thought had ever traversed. In those days, although we did not see it at all clearly, we instinctively felt it as obvious and natural.

After three years of living in France, I became a member of the Cercle François Villon, which was a benevolent society founded by well-off French women to support artists. It was in a multistory building that resembled barracks on Boulevard Edgar Quinet, and the ground floor had a huge restaurant where breakfast, lunch, and dinner were served by the founding women and also by some less well-off women who belonged to the same circle of Parisian society but received some compensation for their work. There was a club room on the first floor where coffee was served.

My membership in the Cercle François Villon had two significant benefits. First, good quality food on a par with that served in French restaurants was available here for less than half the price. Second, the Cercle was frequented by a large part of the Parisian art scene, or at least those living in Montparnasse, and while the various groups rigidly kept to their own seats in the Café du Dôme, artists mingled freely in the Cercle. I met the Surrealist poet Camille Bryen here. He became a good friend and helped me a lot – personally and through his extended circle of friends – while I lived in Paris.

Bryen was not part of the Surrealist group in the strictest sense of the word, but I think his poems can be counted among the modern peaks of Surrealist poetry.

We would meet twice every day: at the Cercle during lunchtime and in the Dôme in the evenings.

By this time I had already moved to the Montparnasse and lived on rue Vavin, across from the Café du Dôme. One evening I invited Bryen to my place and showed him my planist works, of which I had ten altogether. I translated the words and the sentences for him, and tracing the direction of the lines with my finger, I recited the text while articulating everything precisely.

Bryen immediately understood them. He himself worked in a similar spirit. He instantly gave his evaluation of the pieces:

– Great poems. *This is more than Apollinaire, more than Picabia! A brand new achievement! Congratulations, mon vieux Sirató!* And at that he rubbed his thin, bony hands together and gave out little laughs of delight and satisfaction combined with the diabolic intonation that was so characteristic of him.

– These must be immediately translated into French! Immediately!

– All right. Let's do it now.

I sat down and together with him and a journalist friend of his from Nantes called Julien Moreau we translated the ten works then and there.

In the meantime, I studied the relevant sections of my documents and notes and came to the conclusion that it made no sense to refer to planar poetry as Glogoism after an Old Slavic verb that was known in Paris even less than in Budapest. It felt more appropriate *to call planar poetry Planism*, borrowing the French word *plan* for the English *plane*, and *electric poetry should be called Electroplanism*. Moreau and Bryen agreed. We were soon ready with the translation of all ten works and I drew the graphic sections.

My planist poems had a very different effect in French. Similar works by Apollinaire and Picabia provided a kind of basis, an associative ground, and somehow my poems *created the impression that they were an organic continuation of European culture*; in Hungarian they were sort of hanging in mid-air and I myself did not know what to make of them.

After translating my Planist poems, I had the courage to show them to my close friends, and they were not received with the slightest humor or mockery, which was a great surprise since I remember well how they triggered unbridled laughter back in 1928 in Budapest at the miserable student quarters in Liliom Street where I composed them.

In my free time during the years in Paris I also carried on developing the theory of Planist poetry and I wrote two essays titled *Planar Grammar* and *The Role of Planism in World Literature*. I also immersed myself in analyzing *the connections between my Planist means of expression and the space-time theory that had emerged in the new revolution in physics and geometry*.

I began to understand this connection more and more clearly, and I eventually realized what I had accomplished with Planism.

From the very beginning of my time in Paris I had the suspicion that taking litera-ture out of the line and into the plane – i.e., into a form of expression that had an added dimension – was definitely a modern move and it corresponded to the revolution in physics, which had taken our thinking out of the three-dimensional Euclidean space into the four-dimensional space-time continuum.

At the same time, the question arose in me about what role the other branches of art could play in this modern process. I primarily had painting and sculpture in mind. By then Paris was characterized by utter chaos as far as literature, painting, and sculpture were concerned. There were works about which no one knew if they were poems, pictures, or sculptures or whether they were sculptures or sculpture-machines, and there were others that did not fall into the categories of poem, picture, sculpture, or machine; they were simply tolerated separately, along with the hybrid works, with spectators wisely resigned to the fact that things like these existed. And that was that. No one was able to say "what" most of these works were, or what role they could have in art. In this whirling mess, *creating a unified system or any systematization and finding a place for these works through a clear process were utterly lacking*. Cradles and cof-fins were scattered around in the wildest disarray and with the greatest mystery.

How did the theory of Dimensionism develop in this field of ruins as a new branch that eventually led to the creation of a new system with clear connections?

With the help of my notes, I can recall each step of the story.

A Dutch painter, Cesar Domela, had an exhibition in 1934 in the Galerie Pierre on rue de Seine. I really liked his material compositions and his glass and plastic construc-tions. Putting my Planist poems, now translated into French, in my briefcase, I visited Domela in his studio and presented Planism to him. I also told him about an idea that had come to me when I saw his exhibition: I believed that the "poems" and the "pic-tures" he built in space using new materials were, in effect, parts of the same process! What did I do? *I added a new dimension to the line*, which had been the means of liter-ary expression: height to length, resulting in the Planist form of expression. And what did he do? *He added a third dimension, depth, to the two-dimensional form of painting*, thus taking it into space. Domela was surprised but then completely accepted my rea-soning, adding that *he himself had developed from painting into construction*.

"Well, then, this is also 'Planism!'" he cried out.

"Perhaps not exactly 'Planism,' but something similar," I said.

"Then let's call it 'universal Planism,'" he suggested.

I could not think of a better name, so we agreed on this term as a temporary measure. We also decided to *gather together all the artists who work in a similar spirit*, draft our program, and promote it.

We did not have to wait long to find artists working in a "similar spirit." First of all, we were able to count on Robert Delaunay, who had created "architectural painting" years before by sculpting reliefs on walls using sandstone-like materials. In fact, it was he who directed my attention to Domela after he became familiar with my Planist poetry, which he received with absolute recognition and named "*mural poetry*" after his mural painting, which I had no objection to whatsoever.

Delaunay and his wife, Sonia Delaunay, who composed the first two-dimensional poetic pieces for Blaise Cendrars's *Trans-Siberian*, both belonged to Apollinaire's old circle of friends that met every Thursday evening in the Closerie des Lilas, a café where Apollinaire was a regular. Now I was invited here too.

The first time I went to the Closerie, Delaunay introduced me to an Armenian painter from Tbilisi, Ervand Kochar:

"Charles Sirató, poète planiste," he said.

Kochar immediately started asking me about Planism, and when I showed him some of my works, he suddenly grabbed my hand, and acting bewildered, kept shaking my hand, and told me in an emotional tone:

"Sirató! You have no idea what you have accomplished here!"

Then it was my turn to be confused, and I asked: "Why is that?"

"You must immediately come to my place!"

So we took a taxi and drove to his studio, which was close by.

He showed me works here that did not compare to anything else I had ever seen before. On the table and on stands there were pictures painted on various metal plates, some of which were vertical and some folded in the many directions of space but all placed on metal plinths; they all resembled bushes and *the previously one-directional plane of painting was cut up here and unfolded into space*. The huge, robust figures and landscapes were filled with tension and their unraveled bodies showed through one another. "Peinture dans l'espace! Painting in space," Kochar said pointing at the picture-bushes with folded planes. Then he slowly turned the "pictures" around as if they were revolving on gramophone records.

"Look how many additional pictures there are here instead of a single two-dimensional picture! And indeed, as he was turning them around, these formations painted on several planes – these "flower-pictures" as I would describe them – created ever different effects.

It was my turn to express my admiration of his work:

"This is huge! I have never seen anything like this."

Kochar told me how he had invented his new method. He took a blank sheet of paper and drew a figure on it. Then he folded it in two, then in four, and then he completely crumpled it up. After this he unfolded it and the planar drawing produced a completely surprising, new formation as it was broken up by the folds.

"See, this is the basis for my new method. Space is at work in the picture too."

"It is truly surprising that no one ever thought of this before!" I told him. "The various planes, the broken-up space, is part of the means of expression."

Kochar pulled out a notebook and read out his manifesto titled *Painting in Space*, which I fully agreed with.

Then he took me into his living room and showed me some sculptures there.

They were portraits, but the round spherical heads and the chest-blocks were pierced throughout with tunnels, viaducts with railway lines running inside them; factories were composed inside a chest and chimneys were rising up from the depth of lungs. I actually had seen similar sculptures, even though those were not "lined" with such concrete objects.

"Hollow sculpture," said Kochar.

"Exactly!" I replied. "Sculpture ouvert[e]."

Although his sculptures were not as absolutely new as his spatial-bush planar-painting, each one had a completely original concept. I identified with each and every sculpture of his with great delight.

He looked through my planar poems once again and the scene that followed was roughly the same as the one that had already taken place in Domela's studio:

"Écoute, mon Vieux!" Kochar exclaimed. "We are doing the same thing! *You have stepped out of the line and into the plane. I have stepped from the plane into space!*"

"Plus you have broken up the enclosed and solid sculptural space!" I quickly added.

At that point I recalled my studies in physics, the new worldview based on non-Euclidean geometries, whose two forerunners were a Hungarian and a Russian researcher: Bólyai and [Nikolai] Lobachevski; one hailing from the Danube Valley and the other from Kazan.

"You have broken the hegemony of the closed Euclidean space. You have cast away solid sculpture!"

"That is right," Kochar said with a glint in his eye.

"You have exposed Euclid's brain!" I said, now assuming a symbolic tone.

"That is right!" Kochar exclaimed. "I did just that!"

"So here's to the non-Euclidean arts!" I said, raising my glass filled with a wonderful drink given to us by Kochar's wife, who was the daughter of an Armenian tropical fruit wholesaler and who was rather tense and worried by her husband's weird experiments, of which no one up to that point had been able to tell her what they were, where they were coming from, and where they were leading, and so she was unable to understand them.

But the non-Euclidean worldview finally provided the explanation.

Domela gave me reference letters to take to his friends. That is how I had the chance to visit Naum Gabo, who was the leading figure of Russian Constructivists in Paris at the time and in whose studio I became convinced, without a shadow of a doubt, that his constructions derived from painting. In Gabo's art it was possible to precisely reconstruct the process by which he added more and more spatiality (not perspective, but an actual "space-like quality") to his technique, to the point that matters relating to painting completely disappeared and were replaced by those relating to space, which led to pure Constructivism with the use of new materials.

Convinced that my theoretical proposition was correct, I asked myself the question: what direction can sculpture take if we take this new approach?

I had actually arrived at an answer to this question already, but I felt it was so surprising and new that I almost could not believe it myself.

Back in 1929, in Debrecen, right after the publication of *Paper Man*, when I felt profoundly that literature and the fine arts had arrived at a dead end after Surrealism, the idea of a completely new artistic mechanism had come to me intuitively, based mainly on what was the least acceptable about the arts up to then. I even envisioned the slow development of the technical apparatus that would lead to the construction of a brand new art: a total art involving all the five senses, which I called *l'art sunquinique* (sic!). I laid down the foundations of this new art in a sketchy essay in which I described its essence, its relation to the old forms of art, and I wrote down the societal and individual dispositions it requires as a precondition. I also provided the sketch of some of my works. In those days I spent the most time with István Nemes, my friend from Debrecen whom I have already mentioned a few times; he was the first person to whom I presented this whole idea. To my great surprise, despite his intelligence, he was unable to imagine this new art based on my explanatory words. I experienced the same thing later when I presented my theory and plan to other people in Hungary and even in France. So I eventually gave up promoting my brand new art project—only temporarily, hoping that a miracle would eventually take place.

Now that I was dealing with the problematics of sculpture, I started to have the feeling that *if sculpture also absorbs the +1 dimension*—such an absorption having been confirmed by Planism in my own literary development, as well as by an entire modern era both in world literature and in painting—*it will emerge from the three-dimensional into the four-dimensional space,* and there it will be: the new art I envisioned but nobody understood. Based on logic, it could only be concluded therefore, with almost absolute certainty, that this art is bound to happen! In other words, *both in regard to its theoretical framework and genetically, I was the recipient of the art that the entire course of artistic development had been leading toward at an unstoppable pace; the art that I had already developed practically in full, placed into the context of social development, and which I had actually held in my hands since 1930 in the form of sketches I had made for a book, yet it was understood by no one!*

Before spelling out the above even to myself, and before definitively writing down the "+1" dimension, which I hoped would be a law, I needed to examine the most recent

phase of sculptural development to be convinced that it did not conflict with my theory. So from then on I devoted all my energy to studying modern sculpture. I eventually reached the surprising conclusion that "modern sculpture" actually no longer existed in the old, classical meaning of the term, or if by any chance it did, it could no longer be regarded as anything else but "sculpture on the wane." Directly after Cubism, sculpture began to operate with concepts of space and volume using planar surfaces. After that planar surfaces were increasingly opened up and cut into "for no apparent reason," which resulted in inner spaces, while *in the depiction of human figures open masses* ([Henri] Laurens, [Ossip] Zadkine, [Alexander] Archipenko, [Henry] Moore) replaced the old round and closed forms (solid sculpture); in addition, new experiments emerged one after the other, breaking away more and more from the forms and problems of old sculpture. For example, at the exhibition of the Salon des Surindépendants in 1934, [Constantin] Brancusi stuck four iron rods of about one meter in length into the sand, thus creating a square shape; then he tied together the tips of the rods with fluffy cotton yarn and he placed three pebble-like stones in the sand inside the boxing ring-like "space" he had thus built, and he signed the work. Others, such as [Alberto] Giacometti, created large empty inner spaces in which balls were hanging on twine and could be freely moved or swung. Thus temporality was introduced into sculpture: movement appeared, while less and less of sculpture's original essence was preserved. There were an increasing number of sculptural works titled "mobile" (a term first applied in this context by Calder and Arp), which were created to accidentally move or to be moved, and then Calder introduced the first "regular movement": he took a thin black pole with a black sphere on top of it and placed it on a white flat base; behind it, a white sphere on a thicker white pole was swinging or moving from right to left in about 20 degrees. The contraption was operated by electricity. I celebrated the moment when I saw this work and was utterly moved by it.

This convinced me that sculpture was not in conflict with the tendency I had discovered through Planism – what is more, it bore out my theory in the most colorful way and in the most varied forms – and gave me the impetus to write down my train of thought involving the entire "non-Euclidean process of development," which did not have a name at the time since the term "universal Planism," which Domela used to distinguish this more general trend from "my Planism," was far from accurate.

We had to find a fitting name, one that would unambiguously express everything about this epochal development that extended to the entire artistic field up to this point and included several, or even almost all, modern trends. *I proposed the name "Dimensionism," based on the* "additional dimension," *or +1 dimension* well known from non-Euclidean geometries, *which was a crucial element in every field*. I discussed this with Domela, Pierre Albert-Birot, and Mme Apollinaire during the two meetings we had in a small café on Boulevard Raspail in June 1935, and we unanimously agreed.

Passionate debates started on Montparnasse about Planism, and now about the theory of Dimensionism too. There was increasing interest shown in our new ideas, and upon the request of Gaston Diehl, who was the head of the society of young artists called

Regain, we had a Planist evening in a café on Montparnasse, where they presented my Planist works and one of my friends recited my Planist novel titled *The Story of a Night* with resounding success. The next most successful piece was my electric poem, *Paris*.

It was then, after a discussion with Bryen and Moreau, that I decided to formulate the text of the Dimensionist Manifesto. The large-scale international artistic movement we were planning had to have its theoretical foundation.

However, before fully elaborating the theory of Dimensionism, I felt I had to create order in my own art, i.e., *Planism, which was the starting point and basis for the whole theory of Dimensionism.*

Besides my Glogoist Manifesto, which I wrote in 1928, I had already written the Planist Manifesto in Paris, as well as two new draft chapters for the book I planned to publish about Planism, titled *Planar Grammar* and *The Role of Planism in World Literature*, which I was working on whenever I had some spare time. These were relatively easy to write. However, I also planned to have a new, extensive chapter that would be devoted to the analysis and introduction of my Planist experiments based on the new space-time theory of modern physics. I worked on this occasionally, but it required the kind of in-depth focus and energy that were not granted by the hectic milieu of my Parisian hotel room and the constant visits by friends. It was perfectly timed, therefore, when I received an invitation from Constant Cachers, a young actor friend of mine (I also met him in the Cercle François Villonban), who had just then chosen to take up teaching to replace his acting career – to which there were no obstacles in France in those days – and as part of his new job he was assigned a flat in a huge palace in a tiny village in Normandy called Paillencourt. He had three empty rooms, each one larger than the next. So I traveled there, and undisturbed by anyone and anything, I needed only three weeks to write a thirty-page essay titled "Introducing Planism Based on the Space-Time Theory of Einstein and Minkowski." This essay formed the most important section of the "Planism" chapter of my – by then completed – book, *Le Planisme, la littérature à deux dimensions* [Planism: Two-dimensional literature].

Not only did I manage to finish my book during this three-week "sabbatical" in Paillencourt, but I also had the time and opportunity to rethink the entire theory of Dimensionism. I thought about the new non-Euclidean "paintings" I had seen up to that point and realized that they required a completely new explanation, analysis, and presentation. It seemed practical, therefore, to analyze and render an interpretation of the painting revolutions that had broken out from 1905 onward by adopting the new concept. I wanted to include this in the book titled "Non-Euclidean Artists and Arts," for which I drafted a synopsis in Paillencourt.

It also dawned on me here, in Paillencourt, that the book I had written in 1929–30 in Debrecen about the "five-sensed theater" needed to be reworked according to a completely new and more modern concept. On page 5 of "Introducing Planism Based on the Space-Time Theory of Einstein and Minkowski," I explained the concept of time as the single carrier of movement in the Euclidean worldview ... and the fact that it ceased to be the only "movement-carrier concept" in the non-Euclidean worldview:

"*Time ceased to be the sole carrier of activity*. In our new worldview *Space itself has been activated*. As a result, *Literature has lost its elusive capacity to convey something that has artistic integrity [and] wholeness and therefore commands our interest*. In order to regain this lost effect, *we must bring Space itself under our dominion and set it into motion*, since space-motion can only be reproduced by setting space into motion and through space set into motion."

Obviously, by space I did not mean some kind of void but real, earthly space saturated with matter, radiation, and force fields. If we talk about such space being moved, or more accurately being set into motion, and varying it with the help of our sensory organs, we can call it "matter-music," where matter is used to create an artistic effect not in its solid but aeriform state. It was obvious that the only path in art that could organically lead in this direction, namely to the conquering of the four-dimensional space-time continuum, was through three-dimensional sculpture, which was the only "space-art" among the Euclidean arts. I could not think of a better way to denote this new artistic effect than by referring to its origin, calling it "the vaporization of sculpture."

All that I had already written back in 1929 in Debrecen about the construction of this new art fit perfectly into my Dimensionist concept, while it also provided a plausible explanation for it, supplemented it, clarified it, and made it more understandable. Nevertheless, at this point I did not entertain the idea of thoroughly elaborating this new artistic mode of action and this art that was absolutely new in its very essence. I was only able to state that the course of Dimensionist evolution/development was supplemented by, made complete by, and culminated in this new art, having been organically integrated into it. Hence, upon the complete elaboration of my Planist theory, the theory of Dimensionism – as I had expected when I traveled to Paillencourt – itself became developed based on the discoveries of Planism. It was complete in theory.

After rethinking all the above I typed the thirty-page chapter on Planism and returned to Paris without haste as my health had become rather unstable.

In Paris, I talked separately to Domela, Kochar, and Bryen, presenting each one with my thoughts and the by then complete system I had developed. They all agreed with me one hundred percent; there was virtually no debate and only a few concepts and terms needed to be defined more precisely.

It was after such antecedents that I sat down in my Parisian hotel room to formulate the Dimensionist Manifesto, which I envisioned as encompassing all three areas of art and in which I intended to discuss the evolution of the non-Euclidean arts in the briefest and most concise fashion possible.

Upon my return from Paillencourt to Paris, when everything was already crystal clear in my mind, I wrote the Dimensionist Manifesto in 7 or 8 days. I wrote it in French and placed great emphasis on making it not only absolutely comprehensible, but also brief and concise.

Moreau and I analyzed the text sentence by sentence for two days, doing our utmost to use the most precise and succinct terms. After making the last finishing touches, Camille Bryen approved the text.

As soon as we were finished with the text of the Manifesto, I showed it to Kochar and Delaunay. (Domela had left for the Netherlands a few years before, so I would not be able to see him for a long time.) It was mainly with Kochar that we discussed the meaning and essence of the text in detail, since he himself had written a five-page manifesto about "Peinture dans l'espace" [Painting in space].

Kochar said that our manifesto was extremely objective and had a temperate and calm tone, which distinguished it greatly from earlier artistic manifestos. He thought it was not at all "declaration-like," but rather a communication of facts and the laying down of a law based on them, which, as stated in the last paragraph of the Manifesto: was deduced from the past, is inductive in regard to the future, and therefore alive in the present!

It extends to a vast area of the arts and their development, and thus is able to provide a direct explanation for a large number of thus far inscrutable and even incomprehensible artistic phenomena as well as many trends introduced by many artists and how they operate; all in all, it provides a clear and natural summary of the meaning of the entire "series of ism-revolutions."

However, in order to build an artistic movement on the basis of this Manifesto — something we had previously decided to do — we needed to form a small core group consisting of some 20–25 artists and have them sign the Manifesto.

I held separate discussions with Kochar, Delaunay, and Arp, and I drew up the list of those whom I considered important to sign the Manifesto.

I felt without a shadow of a doubt that in contrast with the more or less nihilistic, universal spirit of negation that was characteristic of the artistic revolutions of the past, namely Futurism, Dadaism, and Surrealism, our Dimensionist trend only negated the artistic forms and formulae of the more recent past as opposed to mankind and society, and it was a new synthesis, a new dialectic summation — positive and constructive in its very essence and therefore brand new and imbued with the "will to organize."

That is, the Dimensionist trend contained both positive and negative forces, while over time the positive forces would naturally take the upper hand.

Although in an extremely intricate and complicated way, all this could be felt in the works of artists with a Dimensionist tendency, to varying degrees of course, it was not easy to prove it analytically.

I myself discovered three variations of a more direct manifestation of the Dimensionist tendency in art:

I. Conceptually and formally (works conceived in a Dimensionist spirit and moving beyond the bounds of Euclidean forms).

II. Only conceptually (Dimensionist works within the bounds of Euclidean forms).

III. Only formally (Euclidean works in non-Euclidean forms).

I regarded all three variations as being Dimensionist, since I felt that in the huge process of the direct and modern development of the arts, each of the three stages, and every change in the process, was equally important, especially because they all helped in discerning and presenting the chromatic runs of this transformation! I believed that the gradations and transitions were crucial, and I felt that their identification and analysis would be the key theme of *Non-Euclidean Artists and Arts*, the book I was planning to publish.

I was only able to see this so clearly after the long and heated debates I had with Kochar.

What happened was that Kochar did not agree with including certain artists who were on the list that had been approved by Arp and Delaunay: [including] those who had set out upon the path of conquering space with abstract matter-compositions; he was even more opposed to the inclusion of those "artists" who "had their works function," i.e., they either included variation and the possibility of movement into their works, or they intentionally "designed" movement in their works and composed their "artistic works" to operate with electricity. In a strictly formal sense, Kochar was typically "only a painter" and "only a sculptor," so he did not regard any of the aforesaid as "artists"; nor did he want to collaborate with them.

Kochar was completely right from the perspective of his own art, i.e., art starting out from *peinture dans l'espace* and open sculpture and not moving beyond them. Based on the above classification, I did not find it difficult to categorize his art: he worked with non-Euclidean forms (planes split up into "bushes of folds"; opened-up blocks), but he adopted the Euclidean approach; in other words, he "painted" and "sculpted" according to the classical meaning of these words! His "pictures" with unfolded planes that were standing on the tables depicted figures that resembled apostles and were reminiscent of early Byzantine icons, and of course he used the technique of folding two-dimensional planes to create a three-dimensional effect; his open sculptures were veritable "portraits" with exteriors included in them. Their Dimensionist forms and their groundbreaking significance were beyond doubt! They could not be criticized, nor could their value be denied! They were new and important!

I invited Arp and Delaunay to discuss the details, as I thought they would be best able to help reach an agreement in the most peaceful way. They were both supporters of Constructivism and movement, seeing these, but especially movement, as the most characteristic and progressive attributes of Dimensionism, just as I did.

In the end I was able to find my way back to complete harmony with Kochar by drawing up a "Planist table," which was an explanatory figure: I drew a long trapezoid

with an open bottom base, which illustrated the entire process and covered the entire area of Dimensionism; I inserted small ribbon-like shapes across it, which represented the Dimensionist oeuvre of each artist. Some protruded into the trapezoid deeply with only a small section remaining outside, while others penetrated into it less. No artist covered the entire length of Dimensionism, since the Dimensionist process extends over several generations, and especially since its course is open toward the future and cannot be predicted! Nevertheless, every artist was part of the Dimensionist flow to some degree as fighters for the Dimensionist trend! We had to unite them all! Because they were all led by the same "world-will"!

Kochar fully accepted this reasoning and harmony between us was complete again, and of course I included his manifestos of *peinture dans l'espace* and *sculpture ouverte* in the first issue of the periodical we were planning to launch under the title "N + 1."

After roughly agreeing on the list of artists we would ask to endorse the Manifesto, we decided to go ahead with the process of having the document signed by them.

I copied the text onto the right side of a double sheet of paper in such a way that a 15-cm-wide area was left at the bottom for the signatures. I left the opposite, left-hand side completely blank for possible insertions.

I do not remember now where the three of us, Delaunay, Kochar and I, met to go ahead with the signatures: I think it might have been in Kochar's flat.

As I was the author of the Manifesto, Delaunay and Kochar suggested I should be the first to sign it. So I put Charles Sirató in the right-most corner at the bottom-most part of the zone that was left empty at the bottom of the sheet.

The second to sign was Ervand Kochar, a painter and sculptor from Tbilisi, who was the author of the manifestos of painting in space and open sculpture. At the top left, directly under the text and diagonally across from my signature, he wrote only: Kochar.

The third one to sign, also directly under the text, in the middle, was Robert Delaunay, who wrote his first name, drew slightly under it the emblem of his three-dimensional painting – two segments of a circle and two arcs diagonally opposite each other – and put his family name under that.

The fourth signee was Frederick Kann, an American sculptor and "spatial artist," who, if I remember correctly, Domela had called to my attention. From the first moment Kann ascribed to everything one hundred percent; he fully agreed with the Manifesto and the planned movement too. He was there in the Café du Dôme every evening, so we would often meet and talk. He gave me some excellent advice: his works were mostly variations of planar and spatial divisions, and in their fundamental approach they represented the Dimensionist spirit. I think I looked him up in his flat, somewhere around the Boulevard Montparnasse. He signed the Manifesto between my name and Delaunay's, in the second row, as a sign of his endorsing the basic principles of Dimensionism.

We planned to have Francis Picabia to be the fifth to sign. Of all the works by Dimensionist artists, I saw Francis Picabia's pictures first, combined with words from

his Dadaist period, when I lived in Budapest, perhaps in 1926, when I had not yet written planar poems. These works served as a permanent inspiration to my own ambitions. Even in the critical moments with Raith when I was trying to publish *Paper Man*, I used Picabia as a reference, and even later I always looked at him as a great innovator and someone who stood closest to me and my aspirations. I had contacted Picabia long before asking him to sign the Manifesto, exactly because of the spiritual/intellectual kinship I felt toward him. He welcomed my planar poems and expressed his recognition, seeing them as a continuation and realization of his own ambitions.

I went to see Picabia with one of his old friends, Jacques-Henri Lévesque, who was the editor of *Orbes*, an irregularly published periodical. Lévesque had a *pied-à-terre* somewhere around Étoile; most of the year he lived far away from Paris.

Picabia was not only part of the Dimensionist development thanks to his picture-word combinations – or "dada plans," as we referred to them then, but he also magnificently expressed the negative stance assumed by Dimensionism toward the artistic forms of the past at an exhibition in Zurich: he took a piece of thread, stretched it rising from left to right across the bottom of an empty picture frame, and signed it on the frame. (This picture had a similar effect to Miró's decayed board sculpture I mentioned earlier! Back then I regarded this work by Picabia as being among the most inspiring pieces and one of my best memories.)

Then there were Picabia's latest super-positions, which introduced multiplanar space into painting. They also had a Dimensionist tendency pointing in a very positive direction.

I had sent Picabia a copy of the text of the Manifesto days before I and Lévesque went to see him, and he had already studied it thoroughly and had nothing but praise for it. He immediately signed the Manifesto when I asked him to: he placed his signature under the text, on the right-most edge, after Delaunay's.

We had a long discussion after the signing. Unfortunately, in those times Picabia's financial standing was not as excellent as during the period of Dadaism, and although he promised to give us all the support we needed, we felt that his experiences of having already been part of an artistic movement were the most valuable to us. He handed us a long list with the names of his trustworthy adherents and friends.

He also presented me with a picture that he let me pick out. (I also received pictures and other works from other signees.)

The sixth signee was Enrico Prampolini, whom I had held in high esteem for a long time because of his research-type works that were published in *Hungarian Writing* and in Kassák's periodicals. I think we met in the Café du Dôme. He agreed fully with the Manifesto and signed it immediately upon my request.

The seventh and eighth to sign were Hans Arp and his wife, Sophie Taeuber-Arp. I think I do not need to talk in too much detail about Arp here. He undoubtedly represented the most positive force even in the Dadaist movement: his innovative works demonstrated the ability of the Dimensionist tendency to break open new paths. Not only was he one of the newest pioneers fighting for Dimensionism, but he also became

a crucial member, the heart and soul of our fledgling movement. His wife worked in the same spirit. Since only very few women belonged to this trend at the time, she was the first woman to create truly memorable and great things in this brand new area.

I and Camille Bryen went to their home in Meudon Val Fleury and we spent a really pleasant afternoon there as their guests.

The ninth signee was a Surrealist poet hailing from Brittany, who was one of my oldest friends and helpers in Paris: Camille Bryen. He left the line in several of his poems; moreover, he made more and more Surrealist objects; indeed, "objets surréalistes" was a separate chapter in the Dimensionist evolution. I think he signed the Manifesto in my room in Hotel Dalbret at 1 rue Vavin.

The tenth signee was Robert Delaunay's wife, Sonia Delaunay, a painter who, like her husband, made polymaterial compositions, and she was a co-author of one of the seminal works that launched the two-dimensional literary development of Planism. She also created the planar version of Blaise Cendrars's poem titled *La prose du Transsibérien* … in 1913. (This was a world sensation at the time of its publication, and it is still a one-of-a-kind work even today. One of the monumental, pioneering works of Planism!) If I remember correctly, Mme Delaunay signed the Manifesto in the Closerie des Lilas during one of our regular meetings on Thursday evenings.

At the time I was already in regular contact with one of the excellent older fighters of the French avant-garde, Pierre Albert-Birot, who was living a sequestered life. He also represented a separate chapter in the history of the development of Planism. Simultaneously with the publication of Apollinaire's *Calligramme*s, he had made typograms that represented a further development of the form by adding a new figural aspect, i.e., going beyond the genre of concrete poetry and creating shapes that were partly abstract and partly formed by the content. He had also launched his own periodical titled *Sic*, which had several volumes. Since he was a printer himself and also the owner of a printing office, he set his own typograms with the greatest care. A part of his flat at 26 rue du Départ, near the Gare Montparnasse, was still set up as a home printing office when I visited him about the signing. I had been to his place several times before, and he was very glad that his aspirations would be continued in a trend that was so universal and covered such a wide spectrum. He assured me that we had his support, and he was happy to sign the Manifesto.

The twelfth person to sign was a young Hungarian painter called [Anton] Prinner. This young artist came from a Budapest working-class family and had been living in Paris for a long time. I had met him on Montparnasse by chance. Then I visited him, and to my greatest surprise I discovered among his works some wire constructions that left the two-dimensional plane; I immediately recognized their Dimensionist tendency. Besides the great names I needed new artists to form the 25-member core group, so I wasted no time and called upon him to sign the Manifesto; he happily granted my request. I called Arp's attention to him, and Arp actually paid a visit to him a few days later and afterward praised him to me.

Kochar had another young adherent, who, inspired by Kochar's manifesto about *Peinture dans l'espace* and his other works, had stepped out of the two-dimensional plane and begun to create spatial-abstract art: he was Mario Nissim, a Greek artist of a similar age to Prinner. I and Kochar went to see him to ask him to sign the Manifesto. Nissim organized a lavish gathering in his studio on Boulevard Raspail and invited everyone who had already signed the Manifesto, which he himself signed at midnight sharp as the thirteenth signee.

Everybody was talking about the Dimensionist Manifesto on Montparnasse by then. There were several copies, which my friends passed from hand to hand. I established contact with more and more prominent artists who tried to help me realize my objectives, even if they personally did not fully agree with them. Of these artists I feel especially grateful to [Louis] Fernandez, a Catalan painter, who did not regard himself as a Dimensionist, but the flame of artistic revolutions was very much alive within him, and he saw Dimensionism as the summation of these revolutions.

Fernandez maintained friendly ties with many great artists, including Wassily Kandinsky, who was living in a villa by the Seine near Paris. Fernandez regularly visited him and brought him detailed news about what was happening on Montparnasse. He also told him about the emerging new trend, Dimensionism, and briefly explained its essence, which Kandinsky not only understood from the first moment but also wholeheartedly welcomed.

When Fernandez shared this with me I was beside myself with joy, since I believed Kandinsky was the most crucial cornerstone of artistic revolutions from a Dimensionist point of view! I held him in the greatest possible esteem.

If we saw Dadaism and Surrealism as clearly being the final products of middle-class reality and Euclidean forms of art, it could only be concluded that Abstract painting and Constructivism, the latter either growing out of the former or emerging in parallel with it, marked the start of something new.

Wherever I went, I could not conceal my deepest conviction that *Abstract painting was conceived through the desire to create the world anew*. The positive spirit of Dimensionism was first manifest, in its absolute purity, in Abstract painting.

One of the essential attributes of Dimensionism is to fully take possession of the new 20th-century reality as it really is, i.e., in all the four dimensions of the space-time continuum, using artistic expression and with the aim, of course, of realizing an artistic effect.

I must reiterate: Dimensionism is of a positive character and nature. Although it automatically includes the negation of the modernity of previous arts, that is not its objective but a mere side-attribute, a necessity! *Its objective: to create the world anew, to build society anew, and to create a new order!*

Constructivism developed from Abstract painting. In Hungary, Planism developed from Constructivism. And the theory of Dimensionism developed from the theory of Planism.

And at the front of this entire line of development, which was taking a positive direction, stood Kandinsky, alone, with his emerging Abstract painting conceived in an utterly Dimensionist spirit.

Those who are able to look at Kandinsky's abstract paintings with an understanding and assessing eye cannot possibly miss the presence of a powerful ambition, a monumental desire [becomes visible] when comparing these works to the painting of their age and painting in general, which has fallen into an ever-deepening crisis: [In Kandinsky's art one sees] the desire to reassemble and reconstruct the world that has been broken up into pieces by the complete world-analysis object-anatomy and form-pathology of Cubism – but according to new and different laws!

It was in Kandinsky's pictures that I first discovered the tenet according to which the objective of abstract art is to create the world anew, and I have felt it manifest the most strongly in his art ever since.

Therefore, I was overcome by inexpressible joy when Fernandez told me how valuable Kandinsky regarded the basic principles of Dimensionism, which he had presented to him in outline, and that Kandinsky said he had had similar thoughts for a long time and would love to read the full text of the Manifesto. So I gave Fernandez a meticulously copied version of the text and asked him to deliver it to Kandinsky. My voice must have been filled with emotion when I continued by saying:

"We would all be really happy if he [Kandinsky] approved of the full text of the Manifesto, and we would feel greatly honored if he expressed his approval by placing his signature on the Manifesto."

Kandinsky sent word to us via Arp, who had visited him in his home, saying that he approved of the Manifesto and agreed with it but requested a few alterations in the text. (He was the only artist who made such a request, even though I had left a full page empty for possible modifications!) He also said that if I accepted the alterations, he would be happy to sign the Manifesto.

On an early spring afternoon in 1936, Arp and I visited Kandinsky in his home near Paris. I spent one of the most wonderful and memorable two and a half hours of my life there.

When Arp and I entered the spacious living room, we introduced ourselves and were offered seats by Kandinsky and a young woman, as is the custom in such situations, but I felt there was an unusual amount of anticipation in the air.

Three walls of the room had splendid Kandinsky paintings, and a huge window on the fourth wall enshrined the spring greeting from the banks of the Seine: the beautifully eclectic chaos drawn by the verdant green foliage of the awakening early spring.

There were a few chairs along the back wall, opposite the large window; some of them were turned with their backs to the spring "vue," i.e., the huge window; two chairs were placed along the wall on the right allowing a wonderful view of both the spring outside and the interior of the room.

"Please take a seat. Where do you wish to sit?" Kandinsky asked me while offering me the three options in the room with a sweeping movement of his arm.

Not attaching any real significance to my choice, I decided to take the closer chair on the side and stood there. From there I was able to enjoy both the zigzags of intertwining branches and leaves in varying tones of green and the panorama of the interior.

Kandinsky and the young woman started to smile and Kandinsky asked me:

"Well, it seems you want to observe nature even when you are in a room?"

"Naturally," I replied, "and I enjoy it very much!"

At that point the three of us burst out in relief with laughter. Then Kandinsky told us that the great Dutch painter, [Piet] Mondrian, had visited him a few weeks earlier, and upon entering the room the expression on his face turned grim, he looked at them [Kandinsky and the young woman], unable to hide his pity, sat down demonstratively with his back to the window, and asked:

"Tell me, do you suffer a lot here?"

"Why would I suffer?" Kandinsky asked.

Mondrian twitched his head and scornfully pointed at the window which he was sitting with his back to:

"That is why! Are you able to look at this disarray even in your home? Isn't it enough to see it out there?"

"Well, why not?" Kandinsky said in his defense.

"But how can you stand this absolute disorder?! This tormenting mess? This horrible chaos?"

As it turned out, Mondrian could not stand looking at the resplendent spring landscape that sneaked into the room, and even though he was sitting with his back to it, he was obviously anxious and could barely control himself; he only calmed down when the blinds were finally drawn after sunset.

As far as I know, in those days Mondrian lived in a flat on the third floor of an old block of flats on Boulevard Montparnasse, where the only views opened through the rectangular barred window of his rectangular room onto the rectangular courtyard and up onto the rectangular sky. In that environment he was not troubled either by branches and leaves intersecting at random angles or the psychologically troubling color variations!

Kandinsky and the young woman wanted to know what position I, the author of the Dimensionist Manifesto, took in the debate of nature versus geometrical interiors. (Arp was smiling throughout the discussion, since he had already been told about this "trial," which was planned for me.)

Then we went on to discuss the text of the Manifesto, which Kandinsky had already studied in detail. He congratulated me and expressed his satisfaction. At the same time, he handed over a typed text of six lines containing his refinements, whose approval by me was his condition for signing the Manifesto. Nothing in these six lines contradicted the text of the Manifesto or the principles of Dimensionism; they emphasized the absolute negation of the idea that pure materialism and pure spiritism are

starting points for artistic revolutions and stated that the correct path is marked out by the blending of these two categories into a synthesis of a higher order.

I had no objection to his six lines. However, since they could no longer be inserted into the text of the Manifesto – since it was complete and had its own integrity and unity – I promised that these six lines would be pasted onto the page I had left blank next to the text of the Manifesto, and would stand there as his refinements and declaration.

After this, Wassily Kandinsky signed the Manifesto by placing his family name in the middle of the double-sheet in a way that it extended to the left and right of the middle line and was higher than any other signee's name, while also being most closely aligned with the text.

(Then, at home, I typed Kandinsky's six lines with the same typewriter I had used for the entire Manifesto and glued it on the left-hand side of the double sheet, above his signature, in such a way that it applied equally to my text and his.)

We talked a bit more, mainly about the beginnings of abstract art, and he told me with a smile how entertained he was when, during the first exhibition of abstract drawings (it was in Munich, if I remember correctly), a woman had to be employed by the salon's management specifically to keep cleaning the glass that protected his pictures. ...

"Why was that?" I asked naively.

"Because it was constantly full of the spit of visitors..."

He even related this story with a satisfied smile. And Arp and I also shared in his satisfaction.

Then Kandinsky went on to talk about the last item of the Manifesto: on new art, which I named, in various ways, "The Vaporization of Sculpture," "Le Théâtre Synossens," and the theater of the five senses. I explained to him that I had constructed the theory of this new art in 1928, when I was still living in Hungary, and briefly outlined its essence. In response he told us – taking both Arp and me completely by surprise – that he had written an essay about this same thing before that, in 1915, when he was still living in Moscow. Obviously, I immediately asked him to lend me a copy so that I could publish it in full, and he promised he would.

Kandinsky's endorsement and winning him as an active associate was a result that exceeded all my expectations. Moved by it all, I thanked Fernandez and Arp for their help in making this possible.

The fifteenth signee was another pioneering figure, a giant of modern art: Marcel Duchamp.

The art and career of Marcel Duchamp – I really want to throw light on this side of him – is perhaps the most "éclatant" [brilliant] example of something: if he were not allowed absolute creative freedom, or the opportunity for his works to be freely assessed and evaluated, and if art experts and the managers of exhibition venues were hindered in their work by any interference, mainly those rooted in conservativism – he could have never become the epoch-making, hugely important, pioneering artist he is and would not be revered as a leading figure in the art world.

In the last forty years of his career, Marcel Duchamp did not produce anything that could be regarded as great or even defined as "art" within the old framework of the arts – or at least (as far as I know), he did not present any such work publicly. Every piece of work he made is a breakthrough, introducing new means of expression, new processes and methods into the new world of artistic form and creativity.

Marcel Duchamp, just like Picabia, did not reside permanently in Paris and only rarely spent time in Montparnasse.

Once Arp asked me what I would think if he showed the text of the Manifesto to Marcel Duchamp, since he had already talked to him and Duchamp showed a keen interest in the Dimensionist cause.

I must admit here that Arp's horizon extended beyond mine many times over in regard to the vast area constituted by the artistic revolutions from 1905 onward. No wonder: since 1910 Arp had been a close participant in virtually everything that happened. He knew everyone that mattered, maintained good ties with anyone who was able to render some form of support; he himself had been keeping his eyes open for new talents. I called his attention to Prinner, for example, whom he visited immediately to see his work with his own eyes. As for me, I had only lived in this milieu for just a bit longer than six years, and I was forced to waste a vast amount of time and energy during this period to make a livelihood for myself. I was not able to go to exhibitions frequently enough, and my physical condition did not allow me to pursue an extensive social life that would have enabled me to become fully and thoroughly familiar with the entire artistic scene and nurture valuable friendships. So when Arp proposed something, I usually accepted it, especially because, besides playing a huge part and having a pioneering role in the art world, he was also a policymaker with reliable intuitive feelings, somebody who came up with the most brilliant ideas. "Here it is," I said. I was well aware of the fact that Duchamp was one of the greats of our age, but I did not know enough about his diverse and extensive oeuvre and activities since at the time he was still embedded in the narrower framework of Surrealism, which I had not studied thoroughly enough to understand how closely Dimensionism applied to him, perhaps even more strongly and in more respects than to any other signee. That is why I initially did not invite him to sign the Manifesto, even though he was the most Dimensionist of all the signees in regard to both the form and spirit of his works. Arp was able to see that.

A few days later Arp told me that Duchamp liked the text of the Manifesto very much and had spoken about it using superlatives; he fully agreed with its content and was happy to sign if we wanted him to. Then Arp added that he had already told him we did.

Another few days passed and I received a postcard from Duchamp, who let me know that he was going to meet me at my hotel on the morning of a particular day.

Duchamp came exactly when he said he would and he warmly congratulated me for having discovered the theory of Dimensionism and formulating the text of the Manifesto, praising it for its simplicity and precision; then he signed it, upon my request,

to the left of Kandinsky, outwards, in a completely new direction, seemingly deliberately away from the other signatures.

He then presented me with some of his works — some originals and some in photographs — which were unlike anything I had ever seen but were built upon the law of Dimensionism.

Most importantly, he gave me a *Rotorelief* portfolio: an envelope containing six *rotorelief* sheets, each with a work on its recto and verso. These were cardboard sheets resembling gramophone records and they had different figural, abstract, and geometrical drawings on them. However, these were only the "still" forms of the "artworks" since the actual works came to life only when the sheets were placed on the rotating disc of a record player and the images were looked at from above. The 12 *rotoreliefs* showed 12 moving scenes. Their effect could even be modified by adjusting the speed of rotation. The two-dimensional forms were transformed into moving three-dimensional elements by being rotated. The circles in one of the *rotoreliefs* produced a swinging jug. In another one a fisherman was moving a little fish on his hook around in circles.

The third became transformed into two balls rolling inside three truncated cones. The fourth — which I remember really well because I saw it on the cover of one of the best issues of *Minotaure*, a modern art periodical — showed red and black striped geometrical shapes moving within one another in multiple combinations. He dedicated the entire portfolio of 12 *rotoreliefs* to me on *rotorelief* no. 10 titled *Cage*, a thin motion-construction composed of green circles which, as it was turning around, was actually animated into a cage; he wrote "Sirató Duchamp 1936" in the thin white strip between the largest green circle and the edge of the cardboard.

I also received some photographs from him, including his own portrait. At the time, when we were already working on the publication of the Manifesto and planning its international distribution, we requested that signees contribute a photograph of themselves. Duchamp also gave me the photograph of an apparatus that could be plugged into an electric outlet; it was constructed from a long and narrow propeller-like rotating planar piece, a metal plate, which produced various color circles and other similar motifs while rotating. He also presented me with a photo of his work titled *Optical Machine*.

I also received a number of drawings, designs, and interesting moving constructions of colors and lines. And then he invited me for lunch at one of the most elegant restaurants in Paris, not far from the Étoile.

Although we had never met before the signing, Duchamp and I experienced a feeling of perfect harmony and we felt we had the same ambitions. As he often emphasized: *he felt that his own tendencies were fully explained, supported, and logically legitimated by my text, by the Dimensionist tendency. He looked into the future with utter optimism and certainty about the definite victory of this trend.*

This sense of absolute certainty he felt was of great significance to me!

I did not feel such solid certainty even remotely, not even at the time when I discovered the most obvious connections! My very first daring work had been received in Hungary with tirades of ridicule and accusations of madness, and I was never able to shake off what I had felt as a young artist living in Budapest – these feelings were alive in the depths of my psyche like agents rousing doubt in me, which I mostly managed to suppress but was always there, and which probably played a part in the unfortunate developments in my life that followed.

I must repeatedly stress here, and if possible I would specifically like to emphasize this for future art policymakers, that Duchamp felt this absolute certainty about the future as the creator of works that would not have been called "art" at the time of their making in many countries, including Hungary between the two world wars, and their maker would have probably been arrogantly told to take his "works" to a toyshop and try to sell them as creative toys for children. And no one would have noticed in these countries that *what Duchamp did with these works was to introduce a new element— movement—and even more than that—rotation and cyclical movement—into the realm of completely fixed and static arts*, i.e., he enriched the realm of artistic effect with the most non-Euclidean aspects. He opened an entirely new era in art as early as 1913!

Later on Duchamp formulated his individual refinement that was included in the Mosaic, printed on the verso of the Manifesto:

Rotation ... the quintessence of universes! A thus far unknown dimension in art. We have created movement in the plane in order to create forms in space. This is the secret of rotoreliefs.

Now, in 1964, Duchamp lives in the United States, where fortunes are paid for his works and, as one of the first and most courageous "précurseurs," he is at the vanguard of what is potentially the most far-reaching branch of the entire Dimensionist evolution! His achievement will attain ever more monumental significance as the artistic trends he launched gain more and more impetus.

The next two signees of the Manifesto, as far as I remember, were two quite young artists, namely Siri Rathsman, a Swedish "matter-sculptress" who was recommended to us by Frederick Kann; and Nina Negri, an Italian "matter-sculptress" suggested to us by Mario Nissim.

Altogether, 17 signatures, including those of the above two sculptresses, were placed under the text of the Dimensionist Manifesto.

At this point, based on the goal we had previously set for ourselves, i.e., *we would transform Dimensionism into a large-scale international art movement* (knowing the global presence of the Dimensionist phenomena and observing on a daily basis that Dimensionist-like works were being published in art periodicals in every corner of the world), we presumed that if the theory and essence of these phenomena were made conscious, the Dimensionist development would not only continue but also escalate. I, Arp, Delaunay, and Kochar decided, therefore, that after the publication of the Manifesto

we would organize a large-scale international Dimensionist Exhibition, to which we would invite artists from all over the world – regardless of whether they had signed the Manifesto or not – *whose works tapped into the current of Dimensionism even to the smallest degree.* We also agreed that in order realize our international plans, we would invite the most prominent international artists to be endorsers of the movement – as a kind of "non-Parisian core" and the foreign representatives of our movement.

From the start, Kochar had spoken with praise about a painter living in Tbilisi named Kakabadze, who – as he himself said – worked in the same spirit as Kochar but of course used different solutions. I accepted his inclusion without any hesitation. Since becoming familiar with Dimensionist theory, Fernandez had kept his eye on the Planist works by the writer and poet Vincent Huidobro Santiago de Chile. Huidobro had participated in the Dada movement with his Planist works and had continuously developed his "concrete poetry" technique and means of expression since then. I was also well aware of these aspirations of Huidobro's, which had come to my attention back in Hungary! Gyula Illyés mentioned him in his review of my *Paper Man* in the periodical *Nyugat* [West], and Tibor Déry had presented me with a volume of Huidobro's poetry right before I left for Paris; there was a poem in this book's supplement, titled *Moulin* [Mill], which totally captured my imagination even back then. This supplement included the linear version of the poem in four-line stanzas, and on the other side these same lines were constructed into the image of a mill with a bottom, sides, top, and four sails. I took this volume, which Huidobro dedicated to Tibor Déry, from Budapest to Paris, and during one of my visits to Fernandez I showed it to him, especially praising the strengths of the concrete poem titled *Moulin*.

Unfortunately, in those days [when the Manifesto was first signed] Huidobro was not in Paris, so he became a foreign representative.

In 1935 a large volume of poems by António Pedro, a young Portuguese journalist and poet, was published in Paris in French. The poems were heightened by colors and various additions that functioned as accompanying motifs. These effects were similar to those in Sonia Delaunay's *Prose du Transsibérien*, but perhaps slightly more loosely applied – they lent the piece an individual character. I was happy to add the work of Pedro to my conception of Planism and to have him be a representative of the latest three-dimensional poetry. He actually became an ardent supporter of Dimensionism. (The Planist Manifesto was published in French in his periodical titled *Fradiqueb* in 1936.)

Pedro traveled home to Lisbon in early 1936, so he was asked to be included among the foreign representatives of the movement.

Back in Budapest, when I was already making my plans to build a worldwide movement, I had counted on László Moholy-Nagy from the very first moment. I felt so strongly that almost all his works expressed who I was, I liked every one of his aspirations so much, and I was so profoundly affected by his innovative spirit that I had no doubt that we had to meet.

In early April in 1936, I wrote a letter to him from Paris and sent it to his Amsterdam address. I attached the text of the Manifesto and asked him for his support and

contribution, as well as a manuscript and materials for our Dimensionist periodical that was in the making. (In those days I had to organize not only the Dimensionist Exhibition but also "N + 1," our periodical of non-Euclidean arts.) Moholy sent a detailed reply in a letter dated April 13, 1936. He was pleased that I had included him in the realization of my plans. "Concerning Dimensionism," he wrote, "what I like about it very much is that in a time burdened with reactionaries, the generation coming after us wants to add new ideas to our work. What I like even more is that it wants to realize the new ideas with assertive propaganda. I am happy to support your periodical, and will send you reproductions when needed. A booklet of my works will be published in the coming days; I will send you a copy now in case you decide to choose something for publication." In the rest of the letter he called my attention to the fact that it would not be good if the "signatures led to any confusion in regard to the authorship" of the Manifesto ... "so *I suggest that you alone sign the manifesto.* I do not find it appropriate when the perfectly personal, new work and program of a person is linked with names that have been associated with various other platforms. Of course, the works made by these people can be mentioned or used as confirmation or made part of the objective, but only separately, as mere components among the many new and future components."

This comment by Moholy-Nagy made me think, since the authorship of the Manifesto could not be discerned on the signed copy; what is more, I signed it at the bottom, at the edge of the right corner, specifically to make mine the closing signature. (The typographic arrangement of the first edition of the Manifesto was made based on this observation made by Moholy-Nagy.)

Of course, Moholy-Nagy's name and Amsterdam as his place of residence at the time were added to the column of foreign representatives.

Some time after this—I cannot recall when exactly—Moholy-Nagy visited me one morning when he was in Paris and popped in to see me in my hotel room at 1 rue Vavin, opposite the Café du Dôme. He brought me a complimentary copy of the booklet of his works he had promised me earlier. He looked through my Planist poems with great surprise and satisfaction. He especially liked *Epic Poem about Man* and *The Story of a Night*. When he saw the latter, he immediately mentioned Joyce's *Finnegans Wake*. He asked me if I knew it. I did not and was not even aware that Joyce had any Planist works or any works in a planar form. Later, however, when I was in Budapest, I managed to find something and I was happy to include it among the illustrations.

Another great artist who marched forward and produced works demonstrating the spirit and form of Dimensionism with the same kind of courage as Marcel Duchamp was [Alexander] Calder from the U.S., whose mobiles and later his motorized moving sculptures held permanent fascination for us all.

Calder was not living in France at the time, but Arp and Delaunay insisted that Calder should be included in the movement (although Kochar was sharply opposed and even expressed his vehement protest). So I invited Calder to be included in the left-hand column containing the names of foreign representatives, with New York as his place of residence.

Cesar Domela was also away from Paris at the time of the signing of the Manifesto. As I mentioned earlier, he had played an important part not only in formulating the Dimensionist theory but also in the launching of the Dimensionist movement. He was an extremely devoted artist of solid convictions; he strengthened me, too, with his absolutely unfluctuating views and by relentlessly stressing that Dimensionism is the great artistic trend of the future. I must admit that I profoundly missed his presence on many occasions.

As he was not in Paris at the time, I placed his name in the left-hand column of foreign representatives, and added Amsterdam as his place of residence.

Of course, I also remembered to include the artist Domela had often mentioned as an early representative of the Dimensionist spirit: Kobro from Warsaw, whom we definitely needed on board. "Kobro (Varsovie)" was therefore added to the left-hand column. In those days the inflammation of my joints, which I had developed after not fully recovering from a bout of flu and had been suffering from for one and a half years, became so severe that I found it hard to even walk. I was forced to lie in bed more and more, hoping that my condition would improve. One morning Domela came to visit me in my hotel room. He had just returned from Amsterdam and was enthusiastically listening to my account of the successful launch of the Dimensionist movement. I showed him the "Deed of Foundation"; the Manifesto, with its impressive signatures, long lines, and signatory emblem looked unique and was an art historical curiosity indeed.

Domela looked at it with a satisfied smile and then pulled out his fountain pen, crossed out the word "Amsterdam" next to his name, and added his signature, "Cesar Domela." Then he crossed out "Amsterdam" after Moholy-Nagy's name and wrote "London" above it. The last addition he made was to insert "Ben Nicholson (London)" at the top of the column, between Kandinsky's signature and "Calder (New York)."

This act of Cesar Domela's concluded the signing phase in the history of the Dimensionist Manifesto.

I could not possibly leave out Joan Miró: his works were deeply infused with the most poetic spirit of Dimensionism, and some works were definitely Planist (e.g., *La maternité*); moreover, in the "negative domain" of Dimensionism he was able to mock the classical arts of the past so powerfully (my viewing of his rotten plank–iron ring–feather sculpture, which I saw on Boulevard Raspail, has remained one of the most inspiring and lasting memories of my life) that although his art could not be described formally as Dimensionist, I thought of him as one of the prominent representatives of Dimensionism. Since, even after a long period of waiting, I did not receive a reply to the letter of invitation I had sent to him, *I personally added his name and place of residence* in the blank area between Kobro and Huidobro: "Joan Miró (Barcelona)." In retrospect I could say that *in my great fervor, I appointed him an honorary Dimensionist.*

With 18 signatures and 7 foreign representatives, totaling 25 persons, the core group of Parisian and foreign participants, upon which we intended to build our global Dimensionist movement, was established.

It was a veritably powerful list consisting of the signatures below, in this order:

Charles Sirató, Kochar, Robert Delaunay, Arp, Francis Picabia, Prampolini, Frederick Kann, Sophie Taeuber-Arp, Bryen, Sonia Delaunay, Pierre Albert-Birot, Prinner, Nissim, Kandinsky, Marcel Duchamp, Siri Rathsman, Nina Negri, Cesar Domela, Ben Nicholson (London; in Domela's handwriting)

The representatives, or pillars, of Dimensionism living abroad appeared in the Manifesto in the following order:

Calder (New York), Moholy-Nagy (London), Kobro (Warsaw), Joan Miró (Barcelona; in my handwriting), Huidobro (Santiago de Chile), Pedro (Lisbon), Kakabadze (Tbilisi)

This list exceeded my wildest expectations and dreams. Perhaps it was also an indication of how much the spirit of Dimensionism was in the air and the extent to which artists recognized themselves in the theory we had formulated.

We planned to publish the Manifesto without delay. Then we wanted to go ahead with organizing the first International Dimensionist Exhibition, launching the periodical of non-Euclidean arts with the title "N + 1," and compiling Album I of Dimensionism.

IV. The First Edition of the Dimensionist Manifesto: Paris, 1936

So we had a small community now, a body, or, I do not know what to call it: The Signees of the Dimensionist Manifesto, which was the core of the planned global Dimensionist movement. However, besides myself, the only truly active participants were Arp, Delaunay, Kochar, and Domela.

Arp summoned a meeting for the "executive committee" somewhere, I do not know where exactly (I was unable to attend because of my deteriorating health), and he gave an account of the new developments. He presented our planned platform, which every participant was extremely pleased with, and then he proposed that since up to then I had managed all the affairs very successfully, I should continue to be entrusted with all matters, especially since I always discussed everything with him or Delaunay or one of the other members of the close circle of the Dimensionist core.

Everyone agreed to adopt this practice, so after the meeting Arp told me that I, in my capacity as the "manager" of the Dimensionist movement, was entrusted with the future of the Manifesto, including its publication.

At this point I must say a few words about myself, my financial situation and health, and my position in Paris, since, regrettably, these factors gravely impeded my life along with the launching of the movement, which we all saw at the time as extremely hopeful.

As I already mentioned, I arrived in Paris in 1930 with 500 pengős [about $1,700 USD today]. Had I not been certain that my two-dimensional literary works and my

theory based on them were definitely closely connected to the great artistic revolutions of the age – since they were rooted in these revolutions and would diverge into various branches along the paths marked out by these revolutions – and that I would definitely find and explore this connection – in other words, I saw great potential for development for myself in Paris ... –, I would have turned back and returned to Hungary after the first two or three weeks. But since I was certain, I gathered all my strength and, perpetually activating the smallest particle of my physical capacity and intellectual prowess, I managed to survive in Paris for six years, during which time I did practically all the jobs usually taken on by students, worked as a photojournalist and portrait photographer for a considerable time, and pursued my extensive artistic studies. I was also active in the social scene, meeting many people, and thus gained an almost complete overview of the vast areas of the art and literature of the age, so in the end I formulated and wrote down what I had to say. I managed to have the Manifesto signed by those I regarded as important, and now I undertook many tasks: to organize the global Dimensionist movement, to draft its platform, to write my books, to edit the "N + 1" periodical, and to maintain and nurture the complex and ever-widening social network connected to these ... I did it all completely by myself ... regrettably, because *no one else was able to see all this potential in a way that was even remotely similar to what I perceived within the coordinates of my horizon: this potential that presented itself in a most natural way, all here in front of us.* ... only the dots needed to be connected. ...

In simple terms: *I strained myself many times over!* Not realizing my physical limits, my zeal stopped me from seeing that I had undertaken so many tasks that they would have broken even someone with a capacity and stamina far greater than mine. ...

And another, more important factor: I knew nothing about how to maintain a healthy lifestyle and build up my capacity in the long term! I did absolutely nothing to protect my health and strengthen my stamina. On the contrary, I did everything that people tend to do in modern civilizations – especially artists with an extremely unhealthy lifestyle.

That is how it happened that when I caught a cold during a job I took on as a photojournalist in spring 1935, I was so busy that I did not take my illness seriously and did not "lie it out," so when my fever was gone I was left with residual back pain, which then turned into an acute rheumatic condition which spread to my knee joints, and eventually developed into an inflammation of the knee joint – this progressed into the inflammation of many of my joints, then into the inflammation of the heart tissue ... then I found myself lying immobilized, unable to do anything, in an ever-worsening condition, alone in my hotel room in Paris.

Unfortunately, it was not only the rules of a healthy lifestyle that I had not the faintest idea about. I also did not know how to recover from it all! I kept working even in this state, not sparing myself the least bit, since I was reluctant to believe that anything could be seriously wrong with me ... up to the point when the series of complications reached my heart and I was barely able to breathe.

In May 1936 the disease had not yet reached my heart, and so I felt the decision to undertake the publication of the Manifesto was obvious, even though I was barely able to walk because of my inflamed joints.

At this point the focus of attention was again shifted to the tasks that needed to be performed by the Moreau-Bryen pair and Bryen's circle of friends.

Feeling my health deteriorating, I devised a fast and simple plan for the publication of the Manifesto. The simplest and fastest form this could take was none other than as a "flyer" – customarily used for manifestos at the time – called the "feuille volante" [loose-leaf sheet].

It was obvious that the first page of the flyer should contain the 46-line text of the Manifesto, the title *Manifeste Dimensioniste* written in large eye-catching letters, and the names of the signees. It was also clear that we would print the planned schedule, news, and events of our international Dimensionist movement on the back of the flyer, of course as concisely as possible.

Kandinsky's idea to precisely expound his own views as part of the large Dimensionist process that encompasses all the arts seemed to me like a very valuable and good initiative. As I was making the design for the flyer I also thought how great it would be for other artists to add their respective views. These views could then be published under the title of "Mosaic," and this would add more diversity and vivacity, i.e., it would add clarity to the flyer. Arp and Delaunay both accepted my proposal straight away, and within a relatively short time we collected these added views. I gave the title *Activité* to the plans we had already agreed upon, and I announced the launch of our periodical, *La Revue N + 1*. I also called upon all the artists of the world who shared our principles to join the Dimensionist movement. Of course, at this point – since I already felt I was unable to take on any more, even if I managed to recover by autumn – as I had hoped at the time – (never before that time had I ever been ill like this!), I asked Mario Nissim to be the movement's "secretary general" with Arp's and Delaunay's consent; Nissim was extremely helpful and accepted.

By then Arp had already thoroughly studied my work titled *Le planisme, la littérature à deux dimensions*, the manuscript of which was completed after my return from Paillencourt, with some parts (e.g., the Planist Manifesto and "Planar Grammar") even translated into French, and I explained to him what the Hungarian sections were about. He found the concept, the theory, and the modern energy of the whole book not only excellent but also astoundingly influential, and he especially emphasized, and called it the work's strength, the extent to which it threw light on the whole theory of Dimensionism. Since Bryen had already expressed a similar opinion about my book, being the first to do so, there was no obstacle to announcing its existence – the text of which was almost finalized and which I was planning to publish in the near future – on the flyer. Hence the 17-line promotional text of the book was placed in the right corner of the verso side.

Under this promotional text I announced two additional books of mine, namely *Les arts et les artistes non-euclidiens* and *La Vaporisation de la Sculpture,* as "Nos livres en

préparation" [our books in preparation], although these only existed in a sketchy version. This was directly succeeded by the announcement of the *Album Dimensioniste, Anthologie photographique d'oeuvres des artistes dimensionistes* [Dimensionist Album: Photographic Anthology of the Works of Dimensionist Artists], followed by those of a book that Bryen was working on at the time and of Kochar's planned book, titled *Peinture dans l'espace* [Painting in space]. After this came some brief news about the exhibitions of works by Dimensionists and other events linked to our movement. Under these lines, in the right corner, we printed the advertisement for *La Première Exposition Internationale du Dimensionisme* [The First International Dimensionist Exposition], Paris – Autumn – 1936.

Finally, we included something I regard as being of utmost importance even now, in 1965: I placed an announcement that looked like an editorial in the middle of the page whose first lines went like this: "Dimensionism is not an intended, created, or controlled movement. Dimensionism is a slow evolution, which had already existed and been manifested in latent forms for a long time in the results of other artistic revolutions. The Manifesto itself can be regarded as a general process of b e c o m i n g c o n s c i o u s [of what had already been manifest in the works of some avant-garde artists]!"

After the Manifesto was all ready, Moreau and I took the manuscript to José Corti, who was regarded as the most modern publisher at the time, at 6 rue de Clichy in Montmartre. Corti agreed to publish it but – for publication and commercial considerations – he suggested that it should come out not as a flyer but rather as an amply illustrated thickish booklet, although this could only be realized in autumn 1936 at the earliest. Upon hearing this, we and Corti agreed that we ourselves would print the flyer much sooner than that, within a few weeks or so, but with his guidance.

Two siblings who were among the admirers of Camille Bryen and who also were printers were happy to print the flyer, which was a relatively small-scale job for them. They were so helpful and enthusiastic about anything new that they even included the printing of the prospectus for my book *Planisme* in the original budget.

Therefore, in addition to the Dimensionist Manifesto they also published my six-page prospectus for *Planism* with my electric poem titled *Paris (18×24 cm)* on its third page.

In the meantime, my health was quickly deteriorating, and around the middle of May, on doctor's orders, I was not even allowed to get out of bed because my heart muscle had become inflamed and at that point I could not walk, not as a result of weakness in my knee joints but because I had simply no more strength left in me. I had a constant fever and I was only able to be out of bed for about an hour or an hour and a half a day.

My electric poem *Paris*, which was distributed as part of the flyer, enjoyed great success. One of my friends, an engineer, even made a large-scale version of it for the exhibition titled "L'Art Mural." People were constantly gathering in front of it to see it. As for me, I thought the biggest sign of its success was that the secretary of one of the French workers' parties wanted to reproduce it as an actual electric poster in his campaign for the approaching general election; he personally visited me in my small

room and asked me to take part in the project and its scheduling. I said yes with the greatest joy but, regrettably, my condition had reached such a severe stage that we could not implement this.

Although my friends helped me — someone was always with me, did the shopping, and looked after me — my illness grew more and more severe. Soon I was barely able to breathe and found myself in a state of utter despair and panic. Some unfortunate developments in my circle of friends and immediate surroundings (unexpected deaths, tragedies) also contributed to my bouts of panic, but these are not closely relevant to this book, so I will not go into detail.

As soon as the Dimensionist Manifesto and the six-page prospectus of my book on Planism were ready, it suddenly seemed that the last vestiges of my strength had run out, and I could no longer get out of bed. The publication of the Manifesto sustained me to the very last moment, and when I achieved my goal, I physically collapsed. Under these circumstances I had no option but to return to Hungary, where I did have family, after all — my siblings and relatives — and in some way I felt closer to the Hungarian doctors and their approach to medicine. I thought that I would recover at home … in three … four weeks … and then I could return to Paris as soon as possible, perhaps as soon as September. …

I asked Arp, Delaunay, and Bryen to take over the management of the affairs related to the movement while I was away: to distribute and administer the Manifesto, to promote my book *Planism*, and to realize our monumental program step by step.

On June 2, 1936, i.e., four days after the publication of the Dimensionist Manifesto, Bryen and Moreau called a taxi to take me to the Gare de l'Est to catch the morning train at 6 o'clock. I left most of my personal belongings in the hotel, until "my return in the autumn." They helped me to get on the Orient Express.

I will never forget Bryen's expression of shock mixed with worry, awkwardness, and helplessness when we said our goodbyes. He hugged me, kissed me on the cheek, and coming really close, he looked at me with eyes about to fill with tears:

"Au revoir, mon vieux Sirató! Au revoir!" he said in a voice that was hoarser and huskier than ever.

"A l'automne!" I said in a slightly uncertain voice but with a tone of complete certainty.

"T'attendrons! We will be waiting!" the carriages started rolling and at that point they pulled their handkerchiefs out and started waving.

And the train pulled out of the Gare de l'Est with me in it.

V. The Second Edition of the Dimensionist Manifesto: Paris–New York, 1937

On the train home I happened to be sitting next to a Hungarian doctor living in San Francisco, who was coming to visit Hungary and turned to me with great interest.

Strange as it may sound, it was the first time I was able to clearly focus all my thoughts on my illness. I never had the time to do that in Paris, or the willingness, since all my thoughts and my whole mental universe were taken up by the Dimensionist Manifesto and the movement. Only on the train did I realize that I had paid little attention to my illness in Paris. I probably listened to the French doctors only half-heartedly, in a cursory fashion.

"Sir," said the Hungarian physician from San Francisco after he had interviewed me thoroughly, "I do not even need to examine you to be able to show you the way to complete recovery."

Since Dimensionism ceased to exist for me on the clattering train and my mind was only focused on my illness, I paid full attention to him.

"You have a lot of crowns. I assume these teeth all underwent root canal treatment. If so, they might all be festering. As soon as you arrive in Budapest, have them all x-rayed and whichever ones have a black root canal, immediately have them extracted. Do not let any root canal-treated tooth be left in your mouth! Do you understand?!"

Just then I remembered that a young French doctor in the Hôpital Laennec had said the exact same thing when he examined me. But I did not allow them to pull out any of my teeth. I simply did not believe him when he pointed out this connection, which then seemed absurd to me.

"Focal infection! Inflammation of the joints, heart disease – they all originate from here. And if you do not have them extracted, sepsis can set in! It is life-threatening! … We, doctors in America, can cure this disease. Do not listen to the doctors on the continent if they say anything else. …"

The doctors on the continent actually said the exact same thing. My doctor friends in Budapest were of the exact same opinion. So at this point I could no longer fight it. They started to pull my teeth out. Nineteen of them. I felt better afterward but I was not cured, so the search for more focal infection started. It was discovered that the "regenerated remnants" of my removed tonsils were also festering. These were also removed. But I was still not fully cured. My condition improved, but the slightest strain made me ill all over again, and my condition even worsened.

Another examination followed. More surgery and more treatment. Then thermal baths. Then recuperation. But, unfortunately, my illness was persistent, so not only was I unable to return to Paris in autumn 1936, but one year after another passed and I was still unable to work.

In autumn 1937, when I was in a hospital, the name of which I forget, I had just returned from some treatment and found a quarter-sheet white envelope on my bed. The address went like this: M. Charles Sirató, Hongrie, Budapest. Two addresses were crossed out, and the address of the hospital where I was at the time was written at the bottom. The letter had followed me from hospital to hospital. I opened it: inside there was a booklet with a green cover, and on the front cover it said the following in French:

plastique

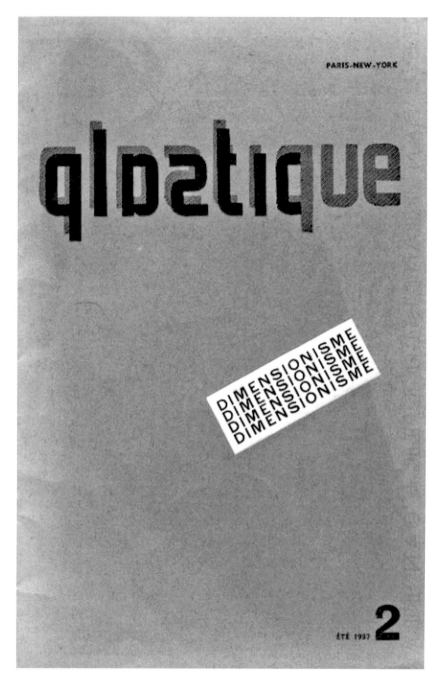

A.9 Cover of the special edition of *Plastique* from 1937 featuring Dimensionism. Image courtesy of Artpool Art Research Center, Budapest.

and then in the same font in English:

p l a s t i c

(the English letters were in solid black, slightly shifted away from the hatched French letters), and in the right-hand side corner:

PARIS – NEW YORK

and in roughly the center of the cover page there was a white box placed diagonally across the page with the following:

DIMENSIONISME

DIMENSIONISME

DIMENSIONISME

DIMENSIONISME

In the bottom right corner: Issue 2, 1937

As I opened the booklet, a reddish brown insert fell out, and to my utter amazement it said: Second Edition of the Dimensionist Manifesto. The typography was just as I had designed it for the first edition. Below it was my name alone (so Moholy's advice was followed, even though I never told anyone about it), and on the second page there were nine Mosaic texts (out of the fourteen) and under them the names of the signees, in alphabetical order according to their first names. The last item was the emblem of our planned periodical:

N + 1

pour Les Arts Non-Euclidiens

and this was followed by the Minkowski quotation, which played an important role in the theory of Planism. [It concluded with the acknowledgment] "Edited by Mme Arp and Domela."

I browsed through the booklet: it was the special Dimensionist edition of the periodical titled *Plastique* with the text in French, English, and German. To a certain extent it already carried the seed of the international art movement.

There, on the hospital bed, between two injections, I was taken by such surprise that I did not know what to think. This meant that the Dimensionist movement continued in Paris, even without me! Here was the second edition of the Manifesto, illustrated by supplementary material. They had published the full series by Picabia and Duchamp, and it also included new works by Domela, as well as new multiplanar cross-sections/reliefs of circles and circular segments by Taeuber-Arp and other works by new artists who had not taken part in Dimensionism before: the periodical included a splendid spatial division composition by Max Bill (whose works I've always loved!), Viking Eggeling's famous abstract *Diagonal Symphonia*, and many other works conceived specifically in the spirit of Dimensionism.

Now, in retrospect, I must say that compared to the *N + 1* periodical of our planned global movement, Arp and Domela's *Plastique* was a very modest little booklet with works by artists in their close circle of friends; there was nothing in it from the all-encompassing great theory of Dimensionism, the further development of the Manifesto — nothing, nothing, nothing! The illustrations were random, too, lacking any system. But at the time, in my hospital bed, I was pleased even with this result, which was achieved without my involvement.

Unfortunately, I was in such a dreadful state that I barely managed to express my happiness. I did decide to write to the editors — Mme Arp and Domela — straight away, but in the end nothing came of this letter; neither did I reply to many other letters I received. All the letters my friends sent me from Paris brought me sadness as my recovery as well as my return to Paris kept being postponed.

"Sepsis!" they told me was my diagnosis at the time. So despite the sites of infection having been removed, the condition that the doctor from San Francisco warned me of actually developed. "Staphilo sepsis!" they said, and then they added: "life-threatening!" And indeed, I saw my fellow patients diagnosed with a similar condition slipping away one after the other, right there on the beds next to mine.

And then came a positive twist of fate. Professor [Gerhard] Domagk discovered Prontosil. And a Swiss variation of this medication, called Ulyron, turned my condition around. I had a three-round course of treatment followed by two more rounds to be on the safe side, and then I was sent for a thermal bath treatment in Hajdúszoboszló for a few months, and I more or less recovered.

My self-confidence was restored. I came round both physically and psychologically.

I delayed no more: I had to return to Paris.

I planned to go back in the summer, just like the first time.

It was 1939. And on September 1, World War II broke out. I could not go anywhere. At the same time, it became clear that my recovery was far from perfect since my ailments returned with a more aggressive strain. I remained a "potential patient," as my doctor friends described my status.

Then, in 1945–46, amid the turmoil, tribulations, anxiety, and privations of the war, my illness returned in full swing, and my condition reached a stage that was more

dangerous than even before. I was bed-ridden for several years, going from one hospital to the next. New examinations, more teeth extracted, and then a four-week penicillin cure! But my condition did not improve. Losing almost all hope in my recovery, I was close to committing suicide. And then another unexpected development took place.

My doctors in Budapest prescribed a "resting cure" for me in the countryside, and as I realized that no progress was being made on the path of recovery with the doctors who were treating me at the time, I sought out a new doctor. After he listened to my story, he told me:

"Well, it seems everything that European medicine can offer has been tried on you. So let's try something entirely different."

"But what is there?" I hung on to his words like a last ray of hope.

"Yoga breathing! Breathing therapy."

I had never even heard of yoga, but I was open to anything at that point, I was so desperate that I was ready to try anything anyone recommended.

To my utter surprise, my discomfort, pains, and weakness started to decrease as a result of the regular breathing therapy. I felt fortified, and not only did I recover, but I felt far stronger, fresher, and was able to work harder than ever before. I can say with confidence that I was a changed man. In 1951 I was finally able to return to Budapest and get back into the swing of things with boosted physical and mental readiness to work.

Around that time the mere thought of leaving Hungary to go abroad was absurd. Thus, returning to Paris was out of the question. Being labeled an avant-garde poet and writer, I was not given any recognition in the literary scene, [coupled with] the fact that I had barely been part of [the avant-garde scene or] anything [else] for decades. Nevertheless, my recovery opened a new chapter in my life, introducing a surprising activity and an even more surprising achievement.

It was my personal experience that no hospitals, no clinics, and no medical facilities were able to cure me, but the regular yoga breathing that supplemented my medical treatment not only cured me completely but rejuvenated me. All this was an amazing experience, and I regarded the results as sensational. So I started studying breathing therapies and experimented with them on myself and then within the circle of my family and acquaintances. In the end, I invented a brand new health-enhancing breathing system. From 1948 to 1960 I devoted virtually all my efforts to developing my own breathing therapy and to recording it in a book.

In the meantime, literary and art policy was also undergoing change in Hungary. In the late 1950s abstract painters were allowed to participate in exhibitions, and more attention was being paid to the Dimensionist Manifesto, too.

In 1959 I was called upon by the Chief Publishing Director to write about the history of the Dimensionist Manifesto. In spring 1963 this official request was followed by another one, from another organization. My working conditions finally allowed me to start this project in the summer of 1963.

VI. The Third Edition of the Dimensionist Manifesto: Paris, 1965

There is no doubt that following my return from Paris I did not devote much effort to Dimensionist theory. In the Hungarian milieu, which was so utterly different from Paris, all that I had written about the non-Euclidian arts seemed so distant and alien that since I knew I had no chance to return to Paris, I became acclimated to the domestic attitude, albeit reluctantly. A crucial contributing factor to this was that from 1936 to 1948 virtually all my thoughts revolved around my illness, symptoms, hospitals, doctors, and my hoped-for but more and more delayed recovery; and then, from 1948 to 1960 I was preoccupied by my recovery and rejuvenation, as well as by my studies and experiments aimed at developing my own health-enhancing yoga system.

Indeed, my collapse in Paris taught me a very important lesson! In the more distant past the prevailing religions might have prescribed medical practices which, if observed, were believed – given the framework of knowledge of those days – to ensure health and one's capacity to work, but the prevailing intellectual/spiritual trends of our modern civilization did not have any similar practices or procedures, especially not ones that proved to be efficient. Successful, active prevention was missing from our lives to complement the general medical practices that were undoubtedly helpful but only served as passive prevention!

Therefore, when I rebuilt myself armed with knowledge of how to regain health and enhance my capacity to work, I focused all my thoughts on *elaborating as perfectly and simply as possible* my own system, in which *the main figure of the success story of active prevention* was not hard to identify, and on *writing it all down in a course book in absolutely clear terms*. "No one should go through what I had to!" – this was the leitmotif of my studies. Hence, my time in Paris assumed ever greater significance for me: not only artistically but also in regard to general human considerations.

Being immersed in these thoughts for years and fully devoting myself to my studies of breathing techniques ... it obviously required a longer time to be able to find my way back to my old themes: those of literature and the arts. This slow return began with literary translations. Then I revisited my own "poems within the line" – in other words, my poems, since no one understood the expression "poems within the line" in Hungary in the 1950s – and I paid more and more attention to the developments in the Hungarian literary scene.

After receiving two requests to write the history of the Dimensionist Manifesto, I finally pulled out the stacks of papers containing the texts of Planism and Dimensionism from the box that I had closed and tied with strings 24 years earlier and which I had only been able to save with my remaining strength amid the greatest adversities: running from bombings, forced to move from place to place, and escaping from conflagrations. As I reread everything, my thoughts and writings seemed to be absolutely unreal, suspended in blank space.

Then, using sources available to me in Budapest, I got down to studying the arts of the past two and a half centuries in order to understand the extent to which my theory had been proven right, and the direction in which European art had developed over a quarter of a century.

It was then that I found my way back to Dimensionism!

I saw it clearly: *the course of development that we analyzed and laid down in the Dimensionist Manifesto in 1936 was followed by the arts in a way so amazingly rich and diverse that I would never have expected it.*

At this point I was ready to write the story of the Manifesto, and while I was studying and collecting the development of the modern fine arts, I increasingly felt that *Dimensionism was alive and valid at this time, too.*

This feeling of mine culminated when the postman delivered another quarter-sheet envelope from Paris in 1965.

It contained the third edition of the Dimensionist Manifesto.

This edition of the Manifesto was even smaller; it was published on white cardboard-like paper and laid out with the exact same typography as the first one. The Mosaic, with its fourteen comments, was printed on a separate sheet just as before.

It was published by the periodical titled *Morphemes*, whose full title is: *Les Feuillets de Morphemes* [The leaflets of morphemes] (Paris, 5e, 322, rue Saint-Jacques), with a brief reference to the first and second editions. The first few copies had the electric poem *Paris,* 1936, "by Ch. Sirató" attached to them.

Morphemes was a small periodical publishing the most modern "treasures," or we could say, the *crème de la crème,* produced by the world's literary and artistic development. Its editor and publisher was Imre Pán (one of the former editors of the Hungarian avant-garde periodical titled *IS* [Too], which had already closed down by then). Although Pán had been familiar with the Manifesto when still in Budapest, it seems he only recognized its topicality and value after moving to Paris and becoming part of the artistic developments there.

"You probably wouldn't have thought that I would be the one to prepare the way for your Parisian renaissance … but it was fate that had me do it," Imre Pán wrote in the attached letter, in which he gave a brief account of the circumstances of how the third edition had come into being and what potential it had for the future.

Indeed, I would not have thought that he would be the publisher of the third edition, but having examined the new areas of artistic development and especially the increasingly frequent manifestos and explanations issued by artists earlier referred to as "painters," I definitely felt that the Dimensionist Manifesto was topical and its new edition was an absolute necessity.

The third edition, the publication of which was apparently brought about by the spirit of the times, filled me with inexpressible joy, and charged me with new enthusiasm and renewed passion to work on this project.

While studying over and over the course of development taken by modern art from 1935 (i.e., the conception of the Dimensionist Manifesto) to the present time (i.e., autumn 1965, when this project was completed), to my utmost surprise I found that *the large-scale, international art movement that myself, Arp, Kochar, and Delaunay were planning took place automatically* ... without any control imposed over it, on its own, organically, and in an ever-expanding fashion; the artistic aspirations developed on the foundations laid down in the Dimensionist Manifesto and based on the laws formulated therein – the Dimensionist tendency was becoming increasingly broader, deeper, more pronounced, and universal ... and *this process is still going on and will probably continue until* a new age in human history – perhaps we could say: *the Atomic Age, the Space Age—creates art that suits its needs: art of a completely new concept.*

Not only was the Manifesto's theoretical tenet – deductive with respect to the past and inductive with respect to the present – borne out by reality, but so were the tactical assessment and statement I published in the center of the last page of the first edition as an editorial statement: "Dimensionism is not an intended, created, or controlled movement."

This means that even though I and the Parisian and international Dimensionist "core" that formed around the Manifesto in 1936 in a most natural fashion were unable to be at the helm of this development – to *make everyone "conscious" of this whole process*! and accelerate its pace of development with the help of our periodical and fight for it with our exhibitions – *Dimensionism "triumphed" on its own, even without our participation.*

We needed to analyze this victory, and from several aspects.

Back in 1935 I had a conversation with Delaunay about the roots of Dimensionism reaching back to 1905 and I explained the section of my book that was devoted to the fourth non-Euclidean art representing the furthest future of Dimensionism, called "five-sensed theater."

"Ça viendra! This will happen!" he said, confirming my line of thought. "It is a natural consequence!"

And then, somewhat bemused, he asked me:

"And how long do you think it will take for this theater to become reality?"

I had to think for some time, and I gave him the following answer based on my calculations in which I reckoned on the slow pace of the process that began in 1905 but which I hoped would accelerate, thanks to our making it "conscious":

"It will require at least 75–100 years for this branch of art to fully develop and actually become successful."

The Dimensionist program will cover such a relatively long period that the term "victory" will be limited to only a few fractions of development in every particular decade.

On the other hand, *this victory cannot and will never mean that the Dimensionist trend will be the only tendency in the arts.* The truth of this tenet might well be almost

self-evident, yet we must examine it in more detail, since the Dimensionist artistic revolutions starting from Dada always emphatically stated their "opposition to their own genres" ("Down with literature!" "anti-novel," "meta-novel," "counter-theater," "the death of painting," etc., etc.) and they sometimes do even today, and this might lead to grave misunderstanding, ill-conceived concepts, and false accusations.

The arts must be seen through their own diversity, in their layeredness and intricate nature – in the same way as the intellectual/spiritual development of humankind. Perhaps this whole thing can be best imagined as a series of phenomena metamorphosing into one another in a delta-like multiplanar solid (to use a term from the world of specifically non-Euclidean arts); as pulsating surface movements, where the movements of the individual parts neither exclude, nor extinguish, other partial movements; on the contrary, a higher-level balance is created among the parts through their being linked by surface and deep tension, and the entire biorhythm of this multiplanar block is produced jointly by all the partial movements.

The movements breaking forth toward the apex angle of the delta create new surfaces and conquer new territory, but they do not exclude or extinguish the reality, life, and values of movements progressing along the sides that are acting at varying levels, some of them expanding their environment and some rising.

Euclidean arts also continue to exist and thrive in their own way (this is the objective conclusion I arrived at after thoroughly examining the development that took place in the thirty years in question!), and *even the founders and proponents of non-Euclidean arts turned to the tried and tested forms of Euclidean arts on many occasions—they exploited the potentials of Euclidean arts and cultivated them*; it is the same process as the one applicable to the life of all humankind: activities are constantly acted out in the most varied intellectual/spiritual spheres that are fit to develop and they exert their influence in their own scope; what is more, they can produce results that can even reach the vanguard! – Even though the simultaneous existence of opposite concepts is impossible in Euclidean "thread-time logic." ... *In the non-Euclidean "four-dimensional space-time continuum" type of thinking, arts pointing in different directions do not exclude one another; furthermore, their mutual existence is essential for a higher-level balance to be realized.* I feel this needs to be specifically emphasized here!

Thanks to the new type of artworks, modern man has reached a stage whereby he can implement the artistic will of Dimensionism – I would go as far as to say that modern man has assumed *a level of internationality that transcends all previous artistic movements*. It is as if we were witness to the great horizontal intellectual/spiritual expansion of Hellenism: European culture and modernity are spreading to all the active peoples of the Earth, bringing with it the possibility of new, vertical development in hitherto passive points. However, in contrast to this practical development manifest in the fine arts, theoretical development was completely stranded! That is, no progress took place in the area that is the key area of the Dimensionist Manifesto.

"The Dimensionist Manifesto can be understood as this [universal art movement] being made conscious!" we wrote in the editorial, previously referred to. *It was the process of raising it all to a conscious level that had been lacking!*

[It was] the development of a theory to back up the development that was going on in practice.

We have often heard the view that "creating art is what is important, not the theory behind it!" It can now be confirmed just how wrong this view is. There might be periods in art in which it cannot be defined "what" the "works" that are created actually are if there is no parallel theoretical development!

This is exactly what has happened in the realm of modern artworks today.

The art aesthetes of our age *are absolutely at a loss* when it comes to the latest periods of modern art. This absolute ignorance extends to several things: primarily to the genre of [individual] works, which is followed by their meaning, goal, and as a result, especially to their evaluation. Not only are they unable to decide if an "artistically" novel work – conceived "as a picture" but which cannot be defined as a picture, sculpture, or poem – is "valuable" at all, they cannot even say "what aspirations" brought them to life and what they actually should be seen as.

Therefore, it is easy to see the widespread use of phrases like "dead end," the "labyrinths of the modern arts," the "overall failure of art" in connection with the most recent achievements of our art, since they have completely destroyed the concepts of the old arts and aesthetics and some of the new genres and artworks can barely be inserted into the rubble. There is no mystery here, of course: just as the radio cannot be understood based on the tenet of the Holy Trinity, the new art of an age-in-the-making cannot be understood using the old artistic concepts and artistic attitudes of a vanishing era.

Regrettably, only now, in 1965, after rereading what I had written in Paris and the material I had on non-Euclidean arts, did I understand a couple of things, which I am happy about but at the same time find hurtful: all the modern artists who read and understood the Dimensionist Manifesto and all those whom I asked to endorse it were happily enthusiastic about it and added their name as a most natural thing as *they discovered themselves, their own thoughts and instinctive artistic ambitions formulated clearly in it*; on the other hand, despite this, *after my enforced leave of absence there was no one who continued my work who looked at this great process from my perspective.* No one carried on the work of organizing the Dimensionist movement and ... most importantly, the further elaboration of its theoretical foundations! No one launched the periodical we had planned. No one organized the exhibitions we had planned.

The concept I formulated in my first work relating to the Dimensionist theory, namely *Le Planisme, la littérature a deux dimensions*, in which I myself discovered the whole theory, was integral to understanding and internalizing the great, all-encompassing process of Dimensionism. Nevertheless, the manuscript of this book, half translated into French, is still lying dormant in my folder containing other manuscripts on Dimensionism. My closest circle of friends in Paris was only familiar with some

cursory details of *La Planisme*, so there was definitely no one who thoroughly understood its concepts, let alone making them their own. Consequently, the "Dimensionist core" I left behind in Paris was obviously lacking the ambition and the ability to further develop and propagate the theory of Dimensionism, with the exception being the efforts by Sophie Taeuber-Arp and Domela, which I truly appreciate. It all happened despite the fact that Dimensionism was increasingly manifest in the circle of my artist friends and the entire art scene around them.

I must admit, of course, that the signees of the Manifesto were all practicing, active artists – painters, sculptors, and poets – and *there was not a single aesthete, art theorist, or similar expert among them.*

Now, in 1965, I have the opportunity again to deal with Dimensionism, so it seems *I can accomplish the task of fully elaborating the theory and making it understandable to all.*

Those of you who will have read these few sheets of my memoirs I believe will *understand the concept and essence of the theory of non-Euclidean arts*, since introducing and explaining them as they were coming into being is the most effective way of presenting them.

However, in the same way that no artwork can be understood completely without a theory that sheds light on its essence and provides an appropriate evaluation of it, no theoretical explanation can be complete without familiarity with artworks that illustrate its essence.

This is why supplementing my memoirs with convincing illustrations seemed essential for various reasons.

While looking for illustrations, i.e., while looking through the art of the last thirty years – which I was only able to do in a cursory fashion – I came upon such a vast body of Dimensionist works (and I did not even go on a study trip to Europe; I stayed in Budapest and my main partner was blind luck) that – fulfilling the promise we made in the Manifesto – I feel justified in calling this volume: the photo anthology of Dimensionism, or "Dimensionist Album I."

If we regard the list of artists compiled for the First International Dimensionist Exhibition and grouped according to the categories laid down in the Manifesto as base notes, then this body of illustrations is a chromatic scale, which cannot be called complete since – as previously mentioned – the material was compiled in a completely haphazard way. Hence, in some places base notes might be missing from it. Therefore, I must express my apologies to Dimensionist artists who created valuable works prior to the thirty-year period I reviewed, since I had no access to them or did not find them during 1963–65, when I was studying the material while living in Budapest.

As a result of the above, it is obviously the case that the album cannot be remotely referred to as complete. Several similar chromatic scales could be created, and this was also our original plan: to come out with a Dimensionist album every year. This plan seems feasible, since the material I had the opportunity to study in foreign art periodicals in Budapest already provided me with such a vast selection of Dimensionist art

that there was no more space left to publish them in this album after I had chosen the first 40–50 works in every genre.

I must stress that the various phases of Dimensionist development do not represent degrees of increasing value. Every Dimensionist tendency is significant and valuable to the emergence of non-Euclidean arts. I must also add here that the illustrations are not included here in a chronological order but instead in the order that seemed natural based on the Dimensionist development presented in the Manifesto.

I had problems in arranging works that represented more than one line of Dimensionist development. So let me apologize if the order I settled on might not be perfect.

I must also apologize for the imperfection resulting from the Euclidean method of publishing this book, as it did not allow me to properly present the non-Euclidean artistic phenomena. A large number of non-Euclidean works are functional and variable by nature, so presenting them in a book where only traditional means of book illustration are available was bound to lead to compromises.

I can say with utmost conviction that there is no phenomenon in modern artistic development (be it the most surprising, daring, or "seemingly super crazy") whose meaning, goal, and development – and resulting from all these, whose artistic value – cannot be established based on the great Dimensionist process encompassing the whole period in question and the new, emerging aesthetic principles of non-Euclidean arts. However, I can only present this in all its complexity in the two works I am working on, which are also announced in the Manifesto. This volume, "Dimensionist Album I," is only a sketchy introduction to works that will interrogate, analyze, and provide an artistic evaluation of the entire period from 1905 until the present day.

The result I hope to see by publishing this album is that the most orthodox skeptics and most rigid conservatives will be persuaded that that this *unprecedented, vast process of the artistic flourishing that extends to almost all the cultured peoples of the world* is not chaos, not a dead end, and not a labyrinth! On the contrary, all of this is clear, systematic, understandable, and everything it entails can be checked by applying the principle of development formulated by the Dimensionist Manifesto.

Thus, the law formulated in the Dimensionist Manifesto is not only confirmed by its prominent signees but also by the results of the artistic development that took place in the thirty years since its [first] publication.

LENDERS TO THE EXHIBITION

For a full checklist of works shown at each exhibition venue, please visit
www.amherst.edu/go/dimensionismchecklist

Allen Memorial Art Museum, Oberlin College, Oberlin, Ohio

The Baltimore Museum of Art, Baltimore, Maryland

The Berkeley Art Museum and Pacific Film Archive, University of California, Berkeley, California

Oliver A. I. Botar

Bowdoin College Museum of Art, Brunswick, Maine

Brooklyn Museum, New York, New York

Calder Foundation, New York, New York

The Cleveland Museum of Art, Cleveland, Ohio

Crystal Bridges Museum of American Art, Bentonville, Arkansas

Davis Museum, Wellesley College, Wellesley, Massachusetts

Frances Lehman Loeb Art Center, Vassar College, Poughkeepsie, New York

Francis M. Naumann Fine Art, New York, New York

George Eastman Museum, Rochester, New York

Gitterman Gallery, New York, New York

Hirshhorn Museum and Sculpture Garden, Smithsonian Institution, Washington, DC

The Isamu Noguchi Foundation and Garden Museum, New York

The J. Paul Getty Museum, Los Angeles, California

Serena Keshavjee

Los Angeles County Museum of Art, Los Angeles, California

Michael Rosenfeld Gallery, New York, New York

Milwaukee Art Museum, Milwaukee, Wisconsin

Mount Holyoke College Art Museum, South Hadley, Massachusetts

National Gallery of Art, Washington, DC

Pennsylvania Academy of the Fine Arts, Philadelphia, Pennsylvania

The Phillips Collection, Washington, DC

Private Collection, Paris, France

Smith College Art Museum, Northampton, Massachusetts

Smithsonian American Art Museum, Washington, DC

Solomon R. Guggenheim Museum, New York, New York

Speed Art Museum, Louisville, Kentucky

Stanford University Libraries, Stanford, California

Wadsworth Atheneum Museum of Art, Hartford, Connecticut

Walker Art Center, Minneapolis, Minnesota

Weinstein Gallery, San Francisco, California

Whitney Museum of American Art, New York, New York

Williams College Museum of Art, Williamstown, Massachusetts

Yale University Art Gallery, New Haven, Connecticut

Zimmerli Art Museum, Rutgers University, New Brunswick, New Jersey

IMAGE CREDITS

ARTISTS' COPYRIGHT STATEMENTS

Harold Edgerton: © Harold Edgerton/MIT. Courtesy of Palm Press, Inc.

Max Ernst: © 2018 Artists Rights Society (ARS), New York / ADAGP, Paris

Naum Gabo: The Work of Naum Gabo © Nina & Graham Williams /Tate, London 2018

Barbara Hepworth: © Bowness

Gerome Kamrowski: © Mary Jane Kamrowski Trust

Wassily Kandinsky: © 2018 Artists Rights Society (ARS), New York

Helen Lundeberg: © The Feitelson / Lundeberg Art Foundation

Man Ray: © 2018 Man Ray Trust / Artists Rights Society (ARS), NY / ADAGP, Paris; except plates 12, 13, 14: © Man Ray Trust ARS-ADAGP

André Masson: © 2018 Artists Rights Society (ARS), New York / ADAGP, Paris

Roberto Matta: © 2018 Artists Rights Society (ARS), New York / ADAGP, Paris

Herbert Matter: Courtesy of the Department of Special Collections, Stanford University Libraries

Joan Miró: © 2018 Successió Miró / Artists Rights Society (ARS), New York / ADAGP, Paris

László Moholy-Nagy: © 2018 Estate of László Moholy-Nagy / Artists Rights Society (ARS), New York

Henry Moore: Reproduced by permission of The Henry Moore Foundation

Ben Nicholson: © 2018 Angela Verren Taunt / All rights reserved / Artists Rights Society (ARS), New York / DACS, London

Isamu Noguchi: © 2018 The Isamu Noguchi Foundation and Garden Museum, New York / Artists Rights Society (ARS), New York

Gordon Onslow Ford: Courtesy of the Lucid Art Foundation

Wolfgang Paalen: © Succession Wolfgang Paalen et Eva Sulzer

Antoine Pevsner: © 2018 Artists Rights Society (ARS), New York / ADAGP, Paris

Pablo Picasso: © 2018 Estate of Pablo Picasso / Artists Rights Society (ARS), New York

Kay Sage: © 2018 Estate of Kay Sage / Artists Rights Society (ARS), New York

Will Henry Stevens: © Will Henry Stevens Estate, courtesy of Blue Spiral 1 Gallery, Asheville, North Carolina

Sophie Taeuber-Arp: © 2018 Artists Rights Society (ARS), New York / ProLitteris, Zurich

Yves Tanguy: © 2018 Estate of Yves Tanguy / Artists Rights Society (ARS), New York

Dorothea Tanning: © 2018 Artists Rights Society (ARS), New York / ADAGP, Paris

PHOTOGRAPHY CREDITS

Frontispiece: Photograph: Jonathan Bloom

Figure 0.1: © CNAC/MNAM/Dist. RMN-Grand Palais / Art Resource, New York

NOTES

INTRODUCTION

1. Charles Sirató, "Manifeste Dimensioniste" [Dimensionist Manifesto], 1936 and 1969. English translations of the two versions of the Manifesto are provided in the appendix of this catalog. Please note that on the Manifesto the artist Sonia Delaunay's name appears as Sonia Delaunay-Terk, perhaps to differentiate her last name from that of her husband Robert Delaunay. Since the artist did not use Terk in her name by this time period, I have referred to her as Sonia Delaunay throughout this publication.

2. Charles Sirató, "History of the Dimensionist Manifesto," 1966/1974, as published in the appendix.

3. Charles Percy Snow, "The Two Cultures," Rede Lecture delivered May 7, 1959, at Senate House, Cambridge University; printed in C. P. Snow, *The Two Cultures* (Cambridge: Cambridge University Press, 2001).

4. Gavin Parkinson, *Surrealism, Art, and Modern Science: Relativity, Quantum Mechanics, Epistemology* (New Haven: Yale University Press, 2008).

5. Linda Dalrymple Henderson, *The Fourth Dimension and Non-Euclidean Geometry in Modern Art*, rev. ed. (1983; repr., Cambridge, MA: MIT Press, 2013).

6. An important introduction to the manifesto is provided in Henderson, *The Fourth Dimension and Non-Euclidean Geometry in Modern Art*, 494–496.

7. Sirató, Dimensionist Manifesto, 1936 and 1969 versions. See English translations in appendix.

8. Ibid.

9. Ibid.

10. Ibid.

11. Minkowski's space-time discovery was explained in many popular sources such as John Q. Stewart, "The Nature of Things: Einstein's Theory of Relativity; a Brief Statement of What It Is and What It Is Not," *Scientific American*, January 3, 1920. For a further discussion of Minkowski's contribution, see A. Einstein and H. Minkowski, eds., *The Principle of Relativity: Original Papers* (Calcutta: University of Calcutta, 1920), 1–52.

12. See Oliver Botar's essay in this publication, 19–47.

13. For more on Calder and science, see Vanja V. Malloy, "Rethinking Alexander Calder: Astronomy, Relativity, and Psychology," PhD dissertation, Courtauld Institute of Art, 2014; Vanja V. Malloy, "Calder and the Solar Eclipse: Breakthroughs in Astronomy, Physics, and Art," in Elizabeth Turner, ed., *Alexander Calder: Radical Inventor* (Montreal: Montreal Museum of Fine Arts, 2018); Vanja V. Malloy, "Calder and the Dynamic Cosmos," in Theodora Vischer, ed., *Calder and Fischli/Weiss* (Basel: Fondation Beyeler, 2016), 164–178; Vanja V. Malloy, "Rethinking Alexander Calder's *Universes* and *Mobiles*: The Influences of Einsteinian Physics and Cosmology," *Courtauld Institute of Art Immediations* 3, no. 1 (December 2012): 9–26.

14. For instance, Nicholson quoted Eddington in the 1934 *Unit 1* exhibition and the 1936 *Circle* catalog. For more on Nicholson and Christian Science, see Norbert Lynton, *Ben Nicholson* (London: Phaidon Press, 1993), 80–81. For a further discussion of the connections between science and religion in Nicholson, see Alan H. Batten, "A Most Rare Vision: Eddington's Thinking on the Relation between Science and Religion," *Journal of Scientific Exploration* 9, no. 2 (1995): 231–255. See J. L. Martin, Ben Nicholson, and Naum Gabo, eds., *Circle of International Survey of Constructive Art* (London: Faber and Faber, 1937), 10, 13.

15. Sirató, Dimensionist Manifesto (see appendix).

16. Ibid.

17. For many of these photographs see Tamkó Sirató Károly [Charles Sirató], *A Dimenzionista Manifesztum története: a dimenzionizmus (nemeuklideszi művészetek) I. albuma: az avantgárd művészetek rendszerbe foglalása* [The History of the Dimensionist Manifesto: Album I of Dimensionism (non-Euclidean Arts). The systematization of avant-garde arts] (Budapest: Artpool and Magyar Műhely Kiadó, 2010). Artpool's publication of the reconstructed illustrations is available at http://www.artpool.hu/TamkoSirato/album/index_en.html.

18. Charles Sirató, "History of the Dimensionist Manifesto," as published in the appendix of this catalog.

1 CHARLES SIRATÓ AND THE DIMENSIONIST MANIFESTO

1. Charles Sirató, Dimensionist Manifesto, loose-leaf insert intended for the unrealized journal *La Revue N + 1* (to have been published by José Corti, Paris, 1936). When it became apparent that *N + 1* would not appear, the insert, already printed, was included as a supplement to the Summer 1937 issue of *Plastique*, no. 2. An English translation was published in Mary Ann Caws, ed., *Manifesto: A Century of Isms* (Lincoln: University of Nebraska Press, 2001), 536–538. The revision of this article from the unpublished 1998 original was carried out, in part, with the support of an

Insight Grant from the Social Sciences and Humanities Research Council of Canada. Thanks to Linda Henderson and Bruce Clarke for invaluable comments on the text, particularly as it concerns Sirató's understanding of the science, and to Megan McIntosh for assistance with research. Unless otherwise noted, all translations, from the French, German, Hungarian, and Italian are by the author.

2. Linda Dalrymple Henderson, "Einstein and 20th-Century Art: A Romance of Many Dimensions," in Peter L. Galison, Gerald Holton, and Silvan S. Schweber, eds., *Einstein for the 21st Century: His Legacy in Science, Art, and Modern Culture* (Princeton: Princeton University Press, 2008), 106. See also Linda Dalrymple Henderson, *The Fourth Dimension and Non-Euclidean Geometry in Modern Art* (1983; rev. ed., Cambridge, MA: MIT Press, 2013).

3. Oliver Botar, interview with Charles Sirató, Budapest, November 20, 1979. See also "Le Dimensionisme" on the loose-leaf insert to the unrealized journal *La Revue N + 1*, verso (see note 1 above).

4. Ibid. By 1966 Sirató had completed the manuscript of the *Premier album Dimensioniste* [First Dimensionist Album], which featured his own photographs of artworks that exemplified his idea of "Dimensionism" and included updates on art made since 1936. In the 1970s he was still hoping for its publication in Paris as a way of developing international artistic exchanges. See Géza Áczél, *Tamkó Sirató Károly* (Budapest: Akadémiai, 1981), 152–153. The material for this album, thought to be lost, was located, in part, in 2007 on a few rolls of film. It was reconstructed by Artpool's cofounder Júlia Klaniczay and published in Károly Tamkó Sirató [Charles Sirató], *A Dimenzionista Manifesztum története: a dimenzionizmus (nemeuklideszi művészetek) I. albuma: az avantgárd művészetek rendszerbe foglalása* [The history of the Dimensionist Manifesto: Album I of Dimensionism (non-Euclidean arts). The systematisation of avant-garde arts] (Budapest: Artpool and Magyar Műhely Kiadó, 2010), compiled, edited, and annotated by Klaniczay, and supplied with an afterword by László L. Simon. On the recovered rolls of film, see Júlia Klaniczay, "Kiadás- és kutatástörténet" [History of publication and research], in Sirató, *A Dimenzionista Manifesztum története*, 190–191. The manuscript for Sirató's "A Dimenzionista Manifesztum története" [History of the Dimensionist Manifesto] was also completed in 1966 in conjunction with the album, and, after a long and tortuous history of failed publication, it also appeared in the original Hungarian in the 2010 Artpool publication. The typescript is in the Archives of the Hungarian Academy of Sciences Art Historical Research Institute, Budapest. Thanks to Gábor Pataki and Edith Nagy for providing me with a photocopy. My citations of the Hungarian text refer to this typescript rather than to the Artpool publication; citations of the English translation refer to the appendix of this catalog. Also see http://www.artpool.hu/TamkoSirato/book.html.

5. Maria Lluïsa Borràs, *Picabia* (New York: Rizzoli, 1985), 382.

6. Enrico Crispolti, "Una dimenticata partecipazione di Prampolini: Il Manifesto del 'Dimensionismo' (1937)" [A forgotten participation by Prampolini: The Dimensionist Manifesto], *Uomini e idee* 10, nos. 15–17 (1968): 151. Thanks to Linda Henderson for providing me with this article. Crispolti employs the French term *inconnu* in this article (151). See Júlia Szabó, "Tamkó Sirató Károly," in Sándor Kontha, ed. *Magyar művészet 1919–1945* [Hungarian art 1919–1945] (Budapest: Akadémiai, 1985), 275–276; and Gladys Fabre, *Paris: Arte Abstracto—Arte Concreto—Circle et Carré–1930* (exh. cat.) (Valencia: IVAM Centre Julio González, 1990), 408. Unless noted otherwise, biographical information on Sirató is from the following sources: Sirató, "A Dimenzionista Manifesztum története"; Áczél, *Tamkó Sirató Károly*; Károly Tamkó Sirató, "Korforduló" [Turning point], *Uj Írás* [New writing], no. 2 (February 1977); and Ilona Bánki, "Harminc évig nem írtam verset: Beszélgetés Tamkó Sirató Károllyal" [I did not write poetry for thirty years: Conversation with Károly Tamkó Sirató] (interview, April 1976), *Kritika* [Critique], no. 3 (March 1980).

7. Henderson, *The Fourth Dimension*, 495. Henderson's view is shared by Hungarian critics such as Miklós Veress and Bálint Szombathy, although Géza Áczél disagrees. See Áczél, *Tamkó Sirató Károly*, 106, 120.

8. There is one exception to this that has only come to my attention recently. Inspired by the discovery of the Dimensionist Manifesto among the papers of the Spanish painter Luis Fernández (1900–1973), a signatory of the Manifesto, the art historian Alfonso Palacio Alvarez organized an exhibition about the Manifesto in Asturias, Spain, accompanied by a publication in Spanish titled *El manifesto dimensionista 1936* (Oviedo: Museu de Bellas Artes de Asturias, 2003). In addition to Alvarez's history of the Dimensionist Manifesto, the texts of the Dimensionist, Planist, and Glogoist manifestos, as well as a selection of Sirató's poems from his volume *Papirember* (translated by Adam Kovacsics), are published in this volume.

9. Károly Tamkó Sirató, *Az élet tavaszán: Károly Tamkó versei 1920–21* [At the springtime of life: Károly Tamkó's poems 1920–21] (Mezőtúr: Borbély Press, 1921); Botar, interview with Sirató; and Sirató, "A Dimenzionista Manifesztum története," 2.

10. On Sirató's "mystic biologism," see Áczél, *Tamkó Sirató Károly*, 110.

11. On Sirató and Kassák, see Károly Tamkó Sirató, "Emlékét saját művészetemben őrzöm" [I guard his memory in my own work], in Ilona Illés and Ernő Taxner, eds., *Kortársak Kassák Lajosról* [Contemporaries on Lajos Kassák] (Budapest: Petőfi Irodalmi Múzeum, 1974), 56–60; and "Kassák Lajos," in Károly Tamkó Sirató, *Kozmogrammok* [Cosmograms] (Budapest: Szépirodalmi, 1975), 61. As András Petőcz writes, Sirató was never able to get close to Kassák, because the latter prioritized political and social goals, while Sirató always foregrounded what were essentially aesthetic/conceptual considerations. See András Petőcz, "'Dimenzionista' művészet: Tamkó Sirató Károly költészeti törekvései a két világháború között" [Dimensionist art: Károly Tamkó Sirató's literary efforts between the two world wars], *Spanyolnátha: Művészeti folyóirat* 7 (Winter 2010) (http://www.spanyolnatha.hu). In expanded form, this essay appeared as a monograph: András Petőcz, *Dimenzionista művészet: Tamkó Sirató Károly költészeti törekvései a két világháború között, illetve annak hazai és nemzetközi megfelelői* [Dimensionist art: Károly Tamkó Sirató's literary efforts between the two world wars and its international equivalent] (Budapest: Magyar Műhely Kiadó, 2010).

12. On Sirató and Futurism, see Sirató, "Korforduló"; and Bánki, "Harminc évig nem írtam verset," 21–23. In 1920–1922 *MA* was heavily Dada in content.

13. I have interpreted this manifesto as an early call for the constructed relief. See Oliver Botar, "Constructed Reliefs in the Art of the Hungarian Avant-Garde: Kassák, Bortnyik, Uitz and Moholy-Nagy 1921–1926," *The Structurist*, no. 25–26 (1985–1986). On concrete poetry in *MA*, see Géza Áczél, *Termő avantgarde* [Creative avant-garde] (Budapest: Szépirodalmi, 1988), 339–343. A copy of the printed Dimensionist Manifesto dedicated by Sirató to "my former poet-associate" Ervin Ember in Budapest on March 18, 1937, with "friendly and non-Euclidean greetings" is preserved in the Petőfi Irodalmi Muzeum (Petőfi Literary Museum) in Budapest.

14. Raoul Hausmann, "Optofonetika," *MA* 7, no. 1 (October 15, 1922): 3–4; "Egyetemes szervműködés" [Universal sensory functioning], *MA* 8, nos. 7–8 (May 1, 1923): n.p.; Raoul Hausmann and Viking Eggeling, "Zweite präsentistische Deklaration" [Second Presentist declaration], *MA* 7, nos. 5–6 (March 15, 1923): n.p.; El Lissitzky, "Proun," *MA* 7, no. 1 (October 1922): n.p.; Émile Malespine, "A művészet irányvonala" [The direction of art], *MA* 7, nos. 7–8 (May 1, 1923): n.p; Filippo Tommaso Marinetti, "Teatro antipsicologico astratto, dei puri elementi e il teatro tattile" [Antipsychological abstract theater: The pure elements and tactile theater], *MA* 9, nos. 8–9 (Sept. 15, 1924): n.p. "Proun" was written in 1920 and also published in *De Stijl* 5, no. 6 (June 1922). While

neither of the two articles by Van Doesburg that appeared in *MA* ("Az épitészet mint szintetikus művészet" [Architecture as synthetic art], *MA* 7, nos. 5–6, and "Az ideális esztétikától a matériális megvalósítás felé" [From ideal aesthetics toward material realization], *MA* 9, no. 1) dealt directly with his ideas on the fourth dimension and art, they were congruent with them, and though Sirató did not indicate an awareness of them, he may have encountered the more relevant texts elsewhere.

15. Kazimir Malevich, "Szuprematizmus" [Suprematism], *Egység*, no. 3 (September 1922): 5–6; Naum Gabo and Antoine Pevsner, "Realista kiáltvány" [Realistic Manifesto], *Egység*, no. 2 (June 1922): 5–6. On Malevich in this respect, see Henderson, *The Fourth Dimension*, 274–294. On the "Realistic Manifesto" as a reflection of Einstein's relativity theory, see Henderson, *The Fourth Dimension*, 298. On *Egység*, see Oliver Botar, "From Avant-Garde to 'Proletkult' in Hungarian Émigré Politico-Cultural Journals, 1922–1924," in Virginia H. Marquardt, ed., *Art and Journals on the Political Front, 1910–1940* (Gainesville: University of Florida Press, 1997), 103ff. See Umberto Boccioni, *Manifesto tecnico della scultura futurista* [Technical manifesto of Futurist sculpture] (Venice, 1914).

16. On Sirató and *Magyar Írás*, see Áczél, *Tamkó Sirató Károly*, 29ff, and Sirató, "A Dimenzionista Manifesztum története," 7, 12. See also Éva Lakatos, *Magyar Írás repertórium* [Repertory of *Magyar Írás*] (Budapest: Petőfi Irodalmi Múzeum, 1973).

17. Áczél, *Tamkó Sirató Károly*, 32. On biocentrism, see Oliver Botar, "Prolegomena to the Study of Biomorphic Modernism: Biocentrism, László Moholy-Nagy's 'New Vision,' and Ernő Kállai's *Biomantik*," Ph.D. diss., University of Toronto, 1998; and Oliver Botar, "Defining Biocentrism," in Oliver Botar and Isabel Wünsche, eds., *Biocentrism and Modernism* (Farnham, UK: Ashgate, 2011), 15–45.

18. Mezei is best known for his collaborative work with Marcel Jean; see the latter's *Genèse de la pensée moderne* [Genesis of modern thinking] (Paris: Correa, 1950); *Histoire de la peinture surréaliste* [History of Surrealist painting] (Paris: Editions du Seuil, 1959); and *Oeuvres complètes d'Isidore Ducasse, comte de Lautréamont* [Complete works of Isidore Ducasse], with commentary by Jean and Mezei (Paris: Eric Losfeld, 1971). Mezei befriended Sirató after Sirató's return from Paris in 1936; he owned a copy of the first edition of the Dimensionist Manifesto, and he agreed with its basic premise (author's telephone interview with Mezei, October 12, 1997).

19. Árpád Mezei, "Forma" [Form], *Is* [Also], no. 1 (1924): 1. Mezei's source on relativity may well have been Károly Czukor's *A relativitás elve* [The theory of relativity] (Budapest: Dick Manó, 1920). This clearly written, sophisticated introduction to Einstein's and Minkowski's theories published by a former lecturer at Palatine Joseph Technical University in Budapest not long after the eclipse of the sun on May 29, 1919, and its confirmation of the new cosmology sold out within months and a second, revised edition appeared by February of 1921. Einstein's book on special and general relativity itself was published as early as 1921. See Albert Einstein, *A különleges és az általános relativitás elmélete* [The theory of special and general relativity] (Budapest: Pantheon, 1921). The fact that my own copy of Czukor's book is from my grandfather Árpád Botár's library (he was a former Austro-Hungarian counterespionage officer at the time living near a small city far from Budapest) attests to the general popularity of relativity early on in Hungarian intellectual circles. A further demonstration of this is the fact that no fewer than five members of the Manhattan Project were Hungarians educated at least partly in Hungary: Leó Szilárd, Eugene (Jenő) Wigner, Edward (Ede) Teller, Nicholas (Miklós) Kürti, and John (János) von Neumann. All this of course suggests the question of why Sirató himself was not better informed on Einstein's revision of his earlier theories.

20. [Árpád Mezei], untitled insert in *Is* [Also], no. 1 (1924). When asked about the Bergsonism of this article, Mezei agreed that Bergson was a strong influence on him at the time. In my interview

with him he still held Bergson to be an important philosopher. In combining Bergson and the New Physics, Mezei was doing what Bergson himself attempted to do the following year in his *Dureé et Simulanéité (à propos de la théorie d'Einstein)* [Duration and simultaneity (About Einstein's theory)], and what other art theorists did during the 1920s, even if such an adjustment ultimately proved unsound. See Henderson, *The Fourth Dimension*, 321.

21. Mezei, "Forma," 3.

22. [Mezei], *Is* [Also], no. 1. Mezei thought it possible that "Forma" influenced the Dimensionist Manifesto, but in my interview with him he did not remember discussing the issue with Sirató.

23. In my interview Mezei indicated that he was reading Spengler's *Der Untergang des Abendlandes* by about 1920.

24. Sirató, "Emlékét saját művészetemben őrzöm," 57. He nevertheless saw himself as Apollinaire's "successor." His dedication of his book *Papírember* [Paper man] (Békéscsaba: Tevan Andor, 1928) to Mme Apollinaire read: "Avec mon plus profond hommage / à Madame Apollinaire / un successeur hongrois du Maitre / Charles Sirató / 21.11.1921" [With my most profound homage to Madame Apollinaire/ a Hungarian successor to the Master]. This volume was formerly in the Ferenc Kiss collection, Budapest, and is now in the Szépművészeti Múzeum, Budapest. His dedication of a typescript summary of the Dimensionist Manifesto to Lajos Kassák reads "To Lajos Kassák, the immediate ancestor of Dimensionism, the inspirer of my Planist poetry, with the hope that this artistic movement – as the most contemporary tendency of our time and its true forward-driving *Kunstwollen* – will at some point gain momentum again … with respect, Károly Tamkó Sirató, 3 January 1963" (Kassák Museum, Budapest, KM-I-86.426; translated by author). Kassák also owned a copy of *Plastique*, no. 3 (Spring 1938) (KM-I-2116).

25. Tamkó Sirató, "Glogoizmus" [Glogoism], in *Papírember*, 42. He derived "Glogoizmus" from *glogao*, the Slavic root for "speech," since, after Spengler, he believed that Slavic civilization would replace the decadent Nordic variety. See ibid., 58.

26. See "Bevezetés a regény-téglába" [Introduction to the novel-brick], "La vie de Bernard dans le Roman-Brique (roman système à quatre dimensions)" [four-dimensional novel], and "L'histoire d'une nuit (nouvelle planiste synchro-simultané)" [new Planist synchro-simultaneity], in Charles Sirató, *Le Planisme: La décomposition de la littérature* [Planism: The decomposition of literature] (Paris: Éditions de la Nouvelle Réalité, 1936). I have consulted the facsimile edition: János Fajó, ed., *Le Planisme 1936/Planizmus 1936* (Budapest: Pesti Mühely, 1981), op. IX, VII. For Sirató "brick" signified "right-angled parallelepiped." Also see *La prose du Transsibérien et de la petite Jehanne de France* [Prose of the Trans-Siberian and of Little Jehanne of France], text by Blaise Cendrars, imagery by Sonia Delaunay (Paris: Éditions des Hommes nouveaux, 1913). In "A Dimenzionista Manifesztum története" Sirató refers to this work as "one of the monumental pioneering works of the Planist tendency" (55).

27. Sirató, *Papírember*, 43. Cendrars published "Advertising = Poetry" in 1927, and proposed an analogy between poetry and the "luminous billboard." On Sirató's visual poetry of the 1920s, see Áczél, *Tamkó Sirató Károly*, 66ff. Sirató was likely inspired by Iván Hevesy's, Kassák's, and Mezei's writings of the late 1910s and early 1920s in which they identified "mass art," especially posters, as the art of the future. See Mezei in *Is* [Also], no. 1, last page.

28. See Sirató, "A Dimenzionista Manifesztum története," 19; Sirató, "Korforduló," 124; and Czukor, *A relativitás elve*, 6–7.

29. The critic of French literature Endre Lázár Bajomi cites a similar list of authors in his memory of Sirató at the time in Debrecen, adding to the list Bólyai, Picasso, Rimbaud, and Apollinaire. Quoted in Áczél, *Tamkó Sirató Károly*, 84.

30. He expressed this realization in his "Planist" poem "Eposz az emberről" composed in Budapest in 1929 and published in *Planizmus 1936*, op. VII. Also see Sirató's poem "Bergson és Einstein" in *Kozmogrammok*, 46; Sirató, "A Dimenzionista Manifesztum története," 23; and Áczél, *Tamkó Sirató Károly*, 94. Bergson's *Durée et simultanéité* [Duration and simultaneity] was published in Hungarian as *Tartam és egyidejüség* (Budapest: Pantheon, n.d. [1923]). On Bergson's belief that he had "brought Einstein's relativity theory into line with his philosophy" by means of this book, see Henderson, *The Fourth Dimension*, 320. The following year Bergson's *Essai sur les donnés immédiates de la conscience* (1899; known in English as *Time and Free Will*) was published by the same publisher using the same translator (Bergson's student Valéria Dienes) and reader (Bernát Alexander) as *Idő és szabadság. Tanulmány eszméletünk közvetlen adatairól.* This book would also have been useful to Sirató and Mezei, as Bergson discussed Einstein's theories in relation to his own. Typically for the time, Sirató seems not to have been concerned by the contradictions between Einstein's and Bergson's theories. It is reasonable to speculate that Sirató may have read Bergson's books in the original: his French comprehension was good even before he left for Paris; he cites the French title *Durée et simultanéité* in the "History of the Dimensionist Manifesto"; and he would have had the assistance, in any case, of his friend István Nemes, who was a student of French literature.

31. Oswald Spengler, *The Decline of the West: Form and Actuality* (1918), trans. Charles Francis Atkinson (New York: Alfred A. Knopf, 1927), 62. For his poem dedicated to Spengler, see *A vízöntő-kor hajnalán* [At the dawn of the Age of Aquarius] (Budapest: Szépirodalmi, 1969), 103–106. On Sirató's discovery and use of Spengler, see "A Dimenzionista Manifesztum története," 23–24.

32. See Kertész's photographs of Hungarians at the Dôme in 1925 and 1929 in Sandra Phillips, *André Kertész: Of Paris and New York* (London: Thames and Hudson, 1985), 25, 27. On the Hungarian artists' colony in Paris, see Endre Lázár Bajomi, *A magyar Párizs* [Hungarian Paris] (Budapest: Gondolat, 1978); Oliver Botar, entry on Kertész in Botar, *Tibor Pólya and the Group of Seven/ Hungarian Art in Toronto Collections 1900–1949* (Toronto: Justina M. Barnicke Gallery, University of Toronto, 1989), 42–43; Valéria Majoros, "Lajos Tihanyi's American Sojourn: 1929–30," *Hungarian Studies Review* 21, nos. 1–2 (Spring/Fall 1994): 10–12; Sarah Greenough, "To Become a Virgin Again, 1925–1936," in Judy Metro, ed., *André Kertész* (Princeton: Princeton University Press, 2005), 60–61; and Michel Frizot and Annie-Laure Wanaverbecq, *André Kertész* (Paris: Hazan/Jeu de Paume, 2010), 65–66. On the Dôme as a "stomping ground for young foreigners" see also Marja Warehime, *Brassaï: Images of Culture and the Surrealist Observer* (Baton Rouge: Louisiana State University Press, 1996), 25.

33. Károly Tamkó Sirató, "A francia szürrealizmus" [French Surrealism], *Literatura* [Literature] no. 1 (1935): 10. On Nemes, see Sirató, "A Dimenzionista Manifesztum története," 19–20.

34. On his early enthusiasm for Surrealist writing, *écriture automatique*, and Surrealist art, see Béla Pomogáts, "Fejezetek a magyar avantgard történetéből: Tamkó Sirató Károly költészete" [Chapters in the history of the Hungarian avant-garde: Károly Tamkó Sirató's poetry], *Új Írás* [New writing] (January 1976): 112.

35. A postcard to Francis Picabia of May 4, 1936, on the occasion of a lecture Lévesque gave on Dadaism at the Sorbonne, is signed by Lévesque, van Heeckeren, Bryen, Sirató, and two others. See Borràs, *Picabia*, 382. The lecture was also announced on the verso of the first edition of the Dimensionist Manifesto as a related event.

36. Sirató, "A francia szürrealizmus," 14. On the exhibitions, see *Camille Bryen: A revers* [Camille Bryen: In reverse], exh. cat. (Paris: Somogy and Musée des Beaux-Arts de Nantes, 1997), 163–166, 241–242. The Café du Dôme drawing is reproduced on page 87. Arriving in Paris from Nantes in

1927, Bryen was seen, as Vincent Rousseau and Gaelle Rageot write in the catalog (163), as someone who was destined to become "une 'figure' très célebre de Montparnasse et du quartier Latin" [a very celebrated figure in Montparnasse and the Latin Quarter].

37. Ibid., 164, and Sirató, "A francia szürrealizmus," 14.

38. Bryen, *L'aventure des objets* [The adventure of objects] (Paris: José Corti, 1937); reprinted in *Camille Bryen: A revers*, 47–55. This may be the final, realized form of the book *5 objets poétiques* [5 poetic objects] announced on the verso of the first edition of the Dimensionist Manifesto. Bryen – along with his collaborators Wols, Michelet, and Georges Matthieu – is credited with founding postwar "Art Informel." See T. Herold in *Camille Bryen* (Paris: Galerie de Seine/Images et Formes, 1970); Daniel Abadie, *Bryen abhomme* (Brussels: La Connaissance, 1973); and Jacqueline Boutet-Kapera, "Camille Bryen, peintre informel" [Camille Bryen, informal painter] in *Camille Bryen: A revers*, 109. See also Marcel Jean, *The History of Surrealist Painting*, trans. Simon Watson Taylor (New York: Grove Press, 1960), 269, and René Passeron, *A szürrealizmus enciklopédiája* [The encyclopedia of Surrealism] (Budapest: Corvina, 1983), 133, 298.

39. Quotations in this paragraph are from Sirató, "A francia szürrealizmus," 11–12, 15. On Sirató's study of biology, see "A Dimenzionista Manifesztum története," 22.

40. Sirató, "Korforduló," 121. In "A francia szürrealizmus" Sirató writes, "In one of the window displays of the Boulevard Raspail, a construction caught the attention of the public for a long time. It consisted of a cheap board, at the upper end of which was a hole of the diameter of a five-pengő coin, an iron nail, an iron hoop, and a bird's feather. Signed: 'Jouan (sic) Miro: Statue'" (12). There is yet another version of this anecdote in "A Dimenzionista Manifesztum története" (30–31), in which he makes clear that the "cheap board" was vertically mounted on a horizontal board. In these texts Sirató may be describing *Object (The Door)*, a work of 1931 (painted wood, metal, feathers, and found objects, 113.9 × 73 cm, private collection.) According to Carolyn Lanchner's notes to a 1993 Miró exhibition at the Museum of Modern Art in New York, this work was possibly exhibited at the exhibition *Sculptures de Joan Miró* at the Galerie Pierre in Paris from December 8, 1931, to January 16, 1932. While the iron hoop of Sirató's descriptions is missing, there is an old metal cupboard handle "at one end," but the "long feather" is attached directly to the "rotting board" (old cupboard door), rather than looped through the handle. In the "History of the Dimensionist Manifesto" Sirató dates this encounter with Miró's work to "five months" after his arrival in Paris, which would place it about January 1931. The Galerie Pierre show's location does not fit with Sirató's description either. By 1927 the Galerie Pierre, where *Object* was shown in 1931–1932, was at no. 2, Rue des Beaux-Arts, rather than on the Boulevard Raspail. Perhaps Miró's object was in a window display apart from any exhibition, or perhaps Sirató is conflating *Object* with *Spanish Dancer* (1928, collage-object, 100 × 80 cm), owned by André Breton, in which the feather is held in place by a steel hatpin at the work's center. This piece was possibly on display in 1930, but before Sirató's arrival in late August. See Carolyn Lanchner, *Joan Miró*, exh. cat. (New York: Museum of Modern Art, 1993), 169, 183, 391, 398, 438–440. Note that elsewhere in the "History of the Dimensionist Manifesto" ("A Dimenzionista Manifesztum története," 37), Sirató mistakenly remembers the Galerie Pierre as having been on the Rue de Seine in 1934, rather than in the nearby Rue des Beaux-Arts.

41. Calder moved to Paris in 1928 and frequented the Dôme, as did Kertész and Sirató. Indeed, he knew Tihanyi, who had photographed him in 1929. See Phillips, *André Kertész*, 169, 268, and James Johnson Sweeney, *Alexander Calder* (New York: Museum of Modern Art, 1943), 24. Sirató might have seen his 1931 show at the Galerie Percier. In any case, in the "History of the Dimensionist Manifesto" he remembers that Calder's "mobiles and later his motorized, kinetic sculptures held all of us permanently in their thrall" ("A Dimenzionista Manifesztum története," 70). On Calder, Nicholson, and the Dimensionist Manifesto, see Vanja Malloy, "Non-Euclidean Space, Movement

and Astronomy in Modern Art: Alexander Calder's Mobiles and Ben Nicholson's Reliefs," *EPJ Web of Conferences* 58 (2013).

265

NOTES

42. The *Lichtrequisit* – a collaboration with István Sebök – was in the German section of the 20th Salon des Artistes Décorateurs in Paris in 1930. Designed by Walter Gropius, Herbert Bayer, Marcel Breuer, and Moholy-Nagy for the German Werkbund, it is described in Richard P. Lohse, *New Design in Exhibitions* (Erlenbach-Zürich: Verlag für Architektur, 1953), 20–27. On the idea that it was displayed behind translucent glass, see Oliver A. I. Botar, *Sensing the Future: Moholy-Nagy, Media and the Arts* (Zurich: Lars Müller, 2014), 112–126.

43. See Phillips, *André Kertész*, 46.

44. Sirató, "A Dimenzionista Manifesztum története," 52–53; Bánki, "Harminc évig nem írtam verset," 22, and Sirató, "Emlékét saját müvészetemben Örzöm," 59.

45. On Robert Delaunay's experiments with materials starting around 1930, and his shift from easel painting to mural work, see Fabre, *Paris: Arte Abstracto*, 92–93, 386; Michel Hoog, *Robert Delaunay, Sonia* (Ottawa: National Gallery of Canada, 1965), figs. 48 and 49; and Michel Hoog, *Robert Delaunay 1885–1941* (Paris: Orangerie des Tuileries, 1976), cat. nos. 103–107. See also Delaunay's 1935 text quoted in Ernst-Gerhard Güse, *Reliefs: Formprobleme zwischen Malerei und Skulptur im 20. Jahrhundert* [Reliefs: Form problems between painting and sculpture in the twentieth century], exh. cat. (Zurich: Kunsthaus Zürich, 1980), 195.

46. On Sirató's encounter with Prinner (whom he met by chance in Montparnasse), see "A Dimenzionista Manifesztum története," 55–56. For reproductions of Prinner's reliefs, see Fabre, *Paris: Arte Abstracto*, 128–129.

47. Sirató, "A Dimenzionista Manifesztum története," 37. Domela, who had been living in Berlin since 1927, arrived in Paris in 1933 as a refugee from the Nazis. See H. L. C. Jaffé, *Domela* (Carmen Martinez, n.d. [c. 1980]), 172.

48. Zdenek Felix, ed., *Francis Picabia: The Late Works 1933–1953* (Stuttgart: Hatje, 1998).

49. See Picabia, *The Handsome Pork Butcher*, 1935, oil on canvas with combs, in Borràs, *Picabia*, 405. On Picabia and the Dimensionist Manifesto, see Borràs, *Picabia*, 382. Born in 1886 or 1887 in Gablonz, what is now Jablonec, Czech Republic, Kann studied architecture, painting, sculpture, and applied arts at the Technical College of Prague and the Academy of Fine Arts in Prague. He exhibited with Die Brücke in 1905. In 1910 he moved to New York, where he worked as a commercial artist, and in 1928 he moved to Paris, where he turned to painting abstractions. He supported himself by teaching art, founding – with Domela – the first serigraphic studio in Paris and exhibiting with Abstraction-Création in 1935. See the biography of Kann on the website of D. Wigmore Fine Art Inc. (http://www.dwigmore.com/kann.html); see also Jaffé, *Domela*, 176; Gladys Fabre, *Abstraction-Création 1931–1936* (Paris: Musée d'Art Moderne de la Ville de Paris, 1978), 305; and A. E. Gallatin et al., eds., *American Abstract Artists, 1939* (New York: AAA, 1939). Sirató remembers Domela's calling Kann and his work to his attention. See Sirató, "A Dimenzionista Manifesztum története," 52. By 1936 Kann returned to the United States, settling in Kansas City, where he directed the advertising and design department of the Kansas City Art Institute. He was a founding member of American Abstract Artists. In 1943 he accepted a teaching position at the Chouinard Art Institute in Los Angeles, where he opened the Frederick Kann-Frank Martin Gallery, also known as the Circle Gallery, which specialized in abstract art. He established the Kann Institute of Art in West Hollywood in 1953 and died there in 1965.

50. Sirató, "A Dimenzionista Manifesztum története," 36.

51. Sirató, "A francia szürrealizmus," 15.

52. Sirató, "A Dimenzionista Manifesztum története," 35–36, and Aczél, *Tamkó Sirató Károly*, 107. On Julien Moreau and Bryen, see also *Camille Bryen: A revers*, 162–163.

53. Sirató, "Korforduló," 121, and Henderson, *The Fourth Dimension*, xxii. See p. 101 on Apollinaire's identification of color as the "ideal dimension" in Delaunay's work. On Delaunay's possible interest in the fourth dimension as early as 1912, see Sherry A. Buckberrough, *Robert Delaunay: The Discovery of Simultaneity* (Ann Arbor: University of Michigan Press, 1982), 104, 106–107, 109. Despite these references, Buckberrough would, I think, agree with Henderson on this point. On Apollinaire and the fourth dimension, see Henderson, *The Fourth Dimension*, 160–162, 75. The Russian artist Clement Redko also remembers the Thursday get-togethers in 1935: "Tous les vendredis, je vais à la Closerie des Lilas" [every Thursday I would go to la Closerie des Lilas] (Hoog, *Robert Delaunay 1885–1941*, 26).

54. See Waldemar-George, *Kochar et la peinture dans l'espace* [Kochar and painting in space] (exh. cat.) (Paris: Galerie Percier, 1966). Thanks to Gladys Fabre for giving me a copy of this catalog. On modernism in Tblisi and Georgia in general, see Ram Harsha, "Special Topic: Introducing Georgian Modernism," *Modernism / Modernity* 21, no. 1 (January 2014), 283–359.

55. Sirató, "Korforduló," 121. Also see Sirató, "A Dimenzionista Manifesztum története," 38–41. In *Kochar et la peinture dans l'espace*, Waldemar-George also reports he was unable to locate a manuscript of the Manifesto among the artist's papers, which he had also heard of from Kochar after the artist left Paris in 1936. For *sculpture-ouverte* Sirató uses the term "üreges szobrászat" [lacunose sculpture]. See Sirató, "Korforduló," 122.

56. Ibid.

57. Sirató, "A Dimenzionista Manifesztum története," 36–38, 41. Despite this contact, Gabo did not sign the Manifesto, perhaps because, as Martin Hammer and Christina Lodder write in *Constructing Modernity: The Art and Career of Naum Gabo* (New Haven: Yale University Press, 2000), in Paris "he was extremely wary of becoming involved in groupings." They explain that "Gabo was anxious to avoid being associated with artists who did not hold exactly the same views as himself, fearing that his own objectives would be misrepresented and that true Constructivism would be compromised" (213). One should also keep in mind, however, that Gabo had moved to London by March 25, 1936, and so he was no longer around to be convinced to sign. On Gabo's and Domela's friendship in Paris, see Hammer and Lodder, *Constructing Modernity*, 219.

58. Sirató, "A Dimenzionista Manifesztum története," 44.

59. Ibid., 45–48; Sirató, "Korforduló," 122, and Bánki, "Harminc évig nem írtam verset," 22. Note that Sirató differs on some details in his three accounts. On Bryen and Dimensionism, see also *Camille Bryen: A revers*, 62, 167–168, and for his own terse recollection, Abadie, *Bryen abhomme*, 156.

60. On "psycho-biology" see Botar, *Sensing the Future,* chapter 2.

61. László Moholy-Nagy, *The New Vision: From Material to Architecture*, trans. Daphne M. Hoffmann (New York: Brewer, Warren & Putnam, 1932), 83, 138, revised English edition of *Von Material zu Architektur* (Munich: Albert Langen, 1929), 93ff. This passage is a development of his "Geradlinigkeit des geistes – umwege der technik" [Directness of the spirit – detours of technology], *bauhaus* 1 (December 4, 1926): 5. See also Wassily Kandinsky, *Punkt und Linie zu Fläche. Beitrag zur Analyze der malerischen Elemente* [Point and line to plane] (Munich: Albert Langen, 1926). On Mikhail Matiushin's theory of the progression of spatial perception in art, see Isabel Wünsche, "Organic Visions and Biological Models in Russian Avant-Garde Art," in Botar and Wünsche, *Biocentrism and Modernism*, 138. On Prampolini's "The Magnetic Theatre and the Futurist Scenic Atmosphere" (*Little Review*, 1926) and its theme of "dimensional progression," see Linda Henderson's essay in this volume.

62. Veit Loers suggests that Moholy-Nagy might have seen Ouspensky's *Tertium Organum* (1912). I agree that the parallels with Ouspensky's ideas are striking, but there is no evidence that he knew Ouspensky's works first hand. See Loers, "Moholy-Nagy und die vierte Dimension" [Moholy-Nagy and the fourth dimension], in Gottfried Jäger and Gudrun Wessing, eds., *Über Moholy-Nagy* [About Moholy-Nagy] (Bielefeld: Kerber, 1997), 157–162.

63. Moholy-Nagy, "Geradlinigkeit des geistes," 188.

64. Leonard Shlain, *Art and Physics: Parallel Visions in Space, Time, and Light* (New York: William Morrow, 1991), 133.

65. László Moholy-Nagy, *The New Vision: Fundamentals of Design, Painting, Sculpture, Architecture*, rev. American edition (New York: W. W. Norton, 1938), 89.

66. Alain Findeli, "Laszlo Moholy-Nagy, Alchemist of Transparency," *The Structurist*, nos. 27–28 (1987–1988): 9.

67. Lucia Moholy, *Marginalien zu Moholy-Nagy* [Moholy-Nagy: Marginal Notes] (Krefeld, Germany: Scherpe, 1972), 56. Moholy did refer to Rudolf Carnap's scientifically respectable texts "Der Raum" in *Kantstudien* (Berlin, 1922), *Über die Abhängigkeit der Eigenschaften des Raumes von denen der Zeit* [On the Dependence of spatial characteristics on those of time] (1925), and *Der logische Aufbau der Welt* [The logical construction of the world] (Berlin: Weltkreisenverlag, 1928). See Moholy-Nagy, "Modern Art and Architecture," in Krisztina Passuth, *Moholy-Nagy* (London: Thames and Hudson, 1985), 340; and Loers, "Moholy-Nagy und die vierte Dimension," 159. While Sirató's psycho-biological view on intuition, his reliance on Spengler's biologistic historicism, and his speculation on the fourth dimension also demonstrate the parallel between his thinking and Moholy's, this is a topic that will have to be dealt with elsewhere.

68. Sirató, "A Dimenzionista Manifesztum története," 54. On Arp's role, see Aczél, *Tamkó Sirató Károly*, 119, and Aczél, *Termő avantgarde*.

69. Sirató, "Emlékét saját emlékezetemben őrzöm," 59.

70. One of the contributions to "Mosaic" is signed "Kotchar-Nissim," suggesting a close relation between the men. On Nissim as a follower of Kochar and of his "Peinture dans l'espace," see Sirató, "A Dimenzionista Manifesztum története," 56. Nissim was one of the illustrators of Philippe Soupault's *Journal d'un fantôme* [A ghost's diary] (Paris: Editions du Point du jour, 1946), which also included illustrations by Victor Brauner, André Masson, and Raoul Ubac, indicating that Nissim moved in Parisian Surrealist circles.

71. Luis de Moura Sobral, *Le surréalisme portugais* [Portuguese Surrealism], exh. cat. (Montreal: Galerie UQAM, 1984), 91. Though I have not seen a copy, Lisbon is named as the place of publication of this version of "Le Planisme" (Fradique, 1936) by Sirató in his *Kozmogrammok*, dust jacket flap, and in his "A Dimenzionista Manifesztum története," 68. Some information on Pedro is from *The Grove Dictionary of Art* (http://www.artnet.com). See Antonio Pedro, *15 Poèmes au hasard* [15 random poems] (Paris: Edition Up, 1935). The portrait of the artist in this volume is by the Hungarian artist Béla Czóbel, who was then living in Paris (3). Pedro's translation of the Manifesto into Portuguese was published as Charles Sirató, "Manifesto Dimensionista," in Petrus, ed., *Os modernistas portugueses: escritos publicos, públicos, proclamações e manifestos* [The Portuguese Modernists: public writings, publics, proclamations and manifestos] (Oporto: C.E.P., 1961), 67.

72. Sirató, "A Dimenzionista Manifesztum története," 49–51.

73. Árpád Mezei, "Marcel Duchamp," in *Mikrokozmoszok és értelmezések* [Microcosms, interpretations] (Pécs: Jelenkor, 1993), 76. On Gleizes and the fourth dimension, see Henderson, *The Fourth Dimension*. Mezei's source was Sirató, who may have met Gleizes through Tihanyi and

Brassaï. On their contact with Gleizes as early as January 1925, see Brassai, *Előhívás* (Bucharest: Kriterion, 1980), 89.

74. In 1965 Sirató wrote: "In my great enthusiasm I elected him to be an honorary Dimensionist, against which he now perhaps cannot have an objection." "A Dimenzionista Manifesztum története," 72.

75. *Telehor*, nos. 1–2 appeared on February 28, 1936. A part of Moholy-Nagy's letter of April 13, 1936, in response to Sirató's request for support, is reproduced in Sirató, "Korforduló," 126, and further passages are reprinted in "A Dimenzionista Manifesztum története," 68–69. Hattula Moholy-Nagy has preserved her father's copy of the "Dimensionism" issue of *Plastique*, no. 2 (Summer 1937) in her archive in Ann Arbor, Michigan. On Moholy-Nagy's suggestion to Sirató, see Szabó, "Tamkó Sirató Károly," 276. On the content of *Telehor*, see Oliver A. I. Botar and Klemens Gruber's introduction to the facsimile edition of *Telehor* 1–2 (1936) (Zurich: Lars Müller, 2013).

76. Linda Dalrymple Henderson, "Paradigm Shifts and Shifting Identities in the Career of Marcel Duchamp, Anti-Bergsonist 'Algebraicist of Ideas,'" in Anne Collins Goodyear and James W. McManus, eds., *aka Marcel Duchamp: Meditations on the Identities of an Artist* (Washington, DC: Smithsonian Institution Scholarly Press, 2014), 82.

77. The quotations and information concerning Duchamp are from Sirató, "A Dimenzionista Manifesztum története," 61–66. In his later montage *A Dimenzionizmus emblémája* [The emblem of Dimensionism] (in "Korforduló," 125), Sirató included the Dimensionist Manifesto, surrounded by what one must presume are some of the most important factors leading to its formulation, including "Virágok 17" [Flowers 17], "a képvers" by Kassák, a "Calligramme" by Apollinaire, Robert Delaunay photographed in front of one of his murals in the early 1930s, another one of Duchamp's *Rotoreliefs*, a work possibly by Calder, a 1936 painting by Domela from the *Dimensionisme* issue of *Plastique*, and *Paris*, one of Sirató's own planar poems.

78. Of Taeuber-Arp, Sirató wrote that "because at that time very few women were on the scene, she was the first woman who produced really memorable works in this completely new field." Sirató, "A Dimenzionista Manifesztum története," 54. Domela had brought Katarzyna Kobro to Sirató's attention as an "early representative of the Dimensionist spirit" (71).

79. On Picabia, see Henderson, *The Fourth Dimension*, 210–218, and Borràs, *Picabia*, 382–384. In the "History of the Dimensionist Manifesto," Sirató indicates how much he "liked Picabia, every one of his works," since he had first encountered his poetry in the 1920s (Sirató, "Dimenzionista Manifesztum története, 52–54). Sirató remembers having gone, along with Lévesque, to visit Picabia at his Paris pied-à-terre in order to discuss the Manifesto (which Picabia approved of) and to collect his signature (53). As indicated by Picabia's statement in "Mosaic," and by the advertisement of a March 1936 exhibition on the verso of the Manifesto, it was Picabia's "superposition" paintings that were seen as dimensionist by the group (see Borràs, *Picabia*, 382, 384–385). On Negri, recruited for the Manifesto by Frederick Kann, see Ulrich Thieme and Felix Becker, *Allgemeines Lexikon der Bildenden Künstler des XX. Jahrhunderts* (Leipzig: Seeman, 1967), 466. Negri was active in the 1930s in Parisian Surrealist circles, particularly the one that formed around Stanley William Hayter and Atelier 17. On Rathsman, see ibid., vol. 4, 221. See also Sirató, "A Dimenzionista Manifesztum története," 66.

80. Sirató would have known Huidobro's work from both *Magyar Írás* and *MA*. Indeed, Sirató received a copy of one of Huidobro's books from Tibor Déry while he was still in Budapest. See Sirató, "A Dimenzionista Manifesztum története," 67–68. Sirató's Paris friend Tihanyi was acquainted with Huidobro. See his Paris portrait of the Chilean poet (1924, chalk on paper, 52 × 32.2 cm, Hungarian National Gallery, Budapest, inv. no. F.70.142, Gift of Brassaï [Gyula Halász]).

Arp was also in close contact with Huidobro at the time, as he had just illustrated Huidobro's *Tres inmensas novelas* [Three immense novelas] (Santiago de Chile: Zig Zag, 1935). Curiously, Huidobro's papers, some of which are now preserved in the Getty Research Institute, contain no references to Sirató or Dimensionism. Despite indications that he was to translate the Dimensionist Manifesto into Spanish, and despite the fact that he owned a copy, there is no indication of this in the most thorough publication on Huidobro known to me: *Salle XIV: Vicente Huidobro y las artes plásticas* [Vicente Huidonro and the plastic arts] (Madrid: Museo Reina Sofía, 2001), 264–266.

81. Albert-Birot, with whom Sirató had been in touch fairly early after his arrival in Paris, founded the Paris avant-garde journal *Sic* in 1917–1918. On *Sic*, and on Albert-Birot as a "Simultaneist," Dada, and Surrealist poet, see Jean, *The History of Surrealist Painting*, 69, 81, 203. See also Sirató, "A Dimenzionista Manifesztum története," 55. Lévesque's journal *Orbes* was described as a "revue aux tendances dimensionistes" [journal with dimensionist tendencies] according to the announcement in the Dimensionist Manifesto (1936: verso).

82. Those missing included Daniel Baranoff-Rossiné, Sirató's Hungarian friend Étienne Béothy, Willy Baumeister, Charles Biederman, Max Bill, Carl Buchheister, Lucio Fontana, Otto Freundlich, Gabo, Jean Gorin, Auguste Herbin, Pevsner, Schwitters, Wladislaw Strzeminski, Léon Tutundjian, and Friedrich Vordemberge-Gildewart. See Fabre, *Paris: Arte Abstracto*; and Fabre, *Abstraction-Création 1931-1936*, 304–306. According to Mezei, Picasso was excluded because "someone in Sirató's circle of friends resolutely opposed" extending an invitation to the expatriate Spaniard. See Mezei, "Marcel Duchamp," 76. When I asked Mezei in my interview who this was, he did not recall, but he remembered that Sirató told him it was an ardent Communist who held Picasso to be a "Salon Communist" and said that if Picasso was asked to sign, he would refuse. This may well have been the Stalinist Kochar who soon returned to the Soviet Union, where, after the mid-1950s, he became one of the foremost sculptors of Soviet Armenia.

83. Sirató, "A Dimenzionista Manifesztum története," 58. Kandinsky's addendum has been omitted from Peter Vergo and Kenneth C. Lindsay, eds., Kandinsky, *Complete Writings on Art* (New York: Da Capo Press, 1994).

84. Szabó, "Tamkó Sirató Károly," 276. While Szabó refers to the document only as "the plan for the first international exhibition of Dimensionism" within her text, it is likely that she is referring to the *Premier album Dimensioniste* [First Dimensionist Album], a document to which she had access when she published her article in 1985.

85. Tamkó Sirató, "A Dimenzionista Manifesztum története," 68.

86. Ibid., 74–79.

87. *Plastique* (Paris and New York, 1937–1939, three issues). The first issue of the journal was produced by Taeuber-Arp and Domela with Arp's assistance. Aline Vidal, interview with Jean Hélion, in Jane Hancock and Stefanie Poley, *Arp 1886-1966* (Stuttgart: Gerd Hatje, 1986), 174. On Domela's role in this regard, see Szabó, "Tamkó Sirató Károly," 276.

88. Aczél, *Tamkó Sirató Károly*, 121.

89. Sirató, "A Dimenzionista Manifesztum története," 85–86.

90. See the published essay, Stephen Peterson, "Space, Infinity, and the Play of Dimensions in the Art of Lucio Fontana, Yves Klein and Piero Manzoni" (c. 2000), typescript provided by Linda Henderson.

91. Borràs, *Picabia*, 383. In his 1966 album, Sirató included illustrations of three of Fontana's "Concetto Spaziale" works. See Artpool and Magyar Műhely Kiadó's copublished 2010 book, Sirató, *A Dimenzionista Manifesztum története*, 138.

270

NOTES

92. Crispolti, "Una dimenticata partecipazione di Prampolini," 151–152. See also Fabre, *Paris: Arte Abstracto*, 408; Udo Kultermann, *The New Sculpture: Environments and Assemblages*, trans. Stanley Baron (London: Thames and Hudson, 1968). This process culminated in Jack Burnham's teleological history of modern sculpture as an inexorable drive toward cybernetic kineticism. See Burnham, *Beyond Modern Sculpture: The Effect of Science and Technology on the Sculpture of This Century* (New York: Braziller, 1968). On Schöffer and Vasarely, see Bánki, "Harminc évig nem írtam verset," 23.

93. See Richard Kostelanetz, "Moholy-Nagy: Proto-Holographer," *The Structurist* no. 27–28 (1987–1988): 12–14.

94. Sirató, "Korforduló," 128.

95. Bánki, "Harminc évig nem írtam verset," 23. See also Sirató, "A Dimenzionista Manifesztum története."

2 THE DIMENSIONIST MANIFESTO AND THE MULTIVALENT FOURTH DIMENSION IN 1936

1. On the role of the fourth dimension in twentieth-century art, see Linda Dalrymple Henderson, *The Fourth Dimension and Non-Euclidean Geometry in Modern Art* (1983; rev. ed., Cambridge, MA: MIT Press, 2013); see also Henderson, "The Image and Imagination of the Fourth Dimension in 20th-Century Art and Culture," *Configurations: A Journal of Literature, Science, and Technology* 17 (Winter 2009): 131–160.

2. Charles Sirató, Dimensionist Manifesto, loose-leaf insert intended for the unrealized journal *La Revue N + 1* (to have been published by José Corti, Paris, 1936).

3. See, e.g., Linda Dalrymple Henderson, "Modern Art and Science 1900–1940: From the Ether and a Spatial Fourth Dimension (1900–1920) to Einstein and Space-Time (1900–1940)," in Cathrin Pichler with Suzanne Neuburger, eds., *The Moderns: Wie sich das 20. Jahrundert in Kunst und Wissenschaft erfunden hat* [How the 20th century invented itself in art and science] (New York and Vienna: Springer, 2013), 175–206. On ether physics and the discoveries that dominated the public's scientific world view before 1919, see Linda Dalrymple Henderson, "Editor's Introduction: I. Writing Modern Art and Science – An Overview; II. Cubism, Futurism, and Ether Physics in the Early Twentieth Century," *Science in Context* 17 (Winter 2004): 423–466.

4. Sirató, Dimensionist Manifesto, paragraph 3.

5. See Oliver A. I. Botar's essay in this book, "Charles Sirató and the Dimensionist Manifesto." First written in 1996–1998, the essay was revised in 2005 and 2007–2010, and in 2017–2018 for this publication. An unpublished 2010 version titled "Sirató and the Manifeste Dimensioniste" was distributed as an insert in Tamkó Sirató Károly, *A Dimenzionista Manifesztum története: a dimenzionizmus (nemeuklideszi művészetek) I. albuma: az avantgárd művészetek rendszerbe foglalása* [The history of the Dimensionist Manifesto: Album I of Dimensionism (non-Euclidean arts) – The systematization of avant-garde arts] (Budapest: Artpool and Magyar Műhely Kiadó, 2010). Please see note 1 of Botar's essay for more details.

6. In the course of his long-term study of the Dimensionist Manifesto, Botar defined "the *topos* of dimensional inflation"; see Botar, "Charles Sirató and the Dimensionist Manifesto," 40. On the theme of expanding perception in the work of Moholy-Nagy, see, e.g., Oliver A. I. Botar, *Sensing the Future: Moholy-Nagy, Media, and the Arts* (Zurich: Lars Müller, 2014), 81–97.

7. Árpád Mezei, as quoted in Botar, "Charles Sirató and the Dimensionist Manifesto," 26.

8. For Einstein's theories, see, e.g., Helge Kragh, *Quantum Generations: A History of Physics in the Twentieth Century* (Princeton: Princeton University Press, 1999); on the delayed reception of relativity theory, see Thomas F. Glick, ed., *The Comparative Reception of Relativity* (Dordrecht, Netherlands: D. Reidel, 1987). Einstein's 1905 special theory of relativity had asserted that the laws of nature are the same for all systems moving uniformly with respect to each other, that no system can be considered absolute, and that in the transition from one system to another, measurements of distance and time will change and are likewise not absolute. Minkowski's formulation of a four-dimensional space-time continuum in 1908 made it possible to relate varying frames of reference to one another mathematically. In Minkowski's interpretation, the space of an individual observer's frame of reference at one instant would be a three-dimensional cross-section of the four-dimensional continuum, with time understood as perpendicular to that frame and extending the length of the continuum.While Einstein's special theory had focused on systems in uniform motion, the general theory of relativity (1915) extended that principle to systems in accelerated motion as well. Adopting Minkowski's model, Einstein incorporated gravitation as curvature in the metric of space-time in the vicinity of matter—specifically, the nonuniform curvature explored by the nineteenth-century mathematician Georg Friedrich Bernhard Riemann. With the curved space of the field determining the motion of bodies within it, space-time (and relativity theory) was now fundamentally non-Euclidean, in contrast to Minkowski's original formulation in 1908.

9. On Moholy-Nagy and Gabo, see, e.g., Linda Dalrymple Henderson, "Einstein and 20th-Century Art: A Romance of Many Dimensions," in Peter L. Galison, Gerald Holton, and Silvan S. Schweber, eds., *Einstein for the 21st Century* (Princeton: Princeton University Press, 2007), 101–129. Gabo was one of the artists Sirató visited in Paris as he studied the state of contemporary sculpture (Sirató, "History of the Dimensionist Manifesto" [translated in the appendix of this volume], 211); he was not among the signers, however.

10. On this subject, see Peter Galison, "Minkowski's Space-Time: From Visual Thinking to the Absolute World," *Historical Studies in the Physical Sciences* 10 (1979): 85–121. This was the spatialization of time Bergson so opposed in Einstein's relativity theory; see Henri Bergson, *Durée et simultanéité: A propos de la théorie d'Einstein* [Duration and simultaneity: About Einstein's theory] (Paris: Félix Alcan, 1922), chap. 6. On the 1922 debate between the two, see Jimena Canales, *The Physicist and the Philosopher: Einstein, Bergson, and the Debate that Changed Our Understanding of Time* (Princeton: Princeton University Press, 2015).

11. Mezei, as quoted in Botar, "Charles Sirató and the Dimensionist Manifesto," 51.

12. Ibid.

13. Ibid., 25–26, 30, 39. As Botar notes (30), Sirató read Bergson's *Durée et simultanéité* and found a way beyond the conflict between Bergson's focus on psychological time and Minkowski's geometrical spatialization of time. See note 10 above.

14. Oswald Spengler, *The Decline of the West* (New York: Alfred A. Knopf, 1934), 174.

15. See Botar, "Charles Sirató and the Dimensionist Manifesto," 51. As Botar notes, Sirató inserted the name of Hungarian geometer János Bólyai in the Hungarian version of the Manifesto (see ibid., 13). On the emergence of non-Euclidean geometries in the nineteenth century and their popularization, see Henderson, *The Fourth Dimension*, chap. 1.

16. See note 8.

17. Sirató, as quoted in "Charles Sirató and the Dimensionist Manifesto," 35; see also Sirató, "History of the Dimensionist Manifesto," 208. Guillaume Apollinaire had likewise loosely associated the fourth dimension with going beyond Euclid in his *Les peintres cubistes* (Cubist painters) of

1913; there he notes that "scholars no longer limit themselves to the three dimensions of Euclid." See Henderson, *The Fourth Dimension*, chap. 2 (section titled "Non-Euclidean Geometry") on such technically incorrect usages as well as actual references to curved, non-Euclidean geometry in Cubism. See also ibid., chap. 1 on the history of these various geometries.

18. Sirató, Dimensionist Manifesto, back page.

19. For the full list of signatories, see ibid.

20. For Kandinsky's request to add "refinements" to the Manifesto, see Sirató, "History of the Dimensionist Manifesto," 223.

21. See again note 3 for ether physics. For an excellent introduction to the science of the late nineteenth and early twentieth century, see Alex Keller, *The Infancy of Atomic Physics: Hercules in His Cradle* (Oxford: Clarendon Press, 1983).

22. For this history, see Sirató, "History of the Dimensionist Manifesto"; and Botar, "Charles Sirató and the Dimensionist Manifesto."

23. For the history of Cercle et Carré, see Lynn Boland, "Inscribing a Circle," in *Cercle et Carré and the International Spirit of the Avant-Garde*, org. Lynn Boland (Athens: Georgia Museum of Art, 2013), 8–55.

24. On Abstraction-Création, see, e.g., Gladys Fabre, *Abstraction-Création 1931–1936* (Paris: Musée d'Art Moderne de la Ville de Paris, 1978).

25. Pierre Daura Diary, December 13, 1929 (Daura Archive, Georgia Museum of Art); quoted in Boland, "Inscribing a Circle," 39.

26. Sirató refers multiple times to Surrealism in his "History of the Dimensionist Manifesto"; see, e.g., 220. For Cubism and Futurism, see note 31 and the related text below.

27. See Gavin Parkinson, *Surrealism, Art, and Modern Science: Relativity, Quantum Mechanics, Epistemology* (New Haven: Yale University Press, 2008), chap. 2; see also Gaston Bachelard, *Le nouvel esprit scientifique*, 5th ed. (Paris: Presses Universitaires de France, 1949), 24–26.

28. See Gaston Bachelard, "Surrationalism," in Julien Levy, *Surrealism* (New York: Black Sun Press, 1936), 186–187.

29. See André Breton, "Crise de l'objet" [Crisis of the Object] (1936), in *Le Surréalisme et la peinture* [Surrealism and painting] (New York: Brentano's, 1945), 125–132; on Breton and Bachelard, specifically, see Parkinson, *Surrealism, Art, and Modern Science*, 58–69. On Dalí and other Surrealist painters' responses to non-Euclidean geometry, see, e.g., Henderson, *The Fourth Dimension* (2013), 499–500, as well as Parkinson, *Surrealism, Art, and Modern Science*, 153–155 (Matta), 191–193 (Dalí).

30. On the major philosophical debates about the nature of geometrical axioms in response to non-Euclidean geometry, see Henderson, *The Fourth Dimension*, chap. 1 (section titled "The Popularization of Non-Euclidean Geometry: Helmholtz to Poincaré").

31. Sirató, Dimensionist Manifesto, paragraph 1.

32. On the "short circuit" that occurred between early Cubist references to a spatial fourth dimension and the increasing prominence of the temporal fourth dimension of relativity theory, see Linda Dalrymple Henderson, "Four-Dimensional Space or Space-Time: The Emergence of the Cubism-Relativity Myth in New York in the 1940s," in Michele Emmer, ed., *The Visual Mind II* (Cambridge, MA: MIT Press, 2005), 349–397.

33. On Princet and these conversations, see Henderson, *The Fourth Dimension*, 171–174, as well as chap. 2 more generally on the circle of Salon Cubists, centered on Gleizes and Metzinger as well as the Duchamp brothers in suburban Puteaux. Duchamp's discussions with Princet occurred separately, since he reported in an interview with Pierre Cabanne late in life, "I knew Delaunay by name, not more." See Pierre Cabanne, *Dialogues with Marcel Duchamp*, trans. Ron Padgett (New York: Viking Press, 1971), 28.

34. See Henderson, *The Fourth Dimension*, chap. 1.

35. See Claude Bragdon, *A Primer of Higher Space (The Fourth Dimension)* (Rochester, NY: Manas Press, 1913), 16–18, and plates 14, 16. See also Henderson, *The Fourth Dimension*, chap. 1, on Charles Howard Hinton, British author of *A New Era of Thought* (1888) and *The Fourth Dimension* (1904), who was a key source for Bragdon and who initiated such discussions of time and motion.

36. See Albert Gleizes and Jean Metzinger, *Du Cubisme* (Paris: Eugène Figuière, 1912), 18; translated as "Cubism," in Robert L. Herbert, ed., *Modern Artists on Art* (Englewood Cliffs, NJ: Prentice-Hall, 1964), 8. On Poincaré's importance for the circle of Salon Cubists, see Henderson, *The Fourth Dimension*, chap. 2.

37. Jean Metzinger, "Cubisme et tradition," *Paris-Journal*, August 16, 1911; quoted in Henderson, *The Fourth Dimension* (2013), 202.

38. Samuel Halpert letter to Robert Delaunay, August 24, 1911 (Fonds Robert and Sonia Delaunay, Bibliothèque Nationale, Paris; hereafter, Fonds Delaunay).

39. Samuel Halpert letter to Robert Delaunay, March 29, 1912 (Fonds Delaunay).

40. For the text by Princet, see Galerie Barbazanges, *R. Delaunay, Marie Laurencin: Les peintres* (Paris: Galerie Barbazanges, 1912).

41. Samuel Halpert letter to Robert Delaunay, December 23, 1912 (Fonds Delaunay).

42. For Robert Delaunay's *Simultaneous Windows* series and the evolution of his style during 1912, see, e.g., Pascal Rousseau and Jean-Paul Ameline, *Robert Delaunay 1906–1914: De l'impressionisme à l'abstraction* [Robert Delaunay 1906–1914: From Impressionism to abstraction] (Paris: Editions du Centre Pompidou, 1999).

43. In a January 1913 letter to Robert Delaunay, Halpert recounts having seen Picabia, who was then in New York for the Armory Show, and hearing about "the 'wars' among the 'cubists'" (Halpert letter to Robert Delaunay, January 29, 1913 [Fonds Delaunay]). Delaunay did attempt to connect color to multiple dimensions in an unpublished text of the 1920s or later, where he writes of the effect of "mélanges optiques" [optical mixture] in the viewer's eye: "Par consequent l'objet measurable que l'on appelle le tableau, surface à deux ou plusieurs dimensions se lisant simultanément dans le rayon visual, deviant un objet à multiples dimensions." [Consequently, the measurable object that one calls the painting, a surface of two or more dimensions reading simultaneously in the visual ray, becomes an object of multiples dimensions.] See Robert Delaunay, *Du Cubisme à l'art abstrait* [From Cubism to abstract art], ed. Pierre Francastel (Paris: S.E.V.P.E.N., 1957), 60.

44. Guillermo de Torre, manuscript draft (early 1920s) for "Destruction et construction: La peinture de Robert Delaunay" [Destruction and construction: The painting of Robert Delaunay], 21 (Fonds Delaunay, filed under "Lettres et manuscrits"). De Torre was a Spanish poet who was much influenced by Apollinaire and who was himself interested in the fourth dimension in the context of the Ultraist movement of the late 1910s. See Willard Bohn, *The Avant-Garde Imperative: The Visionary Quest for a New Language* (Amherst, NY: Cambria Press, 2013), 30–33; and Bohn, *Apollinaire and the International Avant-Garde* (Albany: State University of New York Press, 1997).

45. Peter Brooke documents the interactions between Gleizes and Delaunay in a chapter devoted to Delaunay and elsewhere throughout *Albert Gleizes: For and Against the Twentieth Century* (New Haven: Yale University Press, 2001); on Delaunay's rejection of the term "Cubist" for his art, see ibid., 164.

46. Albert Gleizes, unpublished typescript titled "Robert Delaunay," 79 (Fonds Delaunay, filed under "Lettres et manuscrits").

47. See Botar, "Charles Sirató and the Dimensionist Manifesto," 41.

48. See Brooke, *Albert Gleizes*, 124. On de Broglie's physics, see Parkinson, *Surrealism, Art, and Modern Science*, 23–25. De Broglie's work occurred in the context of the quantum physics that Einstein rejected, so the adulation of relativity theory in the Dimensionist Manifesto could well have been a problem for Gleizes. Bachelard and the Surrealists were also interested in de Broglie as part of the general interest in quantum physics; see, e.g., Parkinson, *Surrealism, Art, and Modern Science*, 62, and throughout.

49. Delaunay, letter to *Vell i nou*, December 15, 1917, in Delaunay, *Du Cubisme à l'art abstrait*, 131.

50. For Delaunay's statement, see Sirató, Dimensionist Manifesto, "Mosaic." In discussing Delaunay's mural paintings for the 1937 Exposition Internationale in Paris, Romy Golan suggests the importance for the French painter of both Prampolini's "Aeropittura" paintings and his use of various media in his "Poly-material Compositions." See Golan, *Muralnomad: The Paradox of Wall Painting, Europe 1927–1957* (New Haven: Yale University Press, 2009), 71–73. See also the essay by Pascal Rousseau, cited in note 109 below.

51. On electromagnetism in Delaunay's art, see, e.g., Linda Dalrymple Henderson, "Bilder der Frequenz. Moderne Kunst, elektromagnetische Wellen und der Äther im frühen 20. Jahrhundert" [Painting frequency: Modern art, electromagnetic waves, and the ether], in Friedrich Balke, Bernhard Siegert, and Joseph Vogl, eds., *Archiv für Mediengeschichte 11 (Takt und Frequenz)* [Beat and Frequency] (Munich: Wilhelm Fink, 2011), 51–65. For Delaunay's discussion of color and dimensionality, see again note 43. Sirató recognized Sonia Delaunay's collaborative project with Blaise Cendrars, *La prose du Transsibérien et de la Petite Jehanne de France* [Prose of the Trans-Siberian and Little Jehanne of France] (1913), as an example of Planist poetry (Sirató, "History of the Dimensionist Manifesto," 75).

52. On Duchamp's artistic response to these geometries, see Henderson, *The Fourth Dimension*, chap. 3. On these themes as well as Duchamp's rejection of aspects of the Cubist doctrines promulgated by Gleizes and Metzinger, see also Henderson, "Paradigm Shifts and Shifting Identities in the Career of Marcel Duchamp, Anti-Bergsonist 'Algebraist of Ideas,'" in Anne Collins Goodyear and James W. McManus, eds., *aka Marcel Duchamp: Meditations on the Identities of an Artist* (Washington, DC: Smithsonian Institution Scholarly Press, 2014), 76–94, 103–106.

53. For the *Large Glass* notes Duchamp published as the *Box of 1914*, the *Green Box* (1934), and *A l'infinitif (The White Box)* (1966), see Marcel Duchamp, *Salt Seller: The Writings of Marcel Duchamp*, ed. Michel Sanouillet and Elmer Peterson (New York: Oxford University Press, 1973); reprinted as *The Writings of Marcel Duchamp* (New York: Da Capo Press, 1989) and hereafter cited as *Writings*. After his death, hundreds more notes were found and published as *Marcel Duchamp: Notes*, ed. and trans. Paul Matisse (Paris: Centre Georges Pompidou, 1980; Boston: G. K. Hall, 1983).

54. On "playful physics," see Duchamp, *Writings*, 49. On Duchamp's use of contemporary science as well as dimensionality to create the contrasts between the realms of the Bride and the Bachelors, see Linda Dalrymple Henderson, *Duchamp in Context: Science and Technology in the Large Glass and Related Works* (Princeton: Princeton University Press, 1998), 60–65. For an overview of

this topic, see Linda Dalrymple Henderson, "The *Large Glass* Seen Anew: Reflections of Contemporary Science and Technology in Marcel Duchamp's 'Hilarious Picture,'" *Leonardo* 32, nos. 2 (April 1999): 113–126.

55. For Duchamp and shadows, see Henderson, *The Fourth Dimension*, chap. 3 (conclusion of section on "The Final Solution: The Mirror of the Fourth Dimension").

56. Sirató, "History of the Dimensionist Manifesto," 226.

57. See Sirató, Dimensionist Manifesto, "Mosaic." For Duchamp's reception as a kinetic artist during the 1940s–1950s and his reassertion of his primary focus on the spatial fourth dimension, see Henderson, "Reintroduction," in *The Fourth Dimension* (2013), 39–42.

58. Sirató, "History of the Dimensionist Manifesto," 224.

59. On the *3 Standard Stoppages*, see Henderson, *Duchamp in Context*, 60–65; and Henderson, *The Fourth Dimension*, chap. 3, section on "The *Large Glass.*"

60. Sirató, "History of the Dimensionist Manifesto," 224.

61. Duchamp, *Marcel Duchamp: Notes*, note 27.

62. Duchamp's close friend Friedrich Kiesler would have understood Duchamp's commentary; see Henderson, "Paradigm Shifts," 88–90.

63. For Delaunay's interaction with Kandinsky and other members of his circle, see, e.g., the detailed "Chronologie" [Chronology] in Rousseau and Ameline, *Robert Delaunay 1906–1914*.

64. Wassily Kandinsky letter to Arnold Schoenberg, January 18, 1911, in Jelena Hahl-Koch, ed., *Arnold Schoenberg/Wassily Kandinsky: Letters, Pictures, Documents* (London: Faber and Faber, 1984), 21.

65. Wassily Kandinsky letter to Will Grohmann, October 12, 1930, quoted in Angelica Zander Rudenstine, *The Guggenheim Museum: Paintings 1880–1945*, vol. 1 (New York: Solomon R. Guggenheim Foundation, 1976), 310.

66. On the role of Theosophy in popularizing the idea of a fourth dimension in the nineteenth century as well as the concept's links to idealist philosophy through the writings of Hinton, see Henderson, *The Fourth Dimension*, chap. 1.

67. See Wassily Kandinsky, *On the Spiritual in Art* (1911), in *Kandinsky: Complete Writings on Art*, ed. Kenneth C. Lindsay and Peter Vergo (New York: Da Capo Press, 1994), 143. See also Linda Dalrymple Henderson, "The Forgotten Meta-Realities of Modernism: *Die Uebersinnliche Welt* and the International Cultures of Science and Occultism," in *Glass Bead* (Paris), no. 0 (2016), http://www.glass-bead.org/article/the-forgotten-meta-realities-of-modernism/.

68. See Henderson, *The Fourth Dimension*, chap. 1; see also Corinna Treitel, *A Science for the Soul: Occultism and the Genesis of the German Modern* (Baltimore: Johns Hopkins University Press, 2004), chap. 1.

69. On Hinton, see again notes 35, 66. For Steiner's lectures, see *Rudolf Steiner: The Fourth Dimension—Sacred Geometry, Alchemy, and Mathematics*, trans. Catherine E. Creeger (Great Barrington, MA: Anthroposophic Press, 2001). Rose-Carol Washton Long has argued convincingly for Steiner's importance for Kandinsky; see Long, *Kandinsky: The Development of an Abstract Style* (Oxford: Clarendon Press, 1980).

70. See Bruce Clarke, *Energy Forms: Allegory and Science in the Era of Classical Thermodynamics* (Ann Arbor: University of Michigan Press, 2001), 112. For Apollinaire's phrase, see Guillaume

Apollinaire, *Les peintres cubistes: Méditations esthétiques* [The Cubist painters: Aesthetic meditations] (Paris: Eugène Figuière, 1913), 17. On this subject, see also Linda Dalrymple Henderson, "The 'Fourth Dimension' as Sign of Utopia in Early Modern Art and Culture," in Mary Kemperink and Leonieke Vermeer, eds., *Utopianism and the Sciences* (Leuven: Peeters, 2009), 1–15.

71. On this shift in philosophy at the Bauhaus, see, e.g., Barry Bergdahl and Leah Dickerman, *Bauhaus 1919–1933: Workshops for Modernity* (New York: Museum of Modern Art, 2009).

72. On Kandinsky's painting and theory, see Linda Dalrymple Henderson, "Abstraction, the Ether, and the Fourth Dimension: Kandinsky, Mondrian, and Malevich in Context," in Marian Ackermann and Isabelle Malz, eds., *Kandinsky, Malewitsch, Mondrian: Der Weisse Abgrund Unendlichkeit / The Infinite White Abyss* (Düsseldorf: Kunstsammlung Nordrhein-Westfalen, 2014), 37–55 (German), 233–244 (English).

73. See Linda Dalrymple Henderson, "Claude Bragdon, the Fourth Dimension, and Modern Art in Cultural Context," in Eugene Victoria Ellis and Andrea G. Reithmayr, eds., *Claude Bragdon and the Beautiful Necessity* (Rochester, NY: Cary Graphic Arts Press, 2010), 80–81.

74. Theo van Doesburg, El Lissitzky, and Hans Richter, "Declaration of the International Fraction of Constructivists of the First International Congress of Progressive Artists," in Charles Harrison and Paul Wood, eds., *Art in Theory 1900–2000*, 2nd ed. (Oxford: Blackwell, 2003), 314–316. The text was published in *De Stijl* 5, no. 4 (1923): 61–64.

75. See Kandinsky, "The Yellow Sound: A Stage Composition," in Wassily Kandinsky and Franz Marc, eds., *The Blaue Reiter Almanac* (New York: Viking Press, 1974), 207–225. On *The Yellow Sound*, see Peter Jelavich, *Munich and Theatrical Modernism: Politics, Playwriting, and Performance 1890–1914* (Cambridge, MA: Harvard University Press, 1985), 217–235. See also Günter Berghaus, "A Theatre of Image, Sound and Motion: On Synaesthesia and the Idea of a Total Work of Art," *Maske und Kothurn* 32, nos. 1–2 (1986): 7–28.

76. Kandinsky, "On Stage Composition," in Kandinsky and Marc, *The Blaue Reiter Almanac*, 191. Kandinsky refers repeatedly to the theme of vibration in *On the Spiritual in Art* as well.

77. Sirató, "History of the Dimensionist Manifesto," 223. Kandinsky scholars have not identified this text, which Sirató included in his discussion of "The Concept for the First International Dimensionist Exhibition" under "Non-Euclidean Art IV." There he lists the text as "'Synthetic Art' (Moscow, 1915)." See ibid., 15.

78. For Kandinsky's entire statement, see Sirató, Dimensionist Manifesto, "Mosaic."

79. See, e.g., Kandinsky, *On the Spiritual in Art*, 138.

80. For "electron theory," see ibid., 142. On the physics of this era, see again note 3.

81. See Maurice Boucher, *Essai sur l'hyperespace: Le temps, la matière et l'énergie* [Essay on hyperspace: Time, matter, and energy] (Paris: Félix Alcan, 1903), 169. The new edition was published in Paris by Gauthier-Villars in 1927.

82. Although Einstein had declared that the ether had no mechanical properties and was hence irrelevant to his new physics, the ether had many partisans, including, most prominently, Sir Oliver Lodge and a number of advocates in France and Germany. See, e.g., Milena Wazeck, *Einstein's Opponents: The Public Controversy about the Theory of Relativity in the 1920s*, trans. Geoffrey S. Koby (Cambridge: Cambridge University Press, 2014).

83. For the occult associations of the ether, see, e.g., Linda Dalrymple Henderson, "Vibratory Modernism: Boccioni, Kupka, and the Ether of Space," in Linda Dalrymple Henderson and Bruce

Clarke, eds., *From Energy to Information: Representation in Science and Technology, Art, and Literature* (Stanford: Stanford University Press, 2002), 126–149.

84. Sirató, "History of the Dimensionist Manifesto," 218. One of the first discussions of the Dimensionist Manifesto occurred in an article on Prampolini by Enrico Crispolti, "Una dimenticata partecipazione di Prampolini: Il manifesto de 'Dimensionismo' (1937) [sic]" [Prampolini's forgotten participation in the Dimensionist Manifesto], *Uomini e idee* 10, nos. 15–17 (May-October 1968), 145–155.

85. See Prampolini's statement in Sirató, Dimensionist Manifesto, "Mosaic."

86. Sirató, "History of the Dimensionist Manifesto," 172.

87. For basic biographical texts on Prampolini, including his connections to Arp and Tzara in Zurich in 1916, see Emily Braun, ed., *Italian Art in the 20th Century: Painting and Sculpture 1900–1988* (London: Royal Academy of Arts, 1989; Munich: Prestel Verlag, 1989), 445; and Bruno Mantura, Patricia Rosazza-Ferraris, and Livia Velani, eds., *Futurism in Flight: "Aeropittura" Paintings and Sculptures of Man's Conquest of Space (1913-1945)* (London: Accademia Italiana delle Arte e delle Arti Applicate, 1990), 191–192.

88. On Prampolini's remarkable presence across Europe, see Günter Berghaus, *Italian Futurist Theater, 1909–1944* (Oxford: Clarendon Press, 1998), 442–444; Berghaus provides the fullest discussion of Prampolini's theories of theater to date. Friedrich Kiesler invited Prampolini to organize the Italian section of the Vienna exhibition and was a key organizer of the *Little Review*'s exhibition. On Prampolini's multiple connections in Paris from the early 1920s, see Barbara Meazzi, *Le Futurisme entre l'Italie et la France 1909-1919* [Futurism between Italy and France 1909–1919] (Chambéry, France: Université de Savoie, 2010), 168–172.

89. See Enrico Prampolini, "Futurist Stage Design," in Lawrence Rainey, Christine Poggi, and Laura Wittman, eds., *Futurism: An Anthology* (New Haven: Yale University Press, 2009), 212–215. See also Giovanni Lista, ed., *Le Futurisme: Textes et manifestes 1909-1945* [Futurism: Texts and manifestos 1909–1945] (Ceyzérieu, France: Editions Champ Vallon, 2015), 898–901. Lista provides a history of the multiple publications of this text, which also appeared in *MA* 9/8 (September 15, 1924) ("Musik und Theater Nummer"): n.p.

90. See Enrico Prampolini, "The Magnetic Theatre and the Futuristic Scenic Atmosphere: Sceno-Synthesis – Sceno-Plastics – Sceno-Dynamics – Poly-Dimensional Scenic Space – The Actor-Space – The Poly-Dimensional Expressive and Magnetic Theatre," *Little Review* 11 (Winter 1926): 101–108. Lista includes the Manifesto in *Le Futurisme*, noting that Prampolini added the final section on "The Magnetic Theatre" for the *Little Review* publication (107–108); he also provides a detailed history of the Manifesto's various publications, including in *Noi* 2 (2nd ser.), nos. 6–9 (Sept. 1924) at the time of the Vienna theater exhibition.

91. This phase of Prampolini's career is discussed and documented further below.

92. On Futurist awareness of Kandinsky's writings, see, e.g., Mario Verdone and Günter Berghaus, "*Vita futurista* and Early Futurist Cinema," in Günter Berghaus, ed., *International Futurism in Arts and Literature* (Berlin: Walter de Gruyter, 2000), 400.

93. Umberto Boccioni, "Futurist Painting," lecture delivered at the Circolo Artistico, Rome, May 29, 1911, in Ester Coen, ed., *Umberto Boccioni* (New York: Metropolitan Museum of Art, 1988), 231.

94. Prampolini, "Futurist Stage Design," 214–215.

95. Sirató, Dimensionist Manifesto, section III.

96. See Prampolini, "Sculptures des couleurs et sculpture totale" [Sculpture of colors and total sculpture], in Lista, *Le Futurisme*, 923–926. Lista notes (923) that while the text was written in October 1913, it was first published in 1916.

97. See Prampolini, "La Couleur des sons" [The color of sounds], in Lista, *Le Futurisme*, 588–592. Berghaus has discussed the impact of Kandinsky's theories on theater on Prampolini; see Berghaus, "A Theatre of Image, Sound and Motion," 20–28.

98. See Sirató, Dimensionist Manifesto, "Mosaic."

99. See again note 74.

100. Prampolini, "Spiritual Architecture," in Lista, *Le Futurisme*, 1478; Prampolini also mentions "four-dimensional architectures" (1479). As Berghaus discusses, Prampolini's text presented a renewed embrace of Kandinsky's ideas after he had critiqued the artist in his 1915 essay "Pure Painting: Response to Kandinsky." See Berghaus, *Italian Futurist Theater*, 267; and Prampolini, "La peinture pure – Réponse à Kandinsky," in Lista, *Le Futurisme*, 843–844.

101. Prampolini, "The Magnetic Theatre and the Futuristic Scenic Atmosphere," 108.

102. Ibid., 103–105. Oliver Grau includes Prampolini's "polydimensional Futurist stage" in his discussion of the evolution of immersive environments in *Virtual Art: From Illusion to Immersion*, trans. Gloria Custance (Cambridge, MA: MIT Press, 2003), 143–146.

103. Prampolini, "The Magnetic Theatre and the Futuristic Scenic Atmosphere," 102.

104. See again the full title of Prampolini's essay for this phrase (at note 90).

105. See Prampolini, "The Magnetic Theatre and the Futuristic Scenic Atmosphere," 107, for the two quotations. Prampolini referred to sound and colored lights as "those essential elements of spiritual attraction" (107).

106. Prampolini, untitled text in *Futurist Exhibition of Aeropainting and Scenography* (1931), reprinted in Mantura, Rosazza-Ferraris, and Velani, *Futurism in Flight*, 203–204. See also Prampolini, "L'aeropeinture cosmique" [Cosmic aeropainting], in Lista, *Le Futurisme*, 1759–1760; Lista notes that this text was reprinted under this title for the exhibition of Futurist painting at the Galerie Bernheim Jeune, April 3–27, 1935 (1759); Pascal Rousseau (see note 109 below) provides the correct title for the exhibition.

107. On Aeropittura, see, e.g., Mantura, Rosazza-Ferraris, and Velani, *Futurism in Flight*, 203–206 (including the various manifestos and texts related to the movement); and Lisa Panzera, "Celestial Futurism and the 'Parasurreal,'" in Vivian Greene, ed., *Italian Futurism 1909–1944: Reconstructing the Universe* (New York: Solomon R. Guggenheim Museum, 2014), 326–329. The "Manifesto of Aeropainting," signed by Prampolini and others, is translated in Rainey, Poggi, and Wittman, *Futurism: An Anthology*, 283–286.

108. Prampolini, "Au-delà de la peinture, vers les compositions de matières" [Beyond painting, toward material compositions] (1934), in Lista, *Le Futurisme*, 1889. Romy Golan discusses these works and Prampolini's Aeropittura-oriented mural painting in *Muralnomad*, 46–51.

109. See again note 50. See also Pascal Rousseau, "La construction du simultané: Robert Delaunay et l'aéronautique," *Revue de l'art* 113 (1996): 28, 31 n. 64.

110. For this passage, see again Mantura, Rosazza-Ferraris, and Velani, *Futurism in Flight*, 204; see also Lista, *Le Futurisme*, 1760.

111. See Sirató, "History of the Dimensionist Manifesto," 177, 213–214. In discussing the ultimate stages of Dimensionism, including the "vaporization of sculpture" and "five-sensed theater," Sirató

clarifies that he was thinking of space as "earthly space saturated with matter, radiation and force fields" and of matter as set in motion "to *create* an artistic effect not in its solid but aeriform state" (see ibid., 214). Here his language echoes early twentieth-century scientific views.

112. Sirató, Dimensionist Manifesto, conclusion of section III.

113. Giacomo Balla et al., "The Exhibitors to the Public" (1912), in Rainey, Poggi, and Wittman, *Futurism: An Anthology*, 107.

114. Both Sirató and Botar recount the dissolution of the movement with Sirató's departure from Paris – as well as the reprinting of the Dimensionist Manifesto as an insert in *Plastique* 2 (Summer 1937).

115. Sirató, "History of the Dimensionist Manifesto," 241.

116. See Linda Dalrymple Henderson, "Park Place: Its Art and History," in *Reimagining Space: The Park Place Gallery Group in 1960s New York* (Austin, TX: Jack S. Blanton Museum of Art, 2008), 811; and Henderson, "Reintroduction," in *The Fourth Dimension* (2013), 57–65, which also considers Robert Smithson's interest in the fourth dimension in this period.

117. See Henderson, "Park Place," 20.

118. See ibid., 9.

119. For the responses of Forakis and Fleming, see ibid., 9, 14–15, 22–24; and Henderson, "Reintroduction," in *The Fourth Dimension* (2013), 61–65. On Malevich and the fourth dimension, see e.g., Henderson, *The Fourth Dimension*, chap. 5.

120. See Henderson, "Park Place," 9–11, 17–18, 25–26. On Fuller's role as a "keeper of the flame" of the spatial fourth dimension, see Henderson, "Reintroduction," in *The Fourth Dimension* (2013), 42–46.

121. See again Duchamp, *A l'infinitif (The White Box)*, in *Writings*, 74–101; and Henderson, "Paradigm Shifts." On the reemergence of the spatial fourth dimension in American popular culture in the 1950s–1960s, see Henderson, "Reintroduction," in *The Fourth Dimension* (2013), 46–57.

122. Sirató, "History of the Dimensionist Manifesto," 242.

123. See Stephen Petersen, *Space-Age Aesthetics: Lucio Fontana, Yves Klein, and the Postwar European Avant-Garde* (University Park: Pennsylvania State University Press, 2009); for the Dimensionist Manifesto as well as Prampolini's writings as precedents for Spatialism, see ibid., 48.

124. See Henderson, "Reintroduction," in *The Fourth Dimension* (2013), 65–75, 79–91.

125. Sirató, "History of the Dimensionist Manifesto," 242.

126. For this work, see http://olafureliasson.net/archive/artwork/WEK100082/your-blind-movement, as well as the artist's website more generally (accessed June 21, 2017).

127. The artist who has engaged the fourth dimension most seriously from the 1970s to the present, both in art works and in writing, is Tony Robbin. See Henderson, "Reintroduction," in *The Fourth Dimension* (2013), 76–79; and *Tony Robbin: A Retrospective 1970-2010* (Orlando, FL: Orlando Museum of Art, 2011); see also http://www.tonyrobbin.net (accessed June 21, 2017). Among numerous artists responding to the fourth dimension in the twenty-first century, Tauba Auerbach is deeply engaged with subject, including the books of Bragdon, two of which she has reprinted in enlarged deluxe editions of silver on black (*A Primer of Higher Space* and *Projective Ornament*, both New York: Diagonal Press, 2016). For Auerbach's art, see http://www.taubaauerbach.com (accessed June 21, 2017).

1. Calder Foundation, chronology section, January 24, 1925, http://calder.org/life/chronology. Also see Vanja V. Malloy, "Calder and the Solar Eclipse: Breakthroughs in Astronomy, Physics, and Art," in Elizabeth Turner, ed., *Alexander Calder: Radical Inventor* (Montreal: Montreal Museum of Fine Arts, 2018).

2. For a historical discussion of this expedition and its popular coverage, see Katy Price, *Loving Faster than Light: Romance and Readers in Einstein's Universe* (Chicago: Chicago University Press, 2012), 12, 19, 23.

3. For instance, the April 1925 issue included several articles about the January 1925 eclipse, such as: Henry Norris Russell, "Two Outstanding Features of the Eclipse: An Account of the Origin of the Shadow Bands and of the Famous Diamond Ring," *Scientific American*, April 1925, 221–222; "Why Was the Moon Late? How the Efforts of Many Volunteer Observers Contributed to the Precise Measure of the Moon's Position in Space," *Scientific American*, April 1925, 223; "The Effects of the Eclipse on Radio: A Preliminary Report of the Comprehensive Observations Made by Our Own Collaborators and Others," *Scientific American*, April 1925, 224–226; "Prize for Criticism of Eclipse Motion Picture: An Announcement of a Contest Which We Hope All Our Readers Will Join," *Scientific American*, April 1925, 227. Also see George K. Burgess, "United States Bureau of Standards Eclipse Observations: Important Spectroscopic, Radiometric, Illumination and Other Observations Were Made by Government Scientists During the Sun's Last Eclipse," *Scientific American*, September 1925, 170.

4. For more discussion of the eclipse, see *Scientific American*, March 1924, 176; and "Help Us Study the Solar Eclipse," *Scientific American*, November 1924, 312. More advice about preparing for the solar eclipse can be found in these *Scientific American* articles: "Do Not Miss Seeing the Solar Eclipse," December 1924, 410; "Eclipse Investigations Not Requiring Special Equipment," January 1925, 13; "For the Next Total Eclipse of the Sun That Will Be Visible in New York and New England We Shall Have to Wait until 2024," January 1925, 30; "'The Best Observed Eclipse in History': A Preliminary Report of What Was Learned on January Twenty-fourth, Including the Results of the Scientific American's Observing Party," March 1925, 155.

5. For a further discussion of Minkowski's contribution see A. Einstein and H. Minkowski, eds., *The Principle of Relativity: Original Papers* (Calcutta: University of Calcutta, 1920), 1–52.

6. Charles Sirató, "History of the Dimensionist Manifest," esp. 242, but also 195, 205, 213, 224.

7. Well before Moholy-Nagy endorsed the Dimensionist Manifesto, he had promoted a new dynamism in the arts through the "Dynamic-Constructive System of Forces Manifesto," which he wrote with Alfréd Kemény in 1922. This proclamation argued that a new art composed of dynamic forces created through movement should replace the older, sculptural concern with material and form. As its ultimate goal, the manifesto cited the creation of a seemingly cosmic "floating" and "freely moving" artwork that would appear disconnected from the physical limitations imposed by Earth's gravitational field. The manifesto explained: "We must therefore replace the *static* principle of *classical art* with the *dynamic principle of universal life*. Stated practically: instead of static *material* construction (material and form relations), dynamic construction (vital construction and *force relations*) must be evolved in which the material is employed only as *the carrier of forces*." See László Moholy-Nagy and Alfréd Kemény, "Dynamisch-konstruktives Kraftsystem," *Der Sturm* (Berlin) 13, no. 12 (December 1922): 186; translated as "Dynamic-Constructive System of Forces," in Krisztina Passuth, *Moholy-Nagy* (New York: Thames and Hudson, 1985), 290.

8. Henderson noted: "Instrumental in establishing the curriculum at the Bauhaus, Moholy-Nagy actually met with Einstein in 1924 to discuss the possibility of his writing a popular book on relativity for the Bauhausbuch series. Although Einstein did not write the book, he lent his name to the school's circle of friends. For Moholy-Nagy, the theory of relativity was emblematic of a fundamental cultural shift toward a more dynamic world view to which artists must respond by replacing the static methods of the past with the art of motion and time." Linda Dalrymple Henderson, "Einstein and 20th-Century Art: A Romance of Many Dimensions," in Peter L. Galison, Gerald Holton, and Silvan S. Schweber, eds., *Einstein for the 21st Century* (Princeton: Princeton University Press, 2007), 112; László Moholy-Nagy, *The New Vision: From Material to Architecture*, trans. D. M. Hoffmann (1928; New York: Brewer, Warren & Putnam, 1932); and László Moholy-Nagy, *Vision in Motion* (Chicago: P. Theobald, 1947).

9. Moholy-Nagy, *Vision in Motion*, 266.

10. John T. Hill, "Matter's Design," in Alexander S. C. Rower, ed., *Calder by Matter* (Paris: Cahiers d'Art, 2013), 298.

11. Herbert Matter in *Arts & Architecture* (May 1944), rpt. in Rower, *Calder by Matter*, 187.

12. For an explanation and diagram of a light cone, see Jeremy Gray, *Ideas of Space: Euclidean, Non-Euclidean, and Relativistic*, 2nd ed. (1983; Oxford: Clarendon Press, 2003), 141–146. Also see Price, *Loving Faster than Light*, 109–111. The constant speed of light had also provided a new unit to measure distance in modern astronomy known as the light-year, which is approximately six trillion miles (Gray, *Ideas of Space*, 190–193).

13. James Jeans, *Physics and Philosophy* (Cambridge: Cambridge University Press, 1942), 119. *Scientific American* provides regular reviews of scientific books geared to a general audience. For example, see its article, "What Has Been Said about Einstein: A Review of the More Important Popular and Semi-Popular Books and Articles in English," *Scientific American*, August 28, 1920, 212. *Scientific American* referenced the sheer quantity of books and magazines articles on the topic of relativity, and reported on how James Jeans is the "unrivaled" author for astrophysics in its December 1923 issue on page 410. Among Jeans's most influential texts are: *The Universe around Us* (Cambridge: Cambridge University Press, 1929); *Through Space and Time* (Cambridge: Cambridge University Press, 1934).

14. Sirató, Dimensionist Manifesto.

15. Price, *Loving Faster than Light*.

16. Michael Hoskin, ed., *The Cambridge Illustrated History of Astronomy* (Cambridge: Cambridge University Press, 1997), 198.

17. For more on the new understanding of stars see popular books on the topic geared toward a general readership such as Arthur Eddington's *Internal Constitution of Stars* (Cambridge: Cambridge University Press, 1926) and *Stars and Atoms* (Oxford: Clarendon Press, 1927).

18. The quality and size of glass lenses in telescopes improved tremendously in the late nineteenth and early twentieth centuries. The invention of reflective telescopes, which used mirrors made of silver-coated glass, allowed for clearer and more powerful magnification. Many new telescopes were located in the United States, the most famous of which was the 100-inch reflector at Mount Wilson Observatory in Los Angeles, California, built in 1917. These high-powered telescopes enabled scientists to analyze stellar temperatures, light spectra, and movement. By the 1920s these developments were regularly covered in popular scientific journals. For instance, starting in 1900 and continuing for forty-three years, astronomer Henry Norris Russell contributed a full-page entry each month in *Scientific American* about the status and progress of astronomy, which often covered developments in telescope design.

19. Vesto Melvin Slipher demonstrated his finding by securing spectrograms of a number of spiral nebulae, which showed that many of these cosmic bodies displayed prominent spectral lines characteristic of stars. After presenting his work at the American Astronomical Society in 1914, Slipher was received with a standing ovation; his research provided indisputable evidence for the existence of many galaxies other than the Milky Way, resolving a question that had stumped astronomers for decades. Hoskin, *The Cambridge Illustrated History of Astronomy*, 293–295.

20. See Albert G. Ingalls, "'The Heavens Declare the Glory of God': How a Group of Enthusiasts Learned to Make Telescopes and Became Amateur Astronomers," *Scientific American*, November 1925, 293–295.

21. "Heavens Built of Concrete: Ingenious Optical Devices Installed in Concrete Dome Are Used to Show the Motions of the Stars," *Scientific American*, March 1925, 170–171. For a discussion of the planetarium's historic evolution and social impact since 1930, see Jordan D. Marché II, *Theaters of Time and Space: American Planetaria 1930–1970* (New Brunswick, NJ: Rutgers University Press, 2005).

22. The first exhibition at the World's Fair showed the properties of cosmic rays and ultra-short-wave radio transmissions. It received great attention when Albert Einstein presided over the opening ceremony, flipping a switch that caused ten cosmic rays to light up the fairgrounds. Marché, *Theaters of Time and Space*, 80.

23. Jean Painlevé was widely known for his scientific films, which were shown in Parisian art cinemas and include, among others: *Mouvements accélérés* (1925), *Phénomènes intraprotoplasmiques* (1925), *La Pieuvre* (1926), and *Les Oursins* (1928). For more on Painlevé's documentary films see the film *Avant-Garde: Experimental Cinema of the 1920s and 30s* (New York: Kino on Video, 2005). In a review of *Mouvements accélérés*, the Surrealist Robert Desnos observed that Painlevé's films instilled a sense of wonder in the viewer by providing intimate perspectives of previously unknown or unfamiliar organisms and environments. For Desnos's review see Robert Desnos, "Mouvements accélérés etc. ...,"*Journal littéraire* (Paris), April 18, 1925, reprinted in Robert Desnos and André Tchernia, *Cinéma* (Paris: Gallimard, 1966), 137.

24. For instance, see Lynn Gamwell, *Exploring the Invisible: Art, Science, and the Spiritual* (Princeton: Princeton University Press, 2002), 207–224.

25. Herbert Read, ed., *Unit One: The Modern Movement in English Architecture, Painting, and Sculpture* (London: Cassell, 1934), 30.

26. J. D. Bernal, "Art and the Scientist," in J. L. Martin, Ben Nicholson, and N. Gabo, eds., *Circle: International Survey of Constructive Art*, exh. cat. (1937; repr., New York: Praeger, 1971), 123.

27. Moholy-Nagy, *Vision in Motion*, 182.

28. Ilene Susan Fort, "Helen Lundeberg: Imagined Rather Than Seen," in Ilene Susan Fort, ed., *Helen Lundeberg: A Retrospective* (Laguna Beach, CA: Laguna Art Museum, 2016), 10–36.

4 REVOLUTIONS IN ART AND SCIENCE: CUBISM, QUANTUM MECHANICS, AND ART HISTORY

1. Linda Dalrymple Henderson, "Four-Dimensional Space or Space-Time? The Emergence of the Cubism-Relativity Myth in New York in the 1940s," in Michele Emmer, ed., *The Visual Mind II* (Cambridge, MA: MIT Press, 2005), 349–397; Meyer Schapiro, "Einstein and Cubism: Science and Art," in *The Unity of Picasso's Art* (New York: George Braziller, 2000), 49–149; Sigfried Giedion, *Space, Time and Architecture: The Growth of a New Tradition* (1941; Cambridge, MA: Harvard University

Press, 1997), 436; Erwin Panofsky, *Early Netherlandish Painting: Its Origins and Character*, vol. 1 (Cambridge, MA: Harvard University Press, 1953), 5, 362 n.

2. Max Planck, "Zur Theorie des Gesetzes der Energieverteilung im Normalspektrum" [The theory of the energy distribution law of the normal spectrum], *Verhandlungen der Deutschen Physikalischen Gesellschaft* [Proceedings of the German Physics Society] 2, no. 17 (December 1900): 237–245; Max Planck, "Ueber das Gesetz der Energieverteilung im Normalspektrum" [On the energy distribution law of the normal spectrum], *Annalen der Physik* [Annals of physics] 4, no. 3 (March 1901): 553–563.

3. Albert Einstein, "Autobiographical Notes," in Paul Arthur Schlipp, ed., *Albert Einstein: Philosopher-Scientist* (Chicago: Open Court, 1949), 45.

4. Niels Bohr, "On the Constitution of Atoms and Molecules," *Philosophical Magazine and Journal of Science* 26, no. 151 (July 1913): 1–25; Bohr, "On the Constitution of Atoms and Molecules," *Philosophical Magazine and Journal of Science* 26, no. 153 (September 1913): 476–502; Bohr, "On the Constitution of Atoms and Molecules," *Philosophical Magazine and Journal of Science* 26, no. 155 (November 1913): 857–875. These classic papers of 1913 received a fiftieth-anniversary reprint as Niels Bohr, *On the Constitution of Atoms and Molecules* (Copenhagen: Munksgaard, 1963).

5. Einstein in *Albert Einstein: Philosopher-Scientist*, 45.

6. Werner Heisenberg, *Encounters with Einstein and Other Essays on People, Particles, and Places* (Princeton: Princeton University Press, 1989), 38.

7. "... so wird durch Quantenmechanik die Ungültigkeit des Kausalgesetzes definitiv festgestellt." Werner Heisenberg, "Über den anschaulichen Inhalt der quantentheoretischen Kinematik und Mechanik" [On the intuitive content of the quantum-theoretical kinematics and mechanics], *Zeitschrift für Physik* [Journal of physics] 43 (May 1927): 197.

8. Hans Reichenbach, "Crise de la causalité" [Crisis of causality], *Documents* 1, no. 2 (May 1929): 105–108.

9. "Jamais un ingénieur n'essaiera de construire ou de réparer une machine selon d'autres principes que ceux de la causalité." Ibid., 106.

10. Ibid., 107.

11. "On ne peut parler d'une véritable crise de la conception de la causalité que depuis ces derniers temps, où les physiciens eux-mêmes ont commencé à douter sérieusement de la précision des phénomènes de la nature. Le doute les a forcés à renoncer consciemment à l'idée de causalité dans l'explication de la mécanique de l'intérieur de l'atome." Ibid.

12. Carl Einstein, "André Masson, étude ethnologique," *Documents* 1, no. 2 (May 1929): 93–102.

13. Carl Einstein, "André Masson, an Ethnological Study" (1929), trans. Krzysztof Fijalkowski and Micheal Richardson, in Dawn Ades and Simon Baker, eds., *Undercover Surrealism: Georges Bataille and Documents* (London: Hayward Gallery, 2006), 245.

14. Ibid., 246–247.

15. Ibid., 247. It might sound contrived, but a strikingly similar argument was made a year later by the philosopher Émile Meyerson; see "Le physicien et le primitif," *Revue philosophique* 55, nos. 5–6 (May-June 1930): 319–358. Meyerson's article was certainly read by Bataille; it was reviewed in *Documents* by his friend Arnaud Dandieu for the prominence it gave "la théorie des quanta, qui réintroduit le discontinu et l'irrationnel dans la science" [quantum theory, which introduced discontinuity and the irrational into science]. See "Émile Meyerson, 'Le physicien et le primitif'" (article review), *Documents* 2, no. 5 (1930): 312.

16. "... une scission entre l'homme et la conception conventionnelle du monde, une reconstruction de la structure de la vue." Carl Einstein, *Georges Braque*, trans. E. Zipruth (Paris: Chroniques du Jour, 1934), 70.

17. Ibid., 47.

18. "Si l'on voulait arriver à une nouvelle conception et à une nouvelle forme de l'homme et de l'univers, il importait avant tout de briser le cliché du reel, de se briser soi-même ainsi que l'histoire conventionnelle. Cette entreprise fut osée par quelques poètes et quelques hommes de science, ainsi que par deux cubists, dont l'audace équivaut à un fait historique de première importance." Ibid., 57. The "deux cubists" are Picasso and Braque, of course.

19. "La théorie des quantums a déchiré la continuité unitaire de l'univers, et l'on a fini par mettre sérieusement en doute la causalité, âme de toute l'ancienne science. Le moi conscient n'est plus aujourd'hui qu'une façade, prête à sombrer dans l'acte spontané. ... Le soi-disant cubisme est un phénomène parfaitement normal dans l'ensemble d'une conception radicalement transformée." Ibid., 63–64.

20. "La fin du sujet 'stable' et déterminé équivaut à une liquidation de l'attitude anthropocentrique." Ibid., 70.

21. "La croyance à un moi hermétique, à la figuration définitive, devait être abandonee." Ibid., 76.

22. For some rare biographical information, see Joseph Campbell, ed., *Man and Time. Papers from the Eranos Yearbooks*, vol. 3 (Princeton: Princeton University Press, 1957), 356.

23. See Georges Bataille, *Choix de lettres, 1917–1962* [Selected letters, 1917–1962] (Paris: Gallimard, 1997), 329–330.

24. Henri-Charles Puech, "Picasso et la répresentation" [Picasso and representation], *Documents* 2, no. 3 ("Hommage à Picasso") (1930): 118–122. See also "Les 'Prisons' de Jean-Baptiste Piranèse," *Documents* 2, no. 4 (1930): 199–204; and "Le dieu Bésa et la magie hellénistique," *Documents* 2, no. 7 (1930): 415–425.

25. "... répugne de plus en plus à toute *représentation*. Il faudra bien un jour mesurer la portée de cette remarque que vérifient toutes les manifestations de la science ou de l'art modernes, nous rendre un compte plus exact que la ruine de l'idée de *représentation* comme le caractère essentiel de notre époque, lui donne son *style*, et tirer enfin de cette position nouvelle des choses et de l'esprit tout le bouleversement qu'elle implique." Puech, "Picasso et la répresentation," 118.

26. Ibid.

27. "Le premier intérêt de l'oeuvre de Picasso a été ... de delivrer la peinture de l'obsession trop humaine de la représentation qui paraissait, cependent, être par essence attachée à ce domaine, d'élargir la forme picturale jusque-là définie par la coincidence des sensations nées de l'oeil et de la main." Ibid., 119.

28. Ibid., 122.

29. "La toute récente promotion de la physique semble interdire à la représentation de retrouver un 'invariant' *en deçà* de la réalité apparente, dans l'élément du *contenu*. Le solide se dissout et se résout en fluide, la matière en rayonnement, le corpuscule en 'paquet d'ondes.' L'enserrement exact du réel fait place à une plus vague considération d'ensembles plus ou moins arbitrairement cernés: le déterminisme strict s'évanouit devant une supputation de probabilités qui s'efforce à composer avec le hazard." Henri-Charles Puech, "Signification et représentation," *Minotaure* 6 (Winter 1934–1935): 52.

30. "… une copie plus ou moins idéalisée, mais à un objet magique ou à un *symbole* mental." Ibid., 52.

31. For the initial Surrealist reception, see my *Surrealism, Art and Modern Science: Relativity, Quantum Mechanics, Epistemology* (New Haven: Yale University Press, 2008), 59–66.

32. Michel Foucault, *The Archaeology of Knowledge*, trans. A. M. Sheridan Smith (1969; London: Routledge, 1989), 5.

33. Christopher Green, *Picasso: Architecture and Vertigo* (New Haven: Yale University Press, 2005).

34. Ibid., 7.

35. Ibid., 9–11.

36. Georges Bataille, "Formless" (1929), in Bataille, *Visions of Excess: Selected Writings, 1927–1939*, ed. Allan Stoekl, trans. Allan Stoekl with Carl R. Lovitt and Donald M. Leslie, Jr. (Minneapolis: University of Minnesota Press, 1985), 31.

37. Georges Bataille, "The Labyrinth" (1936), in *Visions of Excess*, 175 (translation modified).

38. Ibid., 177 n.1.

39. There is no discussion of science in the twentieth century, institutional or conceptual, in any of the revisionist studies of Carl Einstein published in the special issue of *October* (no. 107, Winter 2004); and there is only minor and incidental reference to the theory of relativity, for instance, and none to quantum mechanics in the writing on Einstein and Cubism by Georges Didi-Huberman; see Didi-Huberman, "'Picture = Rupture': Visual Experience, Form and Symptom According to Carl Einstein" (1996), trans. C. F. B. Miller, in *Papers of Surrealism*, no. 7 ("The Use-Value of *Documents*"), 2007, n.p. Given the overwhelming significance of science to the culture of the twentieth century, its absence beyond one glancing mention of Einstein's theory of relativity from one of the most detailed and authoritative studies of the art of the period is bewildering: see Hal Foster et al., *Art since 1900: Modernism, Antimodernism, Postmodernism* (2004; London: Thames & Hudson, 2016), 335.

APPENDIX: THE HISTORY OF THE DIMENSIONIST MANIFESTO, AND RELATED TEXTS

1. Tamkó Sirató Károly, *A Dimenzionista Manifesztum története: a dimenzionizmus (nemeuklideszi művészetek) I. albuma: az avantgárd művészetek rendszerbe foglalása* [The history of the Dimensionist Manifesto: Album I of Dimensionism (non-Euclidean arts) – The systematization of avant-garde arts] (Budapest: Artpool and Magyar Műhely Kiadó, 2010). Also see http://www.artpool.hu/TamkoSirato/book.html.

2. Artpool's publication of the reconstructed illustrations is available to view online at: http://www.artpool.hu/TamkoSirato/album/index_en.html.

3. This overview, part of Charles Sirató's 1974 manuscript, served as a kind of index of the "album" he envisioned, which would have included the text of the "History of the Dimensionist Manifesto" as well as supplemental materials such as photographs of Dimensionist artworks and examples of his poetry and other writing. This appendix does not include the entirety of the manuscript as he outlined it; for instance, we have omitted the photographs he collected, a number of which are now lost.

4. This French version of the Dimensionist Manifesto appeared as a loose-leaf flyer in 1936. This flyer was then inserted into *Plastique* no. 2 (Summer 1937). It was published again in 1965 (Paris: Morphème) and in 1966 in the book *Kochar et la peinture dans l'espace* [Kochar and painting in space] by Waldemar-George (Jerzy Waldemar Jarocinski) (Paris: Galerie Percier).

5. This section comprises texts in French from the verso of the first edition of the Manifesto that appeared as a loose-leaf flyer in 1936 and was subsequently inserted into Plastique, no. 2 (Summer 1937). A longer version of the "Mosaic" was to have appeared in the planned *La Revue N + 1*. Thanks to Claudine Majzels and Gabrielle J. Botar for assistance with the translation.

6. Translated from the Hungarian by Oliver Botar, from the version published in Sirató's poetry collection *A vízöntő-kor hajnalán* (At the dawn of the Age of Aquarius) (Budapest: Szépirodalmi, 1969). Though dated "Paris, 1936," this version differs slightly from the French original, perhaps reflecting the original Hungarian-language composition of the Manifesto. This version probably also incorporates Sirató's thinking on the subject in the mid-1960s, when he returned to the question of "Dimensionism." Note, for example, the addition of Alois Riegl's term *Kunstwollen* (*müvészet-akarat*); the phrase "cultured nation of civilization" in the introductory paragraph, which replaced the more Eurocentric "Western civilization" of the 1936 text; and the addition in paragraph 3 of Bólyai's name to that of Einstein, particularly important in a Hungarian context. Sirató's elaboration of the section on "Cosmic Art" is garbled in the Hungarian version, and is presented here in a slightly simplified form close to the French version. Riegl first employed the term *Kunstwollen* (usually translated in English as "will to art") in his *Die spätrömische Kunstindustrie* (Late Roman art industry), volume 1 (Vienna, 1901).

7. This section appears after the manifesto in the 1974 version of the album manuscript.

8. While Sonia Delaunay's signature on the Manifesto appears as "Sonia Delaunay-Terk," perhaps to distinguish herself from her husband Robert Delaunay, by 1936 the artist went by Sonia Delaunay. As such, we have converted all references to her from Sonia Delaunay-Terk to Sonia Delaunay.

9. This is the section labeled "The history of the Dimensionist Manifesto" in the overview of the album.

10. Two descriptive short paragraphs on the poem *Well in the Puszta* were deleted from the translated text here due to the difficulty of accurately translating poetic verse.

11. In the original text, this paragraph was followed by a reproduction of Charles Sirató's poem *Water Violin with Seven Positions*, 1925. This was the author's first attempt at a two-dimensional poem (image-poem), which according to him remained static and had no movement in it.

12. Charles Sirató, *Glogoism* (Glogoist Manifesto), 1927. Published in the appendix of the volume titled *Paper Man* by Charles Sirató (Békéscsaba: Tevan Publisher, 1928).

13. Here Sirató includes the following phrases from the poem, which, unfortunately, are only partially intelligible in their truncated form and in translation: "Ödönke a halak szeretője ... Ödönke itt. Ödönke ott ... A vérbélű tintatartó ... Zri-Punalua ... Punalua I, Punalua O! Punalua Ü! ... Kék mint a hó, fekete mint a hó, fekete mint a hó, sárga mint a hó ... Élt 25 évet és meghalt, mielött átmuzsikálta volna tüdején a fekete übercígereket ..."

14. J. M. G. Le Clézio received the Prix Renaudot for his novel *Le Procès-Verbal* in 1963. In 2008 he won the Nobel Prize.

SELECTED BIBLIOGRAPHY

Abbott, Edwin Abbott. *Flatland: A Romance of Many Dimensions*. London: Seeley, 1884.

Abstraction, Création, Art Non-Figuratif. New York: Arno Press, 1968.

Áczél, Géza. *Tamkó Sirató Károly*. Budapest: Akadémiai, 1981.

Bachelard, Gaston. *The New Scientific Spirit*. Trans. Arthur Goldhammer. Boston: Beacon Press, 1985.

Bachelard, Gaston. *Le nouvel esprit scientifique*. 5th ed. Paris: Presses Universitaires de France, 1949.

Baljeu, Joost. "The Fourth Dimension in Neoplasticism." *Form*, no. 9 (April 1969): 6–14.

Barr, Alfred H. *Cubism and Abstract Art*. New York: Museum of Modern Art, 1936.

Bataille, Georges. *Visions of Excess: Selected Writings, 1927–1939*. Ed. Allan Stoekl, trans. Allan Stoekl with Carl R. Lovitt and Donald M. Leslie, Jr. Minneapolis: University of Minnesota Press, 1985.

Bataille, Georges, and Annette Michelson. "Celestial Bodies." *October* 36 (1986): 75–78.

Batten, Alan H. "A Most Rare Vision: Eddington's Thinking on the Relation between Science and Religion." *Journal of Scientific Exploration* 9, no. 2 (1995): 231–255.

Berghaus, Günter. "A Theatre of Image, Sound and Motion: On Synaesthesia and the Idea of a Total Work of Art." *Maske und Kothurn* 32, no. 1–2 (1986): 7–28.

Bergson, Henri. *Durée et simultanéité: A propos de la théorie d'Einstein* [Duration and simultaneity: About Einstein's theory]. Paris: Félix Alcan, 1922.

Boccioni, Umberto. "'Futurist Painting." In Ester Coen, ed., *Umberto Boccioni*, 231–239. New York: Metropolitan Museum of Art, 1988.

Bohn, Willard. *Apollinaire and the International Avant-Garde*. Albany: State University of New York Press, 1997.

Bohr, Niels. "On the Constitution of Atoms and Molecules." *Philosophical Magazine and Journal of Science* 26, no. 151 (July 1913): 1–25.

Bohr, Niels. "On the Constitution of Atoms and Molecules." *Philosophical Magazine and Journal of Science* 26, no. 153 (September 1913): 476–502.

Bohr, Niels. "On the Constitution of Atoms and Molecules." *Philosophical Magazine and Journal of Science* 26, no. 155 (November 1913): 857–875.

Boland, Lynn. "Inscribing a Circle." In *Cercle et Carré and the International Spirit of the Avant-Garde*, org. Lynn Boland, 8–55. Athens: Georgia Museum of Art, 2013.

Borràs, Maria Lluïsa. *Picabia*. New York: Rizzoli, 1985.

Botar, Oliver. "Constructed Reliefs in the Art of the Hungarian Avant-Garde: Kassák, Bortnyik, Uitz and Moholy-Nagy 1921–1926." *Structurist* 25–26 (1985–1986): 87–98.

Botar, Oliver. "Defining Biocentrism." In Oliver Botar and Isabel Wünsche, eds., *Biocentrism and Modernism*, 15–45. Farnham, UK: Ashgate, 2011.

Botar, Oliver. "From Avant-Garde to 'Proletkult' in Hungarian Émigré Politico-Cultural Journals, 1922–1924." In Virginia H. Marquardt, ed., *Art and Journals on the Political Front, 1910-1940*, 100–141. Gainesville: University of Florida Press, 1997.

Botar, Oliver. "Prolegomena to the Study of Biomorphic Modernism: Biocentrism, László Moholy-Nagy's 'New Vision,' and Ernő Kállai's *Bioromantik*." PhD dissertation, University of Toronto, 1998.

Botar, Oliver. *Sensing the Future: Moholy-Nagy, Media and the Arts*. Zurich: Lars Müller, 2014.

Boucher, Maurice. *Essai sur l'hyperespace: Le Temps, la matière et l'énergie*. Paris: Félix Alcan, 1903.

Bragdon, Claude. *A Primer of Higher Space (The Fourth Dimension)*. Rochester, NY: Manas Press, 1913.

Bragdon, Claude. *A Primer of Higher Space: The Fourth Dimension to which is added Man the Square: A Higher Space Parable*. 2nd rev. ed. New York: Alfred A. Knopf, 1923. Introduction and design augmentation by Tauba Auerbach. New York: Diagonal Press, 2016.

Bragdon, Claude. *Projective Ornament*. Rochester, NY: Manas Press, 1915. Introduction and design augmentation by Tauba Auerbach. New York: Diagonal Press, 2016.

Braun, Emily, ed. *Italian Art in the 20th Century: Painting and Sculpture 1900–1988*. London: Royal Academy of Arts, 1989.

Breton, André. *Manifestoes of Surrealism (1924, 1929)*. Ann Arbor: University of Michigan Press, 1969.

Breton, André. *Surrealism and Painting*. New York: Harper and Row, 1972 (1928).

Brett, Guy. *Force Fields: Phases of the Kinetic*. London: Hayward Gallery, 1999.

Brooke, Peter. *Albert Gleizes: For and Against the Twentieth Century*. New Haven: Yale University Press, 2001.

Bryen, Camille. *L'aventure des objets*. Paris: José Corti, 1937.

Bryen, Camille. *Camille Bryen: A revers*. Paris: Somogy, in association with Musée des Beaux-Arts de Nantes, 1997.

Buckberrough, Sherry A. *Robert Delaunay: The Discovery of Simultaneity*. Ann Arbor: UMI Research Press, 1982.

Burnham, Jack. *Beyond Modern Sculpture: The Effect of Science and Technology on the Sculpture of This Century*. New York: Braziller, 1968.

Cabanne, Pierre. *Dialogues with Marcel Duchamp*. Trans. R. Padgett. New York: Viking, 1971.

Campbell, Joseph, ed. *Man and Time. Papers from the Eranos Yearbooks*. vol. 3. Princeton: Princeton University Press, 1957.

Canales, Jimena. *The Physicist and the Philosopher: Einstein, Bergson, and the Debate That Changed Our Understanding of Time*. Princeton: Princeton University Press, 2015.

Cendrars, Blaise. *La Prose du Transsibérien et de la petite Jehanne de France*. Illus. Sonia Delaunay-Terk. Paris: Éditions des Hommes Nouveaux, 1913.

Clair, Jean, ed. *Cosmos: From Romanticism to the Avant-garde*. Montreal: Montreal Museum of Fine Art, 1999.

Clarke, Bruce. *Energy Forms: Allegory and Science in the Era of Classical Thermodynamics*. Ann Arbor: University of Michigan Press, 2001.

Clarke, Bruce, and Linda Dalrymple Henderson, eds. *From Energy to Information: Representation in Science and Technology, Art, and Literature*. Stanford: Stanford University Press, 2002.

Delaunay, Robert. *Du Cubisme à l'art abstrait*. Ed. Pierre Francastel. Paris: S.E.V.P.E.N., 1957.

Didi-Huberman, George. "'Picture = Rupture': Visual Experience, Form and Symptom According to Carl Einstein" (1996). Trans. C. F. B. Miller. In *Papers of Surrealism*, no. 7 ("The Use-Value of *Documents*") (2007), n.p. http://www.surrealismcentre.ac.uk.

Doesburg, Theo van, El Lissitzky, and Hans Richter. "Declaration of the International Fraction of Constructivists of the First International Congress of Progressive Artists." In Charles Harrison and Paul Wood, eds., *Art in Theory 1900–2000*, 2nd ed., 314–316 Oxford: Blackwell Publishing, 2003. The text was first published in *De Stijl* 5, no. 4 (1923): 61–64.

Duchamp, Marcel. *Marcel Duchamp: Notes*. Ed. and trans. P. Matisse. Boston: G. K. Hall, 1983.

Duchamp, Marcel. *Salt Seller: The Writings of Marcel Duchamp*. Ed. Michel Sanouillet and Elmer Peterson. New York: Oxford University Press, 1973. Reprinted as *The Writings of Marcel Duchamp*. New York: Da Capo Press, 1989.

Eddington, Arthur. *A különleges és az általános relativitás elmélete*. Budapest: Pantheon, 1921.

Eddington, Arthur. *The Expanding Universe*. Cambridge: Cambridge University Press, 1946.

Eddington, Arthur. *The Expanding Universe: Astronomy's "Great Debate," 1900–1931*. New York: Macmillan, 1933.

Eddington, Arthur. *Ideas and Opinions*. New York: Three Rivers Press, 1954.

Eddington, Arthur. *Internal Constitution of Stars*. Cambridge: Cambridge University Press, 1926.

SELECTED BIBLIOGRAPHY

Eddington, Arthur. *The Nature of the Physical World*. New York: Macmillan, 1928.

Eddington, Arthur. *New Pathways in Science*. New York: Macmillan, 1935.

Eddington, Arthur. *Philosophy of Physical Science*. Cambridge: Cambridge University Press, 1939.

Eddington, Arthur. *Relativity: The Special and General Theory*. New York: Henry Holt, 1920.

Eddington, Arthur. *Science and the Unseen World*. New York: Macmillan, 1929.

Eddington, Arthur. *Space, Time and Gravitation: An Outline of the General Relativity Theory*. Cambridge: Cambridge University Press, 1920.

Eddington, Arthur. *Stars and Atoms*. Oxford: Clarendon Press, 1927.

Einstein, Albert. "Autobiographical Notes." In Paul Arthur Schlipp, ed., *Albert Einstein: Philosopher-Scientist*, 2–95. Chicago: Open Court, 1949.

Einstein, Albert. "Zur Elektrodynamik bewegter Körper." *Annalen der Physik* 17 (1905): 891–921.

Einstein, A., and H. Minkowski, eds. *The Principle of Relativity: Original Papers*. Calcutta: University of Calcutta, 1920.

Einstein, Carl. "André Masson, an Ethnological Study" (1929). Trans. K. Fijalkowski and M. Richardson. In Dawn Ades and Simon Baker, eds., *Undercover Surrealism: Georges Bataille and Documents*, 244–247. London: Hayward Gallery, 2006.

Einstein, Carl. *Georges Braque*. Trans. E. Zipruth. Paris: Chroniques du Jour, 1934.

Fabre, Gladys. *Abstraction-Création 1931–1936*. Paris: Musée d'Art Moderne de la Ville de Paris, 1978.

Fabre, Gladys. *Paris: Arte Abstracto—Arte Concreto—Circle et Carré-1930*. Valencia, Spain: IVAM Centre Julio Gonzalez, 1990.

Felix, Zdenek, ed. *Francis Picabia: The Late Works 1933–1953*. Stuttgart: Hatje, 1998.

Fort, Ilene Susan, ed. *Helen Lundeberg: A Retrospective*. New York: Grand Central Press, 2016.

Gabo, Naum. *Gabo: Constructions, Sculpture, Paintings, Drawings, Engravings*. London: Lund Humphries, 1957.

Gabo, Naum. *Gabo on Gabo: Texts and Interviews*. Ed. Martin Hammer and Christina Lodder. East Sussex, UK: Artists Bookworks, 2000.

Galerie Barbazanges. *R. Delaunay, Marie Laurencin: Les peintres*. Paris: Galerie Barbazanges, 1912.

Galison, Peter. "Minkowski's Space-Time: From Visual Thinking to the Absolute World." *Historical Studies in the Physical Sciences* 10 (1979): 85–121.

Galison, Peter L., Gerald Holton, and Silvan S. Schweber, eds. *Einstein for the 21st Century: His Legacy in Science, Art, and Modern Culture*. Princeton: Princeton University Press, 2008.

Gallatin, A. E., et al., eds. *American Abstract Artists, 1939*. New York: AAA, 1939.

Gamwell, Lynn. *Exploring the Invisible: Art, Science and the Spiritual*. Princeton: Princeton University Press, 2002.

Glick, Thomas F., ed. *The Comparative Reception of Relativity*. Dordrecht, Holland: D. Reidel, 1987.

Golan, Romy. *Muralnomad: The Paradox of Wall Painting, Europe 1927–1957*. New Haven: Yale University Press, 2009.

Grau, Oliver. *Virtual Art: From Illusion to Immersion.* Trans. Gloria Custance. Cambridge, MA: MIT Press, 2003.

Green, Christopher. *Picasso: Architecture and Vertigo.* New Haven: Yale University Press, 2005.

Greene, Vivien, ed. *Italian Futurism 1909–1944: Reconstructing the Universe.* New York: Solomon R. Guggenheim Museum, 2014.

Hahl-Koch, Jelena, ed. *Arnold Schoenberg/Wassily Kandinsky: Letters, Pictures, Documents.* London: Faber and Faber, 1984.

Hammer, Martin, and Christina Lodder. *Constructing Modernity: The Art and Career of Naum Gabo.* New Haven: Yale University Press, 2000.

Head, Jeffrey, and John T. Hill, eds. *Herbert Matter: Modernist Photography and Graphic Design.* Stanford: Stanford University Libraries, 2005.

Heisenberg, Werner. *Encounters with Einstein and Other Essays on People, Particles, and Places.* Princeton: Princeton University Press, 1989.

Henderson, Linda Dalrymple. "Abstraction, the Ether, and the Fourth Dimension: Kandinsky, Mondrian, and Malevich in Context." In Marian Ackermann and Isabelle Malz, eds., *Kandinsky, Malewitsch, Mondrian: Der Weisse Abgrund Unendlichkeit / The Infinite White Abyss*, 37–55 (German), 233–244 (English). Düsseldorf: Kunstsammlung Nordrhein-Westfalen, 2014.

Henderson, Linda Dalrymple. "Bilder der Frequenz. Moderne Kunst, elektromagnetische Wellen und der Äther im frühen 20. Jahrhundert." In Friedrich Balke, Bernhard Siegert, and Joseph Vogl, eds., *Archiv für Mediengeschichte 11 (Takt und Frequenz)*, 51–65. Munich: Wilhelm Fink, 2011.

Henderson, Linda Dalrymple. "Claude Bragdon, the Fourth Dimension, and Modern Art in Cultural Context." In Eugene Victoria Ellis and Andrea G. Reithmayr, eds., *Claude Bragdon and the Beautiful Necessity*, 73–86. Rochester, NY: Cary Graphic Arts Press, 2010.

Henderson, Linda Dalrymple. *Duchamp in Context: Science and Technology in the Large Glass and Related Works.* Princeton: Princeton University Press, 1998.

Henderson, Linda Dalrymple. "Editor's Introduction: I. Writing Modern Art and Science – An Overview; II. Cubism, Futurism, and Ether Physics in the Early Twentieth Century." *Science in Context* 17 (Winter 2004): 423–466.

Henderson, Linda Dalrymple. "Einstein and 20th-Century Art: A Romance of Many Dimensions." In Peter L. Galison, Gerald Holton, and Silvan S. Schweber, eds., *Einstein for the 21st Century: His Legacy in Science, Art, and Modern Culture*, 101–129. Princeton: Princeton University Press, 2007.

Henderson, Linda Dalrymple. "The Forgotten Meta-Realities of Modernism: Die Uebersinnliche Welt and the International Cultures of Science and Occultism." *Glass Bead*, no. 0 (2016). http://www.glass-bead.org/article/the-forgotten-meta-realities-of-modernism/

Henderson, Linda Dalrymple. "Four-Dimensional Space or Space-Time: The Emergence of the Cubism-Relativity Myth in New York in the 1940s." In Michele Emmer, ed., *The Visual Mind II*, 349–397. Cambridge, MA: MIT Press, 2005.

Henderson, Linda Dalrymple. *The Fourth Dimension and Non-Euclidean Geometry in Modern Art.* Rev. ed. Cambridge, MA: MIT Press, 2013.

Henderson, Linda Dalrymple. "The 'Fourth Dimension' as Sign of Utopia in Early Modern Art and Culture." In Mary Kemperink and Leonieke Vermeer, eds., *Utopianism and the Sciences*, 1–15. Leuven: Peeters, 2009.

Henderson, Linda Dalrymple. "The Image and Imagination of the Fourth Dimension in 20th-Century Art and Culture." *Configurations: A Journal of Literature, Science, and Technology* 17 (Winter 2009): 131–160.

Henderson, Linda Dalrymple. "The *Large Glass* Seen Anew: Reflections of Contemporary Science and Technology in Marcel Duchamp's 'Hilarious Picture.'" *Leonardo* 32, no. 2 (April 1999): 113–126.

Henderson, Linda Dalrymple. "Modern Art and Science 1900–1940: From the Ether and a Spatial Fourth Dimension (1900–1920) to Einstein and Space-Time (1900–1940)." In Cathrin Pichler with Suzanne Neuburger, eds., *The Moderns: Wie sich das 20. Jahrhundert in Kunst und Wissenschaft erfunden hat*, 175–206. New York and Vienna: Springer, 2013.

Henderson, Linda Dalrymple. "Paradigm Shifts and Shifting Identities in the Career of Marcel Duchamp, Anti-Bergsonist 'Algebraicist of Ideas.'" In Anne Collins Goodyear and James W. McManus, eds., *aka Marcel Duchamp: Meditations on the Identities of an Artist*, 76–94, 103-106. Washington, DC: Smithsonian Institution Scholarly Press, 2014.

Henderson, Linda Dalrymple. "Park Place: Its Art and History." In *Reimagining Space: The Park Place Gallery Group in 1960s New York*. Austin, TX: Jack S. Blanton Museum of Art, 2008.

Henderson, Linda Dalrymple. "Uncertainty, Chaos, and Chance in Early Twentieth-Century Art: The Cases of Wassily Kandinsky and Marcel Duchamp." *Étant Donné Marcel Duchamp* 4 (2002): 130–145.

Henderson, Linda Dalrymple. "Vibratory Modernism: Boccioni, Kupka, and the Ether of Space." In Linda Dalrymple Henderson and Bruce Clarke, eds., *From Energy to Information: Representation in Science and Technology, Art, and Literature*, 126–149. Stanford: Stanford University Press, 2002.

Henry, Holly. *Virginia Woolf and the Discourse of Science: The Aesthetics of Astronomy*. Cambridge: Cambridge University Press, 2003.

Hinton, Charles Howard. *The Fourth Dimension*. London: Swan Sonnenschein, 1904.

Hoving, Kirsten A. "Jackson Pollock's Galaxy: Outer Space and Artist's Space in Pollock's Cosmic Paintings." *American Art* 16, no. 1 (Spring 2002): 82–93.

Hoving, Kirsten A. *Joseph Cornell and Astronomy: A Case for the Stars*. Princeton: Princeton University Press, 2009.

Hubble, Edwin. *Proceedings of the National Academy of Sciences of the United States of America* 15, no. 168 (1929).

Hubble, Edwin. *The Realm of the Nebulae*. New Haven: Yale University Press, 1982 [1936].

Jeans, James. *The Mysterious Universe*. Cambridge: Cambridge University Press, 1931.

Jeans, James. *Physics and Philosophy*. Cambridge: Cambridge University Press, 1942.

Jeans, James. *Problems of Cosmogony*. New York: E. P. Dutton, 1929.

Jeans, James. *The Stars in Their Courses*. New York: MacMillan, 1931.

Jeans, James. *Through Space and Time*. Cambridge: Cambridge University Press, 1934.

Jeans, James. *The Universe around Us*. Cambridge: Cambridge University Press, 1929.

Kandinsky, Wassily. *Complete Writings on Art*. Ed. Kenneth C. Lindsay and Peter Vergo. New York: Da Capo Press, 1994.

Kandinsky, Wassily. "The Yellow Sound: A Stage Composition." In Wassily Kandinsky and Franz Marc, eds., *The Blaue Reiter Almanac*, 207–225. New York: Viking, 1974.

Kessler, Elizabeth A. *Picturing the Cosmos: Hubble Space Telescope Images and the Astronomical Sublime*. Minneapolis: University of Minnesota Press, 2012.

Kostelanetz, Richard. "Moholy-Nagy: Proto-Holographer." *Structurist* 27–28 (1987–1988): 12–14.

Kragh, Helge. *Quantum Generations: A History of Physics in the Twentieth Century*. Princeton: Princeton University Press, 1999.

Kultermann, Udo. *The New Sculpture: Environments and Assemblages*. Trans. S. Baron. London: Thames and Hudson, 1968.

Lanchner, Carolyn. *Joan Miró*. New York: Museum of Modern Art, 1993.

Lissitzky, El. "Proun." *MA* 7, no. 1 (October 1922): n.p.

Long, Rose-Carol Washton. *Kandinsky: The Development of an Abstract Style*. Oxford: Clarendon Press, 1980.

Lynton, Norbert. *Ben Nicholson*. London: Phaidon Press, 1993.

Majoros, Valéria. "Lajos Tihanyi's American Sojourn: 1929–30." *Hungarian Studies Review* 21, no. 1–2 (Spring/Fall 1994): 10–12.

Malevich, Kazimir. "Szuprematizmus." *Egység*, no. 3 (September 1922): 5–6.

Malloy, Vanja. "Calder and the Dynamic Cosmos." In Theodora Vischer, ed., *Calder and Fischli/ Weiss*, 164–178. Basel: Fondation Beyeler, 2016.

Malloy, Vanja. "Calder and the Solar Eclipse: Breakthroughs in Astronomy, Physics, and Art." In Elizabeth Turner, ed., *Alexander Calder: Radical Inventor*. Montreal: Montreal Museum of Fine Arts, 2018.

Malloy, Vanja. "Non-Euclidean Space, Movement and Astronomy in Modern Art: Alexander Calder's Mobiles and Ben Nicholson's Reliefs." *EPJ Web of Conferences* 58 (2013). https://www. epj-conferences.org/articles/epjconf/abs/2013/19/epjconf_tm2012_04004/epjconf_ tm2012_04004.html.

Malloy, Vanja. "Rethinking Alexander Calder: Astronomy, Relativity, and Psychology." PhD dissertation, The Courtauld Institute of Art, 2014.

Malloy, Vanja. "Rethinking Alexander Calder's *Universes* and *Mobiles*: The Influences of Einsteinian Physics and Cosmology." *The Courtauld Institute of Art Immediations* 3, no. 1 (December 2012): 9–26.

Manning, Henry P., ed. *The Fourth Dimension Simply Explained: A Collection of Essays*. New York: Scientific American Publishing, 1910.

Mantura, Bruno, Patrizia Rosazza-Ferraris, and Livia Velani, eds. *Futurism in Flight: "Aeropittura" Paintings and Sculptures of Man's Conquest of Space (1913-1945)*. London: Accademia Italiana delle Arte e delle Arti Applicate, 1990.

Marché, Jordon D. *Theatres of Time and Space: American Planetaria 1930-1970*. New Brunswick: Rutgers University Press, 2005.

Martin, J. L., Ben Nicholson, and Naum Gabo, eds. *Circle: International Survey of Constructive Art*. New York: Praeger, 1971 (1937).

Meyerson, Émile. "Le physicien et le primitif." *Revue philosophique* 55, nos. 5–6 (May-June 1930): 319–358.

Mezei, Árpád. "Forma." *Is*, no. 1 (1924).

Mezei, Árpád, and Marcel Jean. *Histoire de la peinture surréaliste* [History of Surrealist painting]. Paris: Éditions du Seuil, 1959.

Moholy-Nagy, László. "Modern Art and Architecture." In Krisztina Passuth, *Moholy-Nagy*. New York: Thames and Hudson, 1985 (1937).

Moholy-Nagy, László. *The New Vision: From Material to Architecture*. Trans. Daphne M. Hoffmann. New York: Brewer, Warren & Putnam, 1928.

Moholy-Nagy, László. *The New Vision: Fundamentals of Design, Painting, Sculpture, Architecture*. Rev. American ed. New York: W. W. Norton, 1938.

Moholy-Nagy, László. *Vision in Motion*. Chicago: P. Theobald, 1947.

Parkinson, Gavin. *The Duchamp Book*. London: Tate Publishing, 2008.

Parkinson, Gavin. *Surrealism, Art and Modern Science: Relativity, Quantum Mechanics, Epistemology*. New Haven: Yale University Press, 2008.

Petersen, Stephen. *Space-Age Aesthetics: Lucio Fontana, Yves Klein, and the Postwar European Avant-Garde*. University Park: Pennsylvania State University Press, 2009.

Prampolini, Enrico. "The Magnetic Theatre and the Futuristic Scenic Atmosphere: Sceno-Synthesis – Sceno-Plastics – Sceno-Dynamics – Poly-Dimensional Scenic Space – The Actor-Space – The Poly-Dimensional Expressive and Magnetic Theatre." *Little Review*, no. 11 (Winter 1926): 101–108.

Puech, Henri-Charles. "Picasso et la répresentation." *Documents*, no. 3 (1930): 118–122.

Rainey, Lawrence, et al. *Futurism: An Anthology*. New Haven: Yale University Press, 2009.

Ram, Harsha. "Special Topic: Introducing Georgian Modernism." *Modernism/Modernity* 21, no. 1 (January 2014): 283–359.

Reichenbach, Hans. "Crise de la causalité" [Crisis of causation]. *Documents* 1, no. 2 (May 1929): 105–108.

Rousseau, Pascal, and Jean-Paul Ameline. *Robert Delaunay 1906–1914: De l'impressionisme à l'abstraction*. Paris: Editions du Centre Pompidou, 1999.

Schapiro, Meyer. "Einstein and Cubism: Science and Art." In *The Unity of Picasso's Art*, 49–149. New York: George Braziller, 2000.

Shlain, Leonard. *Art and Physics: Parallel Visions in Space, Time, and Light*. New York: William Morrow, 1991.

Sirató, Charles. Dimensionist Manifesto. Loose-leaf insert intended for the unrealized journal *La Revue N + 1* (to have been published by José Corti, Paris, 1936). Published (in French) as a supplement to *Plastique*, no. 2 (Summer 1937) and (in English) in Mary Ann Caws, ed., *Manifesto: A Century of Isms* (Lincoln: University of Nebraska Press, 2001), 536–538.

Sirató, Charles [Tamkó Sirató Károly]. *A Dimenzionista Manifesztum története: a dimenzionizmus (nemeuklideszi művészetek) I. albuma: az avantgárd művészetek rendszerbe foglalása* [The history of the Dimensionist Manifesto: Album I of Dimensionism (non-Euclidean arts). The systematization of avant-garde arts]. Budapest: Artpool and Magyar Műhely Kiadó, 2010.

Sirató, Charles. *Le Planisme: La décomposition de la littérature*. Paris: Éditions de la Nouvelle Réalité, 1936.

Snow, Charles Percy. *The Two Cultures*. Cambridge: Cambridge University Press, 2001.

Spengler, Oswald. *The Decline of the West*. New York: Alfred A. Knopf, 1934.

Steiner, Rudolf. *Rudolf Steiner: The Fourth Dimension—Sacred Geometry, Alchemy, and Mathematics*. Trans. C. E. Creeger. Great Barrington, MA: Anthroposophic Press, 2001.

Treitel, Corinna. *A Science for the Soul: Occultism and the Genesis of the German Modern*. Baltimore: Johns Hopkins University Press, 2004.

Venn, Beth, ed. *Joseph Cornell Cosmic Travels: Collection in Context*. New York: Whitney Museum of American Art, 1996.

Warehime, Marja. *Brassaï: Images of Culture and the Surrealist Observer*. Baton Rouge: Louisiana State University Press, 1996.

Wazeck, Milena. *Einstein's Opponents: The Public Controversy about the Theory of Relativity in the 1920s*. Trans. G. S. Koby. Cambridge: Cambridge University Press, 2014.

INDEX